Drawing

FOR

DUMMIES®

2ND EDITION

Drawing

FOR

DUMMIES®

2ND EDITION

by Jamie Combs and Brenda Hoddinott

WILEY

Wiley Publishing, Inc.

Drawing For Dummies®, 2nd Edition

Published by
Wiley Publishing, Inc.
111 River St.
Hoboken, NJ 07030-5774
www.wiley.com

For general information on our other products and services, please contact our Customer Care Department within the U.S. at 877-762-2974, outside the U.S. at 317-572-3993, or fax 317-572-4002.

For technical support, please visit www.wiley.com/techsupport.

Wiley also publishes its books in a variety of electronic formats. Some content that appears in print may not be available in electronic books.

Library of Congress Control Number: 2010943050

ISBN: 978-0-470-61842-4

Manufactured in the United States of America

10 9 8 7 6

WILEY

About the Authors

Jamie Combs is an artist and educator who grew up and lived in the Midwest until making a recent relocation to the East Coast. She earned a BFA in painting from Kendall College of Art and Design in Grand Rapids, Michigan, and an MFA in painting from Indiana University in Bloomington, Indiana. For several years, she has been teaching courses in drawing, painting, color theory, and design at various schools, including the Herron School of Art and Design in Indianapolis, Indiana, DePauw University in Greencastle, Indiana, and Ivy Tech Community College in Bloomington, Indiana. Jamie's work as an artist and teacher is heavily informed by her training in and love for drawing.

Brenda Hoddinott is a self-educated visual artist, forensic artist, and illustrator. Her favorite drawing subjects are people, and her styles include hyperrealism, surrealism, and fantasy.

Dedication

For my mom – JC

Author's Acknowledgments

Jamie Combs: I would like to thank Michael Lewis, Sarah Faulkner, and Amanda Langferman from Wiley Publishing for their help and expertise in making this project possible. To Mick Gow of www.ratemydrawings.com, your expertise has made this book so much more valuable.

I would also like to thank the authors of *Pastels For Dummies* and *Painting For Dummies* and my friends and colleagues at the Herron School of Art and Design, Anita Giddings and Sherry Stone, for the opportunity they pointed me to, their advice, and their kind, constant encouragement.

I wish to express my gratitude to all my teachers, especially Perin Mahler, Deborah Rockman, Barry Gealt, Tim Kennedy, and Bonnie Sklarski. I would also like to express my undying gratitude to my students, who have taught me so many surprising things about what it's like to learn to draw.

Finally, to my friends and family: Thank you for being there for me. I can't imagine trying to do this without you.

Publisher's Acknowledgments

We're proud of this book; please send us your comments at http://dummies.custhelp.com. For other comments, please contact our Customer Care Department within the U.S. at 877-762-2974, outside the U.S. at 317-572-3993, or fax 317-572-4002.

Some of the people who helped bring this book to market include the following:

Acquisitions, Editorial, and Media Development

Project Editors: Sarah Faulkner, Kelly Ewing
 (Previous Edition: Mary Goodwin)

Acquisitions Editor: Michael Lewis

Copy Editor: Amanda M. Langferman

Assistant Editor: David Lutton

Technical Editor: Joe Forkan

Editorial Manager: Christine Meloy Beck

Editorial Assistants: Rachelle S. Amick, Jennette ElNaggar

Art Coordinator: Alicia B. South

Cover Photos: Leandra Young

Cartoons: Rich Tennant (www.the5thwave.com)

Composition Services

Project Coordinator: Patrick Redmond

Layout and Graphics: Claudia Bell, Samantha Cherolis, Lavonne Roberts, Christin Swinford

Proofreader: Betty Kish

Indexer: Sharon Shock

Illustrators: Jamie Combs, Brenda Hoddinott, Kensuke Okabayashi, Barbara Frake, Mick Gow, Rosemary Sidaway

Publishing and Editorial for Consumer Dummies

Diane Graves Steele, Vice President and Publisher, Consumer Dummies

Kristin Ferguson-Wagstaffe, Product Development Director, Consumer Dummies

Ensley Eikenburg, Associate Publisher, Travel

Kelly Regan, Editorial Director, Travel

Publishing for Technology Dummies

Andy Cummings, Vice President and Publisher, Dummies Technology/General User

Composition Services

Debbie Stailey, Director of Composition Services

Contents at a Glance

Table of Contents

Introduction

W elcome to *Drawing For Dummies,* 2nd Edition, a book that focuses on the basics of drawing for beginning artists but also includes plenty of challenges for more experienced artists.

Most people begin to draw as soon as they can hold a crayon and then continue drawing enthusiastically throughout childhood. Some people keep drawing right into adulthood, while others wander off in different directions for a while and then rediscover drawing later in life. Because we've designed this book to be a helpful, user-friendly resource that assumes nothing about your experience, *Drawing For Dummies,* 2nd Edition, meets you wherever you are.

Our philosophy is simple: If you know how to see and make comparisons, you have what it takes to draw. Throughout this book, we show you a solid, manageable approach to drawing that works no matter what you're drawing. As you make your way through the book, you may be surprised to discover that after you figure out how to draw one subject, you can apply the same concepts to draw just about anything.

About This Book

Within this book, you discover everything you need to know to get started with drawing, including what supplies, techniques, and processes you need to use to create different types of drawings. The most valuable parts of this book are the numerous exercises and projects we include for you to try, so be sure to keep your drawing supplies handy while you read! Along the way to each exercise and project, you find ideas, tips, and strategies that will help you finish it.

We cover a variety of subjects that all aim to reinforce the notion that good drawing comes from good seeing and to help you develop your drawing skills in a fun and efficient way. But don't feel like you have to read it cover to cover. You can pick and choose what you read without missing the central ideas of the book. In most chapters, you find issues that are covered more fully in other chapters, but don't fret; we provide plenty of cross-references to take you where you need to go to find the information you need.

The hundreds of illustrations you find in this book are there to show you what a solution to an idea or exercise may look like. They're meant to illuminate and inspire, not to be exact replicas of your own drawings. When you work through the exercises and projects in this book, don't worry if your drawings look different than the illustrations. The point is to master the concepts, not to adopt a particular drawing style. Your drawings will be unique creations — even if you follow the instructions exactly.

Your development as an artist is personal. Expect it to be unlike anything you've ever seen or known. Of course, you don't have to navigate the journey by yourself. This book is here to help you understand key ideas about drawing and master important techniques and skills that artists throughout time have discovered again and again. All you need is an open, curious mind and a little patience and persistence.

Conventions Used in This Book

We've established the following conventions to make it easier for you to navigate this book:

- ✔ New terms are in *italics,* and we define them for you.

- ✔ **Bold** text highlights key words in bulleted lists and action parts in numbered lists.

- ✔ Monofont sets off Web addresses. When this book was printed, some Web addresses may have needed to break across two lines of text. If that happened, rest assured that we haven't put in any extra characters (such as hyphens) to indicate the break. So, when using one of these Web addresses, just type in exactly what you see in this book, pretending as though the line break doesn't exist.

- ✔ Before each project or exercise, you find a list of recommended supplies. If you don't have exactly those supplies, don't worry; you can do all the projects in this book with whatever supplies you do have. The results may be a little different, but not having the "right" supplies shouldn't be a barrier to drawing.

What You're Not to Read

It's not every day you're told to skip part of a book, and, in all honesty, we certainly won't mind if you read every page of this one. But if you're strapped for time or just in a hurry to get to what interests you most, feel free to skip the following:

✔ **Any text marked with a Technical Stuff icon:** Although these paragraphs are interesting and may give you more insight into the world of drawing, they aren't essential to your growth as an artist.

✔ **Sidebars:** These gray-shaded boxes of text house information that's often fun and interesting (at least to us!) but slightly off topic.

If you're serious about learning to draw, don't skip over the stuff that looks more like work than fun. If you do skip over it initially, go back to it later because the work-oriented sections contain a lot of info about skills you need to have to kick-start your artistic growth. Art is work, but, as you may already know, the work is totally worth it and, in some cases, is actually the fun part!

Foolish Assumptions

In writing this book, we've made some assumptions about you:

✔ You've drawn a little but not in a serious way, and you'd really like to find out how to do it well.

✔ You may be afraid that drawing well depends on obvious natural ability.

✔ You may think drawing well means being able to draw realistically from your imagination.

✔ You may think drawing is only good if you create a good product.

We've used these assumptions to help us explain a whole new way of looking at drawing. As you make your way through this book, you find that our philosophy of drawing allows you to believe the following: that drawing is more than making a good product, that the act of drawing is a healthy and fulfilling experience in itself, that talent alone isn't enough to lead to good drawings, and that you can learn to be excellent at drawing no matter where you're starting from.

How This Book Is Organized

This book begins by helping you feel comfortable with drawing. From there, you discover the basics, from buying supplies to holding a pencil and from drawing lines to rendering shading. The rest of the book is loaded with various drawing subjects and topics; feel free to skip around in no particular order. Read a little, then draw a little, and then read and draw some more.

Part I: Discovering What It Takes to Draw

The title of this part says it all. If you're not totally convinced that drawing is for you, read through this part chapter by chapter and do the exercises and projects we include here. By the time you finish, you may be surprised by how many of your concerns about taking up drawing are gone.

Here, you find information about what you need to know to start drawing from a list of drawing supplies to use to different ways to find inspiration to a summary of the steps you go through to make a drawing. You also discover what it means to look at the world around you as an artist.

As an added bonus, you find everything you need to know about the world of digital drawing (drawing with your computer and other similar devices) in case you're curious about how that type of drawing compares to traditional pencil and paper.

Drawing is a perfectly natural human ability. As with anything new, taking the first step is the most difficult part. But once you start working through this part, you'll likely discover a whole new, exciting, enjoyable, and productive activity.

Part II: Developing the Basic Skills

If you're a beginner to drawing, you won't want to miss the six chapters in this part. The basic skills we present here offer answers to many of the perplexing drawing questions you've probably been wondering about, like how to get started on a drawing, how to create dimension on a flat piece of paper, and many more. Even if you're a pro at drawing, you don't want to skip this part because you may find some new slants on old skills.

Here, you discover strategies you can use to transform three-dimensional objects into believable two-dimensional illusions. You find out how to use shading to render light and shadow as they move across objects and through space. You also figure out how to arrange and draw your subjects to create a complete and balanced drawing with a convincing sense of depth.

Whether you work your way through this part of the book in a few days or a few months doesn't matter. Just stick with it, and give yourself the gift of a solid foundation for drawing. By taking your time to develop the basic skills you need in drawing, you'll save yourself a ton of frustration down the road.

Part III: Experimenting with Subject Matter

In this part, you find a handful of chapters focused on the four major categories of drawing subjects: still life, landscape, animals, and people. Each chapter presents the drawing issues that come up when you're drawing its particular subject of focus. You find out how to start your drawings in a simple way for both maximum control and maximum flexibility, and you get several opportunities to practice creating finished drawings of each type of subject.

By working through all or even two or three of the chapters in Part III, you discover that you really do have the tools you need to draw anything, because the act of drawing is essentially the same no matter what your subject is.

Part IV: The Part of Tens

This part of the book includes a buffet of tips to help make the drawing process a little easier for you, as well as ideas for drawing cartoons. If you've never thought about cartooning, perhaps this part will inspire you.

In case you finish all the projects we include in this book and still want more, we also include ten ways for you to grow as an artist. Finally, we answer some copyright questions to help you keep your work secure and to keep you from infringing on the rights of other artists.

Icons Used in This Book

In the margins of almost every page of this book, you find little circular drawings called *icons*. The icons are there to alert you to different types of information. Here's what they mean:

This icon saves you time and energy by showing you a helpful method for doing something.

This icon points out important information you need to know as you develop your drawing skills. Sometimes it's a reminder of something covered elsewhere in the book, and other times it lets you know that you need to remember this particular tidbit later.

This icon points out potential problems and positive solutions. Heed the warning so you don't make the same mistakes we've made.

Feel free to skip over (and come back to) the highly technical information marked by this icon. We expect that our more advanced readers will be interested in knowing a little more about the technical aspects of drawing.

When you see this icon, dig out your drawing materials, open your sketchbook, put the cat out, feed the dog, and get ready to spend some quality time drawing. Plan on doing lots of exercises and projects marked with this icon because your drawing skills improve every time you draw.

Where to Go from Here

You don't have to go through this book in sequence. You can poke through the table of contents and jump right into the topics that excite you. To make sure you don't miss out on something important while you're skipping around the book, we provide lots of references to pertinent material so you know where to go to find what you need. For example, you may be asked to apply shading to your drawing on many occasions throughout this book. Because it would take forever to go over everything you need to know about shading (and all the techniques you can use) every time an exercise or project calls for it, we don't explain shading every time we ask you to do it. Instead, we tell you to go to Chapter 9 (the chapter on shading) to find what you need to know.

If you're a beginner to drawing, you may prefer to start at the very beginning with Part I and work your way through each chapter in sequence. When you finish that part, we strongly recommend that you read over all the information and work through each project and exercise in Part II before you move on.

After you have the basics under your belt, you can randomly wander through the rest of this book and read and enjoy whichever chapters and sections you prefer. Even though this is a reference book, it's also designed for those of you who like to work from beginning to end. As you make your way through it, you discover that the level of difficulty increases the closer you get to the end of the book.

If you can already draw well, feel free to pop around this book any way you want. Take a quick flip through the pages, notice which illustrations catch your eye, and start reading wherever you feel inspired. Read some sections, draw a little, read a little while longer, and then do more drawings.

Part I
Discovering What It Takes to Draw

The 5th Wave By Rich Tennant

BLACK LIGHT

In this part . . .

Think of the first five chapters of this book as an artist's version of Clark Kent's telephone booth. Imagine yourself, mild mannered and curious, walking into Part I . . . and a little later, walking out armed with everything you need to know to begin drawing.

The chapters in this part describe the tools, mindset, and processes you need to be familiar with before you start putting pencil to paper. Here, you find an overview of all the subjects you can explore in this book as well as a full chapter on the tips and tricks to keep in mind when choosing your first drawing supplies. To give you a quick glance into the future of your drawing career, this part also includes a chapter that summarizes each of the common steps in the drawing process. And because it's the digital age, you find a whole chapter devoted to using hi-tech drawing materials, like your computer. Finally, you find out what it means to see the world and its inhabitants like an artist sees them.

Chapter 1

Gearing Up to Start (And Continue) Drawing

..

In This Chapter

▶ Taking the plunge to see if you have what it takes to start drawing

▶ Discovering what drawing is

▶ Finding the motivation, supplies, and style you need to keep drawing

▶ Developing drawing habits that'll get you through the rough patches

..

Drawing is primal, universal, and deeply personal all at once. It's primal because the tendency to draw is innate (in other words, you've probably been drawing since before you could talk). It's universal and personal because whether you choose to draw a tree or just a looping spiral, by putting marks on paper, you connect the inner workings of your mind to the outer world.

So you're ready to take a serious step toward honing your drawing skills. Well, you've come to the right place! This chapter is an introduction to drawing as a subject of study. Along with a quick summary of the materials and skills you need to get started, you find useful information about historical and contemporary approaches to drawing. In case you want to know more about any of the topics we touch briefly on here, we've peppered this chapter with references to other chapters where you can find in-depth coverage. As a bonus, we've included some information right at the beginning about how to tell whether or not drawing is for you. (Spoiler alert: Drawing is for you!)

Testing the Waters: Do You Have What It Takes to Draw?

For many burgeoning artists who have a nagging, tickling idea that they may have what it takes to draw, testing out the dream feels like a real risk. After all, if they fail, the dream will be gone — just like that. If you're afraid to risk

losing your dream of becoming an artist, stop worrying! Go ahead and take the risk; you may be surprised to discover that it isn't really a risk after all for one simple reason: Anyone who wants to learn to draw well can do so.

Debunking the talent myth

Every elementary school has at least one kid who can draw an amazing unicorn (or some other detailed animal or object) without looking at any books or photos for inspiration. All the teachers and students look at that kid and say, "That kid's got real talent." Maybe you were that kid in your school. Or maybe you only wished you could draw like that kid. Either way, you can learn to draw well today as long as you're ready to put your mind (and pencil) to work.

What's called *talent* in drawing is actually a heightened sensitivity to visual facts (which, lucky for you, is something anyone can develop!). To draw well, you must be able to see the physical facts, such as size, shape, value, texture, and color, of things and to make comparisons of what you see. Familiar objects are often hard to draw because when you look at them and know what they are, your brain doesn't take time to carefully analyze the way they look. To see things as they actually are, you must practice paying more attention to the facts of what something looks like than the facts of what something is as an object. When you're really tuned in to the facts of what something looks like, that particular something becomes much easier to draw. (See Chapters 5 and 7 for some great tips on how to change the way you see.)

Talent on its own doesn't make an artist. Yes, the ability to see like an artist and make visual comparisons is a necessary condition for drawing well, but they don't matter at all if you don't also have a passion for drawing. Even if you feel like you have no artistic talent whatsoever, if you have a desire to draw running through your veins, you can master the other stuff with a little determination and practice. After all, the bulk of getting better at drawing is work — not talent. No matter how talented you are, you won't grow as an artist if you don't physically work on honing your skills, and passion is what gives you the strength and motivation to do that work.

Embracing your individuality

One of the most compelling characteristics about artists is their uniqueness, or style. But don't think you have to have your own style right away. Even the most well-known and accomplished artists are often influenced by the work of others whom they admire. For example, you can see traces of Cezanne in Picasso, but Picasso was still unarguably unique.

You probably have a few artistic heroes of your own. Perhaps you've made some copies of their works or tried out their styles. If you haven't, give it a try; copying other works is a great way to practice and develop your drawing skills. Just know that you can't claim any copied work as your own. (Check out Chapters 2, 6, and 17 for details on how to develop as an artist by using other artists' works as inspiration, and refer to Chapter 18 for more details on copyright.)

Even as you copy the works and styles of your heroes, don't forget to embrace your own individuality as an artist, and don't try to purge the things about your drawings that are different from those of your heroes. They've already defined who they are as artists; now it's your turn! The things that make you different from your heroes are important clues about who you are as an artist.

Defining Drawing

Essentially, *drawing* is the act of applying marks to a surface. A drawing is usually made up of lines and tones on paper, but it hasn't always been that way and it isn't always that way today (see the following sections for more details).

However you define drawing, it's important to keep in mind that drawing is a verb; it's an action that you do. No matter what tools you use to draw, the act of drawing is the same: You move your hand/arm/whole body while holding a mark-making tool and leave traces of your movement on your drawing surface.

Looking back at the first drawings

The earliest known drawings are the ancient pictures of animals and figures made with natural pigments on the rocky walls of caves. These drawings predate written history and are some of the oldest records of what human life was like as many as 30,000 years ago. The Egyptians used drawings to create the pictograms that later became one of the first systems of writing (called *hieroglyphics*).

For hundreds of years, drawing was seen as a functional craft. People used it to communicate, tell stories, plan paintings, design architecture, and a whole lot more. The resulting drawings may have become beautiful artifacts, but their original purpose was preparatory and functional — not artistic.

Surveying current drawing trends

Today drawing takes many forms. Artists still use drawing as a way to communicate ideas and plan projects. For instance, architects still use drawing to design their buildings and other huge structures, but now they do most of this drawing on computers rather than cave walls or paper.

Although some people still see drawing as a means to plan the more valuable artistic elements found in paintings, drawing has also become its own art form. After all, many artists now choose drawing as their primary mode of expression. Ever curious and experimental, these artists use a startling variety of materials and styles to create their drawings. As a result, you can undoubtedly find your niche in drawing no matter where your interests lie. So whether you love traditional realistic drawings done with pencil or graphic-novel-like drawings done with ink, you're sure to find what you need in today's drawing world. If you don't know what you want to draw, don't worry! The world is yours to explore. (Check out Chapter 5 for details on how to see the world as an artist and Part III for lots of info on the different subject matter you can draw.)

Examining the Motivation behind Drawing

The desire to draw comes with being human. Children are voracious drawers, and although most people draw less often after childhood, they still encounter drawing occasionally when they're doodling in the margins of a notepad during a long lecture or plotting out their gardens for the year. You know instinctively how to connect your hand and brain to make marks on a drawing surface. Add a little motivation to that instinct, and you have everything you need to be great at drawing. So where do you find this motivation? The following sections show you some different ways you can use drawing and a few important benefits you can get from it.

Finding uses for drawing

As you probably already know, the act of drawing is great for planning things out, but you can also use it to create portraits, landscapes, cartoons, and still-life drawings. No matter what you choose to create through drawing, it's important to remember that drawing doesn't have to be a super-serious process that leads to a product worthy of the history books. Something about the act of drawing just feels good — even if the product you make is whimsical, temporary, or just plain silly.

If you ever feel overwhelmed by the seriousness of your drawing endeavors, give yourself a break and make some playful drawings. The following is a list of alternative, playful uses for drawing, just in case you need some inspiration:

✔ Use decorator icing to draw portraits of your friends or co-workers on cakes or cookies. (Keep in mind that realism isn't as important as creativity!)

✔ Use thread to draw on your pillowcases. (Yes, we're talking about embroidering here.)

✔ Draw with your feet. (Warning: This can get a little messy! Put a large sheet of paper on the floor. Dust your feet with powdered charcoal and walk around on the paper to make marks. See if you can make a some-what realistic drawing using your feet. Check out Chapters 12 through 15 for ideas about making realistic drawings of various subjects.)

✔ Draw in the sand or snow.

✔ Arrange rocks or plants in your garden to create a different kind of drawing.

Considering the benefits of drawing

Drawing is satisfying on so many levels: mentally, physiologically, emotionally, and socially. After all, when you draw, your mind reaches through your hand to make direct contact with the world. When you draw from observation, you have the opportunity to physically re-create what you see. It's like you're touching the subject with your pencil and exploring all its subtleties. No matter how your drawing turns out, when you draw something, you feel like you know it better when you're done than you did before you drew it.

Drawing helps you think and process thoughts. Your imagination can be quite fluid and fragmentary, moving from one partially formed idea to another and back again in rapid succession. Drawing out your ideas gives them tangible form and some level of permanence. Even if the form isn't exactly what you were thinking about, having a drawing to work with gives you something you can hold on to and work with.

Drawing is a whole-body experience. Your hand is the most obvious player, but pay attention the next time you draw. Notice the way your arms and shoulders move when you draw and the way your spine supports and responds to the movement. When you stand at an easel to draw, you find yourself falling into a dancelike rhythm — drawing, stepping back to check your drawing, stepping forward again to draw some more, and so on. Even if you sit when drawing, you still develop a physical rhythm. Regardless of where you draw, the process of drawing is a workout — which explains why you sometimes feel exhausted at the end of a drawing session. We can't say drawing is a substitute for a jog around the park, but you'll certainly feel like you've done something after you draw!

Emotionally speaking, drawing is somewhat of a mixed bag. But even though drawing will sometimes leave you feeling upset if not outright distraught, the emotional benefits you get from drawing far outweigh the costs. Consider the following:

✔ The physiological benefits of drawing are part of the emotional benefits. Moving around to draw and tensing and releasing your muscles can really elevate your mood.

✔ Learning to draw boosts your overall confidence. As your drawing skills improve, your confidence grows, and greater confidence makes the tougher drawing days easier to manage.

✔ The feeling you get from making a mark in response to something you see and knowing that the mark is just right makes all the work you put into your drawings worth it. If you catch it just right, even the curve of a vase can be one of the most exhilarating things you've ever seen!

Because drawing is a solitary activity, it may seem like an unlikely source of social benefits. However, because drawing is a solitary activity that generates questions and excitement, you'll likely be itching to talk to people about your drawings as you create and finish them. Enthusiasm is contagious!

Many communities have sketch groups that meet regularly to draw and share ideas. To find one near you, check your local newspaper or try typing *art group* along with the name of your city and state into your favorite search engine. Turn to Chapter 4 for some great tips on how to find online communities where you can meet tons of like-minded people to talk to about drawing and art in general.

Outfitting Yourself for the Job

If you've ever found yourself standing in front of a 4-foot-high shelf filled with 17 different kinds of erasers and even more types of pencils, you know choosing art supplies can be a daunting task. To make it a little more manageable, we suggest that you make a list before you go to the store so you at least know what to look for when you get there. (Check out Chapter 2 for some helpful and specific information about drawing supplies, including a breakdown of the different grades of pencils you can get and some examples of what they can do.)

When you're first starting out, try to buy your supplies at an art supply store. Although you can pick up a few tools from the office supply aisle at your local grocery store, it's best to stick with the experts until you have a better handle on what your supplies can and should do. By shopping at an art supply store, you can also get answers to any questions you may have about different supplies.

Notice that we don't list specific brands in Chapter 2 or anywhere else in this book. The truth is the brand of your tool isn't nearly as important as the way the tool works. Plus, too many brands offer good supplies to point out only one or two. If you can try out a tool or supply in the store before you buy it, do so. Chances are, though, when you're new to buying art supplies, you may not know what a "good" pencil is supposed to feel like. The best way to find out is trial and error. Buy a couple of different pencils and try them out at home to see which ones you like the best. Whenever you can, add a new supply to your drawing toolbox, and, in no time, you'll know which tools work best for you and your drawing style.

If you can't test out your tools before you buy them and you don't have any preferences yet, shop by price. In most cases, you get what you pay for. You can expect higher-quality supplies to cost a little more, but if you're hoping to get some good-quality supplies without taking out a second mortgage, shoot for the middle range of prices. The cheapest supplies may not give you an idea of what they can really do, so try not to buy all value supplies. Colored pencils, for example, vary tremendously in quality. The extravagantly priced supplies probably aren't necessary when you're getting started, but if you fall in love with a marble-handled mechanical pencil, add it to your wish list.

Drawing has something for everyone. When choosing supplies, balance the quality you want with what you can afford. If your budget is tight, don't feel like you have to spend a lot of money to make drawings. A simple No. 2 pencil and any paper can produce a beautiful drawing. If you don't have any money to spend on your drawing, use whatever resources you have available. We've seen beautiful drawings that were made using coffee!

Discovering Your Artistic Style

In drawing, *style* refers to a set of identifying characteristics found in a particular artist's work. You don't have to worry about finding a style for your work because style is something that happens on its own. Unless you put your foot down and refuse to be yourself, your drawings will take on some signature characteristics that become the seeds of your personal style.

Style comes from who you are. Your drawings will be unique in large part because of things you don't control, like the kind of pressure you automatically exert on a tool, the natural rhythms you fall into as you draw, and the natural tendencies you have to make certain types of marks. Your influences play a part in your style, too. You can't help but pick up a few little things from the artists you admire.

Seeing the artistic value in contemporary scribbles

Have you ever been in an art museum or gallery and heard someone say, "My kid could do that painting"? You know exactly what the person's talking about — the seemingly random scribbles and blobs of paint that have been proclaimed "extraordinary art" by critics and artists alike. So how have these less traditional artworks earned the label *extraordinary*? To find the answer to this question, you need to take a little trip through art history.

Before photography came about, the purpose of art was pretty clear: Record reality as it happens. Although artists and methods changed over the years, the overall concept of art continued on the path to greater realism until the late 19th century when photography was born. Photographs represented life and reality so well that painting and drawing suffered a major identity crisis — why have artists who paint and draw when you can have photographers?

Fortunately, it didn't take long for artists to realize everything they could do now that they were free to leave the world of realism behind. They began to ask questions about the meaning of things like art and beauty, and they began to create art that went far beyond what the naked eye could see. Artists like Henri Matisse and Pablo Picasso twisted and flattened the human form into something just barely recognizable. Jackson Pollock dripped paint all over the place. Their seemingly strange work led to artistic experiments in thinking, and eventually, to the contemporary art you see at exhibitions today.

Guard your individuality! It's tempting to adopt the style of an artist you admire as though you're joining an exclusive club. However, if you really want to grow as an artist, you need to allow your own artistic voice to shine through your work.

As long as you're constantly developing as an artist, your work will continue to change and your style will continue to evolve. Know that some aspects of your work will remain the same, though. Embrace the parts of your style that change and those that stay the same because they both have a hand in defining the artist you are.

Practicing Sustainable Drawing Habits

Drawing is a rich and stimulating process. The benefits listed earlier in the section "Considering the benefits of drawing" are only a handful of the reasons why you may get hooked on drawing. Still, you're likely to experience your fair share of times when drawing feels scary and hard and you doubt your abilities. Don't give up! These moments will pass. In this section, we share some tips for how to prop yourself up when the going gets rough.

Acquiring essential skills

Whatever kind of drawing you want to do, it'll be much easier to do if you know the basics about how perception works and how you can create a sense of perception on paper. Chapters 6 through 11 are designed to offer you a solid grounding in the basic skills you need to develop to make realistic drawings. Chapter 6 shows you how to take a drawing from the planning stages to completion, and Chapters 7 through 11 deal specifically with creating a realistic illusion of space. After you acquire these basic skills, you'll have the tools you need to draw anything.

Implementing an effective order of operations

If you've ever spent a long time on one part of a drawing only to realize you made whatever it is you were drawing too big to fit among the other elements you still have to add to your drawing to make it complete, you know how frustrating the drawing process can be. Lucky for you, you can avoid this frustration with a little bit of planning.

The most efficient way to approach a drawing is to begin with the most general aspects and work gradually toward the more specific ones, holding back on the fine details until the very end. For example, if you're drawing an apple, start by drawing its size and shape; then draw the stem and any surface details.

By starting each drawing by mapping out the size, basic shape, and placement of all the objects you want to include in that drawing, you can make sure you have enough room for everything in your drawing space. For instance, if you know you want to include a house and a tall tree in a drawing, first determine where the tree will go and how much space it will take up. That way, you can make sure the house will fit in the drawing, too. To see how this order of operations works in practice, check out the instructions to any exercise or project in this book; we've created all of them using this order of operations. Also turn to Chapter 6 for details about the drawing process.

Following the order of operations saves you time and frustration throughout the drawing process. Because everything in your drawing is loose and general in the beginning, you can make major changes early on without feeling like you're losing a lot of your hard work. After you figure out how big all your objects are and where they go in your drawing space, you can confidently focus on developing the details that make the objects unique without having to worry that you may need to move them or change their sizes.

The hardest thing about working from the general to the specific is waiting to get to the fun parts of your drawings (you know, the details that make everything look real). But do your best to hold off on the fun until after you map out the general layout of the drawing. You'll be glad you did when you see the finished product!

Adapting to ambiguity

Part of what makes drawing exciting is its unpredictability. But, for some reason, the very fact that you know you can't totally control it makes you want to try anyway. When you're just getting started with drawing, the uncertainties may feel like failings on your part. They're not! Try to be patient with yourself, focus on seeing like an artist, and keep telling yourself that you have what it takes to work through the murky parts of drawing. The more you practice, the more confident you'll become, so keep reading and start drawing!

Chapter 2

Gathering What You Need to Get Started

When you look at the masterpieces of the art world, you may think that drawing ability is a gift bestowed only on a privileged few, but that's simply not true. Anyone can learn to draw, which as you've probably already guessed, is where this book comes in.

The truth about drawing is that it's as primal as breathing. Human beings begin to draw as infants, making their first marks before they can even speak. Like talking, drawing is a physical extension of thought. Ideas and senses move from your brain through your arm to your hand and onto the paper as freely as thoughts move through your mouth. Figuring out how to draw realistically is a matter of gaining control over the innate tendency to simply make marks. To start drawing realistically, you need to be able to do two things: see the world around you and hold a pencil. If you can do those two things, your only obstacle to learning to draw is making a commitment.

In this chapter, we show you how to get comfortable with drawing by incorporating your artistic preferences into your work and explain what you need to get started: inspiration, time, space, and the right materials.

As you start to draw, try not to criticize yourself too much. You learn even more from your missteps than you do from your successes. At the same time, though, don't overlook the improvement you see in your drawing skills. With a lot of practice and a little patience, you'll be drawing like a pro in no time.

Exploring Your Drawing Preferences

Because you're a unique human being and no one in the world is exactly like you, it's no surprise that no one in the world draws exactly like you and, more important, that you don't draw exactly like anyone else. Many factors, including the following, influence how and what you draw:

- ✔ The media with which you choose to draw
- ✔ The way you naturally grip your pencil and other drawing media
- ✔ Your life experiences, philosophies, and perceptions
- ✔ Your exposure to art and the history of drawing
- ✔ The kind of art you admire

The following sections help you identify some of your personal drawing preferences by walking you through the different ways to hold your drawing media, the various types of marks you can make with your media, and the basic approaches you can take in your drawings.

Holding your drawing media

How you hold your drawing media influences how you draw and, consequently, how your finished drawings look. Your grip and the amount of pressure you naturally exert on your drawing media influence the kind of marks you make. Some people naturally draw very lightly no matter how soft the pencil they use is (see the section "Pencils" later in this chapter for more info on the different degrees of pencil hardness). Other people are naturally heavy-handed and tend to make darker marks regardless of what drawing medium they use. You can't change your nature, but being aware of what you do can help you make conscious decisions about the way you draw.

To help you better understand how the way you hold your pencil affects your drawings, take a look at the three most common ways to hold a pencil:

- ✔ **Holding your pencil the way you hold a pen when you write:** Figure 2-1 illustrates how most people hold their pencils when they first start to draw. When you hold your pencil this way, you move it by moving only your wrist and fingers, giving you better control over fine movement when you're rendering very small or intricate sections of a drawing. This way of holding your pencil works best when your drawing surface is flat or slanted and your drawing itself is small — 8 x 10 inches or smaller — or when you're drawing the fine details of larger drawings. (If your drawing surface is vertical or if you're working on larger paper, we recommend that you try using one of the other two ways of holding a pencil we cover in this list.)

The downside to holding your pencil like you do a pen is that it facilitates such fine control that you may find yourself making small fine movements too early in your drawings. If you're making small, tightly controlled marks on a big piece of paper (9 x 12 inches or larger), it's easy to get focused on one area and forget about making sure that area relates to the rest of the drawing, and you'll undoubtedly have a hard time erasing and redoing that area after you've invested a lot of time into it. On the other hand, if you hold your pencil in a way that encourages larger, looser marks (like the methods we explain in the next two bullet points), you can block in the basic shapes and basic values of your subject, thus allowing you to get a clear sense of the drawing as a whole so that you can then add more specific shapes and values and, lastly, fine details to complete the drawing. (See Chapter 3 for more information about a good order of operations for drawing.)

✔ **Holding your pencil like you hold a stick of chalk when writing on a blackboard:** Figure 2-2 illustrates this option for holding your pencil. This way of holding your pencil is comfortable to use with a drawing surface at any angle — flat, slanted, or vertical — and it's perfect for drawing on larger surfaces (larger than 9 x 12 inches). When you use this particular hold, the movement for drawing comes from your whole arm rather than just your wrist and fingers. When you draw from your arm, you tend to make larger, looser movements, resulting in larger, looser marks. These loose marks help you lay the foundation for your drawing by creating the basic shapes and values in your subject and keep you from getting too tight too early in your drawing.

Figure 2-1:
Holding a
pencil in
the most
familiar and
traditional
manner.

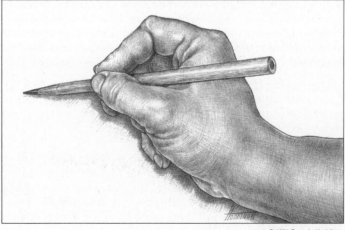

© 2003 Brenda Hoddinott

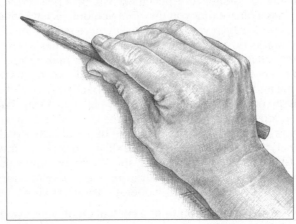

Figure 2-2:
Holding a
pencil the
way you
hold a piece
of chalk.

When you get to the part of your drawing where you need greater control over your pencil, like when you're working on an intricate shape or small details, you can simply switch to holding your pencil like you hold a pen to write (see the preceding bullet for more details).

✔ **Holding your pencil loosely in your hand:** You can hold your pencil this way to make any size drawing on a drawing surface at any angle, but this way of holding your pencil is ideal for working on large drawings (3 x 2 feet or larger) and drawing on vertical surfaces like walls. Holding your pencil loosely in your hand allows you maximum flexibility of hand position, which is helpful when you're drawing from life and need to turn your body away from the paper in order to keep your eyes trained on your drawing subject. (See Chapter 7 for details about when you want to keep your eyes on your drawing subject while you work.)

To try out the hold shown in Figure 2-3, reach out to pick up your pencil from a flat surface; it should automatically be in its proper place in your hand. The farther away from your hand you extend the pencil's tip, the more loosely you can draw.

One or two of these pencil-holding methods may feel a little awkward at first, but with practice, you can get used to them. Choose whichever method of holding your drawing media works best for you at the different stages in your drawing. Depending on the day or the drawing, you may go back and forth between any two or all three of these pencil-holding methods. For example, if you start out holding your pencil as shown in Figure 2-2, you can easily switch to the hold shown in Figure 2-1 when you reach a place where you need more control. If you're holding your pencil as shown in Figure 2-2 and suddenly you need to twist your wrist to be able to comfortably reach part of your drawing, you can switch to the kind of grip you see in Figure 2-3.

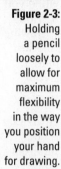

Figure 2-3:
Holding
a pencil
loosely to
allow for
maximum
flexibility
in the way
you position
your hand
for drawing.

© 2003 Brenda Hoddinott

Consider the following as you decide which pencil hold to use:

- How big or small your drawing paper is
- Whether you are at the beginning or end of a drawing
- Whether your drawing surface is flat, vertical, or on an angle

Making marks with your preferred medium

Making marks on a surface is the core of drawing. Diverse mark-making techniques and different drawing media lend themselves to various manners of drawing, as we demonstrate with the variety of approaches to drawing we cover throughout this book.

You have a huge variety of drawing media to choose from, and although many are similar to each other, some are quite unique. For example, a charcoal drawing looks completely different from a graphite or pen drawing, but you may not be able to tell the difference between a drawing done with charcoal and one done with black conté crayon. In addition to the traditional black-gray media, you can also use colored pencils, colored conté crayons, and pastels to bring color into your drawings (see the later section "Choosing Your Drawing Supplies" for more details on these different drawing media).

Every drawing medium has its own range of expressive mark, meaning the texture and degree of softness or hardness of the tool affects whether the marks it makes are clean or messy, smooth or grainy. Additionally, each medium has its own maximum degree of lightness and darkness. For example, graphite is relatively smooth and light (even at its darkest) when

compared to compressed charcoal, which is powdery, grainy, and dark even when applied lightly.

In addition to the differences in media, the kind of marks you make when you draw depend on your unique way of drawing. As we discuss in the previous section, everyone exerts a unique and natural pressure on his or her drawing tool. Likewise, everyone has a natural inclination to certain types of marks. Yours may be emphatic and angular or curvy and lyrical. The possibilities are endless, but one thing is certain: When it comes to mark-making, your personal combination of habits is completely your own.

Knowing your marking habits doesn't mean you should define yourself strictly by them. In fact, it's healthy to try working in ways that aren't common or comfortable, so try experimenting with different drawing media and different types of marks every once in a while. Some may surprise you and become part of your drawing style. But even as you experiment with new marks and media, keep in mind what your habits and preferences are; doing so gives you a better idea of who you are as an artist.

Deciding whether to leave your drawing loose and sketchy or to tighten it up

Every artist has a unique approach to drawing. Some love big, bold, loose drawings. Others like tiny drawings with lots of intricate details. Before you decide once and for all which approach you prefer, give both styles (and everything in between) a try. You never know when your preferences may change or grow to incorporate new approaches you'd never before considered. For example, you may be convinced that you love only sketchy drawings with lots of evidence of process and realism until one day you find yourself mesmerized by the beauty of magical illusion in M.C. Escher's *Drawing Hands.* Or perhaps you're set on drawing only illusion until one day you find yourself transfixed by Käthe Kollwitz's powerful etching *Woman with Dead Child.* (To see either of these drawings, just type the name and artist into your favorite search engine.)

There's no inherently right or wrong way to draw. The approach and style you use in your drawings depend on your perceptions and logic. For example, if you want to make a drawing of a bridge and your favorite part about the bridge is its intricacy, it makes sense for you to render the drawing tightly and with a lot of detail to highlight its intricacy (see Figure 2-4a for an example). If, on the other hand, what impresses you about the bridge is the way it stands up to the wind, you may choose to render the drawing loosely to draw attention to the bridge's solidity amidst turbulence (see Figure 2-4b for an example). So before you start drawing any subject, ask yourself what about that subject and its surroundings grabs you and then try to figure out why.

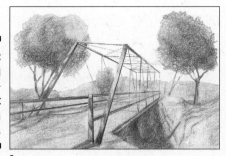 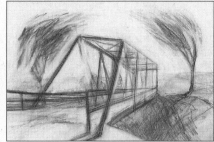

Figure 2-4: Rendering a loose versus a tight drawing of a bridge.

a b _Jamie Combs_

Finding Inspiration

So you know you want to give drawing a try and you've picked up this book to help you get started . . . now what? You need to figure out what you want to draw, of course! You may have a few tried and true subjects that you've grown comfortable with drawing, but we'd be willing to bet you're ready to expand. If you're looking for new drawing subjects or you've ever felt a strong desire to draw without having any idea what to draw, you've come to the right place. This section is all about finding inspiration for your drawings.

Figuring out your interests

Perhaps the most overwhelming thing about finding inspiration for your next drawing is that just about anything can make a good subject. No matter what type of drawing you want to do, anything in the real or imaginary world is yours for the taking. With so many choices out there, how do you choose? Here's a tip: Pick a subject you care about. Passion for your subject matter is extremely important because it's what sustains you when things get difficult. Plus, you'll grow more and faster as an artist if your subject matter makes you feel excited. So before you start your first drawing, spend some time figuring out what kinds of subjects you care about.

To help you determine what kinds of drawing subjects you care about, make a list of things you like. Write down anything that comes to mind and resist the temptation to edit yourself. Designate an area in your home or work space as an inspiration board. Clip and hang anything that grabs you, including photos, poems, and postcards. Over time you may notice patterns in the kinds of things you post to your board; these patterns can help you understand your interests in a whole new way. For example, you may notice that you tend to save poems and postcards that have something to do with water. After you see a pattern, take a little time to explore that interest in a series of drawings.

Getting ideas from other artists' works (and yours, too!)

People have been drawing for a very long time. Throughout history, humans have used art to communicate and immortalize events and objects. For example, drawings in the caves of prehistoric humans provide historians with insight into their way of life. The early Egyptians used drawings to decorate many structures, including tombs. Native people all over the world used natural materials, such as clay, to make drawings that represented their lives. And the drawings of such revered artists as Michelangelo and Leonardo da Vinci explored science, human anatomy, and perspective.

Check out the Internet or your public library to find out more about the history of art and the artists who've made it. Be sure to explore all different types of art. If you don't know where to start, ask a librarian to help you locate some survey books on art history so you can see the various art historical movements that have reached across the globe. By studying past works, you can discover countless different techniques, styles, and subjects that you can use to help you develop your own drawing skills.

Copying great works of art is a great way to learn the ins and outs of drawing, but you don't have to re-create a whole drawing to derive the benefits you get from copying. If you find yourself intrigued by some fragment of a work of art, go ahead and copy just that part. Try to determine what about that fragment interests you, and then try to replicate it in your own drawing.

If you copy from someone else's work, even if only in part, you can only legally do so if you have the permission of the artist who created the work or if you're copying for your own personal research. Although you can't present your copies as your own work, copying is a wonderful way to develop your drawing skills and practice new techniques. See Chapter 18 for more information on copyright laws.

You can also look for inspiration in your own earlier works. For instance, you can use a work you've already made as a springboard to make a new drawing. Choose a drawing you like, pick some element you like in it, and begin your new drawing by re-creating that element. Then use your imagination to take the drawing in a whole new direction. Take a look at Figure 2-5a for the inspiration piece behind the drawing in Figure 2-5b. The artist who made both of these drawings borrowed the composition and basic shapes from the first drawing to use as inspiration for the second drawing. The two swimmers in Figure 2-5a become the two birds in Figure 2-5b, while the pool in the yard becomes a pie on a windowsill.

Figure 2-5:
Finding
inspiration
from your
own earlier
works.

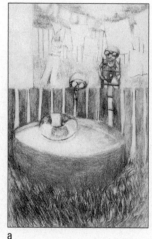
a

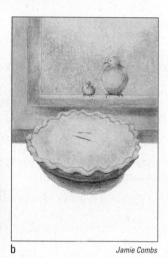
b
Jamie Combs

Drawing on your memories

Your memory can be fertile ground for drawing ideas. After all, nothing is more personal than your own memories. But before you start drawing from memory, remember that memory isn't perfect. To get the most benefit, try to allow yourself the freedom to draw imperfectly whenever you make a drawing based on your memory.

Before you begin any drawing from memory, think about what you want to accomplish through the drawing. If your goal is to make a highly realistic image based on a memory, find some source material, such as photographs or live models, to draw from to help you create the most realistic rendition of your specific memory. If, on the other hand, your goal is to reconstruct the emotional or psychological framework of your memory, don't stress about making the drawing perfectly realistic. Instead, focus on representing the emotions and the thoughts you had during that memory in your drawing.

Sometimes drawing from memory is a practical solution when you see something you'd love to draw but can't at the moment. The trick to remembering your subject and its surroundings is to try to absorb as many of the visual details as you can so that you can re-create them on paper later. Like with any skill, you can sharpen and improve your ability to recall visual details with practice. To start practicing now, try your hand at the following exercise, which gives your visual memory a little workout.

For this exercise, you need a stopwatch or something similar to time yourself with, your sketchbook, an extra piece of paper, a ruler, and a 2B pencil (see

the upcoming section "The necessities" for details on these tools). After you have these materials, follow these steps:

1. **Use your ruler and a 2B pencil to draw a 4-x-4-inch square in your sketchbook.**

2. **Look carefully at the drawing in Figure 2-6 for 30 seconds and try to remember as many details as you can.**

3. **After 30 seconds, cover Figure 2-6 with the extra piece of paper.**

4. **In the square you drew in Step 1, draw as much of Figure 2-6 as you can remember.**

5. **Uncover Figure 2-6 and compare it to the drawing you made in Step 4.**

You can repeat this exercise in infinite variations. Try it with photos or pictures from a magazine. Try it in real life; stare at something for a while and then turn your back to it. Add variety and extra challenge by staring first for 2 minutes, then 1 minute, and then 10 seconds! By exercising your mind this way, you train it to look at your surroundings more closely. With a little practice, you can improve your mind's ability to retain what you see.

Figure 2-6:
Drawing
from
memory.

Jamie Combs

Carving Out Space and Time to Draw

If you're lucky enough to have a spare room in your home, you can easily convert it into your very own drawing studio, devoted exclusively to your art. But you don't have to have a whole room to create an effective, comfortable space for drawing. You can create a personal drawing space in a small, busy home simply by sharing an area with others or by converting a corner

of a room into your studio. The following sections show you how. They also describe how to make time for drawing even when life is at its busiest.

Making your drawing space comfy and effective

Whether you have your own studio or you have just a corner of a room, your drawing place needs to be free of distractions and full of the furniture and other supplies you need to draw comfortably. If others use the same space, do a little careful planning and make some compromises to make sure that you get plenty of personal drawing time without inconveniencing others.

No matter where you set up your studio, be sure to include the following elements to make your drawing space as comfy and effective as possible:

- **Adjustable drawing table:** Adjustable drawing tables are designed so you can adjust the height and tilt of your drawing surface for your drawing comfort. Check out stores and yard sales for a good deal. Many people also sell used equipment over the Internet. Just type *used drawing table* into any search engine.

 If you don't want to purchase an adjustable drawing table, you can easily turn your kitchen or dining room table or your computer desk into an ideal drawing space by moving it into your drawing space. You can also create a portable, sloped drawing surface by using books to prop up one end of a drawing board.

- **Bulletin or display boards:** Bulletin boards allow you to display some of your favorite drawings, inspirational images, photos, and articles in your studio. You can find some relatively inexpensive and readily available display boards at your local hardware store.

- **Comfortable, adjustable chair:** You absolutely must have a comfy chair if you spend several hours a week drawing at a table. After all, you definitely don't want your back to become tired and sore as you draw. An adjustable chair allows you to adjust the height to a level that's right for you, and a chair on wheels allows you to move around easily.

- **Light source:** Having a window in your drawing space is the best lighting option, but, even if you have one, you also need a flexible-neck lamp that you can attach to your drawing table for overcast days and evenings.

- **Sound system:** If you have a hard time concentrating on your projects in your studio (especially if you're using a shared space), use a pair of headphones to listen to your favorite music to block out noisy distractions and help you focus on your drawings. If you have your own studio room, feel free to use a stereo with speakers rather than headphones.

✔ **Storage containers:** Keep your drawing materials organized and safe from small children and pets by storing them in some type of portable container with a lid, such as a large shoebox or a small tackle box. That way, you can easily store them under a bed or in a closet when you're not using them. If you have a free drawer or shelf somewhere near your drawing space, store your supplies there.

You may also want to get a small table or storage cart (preferably one on wheels) for holding your drawing materials as you work. If you have space to put a shelving unit, you may want to get one to hold your art books, drawing materials, and portfolios.

Don't limit yourself to these suggestions. Visit some furniture and art supply stores and look through some decorating books and magazines for more ideas of what you can add to your drawing space to make it work for you.

Keep your color scheme as light as possible to ensure that your special drawing place is bright, welcoming, and enjoyable.

Finding time for drawing

If you allow drawing to become a habit, you'll find that even when you're at your busiest, you can find time to squeeze in some drawing. The following tips can help you make time for drawing in a busy schedule:

✔ **Carry a small sketchbook in your pocket, purse, or backpack.** That way, you're always ready when inspiration strikes.

✔ **If you work outside your home and ride public transportation to work, draw on your way to and from work or during your lunch break.** Take advantage of the opportunity to sketch your fellow passengers or co-workers at lunch.

✔ **Don't forget the evenings and weekends.** You can find lots of opportunities to draw during downtime at social events. For example, if you're at a party watching your friends play games, why not draw them? You can also take your drawing materials with you when you go visit family and friends on the weekends.

✔ **Include family members or friends.** Get a group of friends or family together, and make arrangements to meet one night a week for a kind of drawing club. Take turns bringing refreshments, motivating one another, and sharing ideas as you draw.

Using Your Sketchbook

Your sketchbook is part journal, part best friend. You can use it as a testing ground for new ideas and as a place for documenting different experiences. Above all, though, your sketchbook is a place where you can recapture the excitement you felt for drawing when you were young and didn't care if anyone was watching you.

Some people like to keep only one sketchbook at a time, while others prefer to keep separate books for separate issues. However you like to organize your sketchbooks, get in the habit of carrying one with you wherever you go. That way, you can pull it out to draw at a moment's notice. The following sections explain how to draw on location, so to speak, and how to use your sketchbook to test new drawing ideas.

Sketching away from home

Sketching is a wonderful way to preserve an experience you had away from home. All you need is your sketchbook, a drawing utensil, and somewhere to draw. The beauty of sketching is that you can do it anywhere, even places where cameras aren't allowed.

Whenever you draw on location, try to make yourself comfortable enough that you can concentrate on your drawing long enough to get a complete picture of your subject. If you plan to be out of doors for any length of time, be sure to take sunscreen, a hat, a bottle of water, a coat (if it's chilly), and anything else you may need to make you comfy. Locate restrooms and available shelters near where you plan to go in case the weather turns bad unexpectedly. Consider whether you prefer to sit or stand. If you like sitting, you may want to invest in a lightweight, folding chair.

You follow the same drawing process whether you're drawing at your home studio or on location. Think about it as though you're building your drawing. Start by blocking in a general map of where the different pieces will go. Next, break your subject(s) down into simple shapes. Finally, work to refine the subject(s) to make them look more realistic. Add shading and textures if doing so helps you achieve the look you're going for and if you have enough time to do so. If you don't have time, you can always add shading and textures later; just make a note in the margin about the light source and try to commit the scene to memory so you know what types of shading to add. (Check out Chapter 3 for more details on the drawing process.)

Sometimes when you're drawing on location, you may want to add people to your drawing. Adding people to a drawing livens up the space, but doing so is also a little daunting. After all, people move around a lot, making it difficult to capture all the details of their bodies and faces in a drawing.

To help you get the most out of your on-location drawing sessions, think of sketching people as an exercise to improve your drawing skills rather than as the means to a complete drawing. Focus on quickly getting a sense of how a particular person stands, sits, or walks rather than whether that person is wearing strappy sandals or has an aquiline nose. Quickly sketch the shapes made by the shirts, legs, arms, and heads of the people you're drawing. As you have time, you can think about things like stripes on shirts and hair length. Figure 2-7 shows a quick sketch that includes people.

Sketching people as they move about their days is a great way to practice your skills at gesture drawing. (See Chapter 15 for more on gesture drawing.) Don't add more detail to the people than you do to the area around the people. If the people look too detailed, they won't blend in to the surroundings in your drawing.

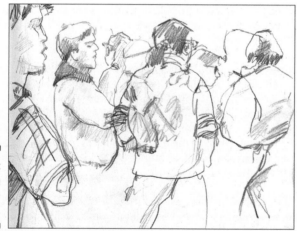

Figure 2-7:
Sketching
people
quickly.

Kensuke Okabayashi

To practice building a sketch on location, grab your sketchbook, 2B pencil, and vinyl eraser (see the upcoming section "The necessities" for details on these tools), and venture somewhere away from your home to a place where you think you can find something interesting to draw. Then follow these steps:

1. **Using your 2B pencil, lightly draw lines to indicate the placement, size, and direction of the major forms in your drawing subject and its surroundings.**

2. **Break down your subject(s) into the simplest shapes you can; draw these simple shapes on your paper (see Figure 2-8a).**

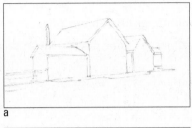

a

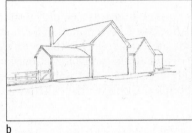

b

Figure 2-8:
Making a
sketch on
location.

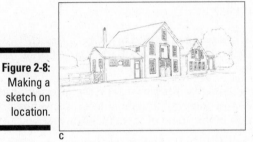

c

Barbara Frake

3. **Compare your drawing to the actual subject to make sure the shapes are in the right relationship to each other and nothing is too high or too far apart; make corrections to your drawing if any of these relationships are inaccurate.**

4. **Add simple shapes of value if you want to add shading to your drawing.**

5. **Refine the simple shapes into more accurate shapes (see Figure 2-8b).**

 Simple shapes like squares and other rectangles are great for blocking in the dimensions and basic shapes of most architecture, but to make the shapes look more realistic, look for places where the architectural features of your subject depart from simple boxlike shapes. For example, the sides of the roofs in Figure 2-8b are basically rectangles. But, to be more accurate, the artist gave them a three-dimensional quality by drawing narrow rectangles running along the edges of the sides of the roofs. Having drawn the simple rectangles first, the artist could easily change the drawing to better reflect the roofs' three-dimensionality because she had already worked out their placement and dimensions.

6. **Add small shapes to indicate windows, doors, and other details in your subject(s) and its surroundings (see Figure 2-8c).**

7. **Adjust the lightness and darkness of your lines to make them look more realistic.**

Playing with ideas

One of the most liberating uses for a sketchbook is as a playground for testing ideas. You don't ever have to show your sketchbook to anyone if you don't want to, so feel free to test all your ideas — even the most outrageous ones. Have an idea you're unsure of and afraid to talk about out loud? Tell it to your sketchbook. Don't worry about accuracy or traditional rules of drawing when you draw in your sketchbook. Just be yourself and let your imagination and pencil run wild.

If you don't have any ideas to work out in your sketchbook, do the following to help get your creative wheels turning:

- Keep a journal in which you make one drawing each day to record something that happened that day; if you have a particularly boring day, make a drawing of something you thought about that day.

- Keep a journal of weird facts. Look up bizarre facts on the Internet or at the library and make a list of the ones you find most interesting. Imagine what would happen if you combined some of them in a drawing.

- Keep your sketchbook by your bed so that when you wake up you can make drawings of any interesting dreams you had while sleeping.

- Ask your friends to tell you something they learned that day; then use their insights to make a drawing.

- Go someplace that scares you, and make a drawing of it. Maybe it's the musty basement or the top of a hill that all the neighborhood kids use for sledding. (Just make sure it isn't someplace where you'd be in actual danger.)

Choosing Your Drawing Supplies

The old expression "You get what you pay for" definitely applies to art supplies. For example, some inexpensive pencils are scratchy instead of smooth, making them incredibly frustrating to draw with. Although you're better off buying good-quality art materials from a reputable art store, you can save money in other ways. Shop around. Sometimes the same brands of high-quality materials are available at several stores at different prices. Another way to save money is to buy only the supplies we include in the

section "The necessities." Purchase just enough to get started with drawing; then when your skills and budget increase, you can invest in some of the fun but less essential items that we cover in the upcoming section "The wish-list items."

The necessities

The following sections describe the basic supplies you need to get started with drawing and to do the projects in this book. Figure 2-9 shows you some of the supplies you need.

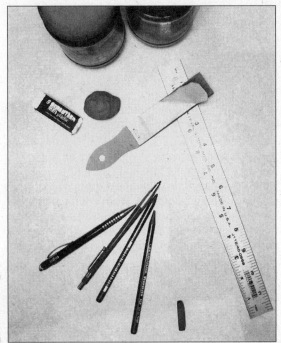

Figure 2-9:
Drawing
supplies.

Jamie Combs

Sketchbook

Sketchbooks come in all sizes and qualities. As a beginner, try to balance the quality you can afford with the quantity of sheets you need. In general, a 50- or 100-sheet pad of recycled sketch paper is an excellent choice. At this point in your drawing career, you want to be able to make lots of drawings without worrying that you're wasting money on extremely high-quality paper. Choose a size that suits your needs. A good all-purpose size is 9 x 12 inches, but you may want to purchase another smaller book that you can toss in your bag for easy access throughout the day.

Pencils

The most important pencils for a beginner are 2H, HB, 2B, 4B, and 6B. The 2H is the lightest (hardest), and the 6B is the darkest (softest). Figure 2-10 shows you the full range of marks made by four of these pencils. You can expect to use the HB, 2B, and 4B the most often.

2H HB 4B 6B

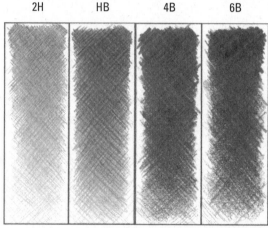

Figure 2-10:
The range of values made by four popular graphite pencils.

© 2003 Brenda Hoddinott

If you hate having to stop midway through your drawings to sharpen pencils, you may want to choose mechanical pencils. We recommend using 0.5mm (available in lots of different stores) for regular drawings and 0.3mm (available at most art supply stores) for very detailed drawings. When you're sketching loosely or on a large surface (or both), try using a 0.7mm mechanical pencil.

Erasers

You need two types of erasers, a vinyl and a kneaded. Here's the difference between them:

- **Vinyl eraser:** This eraser is usually white, long, and rectangular and has a band of paper around it that displays its name. Vinyl erasers are sometimes labeled *soft* or *extra soft.* Either type works just fine, but you may want to pick one of each to see which one you prefer. If you find vinyl erasers that aren't labeled for softness, don't worry; they all erase fairly similarly.

- **Kneaded eraser:** This eraser is gray, and its plastic packaging is usually clearly marked with the name of the eraser. If you have a choice, choose the largest one you can find. The price isn't that different, and the extra surface area is well worth the extra cost. You may want to keep two kneaded erasers, one exclusively for erasing graphite and one just for erasing charcoal.

If you aren't familiar with either of these erasers, have a salesperson help you choose which brands are best. And don't worry if you don't know what to do with these erasers after you buy them; we introduce you to various ways to use them throughout this book.

Avoid using traditional pink erasers for drawing. These erasers sometimes leave pink or gray marks on the paper.

Pencil sharpener

You need a pencil sharpener for some drawing media (even if you're using mechanical pencils for graphite drawings), so be sure to add one to your art toolbox. The pretty or fancy sharpeners don't work any better than the simple, plain sharpeners, so save your money and choose a basic, hand-held metal sharpener with two openings: one for regular pencils and one for oversized pencils. These simple sharpeners last a long time, and you can buy replacement blades for them when your old ones become dull.

You can also use a piece of sandpaper or a *sandpaper block* (which is just a wedge of cardboard to which several small sheets of sandpaper are attached) to sharpen pencils.

Rulers

Rulers come in metal, plastic, and wood, but we suggest buying a metal one because it'll last a lot longer and is easier to use and clean than the wood and plastic varieties. A regular 12-inch ruler works for most projects, but an 18-inch one comes in handy when you're working on larger projects.

Charcoal

Charcoal pencils and sticks come in grades from hard to medium to soft. Though charcoal is available in fewer grades than graphite, many charcoal utensils are labeled the same way as graphite pencils: 2B, 4B, and so on (refer to Figure 2-10 for different pencil labels.) The labeling means the same thing for both charcoal and graphite (see the earlier section "Pencils" for details). Sometimes you may find charcoal that's labeled only hard, medium, soft, and extra soft. Just purchase a few medium (2B) and soft (4B) charcoal pencils and a couple of soft (4B) compressed charcoal sticks for now. We show you how to test-drive your new charcoal in a fun project in Chapter 13.

Spray fixative

Spray fixative (also called *spray fix*) is a protective coating that you apply to your drawing from an aerosol can. It's an essential item to have on hand when you're drawing in charcoal, but it's also extremely helpful when you're working with graphite. This coating helps to prevent smudging by "fixing" the graphite or charcoal to the paper. Spray fixative comes in workable or final types. Workable fixative helps the paper retain its texture so that you can work on it as easily after you spray it as you did before you sprayed it. For

this reason, workable fixative isn't as protective as final fixative. Both fixatives come in a variety of finishes from matte to satin to glossy. Ask a salesperson at your local art store for advice about which brands to buy and make sure to use spray fixative outdoors so that you have plenty of ventilation to protect your health.

Portfolio

Every artist needs a *portfolio,* which is basically just a flat, sturdy case you use to store and/or transport your work. You can store your drawing paper and completed drawings in your portfolio to keep them safe from being crumpled or damaged.

Portfolios are available at art supply stores in a range of sizes, materials, and prices. Most of the time, a portfolio made from lightweight cardboard gets the job done, but if you decide to purchase a cardboard portfolio, look for one that's acid free, or at least ph neutral, to protect your papers and drawings from yellowing. (If you're unsure how to determine whether materials are acid free or ph neutral, ask a salesperson for help.) A water-resistant portfolio is a must if you plan to transport work in rainy or snowy conditions. Canvas, vinyl, and leather portfolios all offer some protection from the elements.

If you don't want to buy a portfolio right away, you can easily make one from corrugated cardboard or matte board hinged with duct tape.

The wish-list items

At some point in your drawing career, you may want to experiment with other media besides graphite and charcoal and higher-quality paper than your basic sketchbook. Here are some fun art supplies you can add to your drawing toolbox when you're ready to move past the necessities we cover in the preceding section:

- ✔ **Colored pencils:** If you want to add a little color to your drawings, buy a set of colored pencils. Just be sure to stay away from the cheap ones; they're too waxy to blend properly, and they fade quickly. Ask someone at an art supply store to recommend a good-quality set for a beginner.

- ✔ **Conté crayons and chalk pastels:** Choose from either sticks or pencils. A basic set of conté crayons includes black, a couple of grays, a sepia (brown), a sanguine (reddish brown), and a white. Pastels come in an infinite range of colors, but you should start with a beginner set of assorted colors.

If you choose the pencil type of conté or pastels, you need to buy a utility knife or sandpaper block to sharpen them. Both are available at art supply stores.

✔ **Powdered graphite and/or powdered charcoal:** You can buy jars of ground graphite or ground charcoal from most well-stocked art and craft stores. You can use either of these powders to tone your drawing paper for subtractive drawings. (See Chapter 9 for details on subtractive drawings.) You can use a brush, cotton swab, or other applicator to apply these powders to your drawings.

✔ **Nonstandard pencils:** You have an enormous range of options within the world of graphite pencils. In many brands, pencils run from the super hard 8H (which is so light you can barely see it) all the way to the ultra-rich, extra soft, black 9B. We recommend getting in the habit of adding one or two new pencils at a time to your collection on a regular basis.

Woodless pencils are one variety to try as soon as possible. These pencils are comprised entirely of graphite encased in a thin plastic coating. Woodless pencils are graded the same way as standard graphite pencils but tend to make a softer, more velvety mark than standard pencils. One challenge with woodless pencils is that they tend to break when dropped. Woodless pencils are especially nice for the continuous tone shading technique because the end is all graphite so you don't have to stop drawing to sharpen them (see Chapter 9 for details on this technique).

✔ **Special drawing paper:** Special drawing papers can add a lot of fun to your projects. They come in hundreds of colors, textures, and types, so feel free to go nuts! The best way to see how a paper works is to try it. One great drawing paper is 140-pound, hot-pressed, watercolor paper. Its surface is fairly smooth, but its *tooth* (or texture) is adequate for most drawing media, and it's very forgiving of erasers. (Some delicate or spongy papers will pill or tear if you erase too firmly.)

Project: The Pupil of Iris

In this project, you get to experiment with each of the drawing tools we list in the earlier section "The necessities." So gather up those tools and follow these steps to draw an eye:

1. **Use your ruler to draw a square in your sketchbook any size you want.**

 This square is your drawing space for your project. Decide if you like drawing large or small objects before you choose the size of your square.

2. **Use your charcoal pencil to draw the outline of a small circle inside your drawing space, leaving out a small section the shape of a backward letter *C* in the top left of the circle; then fill in the circle very darkly with your charcoal pencil (see Figure 2-11).**

Your circle should look like someone took a bite out of it. Don't forget to leave the *C*-shaped section white; this white section will become the highlight of the eye.

3. **Use your 6B pencil to draw the outline of a large circle around your first circle (see Figure 2-12).**

 You may choose to draw the larger circle freehand, but you can also use a compass or some other tool to help you.

4. **Use your HB pencil to outline the other half of the *C*-shaped space you left in Step 2.**

 Look closely at this tiny circle, called a *highlight*, in Figure 2-13. It helps make the iris of the eye look realistic. The highlight stays the white of your drawing paper.

Figure 2-11:
Drawing
the pupil
of the eye
and leaving
a space
where the
highlight
of the eye
will be.

© 2003 Brenda Hoddinott

Figure 2-12:
Drawing
a circle to
represent
the iris
around
the pupil.

© 2003 Brenda Hoddinott

5. **Use your HB pencil to fill in the whole space inside the big circle, except for the highlight (refer to Figure 2-13).**

6. **Pull and stretch your kneaded eraser until it becomes soft, mold it to a point, and use that point to gently pat the shading on the side of the circle opposite the highlight (see Figure 2-14).**

 Keep patting until this small area becomes a little lighter than the rest of the shading. This little technique makes the eye look even more realistic.

7. **Use your vinyl eraser to clean up any smudges or fingerprints on your drawing paper.**

Figure 2-13:
Creating the eye's highlight by leaving it the white of the paper.

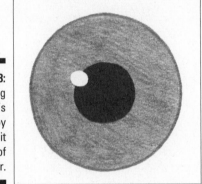

© 2003 Brenda Hoddinott

Figure 2-14:
Using your kneaded eraser to lighten the value of the part of the iris across from the highlight.

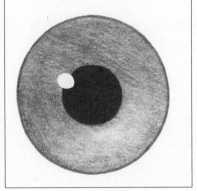

© 2003 Brenda Hoddinott

Chapter 3

Working through the Developmental Stages of Drawing

• •

In This Chapter

▶ Exploring the five developmental stages of drawing

▶ Walking through a simple project to see how the drawing stages come together

• •

"A journey of a thousand miles begins with a single step."

—Ancient Chinese proverb

Mastering the different components of drawing comes with time and practice. As you begin to draw, remember that your efforts won't always look "perfect." Instead of seeking perfection, get ready for a long yet fulfilling journey as you discover and use the skills you need to make drawings that are both personal and satisfying.

In this chapter, we walk you through the five basic stages or milestones most artists go through for every drawing they make. We arrange these stages chronologically — from drawing lines to considering composition — to give you a picture of an effective, all-purpose order of operations for drawing. We give you just enough information so that you have some idea of what to expect at the various stages you'll pass through for each of your own drawings. You find in-depth information about each stage in later chapters.

Save all your drawings, even if you don't like them at first. As you complete each one, write the date on the back of it. By seeing where your skills used to be, you can assess how far you've come in your artistic journey. Drawing is an infinite quest, and as with any pleasurable journey, the destination isn't what matters most. The best and most fun part of drawing is in the process.

Stage 1: Looking for Lines

The line is arguably the most essential component of drawing. In fact, most people get their first drawing experiences by making lines with crayons as children. Although it's possible to create beautiful drawings with no visible lines, nearly all drawings begin with a line. We include lines here as the first stage in the order of operations for drawing because lines are the primary way to get a drawing started. Keep in mind, though, that some drawings begin *and* end with lines. Take a look at Cy Twombly's *Leda and the Swan* for a great example. (To find it, plug the name and title into your favorite search engine.) This drawing is a tangle of energy that never actually develops into anything beyond a mass of lines; yet, it's still a whole and complete drawing.

Although real objects aren't surrounded by visible outlines, lines are a handy way to define the borders of just about anything you see. Sometimes to start a line drawing of a complex object, you have to break the object down into its simplest parts so you can focus on its edges. With a little practice in looking for edges, you can adjust your vision to block out the intricate details of a complex object and see only its lines.

To see what we mean, find a mug or other simple object with a handle. Place it in front of you and look closely at it. Focus your eyes on its edges. Try to visually simplify the object into lines like the ones you see in a drawing in a coloring book (see Figure 3-1 for an example).

Figure 3-1:
Drawing an object by seeing its edges as simple lines.

© 2003 Brenda Hoddinott

Most artists begin their drawing careers by drawing almost entirely with lines — even when their subjects are complex like people or animals. Figure 3-2 shows a couple of examples of one artist's early drawings before she figured out how to add shading.

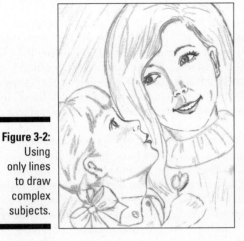 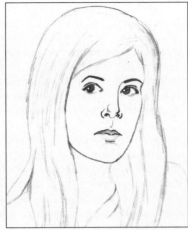

Figure 3-2:
Using
only lines
to draw
complex
subjects.

© 2003 Brenda Hoddinott

Stage 2: Moving from Lines to Shapes

Children have an uncanny knack for seeing simple shapes in complex, three-dimensional objects. For example, to them, a house is a square and its roof is a triangle. A tree is either a triangle or a long, thin rectangle with a circle on top. Breaking objects into shapes is more than a symbolic way of representing the world; it's a useful skill for constructing a drawing. If you start a drawing of an object by drawing the simple shapes that make it up, you can use the shapes as a framework for making an accurate, detailed representation of that object.

Although you can break all objects down into simple shapes, sometimes you need to be a little flexible to see the shapes that make up a given object. For example, the coffee cup in Figure 3-1 is made up of a rectangle with a circle sticking out of it. Although your drawing wouldn't look exactly like this cup if you drew a geometrically accurate rectangle and circle next to each other, the shapes would still serve as an easy starting point from which you could then make a refined drawing of the mug.

As you begin to reduce the objects you want to draw into lines (see the previous section for details), look for the simple shapes, like circles, squares, and triangles, that make them up. If you have trouble seeing the basic shapes in the objects that surround you, try to be more flexible in your thinking; in other words, try to see the world around you as you did when you were a child.

Figure 3-3a shows a photograph of a street in Bloomington, Indiana. In Figure 3-3b, you can see the basic shapes that make up this scene. To determine what shapes to draw, the artist of Figure 3-3b looked at the objects and imagined which geometric shape each one most closely resembled. Notice that some of the shapes that make up the objects in the photo aren't geometrically exact in the simple sketch in Figure 3-3b, but the essence of each shape is there. For example, the bay window on the side of the building is basically a square, the road is basically a trapezoid, and the tree is basically a circle.

Because the objects in photographs are already flat, it's fairly easy to see the simple shapes that make them up. All you have to do is trace around the outline of an object in a photo to discover its simple shapes. In contrast, determining which basic shapes make up objects you see in real life is a little more difficult because the detail and fullness of three-dimensional objects can be distracting. To reduce a three-dimensional object to its simple shapes, you must be able to look at it as though it were flat. Make a habit of paying attention to the essential shapes that make up whatever it is you're drawing. With practice, you'll retrain your eyes to automatically notice the shapes that make up objects. (If you have trouble retraining your eyes, gather up some photographs and look for the simple shapes of the objects in them; doing so can help you train your eyes to do the kind of seeing you need to do to reduce three-dimensional objects into shapes.)

When you draw, begin with a light line drawing of the simple shapes that make up your subject. That way, you can edit or erase your lines later as you add a third dimension with shading; see the next section for details.

Figure 3-3:
Breaking
complex
objects
into simple
shapes.

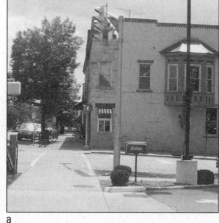

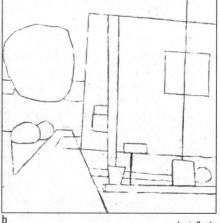

a

b

Jamie Combs

Some subjects look easy to draw but turn out to be quite difficult. On the other hand, some subjects look really hard to draw but turn out to be very easy. Regardless of how complex a particular drawing subject is, the key to rendering it successfully with your pencil is being able to break it down into its basic shapes. If you feel frustrated when drawing a certain subject, remember to simplify, simplify, simplify, and then subdivide! For instance, if you're drawing a block of row houses, focus on the basic horizontal rectangle that holds all the houses together. Draw that rectangle first and then subdivide it into smaller rectangles to represent individual houses. Then subdivide those rectangles to create the doors and windows on each house. If you figure out how to follow this simple drawing sequence, eventually you'll be able to tackle any subject. (See Chapter 7 for in-depth instruction on reducing objects to simple shapes.)

Stage 3: Adding a Third Dimension with Volume

For many drawing subjects, lines and shapes are all you need to make a complete drawing (see the previous sections for details). However, if you want your subject to look realistic and three-dimensional, you need to give your drawing volume.

In drawing terms, *volume* is the illusion of three-dimensional shape. It's what turns a circle into a sphere, a triangle into a cone, and a square into a cube. To give your subjects volume, you need to use perspective and shading. We describe these two drawing tools in the next sections.

Drawing an object with perspective and shading allows you to represent its three-dimensional structure on paper. For instance, when you draw objects with perspective in mind, you can make them recede into space in a believable way. When you draw the light, shadows, and reflected light on and around the objects correctly, you make them look even more realistic. (I show you how to use shading to create volume in Chapter 8 and perspective in Chapter 11.)

Using perspective to create depth

Perspective is basically the way objects and spaces appear from a particular point of view. Hence, *perspective drawing* is the believable rendering of a three-dimensional object or space within a two-dimensional surface. By

paying attention to and accurately portraying perspective in your drawings, you give your subject matter a sense of depth. When you understand perspective, your drawings become more realistic and visually correct.

Figure 3-4 shows how an artist used perspective techniques to create a convincing illusion of depth. This drawing picks up where Figure 3-3b left off and uses simple shapes to help refine and add depth to the original sketch. For example, the diagonal lines drawn on the left and right sides of the bay window tell your eyes that this window sticks out away from the wall.

Figure 3-4 also incorporates a perspective technique called *atmospheric perspective,* which is a way of representing the fact that objects in the distance look less distinct than objects in the foreground. In the figure, you can see that the utility pole is much more distinct than the cars off in the distance on the left-hand side of the drawing. (See Chapter 11 for a lot more details on atmospheric perspective.)

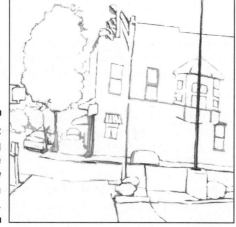

Figure 3-4:
Using
perspective
to show
depth in a
drawing.

Jamie Combs

Building light and volume through shading

Shading refers to rendering the different *values* — various shades of gray — in a drawing. To draw an object realistically in black and white and to give the object volume, you need to translate the colors, light, and shadows into shades of gray.

Before you start drawing a particular object, look for the light and shadows in and around that object; they determine where you need to draw the light and

dark shading to create the right *contrast* (the difference between light values and dark values). Accurate contrast is the primary ingredient of shading that makes your drawings look three-dimensional (see Chapter 9 for more details).

Figure 3-5 shows a realistic rendition of a rather complex subject — a human foot. Notice how the artist used a range of grays to shade the many swells and valleys in the foot to make it look three-dimensional and realistic.

Shading is a wonderful way to address changes in the topography of any object. For example, the soft depressions between your toes usually fall into shadow while the protruding flesh of your foot catches light. You can translate the shapes of light and shadow you see on an object into shapes of gray shading in your drawings. If you get the shapes of shadows and light in the right places and in the right amounts, your drawings will have the same qualities as real life and your volumes will be believable.

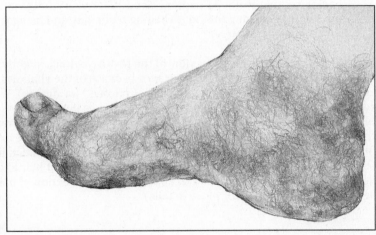

Figure 3-5:
Using value
to create
the illusion
of volume.

Jamie Combs

Stage 4: Rendering Textures

For many artists, the day they discover textures is a major milestone in their artistic journeys. Textures add a definite degree of realism to a subject; plus, they're fun to draw! Think about the trunk of a tree, the surface of a mirror, the fur of a dog, or the wool in a sweater. To represent these textures in a drawing, follow these basic steps:

1. **Look for the shadows in and around the object you're drawing.**

 For example, imagine a tree trunk that's deeply furrowed and knotty with bark that's peeling in several different places. Notice the many shadows that lie within the creases of the knotty, peeling bark.

2. **Choose an appropriate shading technique.**

 An appropriate shading technique is one that allows you to accurately represent the texture of the object you're drawing. In the case of the tree example from Step 1, it makes sense to choose a shading technique that allows you to register all the surface changes of the tree's knotty bark. Hatching and crosshatching — two techniques we cover in Chapter 9 — would both work well for rendering the rough texture of a tree trunk.

3. **Use the technique you chose in Step 2 to draw the shadows in the object.**

 Creating convincing textures depends half on accurately depicting the shapes and values of the shadows and half on selecting an appropriate shading technique. (See Chapters 9 and 10 for everything you need to know about choosing the right shading technique and using it successfully to render textures.)

Figure 3-6 shows you a close-up view of the texture of long, slightly wavy hair. You can tell the hair has slight waves because of the shadows the artist created using the hatching technique (see Chapter 9 for details). When a section of hair swells away from the head, it catches light and consequently blocks light from the part of the hair that turns back toward the head. Notice that although you think you're seeing a mass of hair strands, the artist didn't draw individual strands of hair to create the hair's realistic effect. Instead, she focused on the light and shadows falling on sections of hair and used lines to represent the shadows that appear when one section of hair overlaps another (see Chapter 10 for more details).

Figure 3-6:
Drawing texture to make a drawing of hair look more realistic.

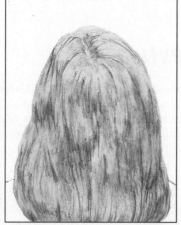

Jamie Combs

Stage 5: Arranging the Elements: Composition

Composition is the balanced and agreeable arrangement of your drawing subject or subjects and the space surrounding them within your drawing format. How you compose your drawing plays a big role in its final impact.

When you're first starting to draw, you may be entirely focused on getting your subject down on paper. The essentials of seeing lines and shapes and adding volume and texture may consume so much of your artistic energy that you end up placing your drawing subjects in random places on the paper.

Unfortunately, your drawings won't look whole until you figure out how to make good use of your entire drawing surface. In other words, you need to consider how you can use the shape and space of the drawing surface to highlight the important qualities of your subject. Take a look at Figure 3-7 for an example. Both drawings involve the same subject matter, but the impact each drawing makes is quite different.

Figure 3-7:
Noticing
how com-
position
affects your
drawing's
overall
impact.

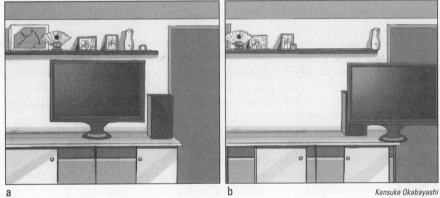

a b *Kensuke Okabayashi*

In Figure 3-7a, the space around the subject frames the subject nicely. The subject is wider than it is tall so the horizontal-rectangle placement is a good choice for drawing attention to the overall shape of the subject. The artist clearly thought about how the shape of the drawing subject would fit best on the paper he was using. Figure 3-7b, on the other hand, shows what happened when the artist didn't think about composition and placed the subject randomly on the paper. He started by drawing the television without considering that if he placed it too far to the side, he wouldn't be able to fit the whole television into the drawing. As a result, the television is cropped at the edge of the drawing. Because the television is clearly an important subject in the drawing, the cropping looks awkward and accidental.

The difference between these two drawings is simple but powerful. So after you figure out how to incorporate lines, shapes, volume, and texture into your drawings, make sure that you give composition some serious thought.

The key words in the definition of composition are *balanced* and *agreeable*. These two words have different meanings for every artist because what constitutes balance and visual appeal are different for each artist. But when you first start out, you may want to follow a few basic guidelines and formulas to help you achieve a balanced and appealing composition in your drawings. Chapter 6 explains these guidelines in detail and shows you how to compose your drawings for the biggest impact. Using these guidelines from the get-go will help you discover what it means to achieve balance and visual impact in your compositions and will provide a foundation from which you can grow.

Project: Taking Apart a Drawing to See How the Five Stages Work Together

In this project, we show you what it looks like to peel away the layers of a drawing one stage at a time so that you can see the separate parts and how they work together.

Unlike most of the projects in this book, this project asks you simply to look at the drawings shown here and examine them for evidence of the five drawing stages we describe earlier in this chapter. However, you can easily make this project more hands-on. All you need are a couple of sharp pencils (2B and 4B are good choices), some tracing paper, a ruler, an eraser, and a finished drawing or two.

When you're looking for a finished drawing to use for this project, check out books that contain drawings by Chris Van Allsburg, Antonio Lopez Garcia, Norman Rockwell, and similar artists. Make a photocopy of the drawing so that you can use it instead of the book when you make the tracings called for in the exercise. But because photocopies are generally less clear than originals, keep the book handy so that you can work from the original as you draw.

Whether you're just following along with the drawings provided here or you're working with your own drawings, the process is the same. Just follow these steps:

1. **Look at the finished drawing.**

 For the moment, separate yourself from the content (or story) of the drawing. Try to analyze the finished drawing in Figure 3-8 (or your own drawing) based only on what you see. Notice how the drawing is a composition (or purposeful arrangement) made up of lines, shapes, values, and textures.

Figure 3-8:
Looking at
the finished
drawing.

Kensuke Okabayashi

2. **Imagine what the composition of the drawing in Figure 3-8 would look like without volume, shading, or texture — that is, as simple lines and shapes (see Figure 3-9).**

 At this stage, the objects are merely suggested by the simple lines and shapes that make them up.

Figure 3-9:
Reducing
the com-
position
to lines
and simple
shapes.

Kensuke Okabayashi

If you're doing the more hands-on version of this project, place a sheet of tracing paper over the photocopy of the finished drawing you're using. Use your ruler and 2B pencil to trace the border of the drawing. Then use a 2B pencil to draw the simple shapes that make up the objects in the drawing. Also use your 2B pencil to draw any essential

lines that don't make shapes. (*Essential lines* are ones that have a big function in the drawing. Horizon lines and electrical wires are good examples of essential lines to include because they typically take up a lot of space in a drawing.) Some lines, like the ones that define wrinkles on someone's face, are detail lines; leave these lines out at this stage.

3. **Imagine what the composition of the drawing in Figure 3-8 would look like as a simple line drawing without value or texture (see Figure 3-10).**

 Compared to the bare-minimum shapes and lines in Figure 3-9, the simple shapes in this version of the composition have been refined into accurate line drawings of the objects. The composition is basic, but everything is in place.

 If you're doing this project on your own, place a sheet of tracing paper over the photocopy of the original drawing, use your ruler and 2B pencil to trace the border of the drawing, and then use your 2B pencil to trace the accurate shapes of the objects. (If you're feeling extra ambitious, try to refine your simple shapes from Step 2 into line drawings.)

Figure 3-10:
Reducing the finished composition to a simple line drawing.

Kensuke Okabayashi

4. **Imagine what the composition of the drawing in Figure 3-8 would look like made up entirely of values and textures without any drawn lines or shapes (see Figure 3-11).**

 The values and textures in this version still form shapes, but no lines separate one shape from another. Even so, you can still get a strong sense of the whole composition without any lines.

If you're doing this project on your own, place a sheet of tracing paper over the photocopy of the finished drawing and use your ruler and 2B pencil to trace the border of the drawing. Then use a 2B pencil to trace the values and textures you see. Switch to your 4B pencil if you need to make darker marks. Pay attention to the lines that make up any textures, and copy them as closely as you can. (See Chapter 10 for more details on accurately recreating textures.)

Figure 3-11:
Reducing
the finished
composition
to values
and
textures.

Kensuke Okabayashi

All the stages of a drawing work together to become the finished whole. Next time you make a drawing, consider the stages we cover in this project. Pay attention to the way you build the drawing to mirror these stages, and remember that each part is just as valuable as the one that comes before or after it.

Chapter 4

Drawing On Your Computer

*N*o matter what experience you have (or don't have) with digital drawing, if you're at all curious about drawing on your computer, this chapter is for you. Don't worry; you don't have to be a computer expert to excel at digital drawing. All you need is a little practice and patience — and a passion for drawing, of course!

When it comes to succeeding with digital drawing, passion for drawing is actually more important than computer knowhow. In fact, an artist who has a passion for drawing will master the art of drawing on the computer more quickly than a computer expert who isn't interested in drawing. After all, technology is getting more advanced, computer art programs are getting easier to use, and drawing programs are getting better and better at mimicking the natural feel of drawing or painting. Some computer devices even allow you to hold a digital pen in your hand and draw in a way that's similar to drawing on paper.

In this chapter, you find tips on everything you need to get started in digital drawing, including how to choose equipment, locate software, use software to create digital drawings, and join an online art community. After you conquer any doubts you may have, master the basics, and pick up a few easy tips, you may discover that sitting in front of a computer to draw is just as enjoyable as picking up a pencil.

Considering the Benefits of Drawing Digitally

Computers and technology are supposed to make life easier, right? Well, in many ways, computers make the art of drawing easier, too. For instance, computers allow you to save different versions of the same project, share your artwork with infinite viewers, and become more flexible in your drawing process (see the following sections for more details on these benefits).

Whether you're new to digital art or you're a seasoned expert, you can surely appreciate the following advantages of adding a computer to your art toolbox:

- ✔ As long as your computer is connected to the Internet, you have instant access to sharing your artwork with your friends and the rest of the world.

- ✔ You can share your drawings via numerous online art communities made up of artists just like you who can give you feedback about your work.

- ✔ You can watch other artists work through the drawing process via online videos on Web sites like www.YouTube.com.

- ✔ As long as your computer is connected to a printer, you can create one drawing and print hundreds of copies instantly.

- ✔ You can rewind your artwork several steps to undo any mistakes you make as you draw (by pressing the Undo button), a process that's both faster and easier than using an eraser.

- ✔ You can use input devices, like drawing pens and touch-screen computers, to make computer drawing feel natural and easy. (In case you're wondering, *input devices* are simply tools for drawing on the computer.)

To achieve the maximum benefits from digital drawing, be sure to make room for some good, old-fashioned sketching in your drawing practice. Drawing with your computer is great because it allows you the freedom to change your mind in an instant and to undo any changes you don't like. But spending time daydreaming with your pencil in your sketchbook makes your digital drawing experience even richer because the process of drawing by hand lets you slowly explore any and all your drawing ideas. Then you can take your ideas and use the computer to give them shape.

One of the things that makes digital drawing fun is how easy it is to add color to your drawings. After all, with digital drawing software, you're just a click or two away from filling your drawings with vibrant color. Later, if you change your mind about your color scheme, you can try a different one with just a few more clicks. But beware: Switching to color from black and white does present a new set of challenges, especially if you want to make digital drawings that look realistic. For example, it's easy enough to use color to make a blue sky, but it isn't as easy to make a sunset sky that gradually

changes from blue to pink to gold. The exercises in this chapter are geared toward helping you use digital drawing tools. You'll master more tools faster if you stick with black and white in the beginning. After you gain a little confidence working with digital drawing tools, you can begin to explore the wide realm of color.

Working with a digital canvas

The world is becoming increasingly less dependent on paper. More and more people are reading books on electronic devices, and businesses in all industries are aiming to be more eco-friendly by reducing the need for printers in their offices. The art world — through digital drawing and other contemporary processes — is also embracing the digital age.

Although we don't expect traditional art galleries to ever disappear, more and more artists are getting excited about the possibilities offered by digital drawing. Because it offers a chance to try more techniques more quickly and move in several different directions at once, drawing on your computer can really change the way you think about making art. As an added bonus, digital drawing offers a whole new way to share your work with others.

Appreciating the power of Undo

In the world of computers, it's easy to take for granted the ever-present Undo feature. This feature is a real game changer when it comes to creating drawings on a computer. All of a sudden, nothing is permanent. In an instant, you can undo your last drawing stroke (and the one before that and the one before that . . .) at exactly the moment you realize you made a mistake. Many art programs actually allow you to rewind your drawing all the way back to the beginning.

Thanks to the Undo feature, making corrections is a lot easier to do when you're drawing on your computer than when you're working with pencil and paper. As a result, the Undo function makes it easy to be adventurous as an artist because it takes the fear out of making major decisions. In essence, by drawing digitally, you can draw anything you imagine using any techniques or effects you want because, if you don't like it, all you have to do is undo it!

Saving versions of your drawings

The easy flexibility of working on a computer is one of the biggest benefits of digital drawing; however, it's easy to get so caught up in changing directions that you forget where you started. To help you keep track of the different stages your digital drawings go through, we recommend that you get in the habit of saving multiple versions of your work. That way, if you realize late in the drawing process that you liked the way your drawing looked four or five stages ago, you can simply open the saved file for that stage and start working from it. Then, if you change your mind again, you can always go back to the later drawing and pick up where you left off.

Save each stage of your drawing as a new file so that you can experiment with different ways of moving forward in the drawing process without losing any of your original work. Going back through your saved versions after you finish a project is also kind of fun because you get the chance to see all the different ideas you had while drawing.

Sharing your artwork

Most artists draw for the enjoyment they get out of creating something, but many of them also draw to share their creations with others. One of the best things about creating digital drawings is that you can share them immediately, thanks to the Internet. And don't think the sharing begins and ends with e-mailing your drawings to your friends and family — it can go much farther.

Many artists have become passionate members of online art community Web sites because doing so gives them access to a whole new audience with whom to share their artwork. Some of these popular Web sites (which we cover later in the section "Joining the World of Online Drawing") have millions of members all waiting to view your artwork and share their reactions. When you join online art communities, your canvas is no longer a single piece of paper stuck in your home; it's a living piece of art being showcased simultaneously worldwide.

Becoming more flexible in your drawing process

Introducing computers to your world of art creation is more than just adding a new tool to your art toolbox. Digital art can change the way you think about approaching a drawing.

For one thing, computers speed up everything. For example, in the world of digital drawing, you don't have to wait for the ink to dry. Some art programs even allow you to record a series of tedious tasks and then access them at the click of a button. When you take advantage of these types of shortcuts, your ability to move through your drawing process gets even faster. You can try hundreds of ideas in an hour instead of the one or two you'd be able to do on paper.

Computers also allow you the freedom to be more flexible and intuitive throughout the drawing process. So don't be surprised if you're more open to experimenting when you draw digitally. After all, you can quickly erase or undo any change you don't like. When you feel fearless during your drawing process, your art reaps the benefits. You can try anything you

think of as soon as it enters your mind without worrying about wasting paper, ink, or time.

To increase your flexibility as you move through your drawing process, try doing the following as you create your next digital drawing:

- The next time you color an element of your drawing, stop and select the area you just colored and use your art program to adjust the color(s). If you don't like the adjustment, change it right back. (You can't do that with ink or paint!)

- Create a collection of textures or drawing elements that you frequently use by saving files from any drawing program every time you draw different objects. Over time, you'll have created a library of different elements, like eyes, head shapes, and trees, that you can add to your drawings any time you need them. Doing so saves time and allows you to call on your previous hard work to draw more productively. Having complex textures or other elements on hand may also remove some of your hesitation to do something because it's time-consuming.

- If you find yourself struggling for inspiration, put your brain on autopilot and let yourself draw any shapes, lines, and colors that come to mind without trying to create something in particular. In other words, spend a little time drawing with emotion rather than always relying on your brain.

- After you finish a drawing and think it's complete as is, save it as a new version and then use your art program's color-adjusting features to change the color balance, brightness, or contrast of the entire drawing. Sometimes making these types of tweaks to a finished drawing creates something fresh and exciting from an otherwise flat or dull-looking image.

- Scan some of your finished pencil drawings into your computer and practice manipulating them. Try turning a black and white sketch into a full-color digital art piece.

Checking the Hardware You Need to Draw Digitally

Most modern computers and even many older computers have more than enough capabilities to get you on your way with digital drawing. You can experiment with drawing on your computer as long as your computer has the bare essentials — a monitor, a keyboard, and a mouse — and it's capable of installing drawing software of your choice. However, to take advantage of the latest drawing software and to draw with ease, your hardware should meet these requirements:

✔ **Monitor:** How you view your artwork on the screen is very important to how your final drawings turn out. After all, if you can't clearly see the details and colors you add during the drawing process, how can you expect them to work well together in your finished drawing? Because you'll be looking at your monitor for hours at a time as you draw, you don't want your screen size to be too small or fuzzy. A good minimum size is a 20-inch screen, but 24 inches and larger is even better. Any of these sizes should have a decent enough resolution to display your artwork and all your art brushes and palettes on the screen at the same time. A high contrast ratio gives you a better range of colors between the brightest white and darkest black.

✔ **Video graphics card:** All computers come with a video graphics card, which is the part inside the computer that sends imagery to the monitor. A decent graphics card is essential because it's the part of your computer that allows you to work with high-resolution artwork and allows your monitor to keep up with you when you're zooming in and out or moving your canvas around frequently. For your computer to perform at its best, make sure your computer has a dedicated video graphics card. A *dedicated graphics card* has its own processor and memory, which help ensure better performance than computers that come with *on-board video* (a video card built into the computer's main motherboard). When choosing a dedicated video card, aim for one with as much dedicated memory as possible. We recommend using a dedicated video card with 512MB of RAM or more.

✔ **Speed (CPU) and memory (RAM):** A faster computer is always preferred, but for digital art, you may find better results if you use a middle-range CPU and invest the money you save into more memory. In terms of memory, aim for the higher end of what's available in your budget. We recommend at least 4GB, but even more RAM is better. One thing to keep in mind is that you can usually add more RAM later if needed.

✔ **Hard drive space:** Your hard drive is where you store all your programs and drawing files. Creating digital artwork can take up large amounts of storage space, especially if you intend to create artwork that you can print at large sizes. Aim for a large-capacity hard drive, but keep in mind that you can always purchase external hard drives to add to your computer later as you need more space.

If you have a DVD drive, you can store your artwork on DVDs rather than on your computer's hard drive. You can also find many services on the Internet that allow you to store files online, which is not only economical but also works as a way to back up your files just in case your computer hardware ever fails.

✔ **Scanner:** A scanner can be a great introduction to digital drawing. If you're new to digital art or find it easier to sketch on paper, you can simply scan one of your quick sketches and use digital drawing software to finish it on your computer. You can even add color! Beginning with your own pencil-and-paper sketches is a great way to help you get familiar with new drawing programs. When choosing a scanner, look for one with the highest scanning resolution and a high *color depth* (the number of colors the scanner can record).

Choosing a new computer for drawing

You can use an older or slower computer if you already have one, but if you have the budget for a new one, you may want to consider buying one. Computers purchased with digital drawing in mind can allow you to work faster with fewer limitations. Before you buy one, do research on which art programs you want to use, verify that you can use them with your computer of choice, and make sure that your computer meets the hardware requirements we cover in the section "Checking the Hardware You Need to Draw Digitally."

Choosing a good computer for digital drawing is less about the brand and more about what's inside. The first decision you need to make is which platform you want to use — a Mac (Apple) or a PC (most other brands, such as Dell, HP, Sony, and so on). To help you decide which one is right for you, ask yourself the following questions:

✔ **What do your friends and family use?** If you think you'll need help getting started or progressing with digital drawing, want to share files with others, or just want to use what all your drawing buddies use, go with the platform they use. Trust us, it'll make your life a little easier.

✔ **Is it compatible with your current hardware?** If you already have some hardware,

like digital cameras, printers, and scanners, find out which computers your hardware works best with. Most devices work with both Macs and PCs, but it's always a good idea to double-check. You definitely don't want to find out that your new computer doesn't work with your digital camera.

✔ **Which software is available to you?** Most art software is available for both PCs and Macs; however; some software is available for only one platform. So if you know of an amazing art program you want to use, make sure it'll work with the computer you want to buy.

✔ **Which one do you like better?** Although PCs and Macs perform many actions very similarly, most people prefer one or the other. If you can, try using both platforms before you settle on which one to buy. Borrow a Mac from a friend for one day and a PC from another friend for another day; then see which one is easier for you to work with.

✔ **How much does it cost?** When evaluating price, make sure you take into account all the software and devices you may want to buy to help you grow as a digital artist. In the end, the computer alone is a small piece of the bigger picture.

Exploring Digital Drawing Software

When it comes to art programs for your computer, you have endless options to choose from. Which programs are best for you depends on your personal style and digital drawing goals. Just keep in mind that most artists use multiple programs to achieve their desired results.

When choosing your art software, consider the following:

✔ **Price:** Although some of the most popular and versatile software is expensive, you can achieve great results with affordable and even free software. Don't be afraid to try free or affordable software to help you determine which drawing features are most important to you. After you get a better understanding of what you want to achieve with your digital drawing software and what particular elements you like best, you can invest in the more powerful and professional options.

✔ **How-to resources:** The more popular art software tends to have more tutorials and similar resources available to help you figure out how to use it. Even though the more popular software may cost more, you may find it easier to learn a wide array of techniques with the help of all the free online resources and books available on that software. Some online art communities are devoted to specific software; they usually provide forums where artists can share tips and techniques for how to use the software.

✔ **Long-lasting reputation:** Consider how long the software has been available. You don't want to spend years using some free art software only to find out the company that created it no longer exists and your art files aren't compatible with any other software.

✔ **Raster- or vector-based:** Art programs are often either raster- or vector-based. *Raster-based software* is more suited to drawing styles that look like sketches, paintings, or photo-realistic art, while *vector-based software* is more suited to flat cartoon or illustrative styles. The programs in the following sections are all raster-based. After you feel confident using raster-based art programs, you may want to start experimenting with vector-based ones, too. Some of the more popular vector-based programs are Adobe Illustrator, Corel Draw, and Xara Xtreme.

Free downloadable drawing tools

The Internet is full of countless free art programs that offer features that are similar to the expensive alternatives and that you can download and install on your computer. These free alternatives are a good introduction to drawing applications for new digital artists. The following are just a few of the free drawing tools that aren't far behind in quality from those that cost hundreds of dollars:

✔ **Paint.NET (`www.getpaint.net`):** This application is comparable to any image-editing application and is considered advanced. It offers features very similar to the popular Adobe Photoshop, but it's only available for PCs.

✔ **Gimp (`www.gimp.org`):** This application was originally created for UNIX-based computers as an alternative to Adobe Photoshop and includes many similar features. It's now available for PCs and Macs, too.

✔ **Artweaver (www.artweaver.de):** This application is like many other image-editing applications, but it puts a little more attention on introducing brushes and effects that are specifically art related.

✔ **TwistedBrush (www.pixarra.com):** TwistedBrush offers both free and paid versions of its software. The free version has a small selection of art brushes, but the paid version has more than 5,000 digital art brushes.

✔ **Seashore (seashore.sourceforge.net):** This popular Mac-based image editor doubles as an art application that includes standard features like layers and brushes.

Entry-level and affordable art software

Entry-level software is aimed at artists who are new to drawing on a computer and is often easier to use and learn than more advanced software. It's also very affordable, costing between twenty and a few hundred dollars, depending on the particular program. Here are some great entry-level options:

✔ **ArtRage:** This program is one of the few that makes a clear distinction between tools used for digital drawing and tools used for image editing. It presents interesting ways to mix colors and use brushes the same way traditional artists mix colors and use brushes on paper or canvas.

✔ **Corel Painter Essentials:** Not to be confused with Corel Painter, the *Essentials* version of Corel's popular painting software is a more affordable and entry-level introduction to the full version of Corel Painter. Corel Painter Essentials does a great job of simulating what it's like to work with traditional painting and drawing tools.

✔ **openCanvas:** This program was developed in Japan and is popular with anime or manga artists. It offers the unique feature of recording your drawing process so you can create replays.

✔ **Corel PaintShop Pro:** This popular image-editing program does a good job of doubling as an art or drawing program. If you need an image-editing program for editing your photos but also want to have some nice drawing tools at your fingertips, give this program a try.

✔ **Pixelmator:** This multifacted Mac-based program has a very cool-looking set of tools, menus, and palettes. It's an affordable alternative to Adobe Photoshop for Mac users.

Work faster and better with digital drawing pens

Graphics tablets are affordable digital devices you can use with your computer to help you master the art of drawing digitally. In a nutshell, they allow you to hold a special pen and draw on a pad (or tablet) to simulate the feeling of drawing on paper. The cordless pen is just like an ordinary pen except that it has a plastic nib and no ink. When it touches the tablet surface, the tablet sends information to the computer the same way your mouse works. Most tablets even have pressure sensitivity, so the harder you press the pen, the darker or thicker your strokes appear — just like a real pencil on paper.

The first time you use a drawing tablet your instinct may be that it feels different from drawing on paper. The reason is that even though you're drawing just like you do with a pen, your artwork appears on your screen, not on the tablet you're drawing on. It's a little like drawing on one piece of paper and having the image appear on a different piece of paper in front of you.

Just like the first time you used a mouse with a computer, a digital drawing pen takes a few weeks to get used to, so don't give up right away. In time, you may just find that your drawing tablet is your new best friend.

Some advanced tablet computers even allow you to draw directly on a screen to make the drawing process even easier and more natural. These versions are expensive but loved by many professional digital artists.

Professional-level software

You don't have to be a professional artist or designer to use professional-level software. Professional-level software is expensive compared to the low-cost or free entry-level software we cover in the preceding two sections. However, using the professional software does offer a few advantages that you may want to consider even if you're a digital beginner. For example, if you use popular software like Adobe Photoshop when you start drawing digitally, you'll be working with software designed for maximum user-friendliness, and you'll have an abundance of helpful how-to resources at your fingertips when you need them. Here are some great professional-level options:

- **Adobe Photoshop:** Photoshop is the most common program that artists use for both personal and professional projects. It may have reached its popularity because it doubles as a professional tool for advanced photo editing and a common tool for graphic designers. Some artists find it has many features they never use as artists. For this reason, this program can be overwhelming to the beginner; however, with this massive feature list comes great flexibility.

- **Corel Painter:** Many digital artists consider this program a favorite, perhaps because it was one of the first programs truly designed with artists in mind. It does an amazing job of simulating what it feels like to use different brushes, canvas types, pencils, inks, and paint.

✓ **Autodesk SketchBook Pro:** We could've listed this program as an afford-able option in the preceding section, but it has enough of a dedicated and growing following among professional artists that it deserves a spot here. For a very affordable price, it's a feature-packed drawing program that offers countless tools that traditional artists find extremely useful. This program is used by professionals and amateurs alike.

Joining the World of Online Drawing

Whether you use free downloadable drawing tools, entry-level software, or the high-quality, professional-level programs, drawing on your computer is only the first step to creating digital art. New trends in online art are becoming more common as more and more artists venture into the world of digital drawing. Thanks to the advancement of technology, many Web sites offer free online drawing tools that you can use right in your browser. Using these tools is as simple as visiting a Web site; most of them load in your Web browser with little or no installation required. The benefit of using these tools is that your artwork is often automatically posted to the site's art community galleries, where other artists can view them and give you instant feedback.

The following is a list of free online drawing tools you may want to explore as you develop your digital drawing skills:

✓ **RateMyDrawings (www.ratemydrawings.com):** RateMyDrawings offers two versions of their online drawing tools — simple and advanced. The simple version records while you draw, replaying your drawings stroke by stroke. Submitted drawings are posted to the highly active commu-nity site. As you may have guessed from the Web site name, other site members then rate (and comment on) the posted drawings.

✓ **Sumo Paint (www.sumopaint.com):** Sumo Paint is one of the more advanced online drawing tools; it's as much a drawing tool as it is an image-editing tool. As a bonus, the drawing tool also allows you to import photos, which may be useful when you're just starting out.

✓ **Queeky (www.queeky.com):** Like many others, this online drawing tool is connected with an active community. One interesting feature on Queeky allows you to submit drawings and invite other artists to create variations of your drawings.

✓ **Aviary (www.aviary.com):** This Web site has a whole suite of online tools. Its image editor and vector editor are two applications that are definitely worth experimenting with.

The following sections offer some suggestions for how to build your online artistic presence through community galleries, personal portfolios, and inter-active collaboration. The last section explains how to use the Internet as a resource for developing your drawing skills.

Building a gallery on art community Web sites

One of the most appealing things about digital art is the ease with which you can share it. If you're looking for a place where you can talk to others about digital art, share art-related ideas, and get some feedback on your work, online art communities are the perfect place for you. After all, an online art community is basically just a playground for creating collaborative art.

To become part of an online art community, the first thing you have to do is join it. Most art communities give you a profile where you can share a little information about yourself and a gallery where you can upload your drawings. Usually you upload your drawings into a themed category; other artists can then browse the artwork that has been submitted into that category, leave comments about it, and often rate it.

Some of the more popular art communities that offer such galleries include the following:

- **deviantART (www.deviantart.com):** This community is one of the oldest and largest online art communities on the Internet with millions of members. With such a long history, good reputation, and large member base, it's one community you should join if only to see what all the fuss is about.

- **Redbubble (www.redbubble.com):** This newcomer to the art scene does a great job of making its community easy to use. One popular feature of this community is the ability to sell prints or T-shirts with your artwork on them.

- **Artician (www.artician.com):** This community offers many of the same features available at deviantART, but it focuses more on allowing you to customize your online gallery.

- **GFXartist (www.gfxartist.com):** This community has been on the scene for a long time. It not only offers the ability to upload your art, but also aims to reach out to the digital community by providing tutorials and industry news.

Creating a personal online portfolio

Online art communities are great for connecting with other artists and sharing your art on the Web, but you may find that you want something a little more personal than the basic public profiles and galleries. Creating your own Web site devoted to your work makes a strong statement about how seriously you take yourself as an artist.

If you have experience building Web sites, creating your online art portfolio will be easy. But don't worry if you aren't tech savvy; you can set up your personal online portfolio with ease by doing one of the following:

✔ **Create an art blog.** Many free blogging services work well as a simple way to upload images of your artwork. These blogging services allow you to customize the design of your blog, include as little or as much information as you want, comment on your own work, and invite others to do the same. They're also a great introduction to maintaining a personalized Web site. Try typing *art blog* into your favorite search engine to see all the blogging options you have at your fingertips.

✔ **Use a basic template on an art portfolio Web site.** You can find many affordable Web sites that will host your portfolio for a fee. To get started, all you have to do is pay the fee and choose an already-designed Web site template from which to build your portfolio. Then you can start uploading images and adding comments about yourself as an artist and your work.

Experiencing interactive online drawing

Web sites that are devoted specifically to online drawing use cutting-edge technology to provide you with numerous opportunities to develop your digital drawing skills through interactive online drawing. Some of the exciting features many drawing Web sites offer include the following:

✔ **Recordable drawing tools:** These tools record your drawing process as you draw so that viewers (and you) can watch your drawing process as an animated movie when you're done. Not only can you develop your own skills by watching the way you draw, but you can also gain insight into how other artists draw by watching their recorded drawings.

✔ **Live drawing chat rooms:** These applications allow you to enter a chat room and share a drawing canvas with other artists in real time. These collaborative drawing sessions can be a lot of fun for both casual and serious artists and can even produce some amazing results.

✔ **File sharing:** If drawing live with other artists is a little too overwhelming, you may want to consider using a drawing Web site that allows you to pass drawing files back and forth. That way, you can still build on other people's work (and they can build on yours) without the added stress of having others watch while you work.

Gaining insight from the Internet

The Internet is an artist's dream when it comes to ready-to-use resources. If you want to learn about a specific topic or technique in drawing, someone has likely already created a tutorial or walk-through on that particular subject on the Internet. All you have to do is search for it.

The following sections give you an overview of the different online drawing-related resources you may find helpful.

If you have the urge to draw but just can't think of what you want to draw, try using the Internet as a source of inspiration. Browse a handful of images on different art Web sites to try to spark your imagination. Seeing an image of something striking may encourage you to try to draw something similar. To challenge yourself not to simply copy an image you like, stare at the image for five full minutes and then look away and start drawing from memory. While you work, try changing the image slightly on purpose.

Keep in mind that the rewards you get from seeing how someone else approaches a particular drawing technique in a tutorial or how-to video are purely inspirational. The techniques you read about and see in action online are not the surefire way to become a good artist and are certainly not the only right way for you to draw.

Using traditional step-by-step tutorials

If you're trying to find out how to perform a particular drawing technique or skill, the Internet is a great place to look. Many Web sites are devoted to creating and posting drawing tutorials like the traditional step-by-step lists you find throughout this book. They're easy to follow, and, because you can peek ahead to see how the process turns out, they're also a great way for you to develop technique and build confidence.

Some popular Web sites with traditional drawing tutorials are

- Drawspace (www.drawspace.com)
- Duey's Drawings (www.dueysdrawings.com)
- Drawing Tutorials Online (www.drawing-tutorials-online.com)

Watching replays of drawings

Many online drawing Web sites have a feature that allows you to watch time-lapse videos of drawings being created by members of the sites. Simply studying how other people approach their drawings from start to finish can help you develop your own skills and really think about how you draw.

Figure 4-1 shows a drawing replay over time from start to finish. By watching each step in the drawing replay, you can see how the artist constructed his

drawing. In this case, the artist started by drawing the sky and water, then drew the detail of the pier, and finished by adding details and texture to the beach and foreground.

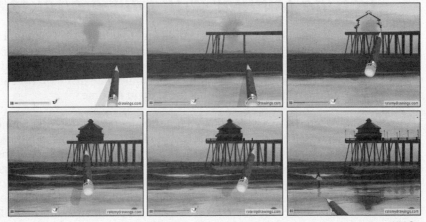

Figure 4-1:
Screenshots
of an online
drawing
replay.

Mick Gow

Viewing videos from artists across the Web

The Web is home to many user-generated video Web sites, like YouTube, that give artists an insight into each other's art studios. Many artists create videos of themselves drawing and then post them online for other artists to view. Like the drawing replays we cover in the preceding section, these videos provide a great opportunity for skill development and assessment.

Many artists create time-lapse drawing videos by using screen-recording software to take videos of them drawing on their computers. They then upload those videos to video-sharing sites. If you want to see how this video-creation process works, type *speed painting* into the search box at www.youtube.com. Then click on a drawing that looks interesting and watch the video about how the artist created it.

Getting Started with Digital Drawing

Just like drawing on paper, digital drawing becomes much easier when you understand your tools and the various techniques or methods you can use to create your drawings. And like all things, practice makes perfect. Set realistic expectations when you first start drawing digitally and don't get discouraged if it takes many months before drawing on the computer feels natural and easy. After you become familiar with your computer as an art tool, you may find yourself turning on your computer more often than you grab a pencil and paper.

In the following sections, we show you how to use some common digital drawing tools and how to plan your drawings using rough sketches and layers.

Getting familiar with your digital tools

Open any drawing program, and you'll find tons of tools. Don't feel intimidated! You need only one or two to get started. After you get comfortable with the basic tools you start with, try another tool to see what it does. When you're starting out, it's healthy to spend some time just experimenting to locate all the features. You'll pick them up in no time.

Figure 4-2 shows examples of some of the most common tools found in most art programs. The top row and left side of the bottom row of Figure 4-2 show different toolsets available in various programs; the right side of the bottom row shows examples of different types of brush effects. Even though each drawing program presents its tools and brushes differently, many of them contain the same basic pen, brush, shape, zooming, and editing tools. Keep in mind, though, that the *icons* (the symbols that visually represent the tools) differ from program to program.

Figure 4-2:
Digital art programs generally have the same types of tools.

Creating rough sketches

Whenever you start a digital drawing (or any drawing, for that matter), your first instinct may be to just start drawing or painting away without thinking about where you want your drawing to go. Trust us, you'll save yourself a lot of frustration if you make a quick sketch with pencil on paper to plan your drawing first. (See Chapter 6 for details on planning your drawings.)

You can start a drawing using traditional tools like pencil and paper and then transfer these artworks to your computer to help you get confident with digital technology. All you have to do is use a scanner to import your sketch into the drawing software you're using (as shown in Figure 4-3). You may be surprised to find that the results turn out even better than if you used a computer alone. (See the instructions that came with your software and/or scanner for details on how to import your hard copy drawing into your drawing program.)

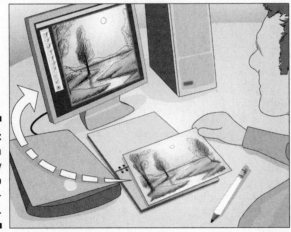

Figure 4-3: Scanning a hard copy sketch into your drawing program.

Mick Gow

If you're having a hard time coming up with ideas for your digital drawing, you can use a reference image like a photograph or a sketch you've already made on paper to help you plan your drawing. Just keep your reference image in view so that you can refer to it as you draw.

Understanding layers

When it comes to digital drawing, most art programs allow you to work in layers. Unlike a piece of paper that's just one layer, in digital drawing, you can create many layers and draw different parts of your drawing on each layer.

As a drawing tool, working in layers is like having a clear sheet of glass or acetate that you place over any stage of your drawing to make additions without changing what you already have. You can then move around, erase, and add to what you draw on each layer without affecting all the other layers. Because you can see through whatever layer you're working on to the layers underneath, you can instantly see the effect of any changes you make on the drawing as a whole.

Thinking in layers while planning your drawing can give you enormous flexibility as you draw. Before you start working on your digital drawing, take some time to plan what layers you want to create and how they'll work together to become your finished drawing.

Figure 4-4 shows all the layers that make up the digital drawing you see in the bottom-right corner of the figure. Each layer is devoted to a different aspect of the drawing, but because the layers are transparent, when they're all stacked together, the layers blend together to give the impression of one complete drawing.

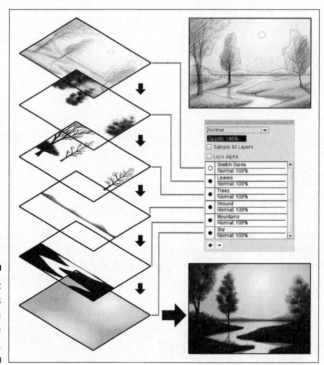

Figure 4-4:
Using layers
to plan a
landscape
drawing.

Rosemary Sidaway

To better understand the flexibility and control you gain by using layers in your digital drawings, imagine that you're planning a portrait drawing of someone's face. You may take an approach like the following with your layers:

1. **Create a background layer where you draw the backdrop behind the face.**

2. **Create a layer for the head and overall face.**

3. **Create separate layers for each element in your portrait that you may want to edit individually, like the mouth, the nose, and each eye, for example.**

4. **Create a layer for the hair, which usually sits above all the other parts of the face.**

Creating the background of your portrait as an independent layer means you can change the color and any other attributes of the background at any point in the drawing process without affecting the rest of the drawing. For instance, you can start by drawing your person standing in front of a sky, a textured wall, or basically any backdrop you want; then if you change your mind as you progress in your drawing, you can change the background again. With the head of the portrait on a separate layer, you can move or nudge the head into different parts of your drawing. With the eyes, mouth, and nose on separate layers, you can move these elements around and adjust the portrait very easily without affecting the background or other layers of your drawing. Finally, with a separate layer for the hair, you can give your portrait different hairstyles without having to take it to the hairdresser.

Although layers offer great advantages, they present some unique problems, too. For example, you may find out halfway through a drawing that putting a certain element on a different layer makes it difficult to blend or smear colors and textures from one layer to the next. To reduce problems like this one, you simply have to practice working in your drawing program and get used to using layers to create well-blended projects.

Project: Creating Your First Digital Drawing

In this project, we walk you through the basic process of creating a digital drawing. Specifically, we show you how to use the Layers tool to create a simple landscape drawing. Keep in mind that you can use many different techniques and approaches as you draw with your computer; this project simply incorporates some of them.

REMEMBER

As long as you have an Internet connection and a computer, you can do this project with us; we use the advanced online drawing tools available for free at www.ratemydrawings.com. Feel free to use a different art program if you prefer. Just know that the steps you take and the screenshots shown here may differ from what you do and see in your program. If you use a different program, make sure to use one with a feature that lets you make layers.

1. **Start with a new horizontal large canvas on www.ratemydrawings. com and use the advanced drawing tool to draw the basic shapes of your drawing.**

 After the program has loaded, create a new layer by clicking the + (plus) icon in the Layers panel (shown in Figure 4-5). Double-click this layer and name it *Sketch.* Select the Pencil tool and use your mouse or drawing tablet to draw the basic shapes of your drawing. This layer is only a guide for the rest of your drawing, so it doesn't have to be perfect.

2. **Create separate layers for each of the key components of your drawing.**

 Click the + (plus) icon in the Layers panel to create seven more layers. Double-click each layer to name it, as shown in Figure 4-6: *Detail, Leaves, Trees, Ground, Mountains, Water,* and *Sky.* Make sure each layer is in the exact order shown in Figure 4-6.

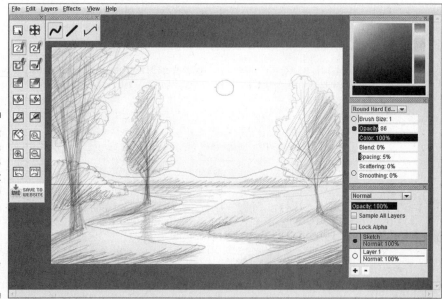

Figure 4-5:
The Layers panel (lower-right corner) shows the layer in which you're currently working.

Rosemary Sidaway

Figure 4-6:
The order in
which you
need to set
up your
layers.

3. **Draw the sky of your drawing in your Sky layer, using your Sketch layer as a guide.**

 Click the Sky layer to select it. Using the Airbrush tool and the color panel, select the shades of gray you want to use, and fill in the sky however you want it to look (see Figure 4-7 for an example of a finished sky). You can make the brush size bigger or smaller, depending on the effect you want to create.

 Click the Undo button any time you want to quickly undo any mistakes you make as you draw.

4. **Draw the water, mountains, and foreground of your landscape in your Water, Mountains, and Ground layers.**

 Select one layer at a time to continue drawing each element of your drawing; be sure to work from the bottom layers to the top layers.

 Select the Water layer and fill in the water in the lake using the Watercolor or Airbrush tool. Then select the Mountains layer and fill in the mountains in the distance. Go back and forth between showing and hiding your Sketch layer as needed so that you can see the boundaries of your mountains. (To hide the Sketch layer, simply click the circle to the left of that layer. Click the circle again to make the Sketch layer visible.) Finally, select the Ground layer and use the Pencil or Pen tool to fill in the foreground of your drawing. Adjust the brush size as needed to make it easier to fill in larger areas of color while you draw. (Figure 4-8 shows an example of what your drawing may look like with the water, mountains, and ground in place; notice that the Sketch layer is hidden.)

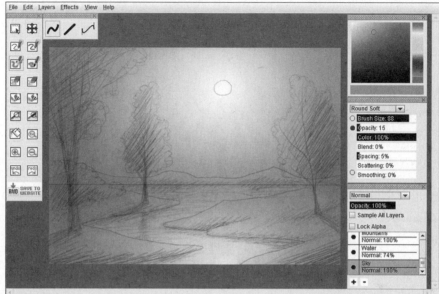

Figure 4-7:
Drawing the
sky in the
Sky layer
while look-
ing at the
Sketch layer
as a guide.

Rosemary Sidaway

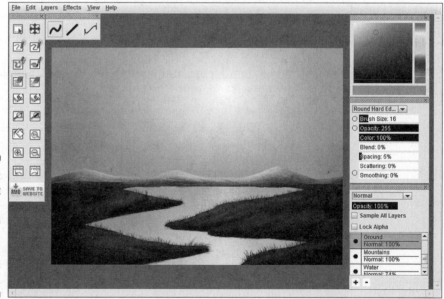

Figure 4-8:
Seeing what
your draw-
ing looks
like with
the water,
mountains,
and ground.

Rosemary Sidaway

5. Select your Trees layer and draw the trunk and branches of your trees.

Use the Pencil tool to draw the trunk and branches of your first tree. After you finish this tree, use the Move tool to click and drag your tree around to see how it looks in different locations. When you're happy with your first tree, continue drawing any other trees or shrubs you want to include in your landscape. (Figure 4-9 shows an example of a finished Trees layer with three trees.) If you want more flexibility, you can draw each tree on a separate layer so that you can move each one to a different location at any time.

6. Select the Leaves layer and add leaves to your trees.

Use a small brush size with the Pencil tool and set the Scattering quality (see Figure 4-10) to approximately 800% so that you can paint masses of leaves very quickly. Use various shades of gray on your color panel to paint your leaves over the tree branches. Notice how you can add value to your leaves however you like without affecting the tree branches that you drew on the layer beneath. You can even use the Eraser tool to delete some leaves, again without affecting the tree branches below. (Figure 4-10 shows an example of what your trees may look like after you add leaves to the Leaves layer.)

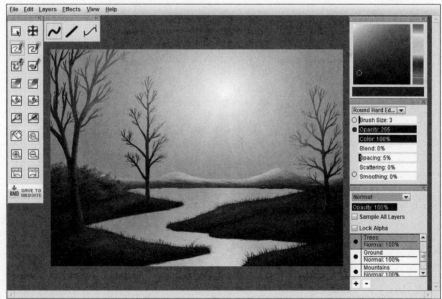

Figure 4-9:
Drawing the trees in your Trees layer.

Rosemary Sidaway

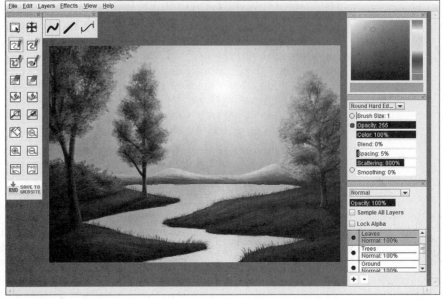

Figure 4-10:
Giving your
trees life
by adding
leaves to
the Leaves
layer.

Rosemary Sidaway

7. **Select the Detail layer of your drawing and add the finishing details to your drawing.**

 Because the Detail layer lies on top of all the other layers, you can use it to add any final details, like shadows, highlights, and reflections, that sit on top of the rest of the drawing. You can create as many Detail layers as you want and use them to experiment with different effects. Figure 4-11 shows what it looks like to add reflections on the lake to the Detail layer, but you can easily add some birds flying in the sky or some flowers in the grass, depending on the landscape you want to create. You can also add a second Detail layer for some fog or misty rain to create an alternate version.

When you finish your digital drawing, take some time to reflect on the process as a whole and admire the finished product. Don't expect it to be perfect. It'll take time to get used to all your new tools, but you're already well on your way. Try making different kinds of digital drawings on your own by following the basic steps covered in this project.

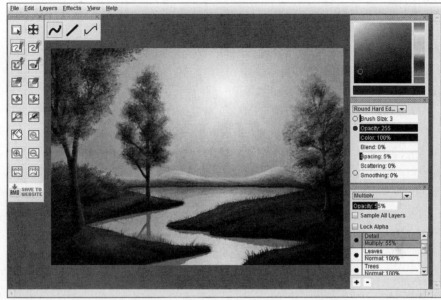

Figure 4-11:
The
completed
drawing.

Rosemary Sidaway

Chapter 5

A New Kind of Seeing: Getting Familiar with the Artist's Perspective

As you may already know, the world looks totally different when you see it through the eyes of an artist. From an artistic point of view, ordinary objects you've seen hundreds of times before suddenly swarm with new angles, lines, and importance. When you adjust your eyes (and brain) to seeing your surroundings in this way, you discover that even the mundane parts of your life are jampacked with subjects just waiting to be drawn.

In this chapter, you have the opportunity to explore and expand your artistic visual abilities so that you can start seeing your world as an artist. So keep your drawing supplies close by and get ready to exercise both your brain and your vision in a whole new way!

Dissecting Your Brain to See Which Side Affects Your Drawing Abilities

Many aspects of your brain work together with your vision when you draw. Although you don't have to understand all the details of how your brain functions as you draw, being aware of your brain's different capacities can help

you realize some interesting characteristics about yourself. In turn, those realizations can impact your development as an artist.

Your brain has two sides: the right hemisphere (right brain) and the left hemisphere (left brain). Both sides of your brain play an equally important role in drawing.

Right-brain thinking is visual, perceptive, intuitive, insightful, and creative. The right side of your brain is responsible for doing the following:

✓ Seeing relationships and likenesses between shapes and spaces

✓ Combining various visual elements to form a whole image

✓ Seeing harmony and balance instinctively

Although it may seem like the right brain shoulders the bulk of the work of drawing, the analytical left brain pitches in by doing the following:

✓ Using mathematical logic to establish proportion

✓ Planning a drawing according to the rules of composition (see Chapter 6 for more on these rules)

✓ Analyzing the step-by-step procedures of composing a drawing

As you can see, you need to activate both the creative and the analytical sides of your brain to draw well.

Waking Up the Right Side of Your Brain

For most people, the left brain gets plenty of exercise in everyday life when they make routine decisions like what to fix for dinner, add up bills, or attend school, all of which emphasize the importance of left-brain functions. As a result, many people end up being *left-brain dominant* by default; that is, the majority of people find that the analytical parts of their brains take over most of the time, thus silencing the more creative parts.

If you're one of the left-brain-dominant people, get ready to give your right brain a wake-up call! Because the right brain processes many of the perceptive skills you use when drawing, you need to exercise the dormant abilities of your right brain if you want to make progress in your drawings. This section is here to help you do just that!

Flipping between the left and right sides of your brain

In general, the right brain has a greater capacity for perceiving shape and space, while the left brain tends to process visual information by sorting and classifying. To get both sides of your brain up and running, take a look at Figure 5-1. What do you see?

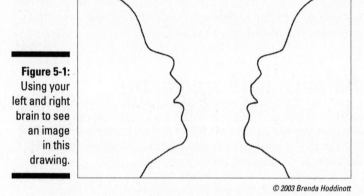

Figure 5-1: Using your left and right brain to see an image in this drawing.

© 2003 Brenda Hoddinott

To see both parts of the optical illusion in Figure 5-1, your brain must use both its right and left sides. While your right brain registers a collection of lines, shapes, and spaces, your left brain starts out seeing either a vase or two faces (see Figure 5-2). Satisfied that it has grasped the important parts of a scene, the left brain ignores the seemingly unimportant empty spaces around the vase or faces.

Figure 5-2: Refocusing to see two separate images in the drawing from Figure 5-1.

© 2003 Brenda Hoddinott

The first time you see an illusion like the one in Figure 5-1, you may not even realize there's another way to look at the image until someone else points it out to you. After someone points out the second image, your right brain can go to work focusing your eyes on the so-called empty space, leading your left brain to realize that what it thought was empty space is actually a second object.

When you're getting ready to draw an object like a vase, it's more helpful for you to see its shape than to know its name or to think about its function because drawing involves representing its shape on paper, not its name or function. Therefore, your right brain — the side more involved in recognizing shapes — is the side you want to have in charge whenever you draw. See the later section "Controlling the left-to-right flip" for details on how to control which side of your brain you use when you draw.

Striking balance with symmetry

Symmetry is a perfectly balanced arrangement of lines and shapes on opposite sides of an often-imaginary centerline. Many drawing subjects, including vases, frontal views of faces, wine glasses, flowerpots, and geometric forms, such as spheres, cones, and cylinders, are symmetrical.

Human beings are hardwired to look for and appreciate balance. Because symmetry is an exact, mirrorlike reflection of line and shape across an imaginary centerline, it's the ultimate state of balance.

The right and left sides of the brain work together to recognize symmetry:

✔ The right brain recognizes the similarity of the shapes on either side of a symmetrical object.

✔ The left side recognizes that similarity as symmetrical balance.

To test your brain's ability to pick out symmetry in a drawing, take another look at Figure 5-1. Imagine a line down the center of the image. Each side is a mirror image of the other. In other words, the image is symmetrical.

Controlling the left-to-right flip

You don't have to look at Figure 5-1 to shift from left- to right-brain thinking; you can do so simply by focusing your thoughts. The left brain naturally focuses on concrete objects (often called *positive shapes*), while the right brain focuses on abstract things like the shapes and spaces that surround those objects (often called *negative shapes*). If you consciously shift your thoughts from positive shapes to negative shapes, you can almost feel your brain switch gears.

Take another look at Figure 5-1. One of the reasons why Figure 5-1 functions as a clever illusion is that both the vase and the faces can be positive shapes or negative shapes, depending on which one you focus on. If you focus on the two faces, the faces are the positive shapes and the space between them (the vase) is the negative shape. If you focus on the vase, the spaces around the vase (the faces) are the negative shapes.

Here's another way to visualize the difference between positive and negative shapes: Look at the legs of a dining room chair. The legs make up the positive shapes, while the space between the legs makes up the negative shape. When you focus on the legs themselves (the positive shapes), you're mostly using your left brain, but when you focus on the space between them (the negative shapes), you're using your right brain.

You can also shift your thinking from left brain to right brain by describing your surroundings in terms of abstract things like shapes, lines, values, and colors. The left brain likes to name things. For example, to the left brain, a grape is a grape. The right brain, on the other hand, is more interested in abstract notions like shape, so, to the right brain, a grape is a small sphere.

For more practice making the left-to-right shift, look around you and describe the things you see using only words that describe their shapes. Use geometric shapes like square or circle rather than symbolic references like panda-shaped. If you can't name something's shape with one word, determine what shapes make it up. For example, if you see a birdhouse, you may use your right brain to name it, "Square with a triangle on top." (This habit comes in handy in Chapter 7, so go there if you want to get more practice with defining objects by the shapes that make them up.)

Giving your left brain a vacation

Familiar objects often look very unfamiliar when you view them upside down. After all, the visual information that your left brain automatically applies to certain objects is no longer available when you look at them from a new perspective. When your left brain can't name the various parts of a particular drawing subject, it gets confused and eventually gives up trying to identify that subject — which is when the right brain jumps in and takes over. The right brain sees the lines of your drawing subject differently than the left brain sees them. It focuses on the way the lines curve and how they create shapes and spaces within the boundaries of your drawing paper instead of trying to classify the lines and shapes as belonging to a particular object.

Grab your paper and whichever pencils you prefer because it's time to deliberately confuse your left brain so that your right brain can take over. As you follow the steps we outline here, resist the urge to sneak a peek at the object you're drawing until you're finished with it. No cheating! As you make your way through this simple drawing, keep in mind that both sides of the drawing are symmetrical.

1. **Draw a rectangle that's 4 inches long by 2 inches high.**

 If you prefer a larger drawing surface, make the rectangle 8 inches by 4 inches.

2. **Very lightly draw a dotted line down the center of your rectangle to divide it into two 2-inch squares (or 4-inch squares if you're using the larger format).**

 This line visually represents the imaginary line of symmetry in your drawing. Make sure you draw it lightly enough that you can erase it later.

3. **Draw the first set of three lines that you see in Figure 5-3.**

 Place this first set of curved lines almost halfway between the top and bottom of your rectangle. The line in the middle looks like a small section of the top of a circle. The other two curved lines touch the middle line and then curve outward and upward.

 Make sure the line of symmetry you drew in Step 2 cuts the image of the three lines exactly down the middle and that each half of the image mirrors the other half.

Figure 5-3:
Drawing the
first three
lines.

© 2003 Brenda Hoddinott

4. **Draw the second set of lines that you see in Figure 5-4.**

 Draw a slightly curved line directly above your first line. Note that this new line is almost at the top of your drawing space. Then draw a second line, curving up and then back down, below the first line, close to the bottom of your drawing space.

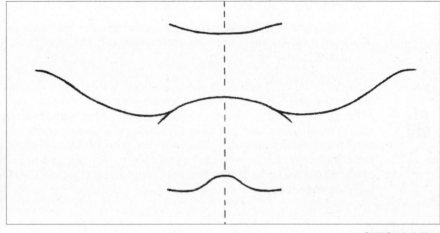

Figure 5-4:
Drawing the
second set
of lines.

5. **Put your pencil on one end of the top line and draw a line that curves outward and downward and connects to the end of the centerline on that side.**

6. **Do the same thing on the other side of the top line, completing the upper shape.**

7. **Put your pencil on one end of the centerline and draw a line that curves outward and downward and connects to the bottom line.**

8. **Do the same thing on the other side of the centerline, completing the lower shape (see Figure 5-5).**

Figure 5-5:
Completing
the shape.

9. **Erase the centerline running down the middle of the drawing.**

 Turn your sketchbook right side up and let your left brain come back from its short vacation. Now you can identify the object you just drew — a nice pair of lips!

Your left brain can't make out objects as well when they're upside down, so, at a certain point, it stops trying. Because your right brain ignores the names of things in favor of the values, shapes, and lines that make them up, you're able to create a realistic pair of lips without even knowing what you're drawing. This creativity-inspiring place — where your left brain is quiet and your right brain is in charge — is where you need to be when you draw because everything is easier to draw when you forget about what it is and focus only on what you see.

Exploring the World as an Artist

As an artist, you're always looking for something new and inspiring to draw, and the best place to find your next subject is, well, anywhere. Think of the world around you as your personal all-you-can-see buffet. Everything you see is a potential subject for drawing. In the following sections, we offer you some food for thought — literally and philosophically — on what kinds of things make great drawing subjects, so give your drawing supplies a break and prepare your mind to be opened. We're about to challenge your current conceptions about what makes a drawing subject ideal.

When you're looking for drawing subjects, take time to actively search for something that interests you. Root through the attic, take a trip to the garage, or shine a light into the deepest corners of your basement until you find an object or scene that calls to you. Having an interest in your subject matter keeps you from becoming bored or giving up when the first few lines don't work out as you expected.

Finding fun drawing subjects right in front of you

Sometimes the best drawing subjects are right in front of you. Look around for compelling shapes, lines, patterns, and textures. Focus on the unfamiliar parts of familiar objects. You can turn just about anything into a subject worthy of your pencil.

Your kitchen and bathroom are full of objects you see all the time but probably never really look at. For example, take a close look at the faucet on your

kitchen or bathroom sink. Try to draw it. See how much more fascinating a simple faucet becomes when you make it your pencil's subject?

Houseplants make great drawing subjects when you're trying to give your mind a break and let your pencil do the work. The complexity of plants is manageable only after you let go of the urge to control every aspect of your drawing.

When you're ready to pick out a few more subjects in ordinary places, check out that mess in the garage (your own or someone else's). With just one glance, you can probably find lots of mundane objects that turn out to be great drawing subjects. Bicycles and tricycles, for example, are great to draw because they're both complex and simple at the same time. If you think you know what they look like already, try to make one from memory. Put that drawing away and try another drawing with a bicycle in front of you. Then compare the two drawings. Notice the details you missed when you drew the bike simply from memory.

When you're searching your surroundings for new drawing subjects, don't forget to consider objects you especially like. Figure 5-6 is a drawing made from an in-progress 1,000-piece puzzle. This puzzle makes an interesting drawing subject for many reasons, but what captured the artist's attention right away were the alternating convexities and concavities of the puzzle pieces.

When you realize you like the way a particular object looks, don't let yourself off the hook simply by saying, "I like this." Try to figure out why you find that object visually compelling. (See Chapter 17 for more ways to grow as an artist.)

Figure 5-6:
Taking note of the drawing possibilities in everyday objects.

Jamie Combs

Seeing your home from a whole new perspective

After you draw a few ordinary objects, try focusing your drawings on something a little bigger. To help you get started, take a walk around your home. Try to see beyond your complex perceptions of your home's rooms as you look for drawing subjects.

If looking at a whole room is too overwhelming, find a smaller section that intrigues you. You can use the viewfinder frame we show you how to make in Chapter 6 to help you narrow your drawing scope to something more manageable.

Figure 5-7 shows a partial view to the upstairs area of one artist's home from her studio desk. The painting on the far wall of the dining room beyond the kitchen captured her attention as she sat at her desk, so she created the drawing you see in the figure. As the only object drawn with shading, the painting creates a strong contrast with the simple lines in the rest of this drawing. By making note of the lines in this scene, the artist found a dynamic subject for a drawing in a humdrum space she passed through many times during the course of a typical day.

Figure 5-7:
Seeing
dramatic
drawing
subjects in
your home.

© 2003 Brenda Hoddinott

From the fridge to your drawing paper

Food has always been a favorite drawing subject for artists because it's symbolic of many positive aspects of life, such as abundance, comfort, memory, and lifestyle. The meaning your food-inspired drawings have depends on the type of food you choose to draw. For example, if you make a drawing of corn dogs, the meaning of the drawing comes, in part, from the different associations your viewers make with corn dogs. From fruit to vegetables and bread to fish, an eclectic menu of drawing subjects awaits your drawing appetite. All you have to do is decide what looks the most appetizing to you — and your pencil.

Check out your cupboards, fridge, and other places for food-related items to use as drawing subjects. Figure 5-8 shows a classic example of an egg, but any kind of food is worth trying. Plus, you can always eat your subject after you finish drawing it! We don't know about you, but we think cupcakes would make a great subject.

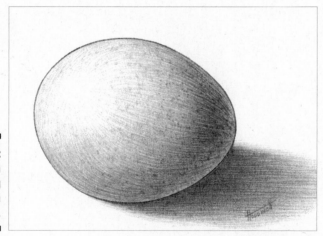

Figure 5-8:
Finding a
fun drawing
subject in a
simple egg.

© 2003 Brenda Hoddinott

Surveying your neighborhood and beyond

No matter where you live, the landscape that surrounds you is full of aesthetic potential. A suburban street lined with electrical wires may not seem as romantic and awesome as a canyon dotted with Joshua trees, but then again, depending on what you choose to focus on in your drawing, it may turn out more beautiful after all.

Take a moment to appreciate your neighborhood and the landscape that surrounds your home from the eyes of an artist. Try to see beyond your habitual perceptions. Notice the way a flower struggles to grow from a crack in the sidewalk. See how a simple park bench becomes a makeshift office for someone working through lunch on a sunny afternoon. Look at the striking contrast when sunlight illuminates buildings in front of a dark and cloudy sky. Capture some of these images in the pages of your sketchbook. Just be prepared to explain to your neighbor why you're staring at her house!

Figure 5-9 shows you what one artist sees as she steps from the back deck of her home. At first glance, you may think it's just a typical view of some trees and grass, but, on closer inspection, notice the steady beauty in the parallel lines of the tree trunks. No matter what kind of image surrounds your home, take some time to appreciate its infinite drawing potential and then grab your pencils and sketchbook and start drawing!

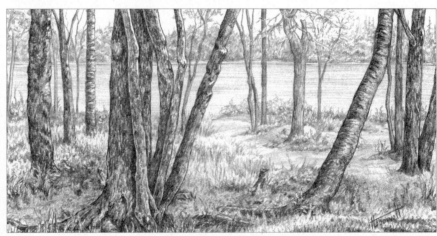

Figure 5-9: Taking advantage of the artistic possibilities in your neighborhood.

© 2003 Brenda Hoddinott

Discovering the Inner Eye of the Artist

Your *inner eye* (sometimes called your *mind's eye* or *third eye*) offers infinite views of the world that are both imagined and remembered. To see what we mean, close your eyes and visualize a blue sky with white, fluffy clouds. Now try to visualize the face of someone you know well. As you do so, your memory and imagination work together to create worlds similar to the one you inhabit but marked by your personal impressions. Those same impressions make it into your drawings whether you draw from imagination or from what you see in front of you. The results are often imperfect in some ways, but that's totally fine. Capturing the spirit of the idea is what matters.

Even when your eyes are open, your memory and imagination are active participants in creating your perception of the world. Because your subjective experiences frame what you see, your impressions of your surroundings are different from the impressions of everyone else. The following sections explain how your inner eye plays with the facts of what you see. You find out how to use doodling to tap into the workings of your own inner eye and how to use what you discover about your inner eye to grow as an artist.

Comparing right- and left-brain perceptions

Your inner eye filters what you see through your experience. Whenever you look at anything, you simultaneously perceive the facts of the object or scene you're seeing and your subjective impressions of that thing. Although the inner eye is mostly a function of your right brain, your left and right brain always work together when you look at the objects and scenes around you. Your more logical left brain uses facts to classify what it sees, while your more intuitive, relational right brain registers impressions of the appearance of whatever it is you're looking at in relation to everything else around it.

To help you understand how your right-brain and left-brain perceptions impact your drawings, here are a couple of simple exercises for you to try:

- ✔ Examine the clouds in the sky the next time you go outside. Your left brain registers clouds, but your right brain looks at those clouds and sees the shapes of completely different objects, like sheep and dinosaurs.

- ✔ Check out fabrics, flooring, rocks, pieces of wood, and anything else that has patterns or textures. What do you see? The logical left brain understands the difference between textures like wood grain and a tiger's stripes. On the other hand, the right brain notices different images in everyday patterns or textures, such as a face hiding in the texture of your carpet.

After you let both sides of your brain perceive a textured or patterned object, take some time to put those perceptions on paper. Figure 5-10 demonstrates what can happen when you and your pencil allow a particular form to emerge from a certain texture. If you look carefully at the center of the wood-grain texture in Figure 5-10, you can see the outline of the group of figures the artist saw and turned into the drawing on the right. By letting your right brain take over, you may create a drawing you didn't envision when you began but found along the way. How exciting is that?

Figure 5-10:
A texture
becomes
something
else when
the right
brain takes
over.

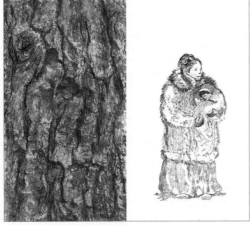

Barbara Frake

Doodling with doodles

Although the act of doodling has gotten a bad reputation over the years (as a way to waste time during boring meetings or classes, for example), it's actually a great way to exercise your right brain. It allows you to let go of any control you have over your pencil and activate your brain and your creativity.

The *surrealists,* a group of artists committed to the idea that art should plumb the subconscious depths of the artist's mind, came up with a way of drawing that is essentially *doodling,* or making drawing movements with no preconceived intent. Surrealists believe this type of drawing can produce evidence of the psyche of the artist. Many surrealist drawings begin without any imagery but end up full of images partially hidden in a haze of doodles.

Just as it is unlikely that any two people will perceive things in exactly the same way, so it is also unlikely that two people will see exactly the same kinds of imagery emerging from patterns or textures. The imagery you notice may be a surprise to you, but the type of imagery you tend to see is particular to you. Regardless of whether the surrealists were correct and you're actually plumbing the depths of your psyche when you doodle, there's something undeniably your own about the way your doodles take shape. In fact, your doodles may be the perfect place to look for the kinds of clues about your natural inclinations that help you grow into a self-confident artist. For example, if your doodles usually include looping marks, you may have an innate preference for curves and continuous motion rather than straight lines and linear patterns. Pay attention to the kinds of emergent imagery you notice in your doodles. The more you know about your interests and inclinations, the easier it is to make good drawing decisions as they relate to ideas, subject matter, techniques, and materials.

To see how a simple doodle can lead to all sorts of imagery, check out the doodle in Figure 5-11.

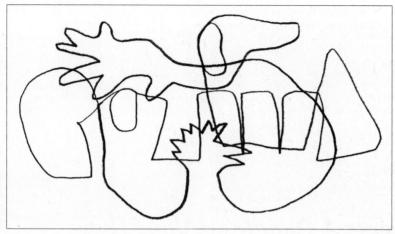

Figure 5-11:
A doodle.

The artist of Figure 5-11 made this doodle in one continuous line. She started with no preconceived idea except that she would cover the entire rectangle with doodling. She changed the way she was moving the pencil (spiral, languid, angular) whenever it occurred to her to make a change. Try turning this book around in all four directions and look at the doodle from each different point of view. You may see a couple of familiar things in the doodle as you allow your right brain free reign.

Figure 5-12 shows some of the shapes, objects, and other images that you may see in the doodle in Figure 5-11. How many of them did you see? Try turning the book around in different directions to find more images.

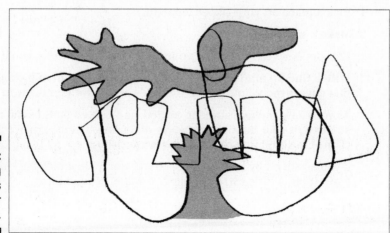

Figure 5-12:
Finding
shapes
in your
doodles.

Check out Figure 5-13 to see what happens to the images from Figure 5-12 when they become line drawings.

Figure 5-13: Turning simple doodle shapes into line drawings.

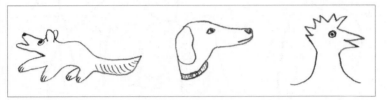

Project: A Doodle of Your Own

Each time you draw, your artistic visual skills improve. This project, which is divided into three separate parts (each with its own set of instructions), helps you give your right brain a workout through doodling. You have no illustrations to guide you, only your right and left brain, so grab your markers, pencils, and sketchbook and get ready to have some fun!

Putting down the lines

This part of the project works best if you start without any preconceived ideas, so don't think about what you're going to draw. Just jump in by following these steps:

1. **Pick a place on your paper to begin.**

2. **Make a small dot.**

 This dot is where you begin your doodle and also where you'll end it.

3. **With a fine-tip marker or a pencil, draw a doodle in one single line that covers the whole paper and ends at the dot you drew in Step 2.**

 As you draw, include straight, angled, and curved lines as the mood strikes. Let your doodle cross over other lines in lots of places, and change the direction of your lines frequently.

 If you accidentally break the line, don't worry. Just pick back up where you left off. A little extra doodling certainly doesn't hurt!

Seeing beyond the lines

After you draw your doodle, clear your mind by taking a short break. Then sit comfortably in your chair with your doodle drawing in front of you. Notice that your drawing paper has four sides; as you turn your paper around in each direction, each side becomes a bottom. Follow these steps to see the possibilities in your doodle:

1. **Turn your paper so the first side is the bottom; relax your mind and observe the doodle from this perspective.**

 Find something that reminds you of a face or an object. If you find something, use your marker or pencil to retrace the lines that make up the image you see. At this point, you're simply calling attention to whatever it is you see, so don't worry about creating a complete image.

 Don't be disappointed if you don't see anything at all for the first few minutes. Take another little break; then come back and have a fresh look. Try closing your eyes for a few seconds and then opening them again. You can even let your eyes go "out of focus" for a few seconds and then bring them back into focus. Sometimes things you see normally when you aren't trying to see them are nearly impossible to see when you're trying to force yourself to see them.

2. **Turn your paper so the next side is the bottom and see what you can find by following Step 1 for that side.**

3. **Repeat Steps 1 and 2 for the remaining sides of the paper.**

 Don't worry if some shapes overlap others as you turn the paper to each side. The more images you see, the better! If the images get too confusing, try blackening some or all of the shapes with a marker or 6B pencil.

Creating drawings from doodles

How many shapes and objects did you find in your doodle? Choose your favorites and add more lines and details to turn them into drawings. Don't worry about turning out masterpieces! Simply use your imagination and have fun with these doodle-inspired drawings.

Part II
Developing the
Basic Skills

The 5th Wave By Rich Tennant

In this part . . .

Have you ever found yourself in front of an amazing drawing, scratching your head and wondering, "How did the artist do that?" Well, you're about to find out!

This part introduces you to the basic skills and techniques you need to know to start drawing. It shows you how to put lines and shapes on paper and then how to add to them with volume, shading, texture, and perspective. Armed with these skills, you'll be drawing with the best of them in no time. After all, the difference between being an artist and not being an artist isn't talent; it's desire and work. You get the chance to practice both as you move through the chapters in this part.

If you've been drawing for a while and are looking to improve your skills, Part II is the right place for you, too. No matter how long you've been drawing, the refresher course we offer here will add new life to your drawing practice.

Chapter 6

Planning Your Drawings

In This Chapter

▶ Understanding the basic elements of composition

▶ Identifying and applying a few proven compositional strategies

▶ Planning and composing with various drawing tools

▶ Putting composition to work with a simple project

The idea of planning your drawings before you put pencil to paper may seem to oppose the romantic image of the sensitive artists who pour out their souls through their works, but trust us, if you aren't in the habit of planning your drawings, you just might change your mind after reading this chapter. If you've ever had a drawing fail because you've drawn a beautiful object only to find out you don't know what to do with the rest of the paper, you've come to the right place. Don't worry; making a few plans before you start drawing won't take away all the fun!

Planning a drawing begins with the impulse to draw. If your impulse to draw is inspired by a particular subject, lucky you! (If not, check out Chapter 2 for ideas about how to find inspiration.) After you know what you want to draw, try to articulate what you find compelling about your subject. When you know what draws you to something, you have a story to tell in your drawing. So you're not really a storyteller? No worries. Your story doesn't have to be elaborate. For instance, the story you want to tell about that sunflower in your garden may be simply that you like the way the plant catches the sunlight.

The central focus of this chapter is the phase of planning called composition, which basically just outlines the steps you can take to work out your story visually on the paper. Don't worry if the idea of composing your drawings sounds a little intimidating; we're here to help you through it!

The term *composition,* as it relates to drawing, refers to the purposeful arrangement of lines, shapes, values, textures, and sometimes colors within the borders of a drawing space. Good composition is one of the most important, if elusive, aspects of making art. When a composition works, it captivates the viewer's attention and provides clues to the meaning of the artwork. In this chapter, you find some simple and effective strategies to help you start making strong compositions.

Focusing on the Elements of Composition

To make good compositions, you first need to know what the elements of composition are and how to use them; then you can focus on working them into your drawings for maximum effect.

The elements of composition are like the words that make up a sentence. Each one means something on its own, but the real significance lies in how you put them together. Here's a brief look at the major elements of composition:

- **Focal point:** A primary center of interest (or focus) in a drawing
- **Overlapping:** The visual suggestion of depth made when one form overlaps another
- **Negative space (or shape):** The shape around the main subject(s) in a drawing (The main subject itself is the positive shape.)
- **Lines:** Lines in a drawing, whether actual or implied, that guide the viewer through the different parts of the drawing
- **Balance:** A stable arrangement of visual weight within a composition
- **Contrast:** The differences between light and dark values that create shapes and patterns in your composition
- **Proportion:** The amount of space allocated to the various components of a drawing

In the following sections, we explain each of these elements in more detail and provide examples of how you can use each element in your compositions.

Emphasizing the focal point

A drawing becomes much more interesting when it has a *focal point* — a specific area where you want your viewers to focus the majority of their attention when they look at your drawing. For example, the focal point in a portrait may be the subject's eyes, and, in a landscape, it may be one specific tree or flower.

Your drawings illustrate your subjects from your unique perspective. Think about what you want your drawing to say and choose a focal point that helps you express that message. Keep in mind that you can choose to have more than one area of focus in your drawing if doing so makes sense for your subject and the story you want to tell about it. In that case, you have a *primary focal point* and one or more *secondary focal points*.

After you choose your main point (or points) of interest, you can use many artistic devices and techniques to highlight that point. Follow these tips as you work to emphasize your focal points (Figure 6-1 shows these tips in action):

- **Always place your focal point off-center in your composition.** Stay away from your drawing space's bull's eye (or dead center). Placing a focal point in the very center of your paper is a big no-no unless you have a specific artistic reason for doing so. Any object that you place dead center commands the viewer's full attention, while all the other important elements of your drawing get ignored. As a result, the drawing loses its impact. In Figure 6-1, the main focal point (the girl pedaling a tricycle) is below and just to the right of center. Your eye may automatically go to this focal point first, but you still register the other objects in the drawing.

- **Make good use of secondary focal points.** Secondary focal points are like supporting characters, important to the story but not the most important aspect. Use secondary focal points as anchors to help balance a composition, especially when the primary focal point takes up only a small amount of space in the drawing. In Figure 6-1, the car is the secondary focal point, and the girl pedaling a tricycle is the primary focal point. The car creates balance in the drawing because its presence encourages you to look at the whole drawing. In other words, it keeps your eye from going straight to the focal point and getting stuck there. (Check out the upcoming section "Balancing subjects in a composition" to find out how secondary focal points can help balance a drawing.)

Figure 6-1:
Focal point
hierarchy.

Kensuke Okabayashi

✔ **Use objects within your drawing space to point to your focal point.** You can guide the eyes of the viewer to your focal point by arranging objects in such a way that they function like arrows. For example, if your focal point is a particular tree in a field, you can arrange your drawing so that a line of less significant trees forms a path leading the eyes of the viewer to the focal point. In Figure 6-1, the diagonal thrust of the car leads your eye to the focal point (the girl on the tricycle). (See the upcoming section "Creating a functional eye path" for more about using other objects to point to your focal point.)

✔ **Define the focal point with more detail and a stronger contrast in values than other aspects of your drawing.** A focal point is a part of the drawing that you think is significant and that you want the viewer to pay special attention to. To attract your viewer's attention, you need to enhance the visual interest of your focal point compared to the rest of your drawing. For example, when an aspect of your drawing is high in contrast or intricately detailed, it tends to draw the viewer's eyes more strongly than aspects that are lower in contrast or less intricately detailed. In Figure 6-1, the focal point is set in the distance, yet it's also the most detailed and clearly visible part of the drawing. (See the upcoming section "Balancing subjects in a composition" to find out more about how visual interest equals visual weight.)

Overlapping for unity and depth

Overlapping is the most basic way to give your drawings the illusion of depth. The simple act of making one thing appear to be in front of another is enough to make the viewer believe it actually is in front. Imagine how much depth you could suggest simply by lining up a row of trees, each one overlapping the next.

Overlapping also helps bring unity to the different parts of a composition. When objects overlap, the physical connection you draw on the paper ties them together in the eyes of the viewer, thus creating a link that the eyes follow across the drawing.

In Figure 6-2, overlapping creates an illusion of depth (the lightest balloons are in front of the darker ones) and helps tie together the different balloons in the composition.

Taking advantage of negative shapes

In composition, the term *positive shapes* refers to the shapes made by the significant objects, while *negative shapes* refers to the shape(s) made by the space surrounding the positive shapes. The appearance of an object depends on the negative shape that surrounds it. In fact, if you change the appearance of the negative shape, the appearance of the object changes, too. Picture a

simple hair comb. Without the negative shapes you see between the comb's teeth, the comb wouldn't look like a comb, and it would be useless for untangling your hair. (See Chapter 7 for more info about how you can use the negative shapes of objects to draw the positive shapes of objects.)

Figure 6-2:
Creating
depth and
unity by
overlapping
your
subjects.

Kensuke Okabayashi

In addition to defining the shapes of objects, you can use negative shapes in composition to tell stories about your subject matter. Here are just a few examples of how you can tell stories with negative shapes:

- ✔ **You can use negative shapes to define relationships between objects.** For example, if your viewer sees few or no negative shapes between two objects (people, vases, fruit, and so on), he likely perceives those objects as a group; whereas, if he sees a lot of negative shapes between two or more objects, your viewer is less likely to perceive them as a group.

- ✔ **You can use negative shapes to call attention to similarities of shape.** For example, if two objects of complementary shapes are near each other in a drawing, the negative shape(s) between them will call attention to the relationship between them. *Complementary shapes* appear to fit together like pieces of a puzzle. For example, imagine that you arrange an orange next to a banana so that the curve of the orange nestles into the curve of the banana. If you move either fruit to create a space between them, the negative shapes between them draw attention to the curved shapes of the fruit. In Figure 6-3, the curve of the right side of the glass is complementary to the shape of the pan. It appears as though the shape of the pan would fit into the shape of the glass. The negative shape between these two objects draws attention to this similarity.

- ✔ **You can use negative shapes as a frame to call attention to the shape and orientation of an object or group of objects.** For example, if an object has a tall, vertical shape and you frame it with a negative shape

that has a tall, vertical shape, your reader will be more aware of the height of the object. Consider this: A tall, narrow tree will look taller if you design your drawing so the negative shape (the shape around the object) is also tall and narrow. To do so, use a tall, narrow piece of paper to make your drawing or simply draw a tall, narrow rectangle to use as a border for your drawing.

✔ **You can use the negative shape of a large foreground object as a window for viewing other objects.** For example, the negative shape formed by the limbs of a tree may provide a portal for looking into the scene behind the tree.

Figure 6-3: The negative shapes in this drawing look the way they do because of the way the artist arranged the positive shapes.

Kensuke Okabayashi

Using lines to your advantage

Lines are multipurpose drawing tools. In your drawings, you use lines to describe the objects, values, and textures that you draw. Similar yet different to the lines you draw in your drawings, a *compositional line* is a path that moves through a drawing. This path, or line, through a drawing encourages the eyes of the viewer to move through the drawing at a particular speed and in a particular direction. It can be an actual line or series of lines, like those in a highway that snakes through a landscape, or it can be an implied line, like the imaginary line that goes through a row of people waiting for the bus. The character of the line — whether it's curvy or straight, horizontal or diagonal, and so on — elicits an emotional response from the viewer, and that response becomes part of the drawing's overall meaning.

Creating a functional eye path

When you create an eye path through a drawing, you control the direction and speed at which the viewer moves through a drawing. If the lines you use to create this eye path meander through the space in long, gentle twists, the

viewer will move through the drawing in a similar way (by twisting slowly down the eye path). However, if you use sharp, diagonal lines, the viewer will move through the drawing in sharp diagonals, too. You can use either of these eye paths and numerous others to guide the eyes of the viewer through your drawing in a particular way.

If you don't know what you want your eye path to look like, think about how you want your viewers to feel when they look at your drawing. Do you want them to feel relaxed? If so, use lines that change direction smoothly and gradually to allow the eyes of the viewer to drift slowly through the drawing. If you want them to feel rushed, use lines that change direction frequently, encouraging the eyes to move rapidly through the drawing.

Think about your eye path as a tool that helps your viewer circulate through your drawing. To make sure no one gets stuck in any part of your drawing, try to create an eye path that guides the eye to one subject and then provides an exit route to other areas of your drawing. Figure 6-4 shows an example of a drawing with a clear eye path that guides the viewer through the drawing.

Figure 6-4:
Using com-
positional
lines to
create an
eye path.

Barbara Frake

Make sure that your eye path doesn't lead the viewer right out of the drawing. In Western cultures, people tend to read images the same way they read text, from left to right. If your eye path leads to the right side of the paper, it may point the viewer directly out of the drawing, just as effectively as a big neon

EXIT sign. To make sure your viewer doesn't exit your drawing too soon, you can change the direction of the line to guide the eyes of the viewer back into the drawing. For example, if your eye path takes the viewer to the right side of the drawing, arrange an object or group of objects on that side in a way that makes the eye path turn or curve, angling the eyes of the viewer back into the action of the drawing.

Breaking down static and dynamic lines

All the different compositions you can create using lines fall into two basic categories: static and dynamic. The way you organize the lines in your composition determines whether your composition is static or dynamic. In general, vertical and horizontal lines dominate static compositions; curved and diagonal lines dominate dynamic compositions.

The character you give the lines in your composition helps resonate the emotions your viewers feel when looking at your drawing. Here are some examples of different types of lines and the feelings and emotions typically associated with them:

- Gently curving lines often reflect beauty, gentleness, and calmness. Specifically, the *s*-curve denotes balance and grace.
- Tightly curving or coiled lines can reflect a tangled or frantic energy.
- Horizontal lines often reflect stability, peace, and/or serenity.
- Vertical lines often reflect strength, grandeur, and/or dignity.
- Diagonal lines often offer a sense of change, movement, and power.

In a *static composition,* the viewer feels an overall sense of order and stability. To convey strength, balance, and permanence in your drawing, you need to emphasize the vertical and horizontal aspects of your subject matter. Any diagonal lines within a static composition are firmly supported and locked in place. Think of a sloping roof sitting on top of a house. The diagonal lines that define the roof press together for stability, and both lines rest firmly on a vertical and horizontal foundation. Artists often use static compositions to create family portraits. Figure 6-5a shows an example of a static composition in which the horizontal and vertical lines work together to create a sense of order.

In a *dynamic composition,* the viewer feels an overall sense of movement and change. Both curved and diagonal lines begin in one place and move outward and up or down, moving beyond the horizontal and vertical locations of their origins. A dynamic composition may reflect any degree of motion from gentle to frantic. You can use dynamic compositions to underscore movement or overwhelming scale. For example, you'd need to rely on sharp, diagonal lines to create a realistic image of airplanes flying across the sky. See Figure 6-5b for an example of a dynamic composition.

Choosing the shape of your drawing space

Before you start putting pencil to paper, you need to consider the orientation and shape of your drawing space (sometimes called the *drawing format*). If your goal is to show a subject to the best possible effect, the way the paper frames the subject makes a big difference. For example, if your subject is a portrait, a vertical rectangle is a good choice because people are often pictured vertically. However, if your subject is something more horizontal than vertical, like an expansive view of a landscape, a horizontal orientation may be a better choice because the horizontal rectangle draws attention to the way the landscape spreads out before you. For the most part, rectangles work best as drawing spaces because most sheets of paper are rectangles. Keep your mind open to other shapes, though. If you're drawing a portrait or a cityscape, for example, a round or irregularly shaped format may be a fun change.

Most compositions fall somewhere between purely dynamic and purely static. When you're trying to decide where on this spectrum you want your composition to be, consider your subject matter and the attributes you want to highlight in your drawing. If you're still unsure, make small test drawings using a couple of different compositions before you start your actual drawing.

Figure 6-5:
You can use lines to create dynamic or static compositions.

a

b *Kensuke Okabayashi*

Carefully planning your compositions before you start drawing can save you a lot of time and frustration. You can usually avoid having to start a drawing all over again if you have a solid composition from the beginning. Before you start working on whatever paper you want to use for your drawing, make lots of sketches in your sketchbook to test out possible compositions. Sketches can help you figure out the best way to represent what you think about your subject. For instance, sketches help you answer questions about where things go, what size things are, and what types of lines you need to use to represent things the way you see them. There's no right number of sketches to make before you start your actual drawing; just work on sketches until you feel like

you have one that feels balanced, whole, and interesting to you. Five or six sketches are a good number to start with, but for some drawings, you may want to make more. Even if you think you know the first sketch you make is the one you want to use, try a few more possibilities just to be sure.

Balancing subjects in a composition

A balanced drawing is typically more aesthetically pleasing and harmonious than an unbalanced one, so before you start drawing, take some time to plan your composition and think about where you want to position the visual weight in your drawing. *Visual weight* is an imaginary gravity that compels you to look at a particular subject. When a subject is highly compelling, it has a lot of visual weight; when you don't really notice something, it has little visual weight.

The main problem you run into when drawing subjects with a lot of visual weight is making sure they don't hold the viewer's eye disproportionately, throwing off the balance in your drawing. For example, people in drawings automatically have a lot of visual weight, so you have to be careful how you draw your people so as not to create unbalanced proportions of weight. When balance is absent from a drawing, the human eye tries to resolve the problem, and you certainly don't want your viewers to focus on fixing balance problems rather than seeing the meaning you intended in your drawing.

To achieve balance, spread out the visual weight so that every part of your drawing attracts the eye. For example, if you notice that you aren't really looking at the top of your drawing, create a reason for the eye to go there. You could put something like an airplane or hot air balloon in the sky, or you could use other objects in the drawing to create an eye path that gets the eye of the viewer to the sky. Something as simple as a steeple pointing into an empty expanse of sky can give the sky visual weight. (See the earlier section "Using lines to your advantage" for more details on creating an eye path through your drawing.) Don't worry if a single object has more visual weight than any other thing as long as you balance it with other objects that are still interesting enough to draw the eye. Whatever you do, keep it simple! Too many objects in a drawing tend to create overcrowding and disharmony.

Imagine that your drawing subjects are on a teeter-totter. If your subjects are the same size, you can balance them perfectly by putting them both the same distance from the center point (see Figure 6-6a for an example). On the other hand, if your objects aren't the same size, arrange them asymmetrically. For example, you can balance a tiny object with a larger one if you place the smaller one far enough away from the larger one that your eyes naturally flow to both objects.

To test whether your arrangement of two differently sized objects works, notice whether your eyes seem to get stuck on the larger one. If they do, keep

moving the two objects apart on the paper. Figure 6-6b shows a woman on the right balanced by a small purse placed far to the left. Because the two subjects are far enough apart, your eyes are drawn to the small purse just as much as to the woman.

Without balance, your drawings may end up visually lopsided, so don't skip over this element of composition as you plan your next drawing.

Figure 6-6:
Balancing visual weight.

a

b

Kensuke Okabayashi

Considering contrast: Balancing values and shapes

Subjects aren't the only weighted things you need to consider when balancing your drawing. *Values* (the light and dark areas of your drawing) have visual weight, too. For instance, a large dark shape in one part of your drawing can throw off the balance of the whole drawing if you don't balance it with something else that has substantial visual weight. In Figure 6-7, for example, the visually heavy dark shape on the far left of the drawing is balanced by the similarly visually heavy dark shape of the wine bottle on the right.

No matter how tiny it is, a dark shape can draw a lot of attention to itself if it's the darkest value in the drawing. Likewise, an intricate pattern of light and dark can attract a lot of attention if it's the part of your drawing with the greatest contrast.

To achieve perfect balance in your drawings, spread out the dark and light values in your drawing space in much the same way you spread out the objects. In other words, don't group all the dark objects or all the light objects on one side of your drawing space; if you do, your composition will be visually lopsided. If your composition looks a little lopsided, try moving a few of the objects slightly to the right or left in your drawing space or making them lighter or darker than their actual values. Doing so often switches the contrast in the overall drawing just enough to create a more balanced whole.

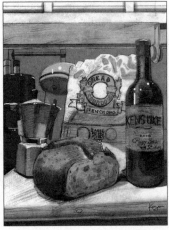

Figure 6-7:
Achieving
balance by
distribut-
ing visual
weight
throughout
a drawing.

Kensuke Okabayashi

The light and dark values in Figure 6-7 are evenly distributed throughout the drawing. The dark shadow on the bread creates a link across the drawing between the dark shapes on the left and right. The light value on the top of the flour bag creates a link to the bottom of the drawing, where a similar light value runs along the table.

One of the pitfalls of balance is that balance itself, if overdone, can result in dreadful monotony. Think of a checkerboard. Nothing is more balanced than that, but a checkerboard pattern would make for a very boring drawing. To help you avoid overdoing balance in your drawings, try to use an odd number of objects rather than an even number. A drawing with three objects on one side of a composition and four on the other is usually much more satisfying to look at than an arrangement of four on either side. Remember, though, that this tip is just a guideline. Feel free to break it if it doesn't work with your idea. For instance, if your goal is to create a symmetrical drawing, you'll probably want to use an even number.

Delegating proportions to your subjects

When you plan a drawing, you have to decide how big to make each object in the composition. The proportion of each element relative to the others depends on what you want to emphasize in your composition.

As you think about how big or small you want to make the different objects in your drawing, ask yourself the following questions:

✔ **What do I consider to be the most important subject within this composition?** The answer to this question may decide what your focal point should be. For example, if you're drawing a landscape of an apple

orchard, you may think the apple tree closest to you is the most important subject; therefore, that tree is your focal point.

✔ **Where should I put my focal point, and how much of my total drawing space should my focal point occupy?** You can place your focal point high or low in the drawing, left of center, right of center, or down the middle (especially if the drawing is a portrait). Just make sure the center of the subject isn't lined up with the center of the paper (to avoid the dead center of the drawing). If your drawing is a portrait, place the main figure in the drawing so that the vertical midline of the body is just off-center to the left or right.

The amount of space you allocate to the focal point depends on what you want to say about the focal point. If the focal point is the main event of many others in your drawing, you may keep the size of the focal point down so you can fit the other subjects into the drawing. Many beginners choose to make their focal points the largest objects in their drawings, but you don't always have to do so. You may want to experiment with some other ways to draw attention to the focal point, like surrounding the focal point with a "frame" of other less significant objects.

✔ **How much of my drawing format should be background (or negative shape)?** Positive and negative space must work together well in a drawing for it to look well balanced. Negative shape is often the frame around the main event. The amount of negative shape you need depends on what you're trying to do. Unless you're trying to make your subject look cramped or cropped in a drawing, leave enough negative shape around your main subject to frame it comfortably. To create a composition that feels full or empty, all you have to do is adjust the proportion of positive to negative shape accordingly. Check out Figure 6-8 for two different proportions of negative to positive shape.

Figure 6-8: Changing the amount of negative shape impacts your perception of the positive shape.

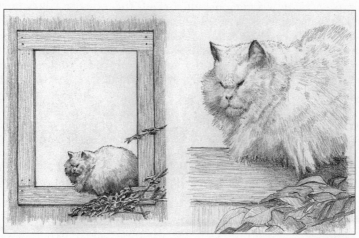

Barbara Frake

Considering Basic Composition Formulas

The human eye seems to prefer certain compositions over others. For example, the human eye looks longer at compositions in which the artist achieves balance by thoughtfully arranging various but compatible shapes and values than compositions in which the artist achieves balance by arranging objects symmetrically. Although humans seem to find beauty in symmetry, when it comes to drawings, they tend to favor the relatively complex asymmetrical type of balance over simpler symmetrical balance. This preference for asymmetry in art may explain why viewers tend to respond more favorably to drawings with proportional relationships based on thirds than to drawings with proportional relationships based on halves or quarters.

Over the years, artists have developed some conventions of composition in response to these preferences. For example, in most landscapes, you find the horizon line positioned either one-third or two-thirds of the way down from the top of the composition. You hardly ever see a landscape in which the horizon line is placed halfway down from the top of the composition.

In this section, we introduce you to a few traditional composition formulas that can help guide you as you produce your first few drawings. Don't think of these formulas as strict rules that you must follow in every drawing. Instead, think of them as guidelines that can help you put together and organize the basic elements of composition that we explain in the earlier section "Focusing on the Elements of Composition."

The rule of thirds

The *rule of thirds* is a composition formula that you can follow by dividing your drawing space into thirds both vertically and horizontally (using actual or imagined lines). You can create balance in your composition by placing the focal points in your subject along those lines, particularly at the points where those lines intersect. The rule of thirds isn't an unbreakable law that you should never cross, but it is a great and reliable tool that can help you create balance in your drawings.

To start planning a composition using the rule of thirds, you simply divide your drawing surface into thirds. To see what we mean, grab your sketchbook, HB pencil, and a ruler and follow these steps:

1. **Use your ruler and HB pencil to draw a horizontal rectangle on your paper.**

 Your rectangle can be any size; it represents your drawing space.

2. **Use your ruler to divide the rectangle into three equal sections vertically.**

3. **Use your ruler to divide the rectangle into three equal sections horizontally.**

Look at the four points where the lines you drew in Steps 2 and 3 intersect in Figure 6-9 (they have circles around them in the figure). Any one of these points makes a great place for a focal point, but the best focal points are the two points on the right because most people read from left to right and the eye usually enters a drawing from the lower left. When you place a focal point on the right side of your drawing space, you make it easy and natural for the viewer to come into the drawing from the lower left and then continue toward the focal point on the right.

Figure 6-9:
Pinpointing
great focal
point
locations.

© 2003 Brenda Hoddinott

Using the gridlike rule of thirds to make decisions about placing focal points is an effective way to achieve balance in your compositions. It works especially well for static compositions in which vertical and horizontal composition lines dominate your drawing subject.

To use the rule of thirds to achieve balance in more dynamic compositions — those in which diagonal lines dominate the drawing subject — you can draw diagonal lines to divide the drawing surface into three *right triangles* (triangles that have one 90-degree angle) instead of using horizontal and vertical composition lines. The point where all three triangles intersect is a perfect location for the focal point of your drawing subject.

To practice the rule of thirds for dynamic compositions, gather your sketchbook, HB pencil, and ruler and follow these steps:

1. **Use your ruler and 2B pencil to draw a horizontal rectangle on your paper.**

2. **Draw a line diagonally from one corner to the corner across from it (see Figure 6-10a).**

 It really doesn't matter which set of opposite corners you choose. This line divides your rectangle into two equal right triangles.

3. **From one of the other two corners, draw a second diagonal line that intersects the first line at a right, or 90-degree, angle (see Figure 6-10b).**

The place where these two lines intersect makes a great place for a focal point. Notice that the place where the points intersect is one-third of the way up from the bottom of the rectangle and one-third of the way in from the right of the rectangle.

Figure 6-10:
Using right
triangles
and the rule
of thirds to
find a good
focal point
for dynamic
compositions.

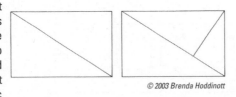

© 2003 Brenda Hoddinott

You may notice that dividing your drawing space into three triangles according to the rule of thirds for dynamic compositions results in only one ideal place for your focal point. This doesn't mean you're limited to a single point of interest in your drawing; it just means this point would be a good location for your main focal point. You can come up with another focal point by drawing a diagonal line that divides the largest triangle in Figure 6-10b into two right triangles. The point where that diagonal line intersects the line that runs from opposite corners of the rectangle is the perfect place for a secondary focal point.

Compositions with S-O-U-L

Four of the most popular composition formulas are named after letters of the alphabet. Each of these formulas is named after the shape of the eye path that makes up its defining feature. For example, *S* compositions have an eye path shaped like the letter *S*, and *O* compositions have an eye path shaped

like the letter *O*. Each formula is useful for creating a complete, balanced composition, and each one has a unique set of qualities that you can use to help you tell your subject's story.

Good compositions tell a story about your subject matter. No matter how simple your story is, aim to make compositional choices (like what values to include and where to place your focal points, negative shape, and eye path) that best express your story.

"S" composition

In an *S* composition, the subjects form a shape similar to the letter *S*. This composition formula reflects gentleness, fluidity, and gracefulness. The curves of pathways, rivers, or lines of trees work well in this composition. Figure 6-11 shows an example of the *S* composition; notice how it seems to invite the viewer into the drawing.

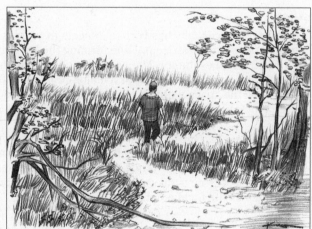

Figure 6-11: *S* compositions are graceful and fluid.

Kensuke Okabayashi

"O" composition

In an *O* composition, the objects form a kind of *O* shape on the paper (see Figure 6-12 for an example). The circular movement of the *O* keeps the viewer's eyes inside the drawing.

The opening of an *O* composition is a good place to draw your focal points. To find the perfect place for your focal points, draw several objects, value masses, and/or lines to form your *O*. Then place your focal points within that circle. In Figure 6-12, the woman is the primary focal point, and the truck is the secondary focal point.

Figure 6-12:
O composi-
tions keep
the viewer's
eyes inside
the drawing.

Kensuke Okabayashi

"U" composition

The dynamic *U* composition usually has vertical objects or masses on either side of the drawing space with a horizontal line forming the bottom of the *U* shape (see Figure 6-13 for an example). The area within the *U* can be either a peaceful place for the viewer's eyes to rest or a major contrast to the activity of the *U*. Either way, the space within the *U* makes for a good location for your drawing's focal point.

Figure 6-13 shows how you can turn a subject into a focal point by placing it inside the *U*. Although the person standing behind the fence is small and somewhat indistinct because of the distance, your eye is drawn to him. The dark shadows of the nearest tree trunks and earth form a *U* that frames the person, presenting him as the focal point.

Figure 6-13:
U composi-
tions create
an ideal
location
for a focal
point.

Kensuke Okabayashi

"L" composition

You can create an *L* composition by placing a vertical mass on one side of your drawing and balancing it with an open area or distance on the other side and a horizontal base at the bottom (see Figure 6-14). This dramatic and solid composition firmly anchors your subjects on two sides of the drawing space, thus drawing the attention of the viewer both vertically and horizontally.

The open area in this composition can provide a great frame for your focal point. Or you can choose to make your focal point the vertical mass of the *L*, which the artist has done in Figure 6-14.

Figure 6-14:
L composi-
tions draw
attention
vertically
and
horizontally.

Kensuke Okabayashi

Using a Few Drawing Tools to Help You Plan Your Compositions

As you plan your drawings, you have the option of drawing your subjects exactly as you see them or using your artistic license to represent your subjects in a way that's completely different from how they really look. Even if you decide to draw your subjects with something other than real life in mind, though, you need to take some time to plan your composition. By considering the elements we cover in the earlier section "Focusing on the Elements of Composition" and by using some of the drawing tools we describe in the following sections, you can plan strong compositions for all your drawings.

REMEMBER

Sometimes when you're searching for inspiration for your next drawing, you discover perfect subjects with imperfect compositions. Instead of writing off those subjects, call upon your artistic license and give them the compositions you want them to have. For example, if you see a pier you'd like to draw and some boats a small distance from the pier that you wish were in front of the pier, you can use your artistic license to combine the two elements and draw the boats in front of the pier. After all, it's your drawing, and you have the right to edit or exaggerate to your heart's content.

In Figure 6-15, you see a drawing in which the artist used artistic license to make a real-life scene look a little more whimsical. When the artist looked at the cloudy scene in Figure 6-15a, she thought the cloud on the left looked a lot like a dog. To show this perception in the drawing in Figure 6-15b, she altered the composition by replacing the cloud shape with the shape of a dog.

Figure 6-15:
Using artistic license to make real-life subjects more interesting.

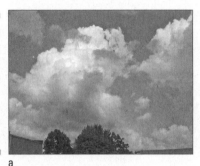

a b *Jamie Combs*

Choosing your composition by framing the subject

A *viewfinder frame* is a simple drawing tool you can use to help you filter out some of the world's distractions so that you can more easily find and plan strong compositions. As an added bonus, the viewfinder frame lets you test-drive hundreds of compositions without even picking up a pencil: You simply hold up the frame, look through it at the scene you're thinking about drawing, and move it around (like you do when you look through the lens of a camera) until you see an ideal composition.

To make your own viewfinder frame, gather together some cardboard, scissors or a knife, and two large paper clips and then follow these steps:

1. **Cut out two identical *L*-shaped pieces of cardboard, any width you want (see Figure 6-16a).**

 The wider you make the *L*-shaped pieces, the more distracting, unwanted objects you'll block from your view.

2. **Use two large paper clips to join the pieces of cardboard together to form a frame (see Figure 6-16b).**

 You can easily adjust the size of the frame to make it proportionate to your drawing paper.

After you make your frame, look at your subject through the frame to choose an ideal composition for your drawing (refer to 6-16b).

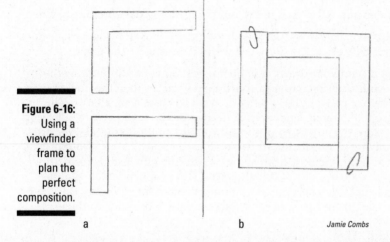

Figure 6-16:
Using a viewfinder frame to plan the perfect composition.

a b *Jamie Combs*

Planning a composition from a photograph

Photography allows you to capture a composition that you want to draw, take it back to your drawing space, and work on it for hours or days until you get it just the way you want it. The trick to creating successful drawings from photographs is knowing how to plan strong compositions from them.

Whenever you want to base a drawing on a photograph (or any other image, for that matter), you can use a simple grid to help you plan your composition. All you have to do is grab your sketchbook, photo, pen, HB pencil, and ruler and follow these steps:

1. **Use a pen and ruler to draw a grid of squares on your photograph.**

 If your subject and photo are fairly simple, use larger squares. If your photo is highly detailed, you may want to use a lot of small squares.

 Draw the grid on your photo (or a copy, if you don't want to ruin the original) with an ordinary ballpoint pen. It doesn't smudge as easily as a marker and can be seen more clearly than a pencil. Use your ruler to keep everything straight and tidy.

2. **Label the horizontal rows of squares down the side of your photo with letters and label the vertical rows of squares across the top of your photo with numbers.**

 That way, you can easily keep track of which square you're working on as you transfer the visual information from the photo to your drawing surface.

3. **Use a ruler and HB pencil to lay out the grid on your drawing surface.**

 Draw the lines lightly so that you don't indent your drawing surface and can eventually erase the grid lines without tearing up the paper.

 When you want your drawing to be larger than your photo, draw the grid on your drawing paper proportionately larger than the one on your photo. If your photo is large and you want to make a smaller drawing, use a proportionately smaller grid. To decide the final size of your drawing, measure the size of your photo and then multiply (for a larger drawing) or divide (for a smaller drawing). For example, if your photo is 4 x 6 inches, you can multiply both sides by 2 to find dimensions for a drawing that's twice the size of the photo but still proportionately equivalent. As long as you multiply both dimensions of the photo by the same number, the proportions of the enlargement will be equal to those of the photo.

4. **Outside the perimeter of your drawing space, label the horizontal and vertical rows of squares to correspond to the labels you marked on your photo in Step 2.**

 Marking the same labels on both your photo and drawing space makes transferring the visual information from the photo to your drawing surface much easier.

5. **Draw what you see in each square of your photo in the corresponding square on your drawing surface.**

6. **Check the positioning of everything you drew in each square to make sure your drawing matches the photo; then erase your grid lines.**

Project: Planning a Composition

In this project, we walk you through the process of planning a composition, from its conception as two separate photos to its completion as an original drawing. Take a look at Figure 6-17 and consider the following problems that we hope to resolve with the project in this section:

✔ We have two photos that we like, but we aren't fond of the composition in either. We're looking for a balanced, flowing, and serene alternative.

✔ Each photo contains too many focal points, and we want to find a way to eliminate some of the clutter.

✔ The broken and abandoned lobster trap in the lower-right corner of Figure 6-17a is a fun and interesting object, and we want to find a way to make it the primary focal point.

Figure 6-17: Combining the best parts of two images into one harmonious composition.

a

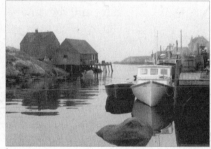
b

© 2003 Brenda Hoddinott

To do this project, first pick one photo you want to draw as it is or find two photos you want to combine into one (as we do here). Then grab your sketch-book, 2H, 2B, 4B, and 6B pencils, ruler, kneaded eraser, and vinyl eraser and follow these steps.

Note: Use whichever composition formula works best for your photo(s); we use an *S* composition to combine the photos in Figure 6-17 (see the earlier section "Considering Basic Composition Formulas" for more details).

1. **Using your 2H pencil, roughly sketch the basic composition you want to use for your drawing.**

 The artist of Figure 6-18 chose to use an *S* composition. She drew a loose, tapering *S* shape to create the foundation for the drawing's eye path and to represent the water from the photos in Figure 6-17.

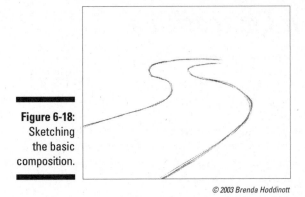

Figure 6-18:
Sketching
the basic
composition.

2. **Using your 2H pencil and ruler, draw lines to divide the drawing space into thirds; do so both horizontally and vertically (see Figure 6-19).**

 The four places where your lines intersect are ideal locations for primary and secondary focal points. Notice that the artist of Figure 6-19 has chosen the upper horizontal line to be the horizon line.

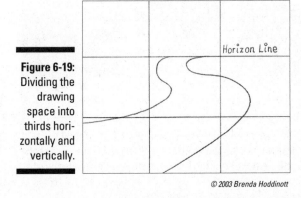

Figure 6-19:
Dividing the
drawing
space into
thirds hori-
zontally and
vertically.

3. **Decide what elements of your photo(s) to include in your drawing, what to leave out, and where to put everything.**

 To help you decide what elements you want to use and where you want to place them, make a photo collage to plan your composition. Scan and print or photocopy your photo(s) in two or three different sizes. On a separate piece of paper, use your ruler and 2H pencil to draw a rectangle the same size and shape you want your drawing to be. Cut out the parts you like from the photocopies in the sizes that best fit your artistic design. Choose a good place for your focal point(s) on the rectangle you just drew and then arrange the other photo pieces around your focal point(s) until

they fit nicely within your composition. As you arrange your photo pieces, tape them in place on the rectangle.

See the cut and taped plan in Figure 6-20 for an example. The focal point is located on the lower-right point of the intersecting lines of the rule of thirds. The artist moved a couple of the big rocks from the photos to the front of the lobster trap to add dimension to the drawing. This preliminary composition looks pretty good, but the boat spoils the *S* shape and has to go! So the artist removed it from the drawing plan.

Figure 6-20:
Using a
photo col-
lage as a
plan for your
drawing.

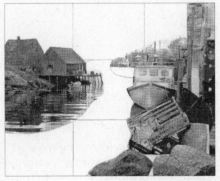

© 2003 Brenda Hoddinott

4. **Using your 2H pencil, lightly sketch the outlines of the focal point, the secondary focal points, the foreground, the middle ground, and the distant space in your sketchbook.**

 In Figure 6-20, the lobster trap is the focal point, the rocks around it are the secondary focal points, the lower-right corner is the foreground, the fishing shacks and wharf on the left are the middle ground, and the land and buildings in the background are the distant space.

 Find the vanishing points on the horizon line and use geometric perspective to draw the buildings correctly. (See Chapter 11 for details on how to draw vanishing points using geometric perspective.)

5. **Examine the flow of your composition and make sure that everything looks the way you want it to look.**

 In Figure 6-21, the lobster trap (#1) is the focal point. The viewer's eyes naturally enter this *S* composition from the lower left and move directly toward the lobster trap. The tops of the rocks in front of the lobster trap are sort of shaped like rounded arrow points, navigating the viewer's eyes upward. The upper-right corner of the lobster trap serves as a sharp arrow point, clearly directing the viewer's eyes upward and to the right, where you see the edge of a building.

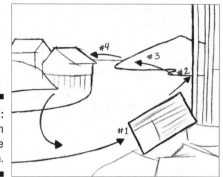

© 2003 Brenda Hoddinott

Figure 6-21:
Rough
sketch of the
composition.

The edge of the building (#2) serves as a *stopper,* meaning that it stops
the eyes from moving farther to the right and possibly exiting the com-
position altogether. Thanks to another stopper, a horizontal board jut-
ting out from the edge of the building (to be added later), the viewer's
eyes don't exit the composition as they move upward either.

The end of the section of land (#3) to the left of the building, is shaped
like another point of an arrow and is pointing directly toward the fishing
shacks on the right side of the composition.

The fishing shacks (#4) are detailed enough to offer the viewer's eyes a
place to rest for a second. To keep the viewer's eyes inside the composi-
tion, rather than exiting to the far left, the artist emphasizes the ripples
and reflections in the water, navigating the viewer's eyes downward and
back toward the lobster trap and completing a full-circled composition.

6. **When you think the composition looks the way you want it to look,
 use your kneaded eraser to lighten all the lines of your sketch; then
 switch to your 2B pencil to refine the contours of the objects in the
 drawing (see Figure 6-22).**

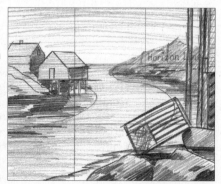

Figure 6-22:
Adding
more details
to direct the
viewer's eye
around the
composition.

© 2003 Brenda Hoddinott

7. **Use your 2B, 4B, and 6B pencils to add shading to your drawing (see Figure 6-23).**

 Choose any shading technique you prefer. Notice that the darkest values are in and around the primary focal point (the lobster trap in Figure 6-23). The other values, from lights to darks, are on both sides of the drawing, distributing their weights evenly so as to create a balance of values throughout the composition.

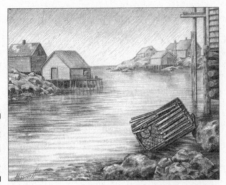

Figure 6-23: The finished drawing.

© 2003 Brenda Hoddinott

Chapter 7

Seeing and Drawing Lines and Shapes

In This Chapter

▶ Translating complex objects into contour and gesture drawings

▶ Considering the line's versatility in drawing

▶ Breaking objects into basic shapes and proportions to simplify the process of drawing

▶ Putting your line- and shape-drawing skills to the test with a simple project

To see the world as an artist, you have to give up all your preconceived notions about the way the world is. In other words, you have to look at the objects and people you want to draw as though you've never seen them before. Try to describe them using words like *round, rectangular, light,* and *dark* rather than their actual names. Because what you already know about your subject can get in the way of your ability to see it on a purely visual level, you need to overcome these mental blocks to seeing before you start drawing. Lucky for you, this chapter is here to help you do just that!

In this chapter, we show you how to make accurate drawings using only lines and your innate ability to see and compare. We walk you through the process of building any object from the ground up and then show you how to check the proportions of that object and its surroundings to make sure your drawing is accurate. The exercises we include here challenge you first to examine the nooks and crannies of an object and then to break that object into its most basic components to help make the drawing process a little easier.

Getting Comfortable with Lines

Even though many people think of line drawings as lesser art forms than drawings that include shading, line drawings can be just as complete and beautiful as fully shaded drawings. As a matter of fact, most drawings — even those that include lots of shading and textures — begin with lines.

You already know everything you need to know to make lines. After all, you can use the same motions you use to make mindless doodles to create lines to describe anything in the visible or imaginary world. When you draw, you use your arm and hand to make marks that register the boundaries and surface details of your subjects. To see what we mean, imagine drawing a skyscraper. The sides of the building go up and down, so your arm moves up and down to describe them. The windows march across the side of the skyscraper, so your arm and hand move sideways to describe the tops and bottoms of the windows.

Getting comfortable with drawing lines means getting comfortable with the idea that drawing is a way to learn about the world. In other words, you have to let go of the notion that your drawing has to be a perfect representation and allow yourself to simply look at your subject and let your pencil re-create what you see on paper.

Blind contour drawing is a method of drawing in which you draw without looking at your paper. In other words, you look only at your drawing subject. To do this type of drawing, you have to synchronize the movements of your hand with the movements of your eyes. Coordinating your vision with your drawing hand is an integral aspect of drawing accurately, and drawing with your total focus on the subject allows you to discover the *contours* (the exterior and interior edges) of your subject in a way nothing else does.

This exercise gives you some practice with blind contour drawing. After you find your starting point on the paper, you won't look at the paper again until you're finished with your drawing. Don't worry about making a perfect drawing because you can't make a perfect drawing using this method. Choose a time and place where you can work without interruptions and get ready to focus your complete attention on the contours of your drawing subject. Gather your sketchbook, some tape, and any pencil and then follow these steps:

1. **Tape a sheet of drawing paper to your drawing surface so that the paper doesn't move as you draw.**

2. **Find a simple object to draw and place it in front of you.**

 You can use any object you want, even your own hand.

 If you're right-handed, place the object in front of you on your far left, and if you're left-handed, place it in front of you on your far right.

3. **Face the object, sit in a comfortable position with your drawing surface below your eye level, and rest your drawing arm on the table.**

4. **Choose one point on your object to use as a starting point, place the point of your pencil in a corresponding spot on your drawing surface, and then look back at the object.**

 For the rest of this exercise, resist the urge to look at your drawing's progress. No cheating!

5. **Slowly move your eyes along the contours of your object; at the same time, move your pencil very slowly, following along with the movement of your eyes.**

Try to forget about the paper. Imagine that your pencil is actually drawing on your subject. Keep your eyes and pencil moving together at the same slow, steady pace. Don't take your pencil off the paper as you draw. If you do, you may get lost!

Carefully notice each time the line on the edge of the object changes direction. Without peeking at your paper, allow your pencil to record every detail of the line (or lines) you see on your subject.

6. **Continue drawing and looking at your subject until your eyes return to the place where you began your drawing.**

You may want to repeat this exercise (with the same object or different objects) several times. Don't worry if you accidentally look at the paper as you draw; just redirect your focus to the subject and keep drawing. Although you may be uncomfortable drawing without looking at first, the more practice you get drawing this way, the more comfortable it'll become.

Synchronizing your hand with the movements of your eyes allows you to experience true right-brain contour drawing. (The right side of the brain is responsible for spatial comprehension. See Chapter 5 for more information about rousing the right brain.) When you're no longer naming the individual parts of your drawing subject and, instead, are focusing on the contours themselves, you know you're drawing with the right side of your brain.

The process you use to create your blind contour drawings is more important than what the final drawings look like. After all, drawing this way gives you more confidence in drawing what you actually see rather than drawing your preconceived notions of what must be there. You may not be happy with the drawings you create using this method, but your new visual skills will lead to improved drawing skills overall.

Figure 7-1 shows three drawings created using this blind contour drawing technique.

Figure 7-1:
Using blind
contour
drawing to
draw three
simple
objects.

a b c

© 2003 Brenda Hoddinott

Appreciating Diversity in Lines

The characteristics of lines in drawings vary as wildly as the artists who use them. The character of lines can fundamentally alter the meaning of a drawing. For example, imagine you're getting ready to make a drawing of your television set. You'd get very different results if you decided to use only curved lines than if you decided to use only thick, dark lines.

Lines are essentially either curved or straight, but they can also be coarse or fine, light or dark, bold or tentative, and anything in between. The variety of lines available makes it possible to represent anything in the visible or imaginary world, and you may find a use for many different types of lines within the same drawing. After all, although the most common use of lines is to describe the contours of objects, you can also use them to describe patterns, textures, and values. (See Chapters 8, 9, and 10 for more information about drawing patterns, textures, and values.)

You determine the *weight,* or thickness, of lines by how much darkness you apply when making them. You make lines lighter by easing up on the pressure on your pencil until you're barely touching the paper. You make lines heavier by drawing over them again and again.

Keep in mind that lines carry emotive value, too. You can use lines purposely to communicate something beyond a visual description of your subject matter. Some types of lines are preloaded with expressive effects. Curved lines, for example, automatically evoke different emotions than straight lines.

Whenever you see drawings, look carefully at the lines used to make them. Mentally catalog the different types of lines you see, noting which ones you have a strong response toward and whether your response is positive or negative. As you draw, try to incorporate new types of lines into your work to add different visual effects and emotions.

The choices you make about lines when you're drawing will probably be intuitive at times and at other times calculated to create a specific effect. In this section, we explain the character and function of lines that are straight, angular, and curved so that you can choose the best and most effective lines to incorporate into your drawings. Figure 7-2 shows a random sampling of different types of lines that are useful for drawing. Keep in mind that these are only a few of the lines you can use in your drawings; you're sure to find many more as you continue drawing.

After reading about the different kinds of lines in this section, take a few moments to look around you. See how many different types of lines you can find in actual objects. Try combining different types of lines to draw an object or a doodle. Don't worry about how the drawing looks. Simply experiment with combining different types of lines.

Figure 7-2:
A variety
of straight,
angular,
and curved
lines.

Jamie Combs

Lining up straight lines

Straight lines can be thick or thin, long or short, and you can draw them in any direction. The various types of straight lines illustrate different concepts and emotions in drawings. The basic types of straight lines include the following:

- **Horizontal:** Lines that are parallel to the top and bottom edges of rectangular paper and *perpendicular* (at right angles) to vertical lines. Horizontal lines reflect stability, peace, and serenity.

- **Vertical:** Lines that are straight up and down, parallel to the left and right sides of rectangular paper, and perpendicular to horizontal lines. Vertical lines reflect strength, grandeur, and dignity.

- **Diagonal:** Lines that are not vertical or horizontal but instead slant at various angles. Diagonal lines reflect a sense of movement and change.

Being able to sketch a relatively straight line freehand comes in handy in the initial stages of many drawings. (After all, sketching is a lot more fun when you don't have to depend on a ruler.) Although drawing straight lines freehand isn't easy, with practice, you can master this skill. To help you get started with drawing freehand straight lines, grab any pencil and sketchbook and follow these three easy steps:

1. **Draw one dot on your paper where you want your straight line to begin and another dot where you want it to end.**

2. **Imagine a straight line connecting these two dots.**

3. **Connect the dots with your pencil.**

 Keep your wrist still and draw from your shoulder.

You can draw the straight line in between the dots in one continuous movement or in a series of stroking movements. Practice both methods several times to find out which one is most comfortable for you.

Using a ruler to get comfortable with drawing straight lines

If you have trouble drawing straight lines freehand, you can use a ruler to draw them when you're first starting out. Just remember that it's important to consider perspective even when you're drawing straight lines. For instance, sometimes a line looks diagonal to your eye (meaning you need to draw it diagonally) even though your brain knows it should be vertical in real life.

To understand what we mean, imagine that you're looking at a house. Depending on factors like how straight your head is when you look at the house and whether the foundation is truly level, the house may appear to have edges that slope slightly left or right. Because your brain knows buildings are generally vertical, you may start drawing the house by making some vertical lines to define its edges. But if the house doesn't actually look vertical to you and you still make it look vertical in the drawing, you'll have a hard time matching the perspective of everything else in the drawing to the perspective of the house. In cases like this, trust your eyes, not your brain. (See Chapter 11 for more details on perspective.)

If your ruler doesn't have a beveled or raised edge, it may smudge your straight lines as you draw. To help prevent smudges, try taping three pennies to the underside of your ruler to raise its edges from your drawing surface.

Using straight lines to create line drawings

Although straight lines can go in only three directions on a flat piece of paper — vertical, horizontal, and diagonal — there's a lot of power in those three directions! Before you start thinking straight lines are boring, we want to show you how to use these lines to create line drawings.

Figure 7-3 shows you a tissue box drawing made in the following three stages with only straight lines. (Note that the artist used some curved lines to draw the tissue in the box. See the later section "Following the flow of curved lines" for more info.)

- ✔ **The first stage:** Figure 7-3a is a very rough freehand sketch. The artist used a 2H pencil and kept the pressure on the pencil light. Her goal was simply to establish the size and placement of the structures in the drawing.

- ✔ **The second stage:** In Figure 7-3b, the artist refined the drawing and added a little more detail. However, she still used the 2H pencil and pressed lightly because she knew she'd want to make changes to these lines later.

 The artist lightened her first lines by patting them with a kneaded eraser. Then she drew in a new set of straight lines freehand.

✔ **The final stage:** In Figure 7-3c, the artist lightened the second set of sketch lines with a kneaded eraser until she could barely see them. Then she used a 2B pencil and a ruler to create a more precise drawing.

Figure 7-3: Using straight lines to draw objects.

a b c

© 2003 Brenda Hoddinott

Cutting corners with angled lines

Angled lines are basically just diagonal straight lines. You can use them to construct curved forms without using curved lines (see the next section for details on curved lines). Building rounded forms with angled lines adds a sense of mechanical stability to those forms.

Figure 7-4 shows you how you can combine different angled lines to help your drawing subjects take shape. Notice that the way the artist arranged the various lengths of lines is very important to creating the curved shape you see in the figure. To help you arrange your angled lines for maximum effect, first lightly sketch the curve you want to make. Then use that sketch as a guideline for placing your angled lines.

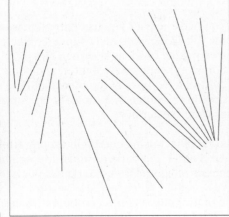

Figure 7-4: Drawing curves using angled lines.

Jamie Combs

 If you're drawing a structure with diagonal lines, you can measure the angles of the lines with a measuring tool like a ruler or another long, straight tool (like a knitting needle or straight barbecue skewer). Simply hold the measuring tool in your hand so that it's parallel to your face. (In other words, don't point it at the object). Twist your wrist to line up the tool with the edge you want to draw. Put your pencil on the paper at the spot where you'd like the line to go, and copy the angle on your paper.

Following the flow of curved lines

Curved lines are basically just straight lines that bend or curve. Curved lines typically reflect beauty, gentleness, and calmness. They can be thick or thin, and they can even change directions midway through, creating an *S-* or ribbon-candy-like configuration called a *compound curve.* Common examples of curved lines include the letters *C, U,* and *S.*

A curved line becomes a circular shape when the ends meet. For this reason, you can use curved lines to draw highly believable round objects, particularly when you draw your curved lines with attention to the weight, or thickness, of the lines. (See the later section "Breaking objects into simple shapes" and Chapter 3 for more details on drawing rounded volumes and other shapes.)

Whenever you see a realistic line drawing of a rounded object, the reason the illusion is convincing is because the artist showed the way light plays across the object. A form that swells toward you catches the light differently in different spots, and you don't have to use shading to show this play of light. Instead, you can use variations in line weight to show the way light plays across an object.

So how do you know when you need heavier versus lighter line weight? The object shows you. To see how this works, find any rounded object. (If you're stuck for ideas, use an inverted mixing bowl, as shown in Figure 7-5.) Examine the contours of the object. Some of the edges are lighter, and some of them are darker. Look at the line between the base of the object and the surface on which it sits. Notice a dark line there. Notice that the dark line stops at the point where the object raises from the surface.

When you're drawing a rounded object using curved lines, pay attention to the parts of the object that are lighter and darker. Adjust the weight of your lines to compensate for the areas of lightness and darkness you see.

Figure 7-5 shows an example of how curved lines combine with line weight variation to create not only shapes but also believable contour drawings of objects.

Figure 7-5:
Combining
line-weight
variation
with curved
lines to
describe a
believable
inverted
mixing bowl.

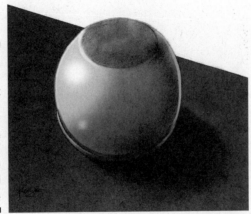

Kensuke Okabayashi

Capturing Gesture

The word *gesture* in the context of drawing refers to the way something takes up space. Every object, whether it's animate or inanimate, has gesture, so it's important that you know how to represent gesture in your drawings. You can do so through simple *gesture drawings,* which are bare-bone drawings that capture the pose something is in rather than the way something looks. Beginning any drawing with a gesture drawing is extremely helpful because a gesture drawing gives you a skeleton on which to build the rest of your drawing.

To make a gesture drawing, follow these steps:

1. **Set up your paper so you can comfortably see your subject.**

2. **Set a timer for one or two minutes.**

 When you get comfortable with this exercise, shorten this time to 30 seconds or maybe even 15.

3. **With your eyes trained firmly on your subject, imagine a line, or *axis*, running through the center of the longest side of your object; draw that imaginary line on your paper while keeping your eye on the subject (see Figure 7-6).**

 Don't look at the paper as you draw! Imagine that you're actually drawing on the subject.

Figure 7-6:
Search for
and draw
the imagi-
nary axis of
the longest
dimension
of your
drawing
subject.

Jamie Combs

4. **Repeat Step 3 for the shorter side of your object.**

5. **Repeat Step 3 for any other lines that run through your object until you've built a skeletal representation of the object's underpinnings (see Figure 7-7).**

These extra lines can be diagonal, horizontal, or vertical.

Figure 7-7:
Build a
skeletal
representa-
tion of the
object's
under-
pinnings.

Jamie Combs

6. Next, change direction; search for and draw the imaginary axis lines that describe the dimension perpendicular to the first one you drew — in this case, the parts that stick out from the central axis line.

7. With quick, circular motions, draw any rounded volumes that are part of your object (see Figure 7-8).

 Keep your eyes on the subject as you draw! Although you'll likely make a mess by not looking at the paper as you draw, you'll understand your subject much more completely because you remained focused on it the entire time you were drawing. With time, you can retrain your hand to move in time with your eyes.

Figure 7-8: Draw any rounded volumes that are part of your object.

Jamie Combs

8. Finally, keep searching for and drawing the imaginary axis lines that make up the skeleton-like structure of your subject.

 Gesture drawing is a way of learning about what your drawing subject does in space. You look rapidly up, down, side-to-side, and all round to take in the essential posture of your subject. Simultaneously, you draw rapidly, synchronizing the movements of your hand to the movement of your eyes.

As you work through each gesture drawing you make, keep in mind the following ideas:

- ✔ **Make your gesture drawings fast and keep your eyes trained firmly on the subject.** Everything you need to know about your subject is on the subject, not on the paper. The temptation to look at your paper may be strong, but don't give in. If you find that you're looking at your paper more than at the subject, just redirect your focus to your subject and try again.

- ✔ **Try to keep your drawing tool in contact with the paper the entire time.** Lifting your drawing tool to think about where to put it next interrupts the flow of your drawing (and makes it hard to know where to start drawing again). When you need to move from one place to another in your drawing, you may be tempted to lift your drawing tool. For example, if you're making a gesture drawing of a person and you get to a foot, it may seem like you have to lift the tool to get to the next form you need to draw. Resist! When you get to a point where you've reached the end of a form, keep your eyes on the subject and draw a line from the form you're in to the next form. Allow yourself to move between one place and another in the drawing without stopping to check and see where you are. In fact, your ability to judge spatial relationships will improve the more you're able to synchronize the movement of your hand with the movement of your eyes.

- ✔ **Remember that your gesture drawing is just a preliminary sketch.** Artists make gesture drawings to help them get to know their subjects better before they attempt to draw them. Allow yourself some playful savagery in your pre-work; then you can focus on making your finished work look neat and accurate.

- ✔ **Don't be afraid of messiness.** The messiness of gesture drawing comes from looking very hard at something and responding energetically with your hand and arm. Gesture drawing is a full-body attempt to understand the essential nature of a pose, and messiness is just part of the process.

Focusing on Proportions and Shapes

One of the challenges to creating realistic drawings is achieving accurate proportion from one element to another. *Proportion* refers to the relative size of one element in your drawing compared to another element. Often when one area of a drawing is off, the rest of the drawing falls apart in a sort of domino effect, which can be dispiriting, especially when you're just starting out.

But don't worry; achieving proportional accuracy in drawing is absolutely possible when you become familiar with a few simple strategies. In this section, we show you how to draw accurate proportions both within single objects and between different objects by using these basic strategies.

Breaking objects into simple shapes

If you've ever tried to draw an object that's more complex than a square, you know how frustrating it can be when the two sides of something don't quite match up. The easiest way to eliminate this frustration is to reduce objects to an assembly of simple geometric shapes. Essentially, all objects are comprised of some combination of spheres, boxes, and cones — volumetric forms derived from the simple circle, square, and triangle shapes.

Figure 7-9 shows how you can draw a realistic-looking pear by first breaking it down into simple shapes. Look at the circles the artist used to draw the rounded volumes of the pear. They're not perfect circles because the round parts of the pear aren't perfectly round, but they are both based on the simple circle shape. Also notice that the top round part of the pear connects to the stem of the pear, which the artist represented with a simple rectangular shape. Notice how much easier it is to get the proportions right when you break an object like a pear into its basic shapes instead of trying to draw the whole thing in one line.

If a form seems to be composed of two or more separate volumes, don't be afraid to draw through the boundaries of solid form to simplify your drawing process. Just be sure to erase or lighten any lines you make specifically to describe the simple shapes of your object (called *construction lines*) before you finish your drawing.

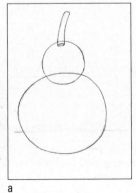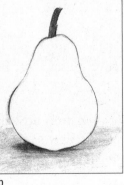

Figure 7-9: Breaking a pear into its simple shapes.

a

b

c

Kensuke Okabayashi

This exercise shows you the step-by-step process of using simple shapes as the foundation for creating a line drawing of an object. We use a floor lamp as our subject, but you can use any object you want. Grab your sketchbook, 2H and 2B pencils, and kneaded eraser, find an object, and then follow these steps:

1. **Determine which simple shapes make up the object.**

 Keep in mind that some parts of the object may be made up of a few shapes, while other parts may look somewhat like a specific shape but not exactly. Do your best to imagine the width and height of each particular shape in your object. For example, a round part of your object may be like a circle that's a little squished.

2. **Use your 2H pencil to draw the shapes you identified in Step 1 to create a rough sketch of the object (see Figure 7-10a).**

 Pay attention to the size of the shapes. If one part of the object is twice as big as another, draw the shapes to suggest this particular size difference. Don't worry if the object looks incomplete when you're done with this step. The only purpose of the shapes is to become a foundation on top of which you can build proportionately accurate contour lines.

Figure 7-10:
Using simple shapes and line weight to draw a realistic-looking lamp.

a b c

Jamie Combs

3. **Lighten the lines you drew in Step 2 so that you can just barely see them.**

4. **Use your 2B pencil to render the contours of the object (see Figure 7-10b).**

5. **Adjust the line weight as necessary to account for the lighter and darker parts of the object's contours (see Figure 7-10c).**

In some cases, it's okay for your line weight to become so light that the line disappears altogether. If a part of the form you're drawing is very strongly illuminated or if one of its edges blends in with the background, you can erase the line completely at that spot. Don't worry; your object will still appear to be whole as long as visible lines remain on either side of the "lost" line. This type of line-weight variation is often called *lost and found edges*. Lost and found edges add realism to your drawings because they reflect what happens when the lighting of a subject blurs your perception of its edge.

Fixing proportion problems

You may notice that even after breaking your objects down into simple shapes and then drawing the appropriate contour lines, your drawing still looks out of kilter. Don't start panicking just yet! In this section, we show you how to check your drawings for a few common proportion problems — and how to fix them, of course!

Comparing positive and negative shapes

One way to check for proportion problems is to compare the positive and negative shapes in your drawing to those in your subject. The *positive shapes* in a drawing are the major subject matter. The *negative shapes* are the spaces made between the positive shapes. To help you visualize these two types of shapes, picture this: You're hanging down from the ceiling and looking at your living room. The sofa, chairs, and tables are the positive shapes, while the parts of the floor you see between them are the negative shapes.

The negative shapes in any drawing have particular shapes because of the arrangement of positive shapes. If you rearrange the positive shapes, the negative shapes change, too. But even though the negative shapes in drawings are dependent on the placement of the positive shapes, they're just as important.

To help you get better at identifying and representing negative shapes in your drawings, take some time to look for them in the world around you. The next time you see two objects near each other, shift your focus so that you're looking at the space between them. For example, pay attention to the shapes that happen between the trees in the woods behind your house or between two people waiting for the bus at the end of your street. With a little practice, you'll be seeing negative shapes everywhere. (See Chapter 5 for more details on seeing positive and negative shapes in your subjects.)

When you're drawing from life, you can use negative shapes to check the accuracy of positive shapes. For example, if a negative shape in your subject is formed between two tree trunks, you can compare the negative shape in

your drawing to the negative shape in your subject to see if the trees are the right shape and in the right places relative to each other. If the negative shapes in your drawing don't match up to the negative shapes in your subject, you know right away that something is off. Use the negative shapes in the subject to figure out what you need to change in your drawing. Using the example of the two trees, if the negative shape in your drawing is wider than the negative shape in real life, your drawn trees are too far apart. You can fix your drawing by moving the trees so that they're closer together.

To practice using negative shapes to check proportions in your drawing, check out Figure 7-11, which shows a photograph of a drawing subject and two drawings made from it. The drawing in Figure 7-11b is pretty close, but it has some proportion problems. The photograph in Figure 7-11a shows an apple sitting on a table. A cast shadow comes forward from the base of the apple and angles slightly to the right. If you compare the negative shape in the drawing in Figure 7-11b (the white space around the shadow and apple) to the negative shape in the photograph in Figure 7-11a, you can see that the negative shapes don't match. At the lower-right corner of the drawing, the negative shape goes too far to the left, meaning that the cast shadow isn't the right shape. In the drawing in Figure 7-11c, the artist has adjusted the shape of the cast shadow so that the negative shape in the drawing matches the negative shape in the photograph.

Figure 7-11:
Using
positive and
negative
shapes
to check
proportions.

 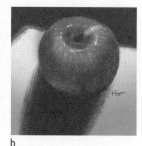 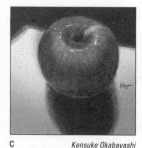

a b c *Kensuke Okabayashi*

Measuring one dimension against another

Another way to check for proportion problems in your drawings is to measure one dimension against another. For example, in Figure 7-12, the height of the orange is roughly equal to its width. Comparisons such as "the height is roughly equal to the width," "the width is one-third of the height," and "the height is one-half of the width," are called *proportional relationships*. You can use proportional relationships in real-life drawing subjects to check the accuracy of proportional relationships in your drawings.

TIP

You can eyeball proportional relationships, but, for greater accuracy, you can use a measuring tool (like the pencil shown in Figure 7-12) to make sure the dimensions in your drawing match those of the subject itself. A good measuring tool to use when making height and width comparisons is one that's long, narrow, and reliably straight, like a thin knitting needle, thin paintbrush handle, or pencil. It's important to use a thin tool because you need to be able to see your subject behind the tool to check proportions. To use a measuring tool to make height and width comparisons in order to see how the proportions of your drawing compare to those of your subject, follow these steps:

1. **Choose a unit of measure in your subject.**

 Your unit of measure can be any dimension of any object. For example, if you're drawing a still life with apples and oranges, you may choose the height of one orange to use as your unit of measure. After you have a unit of measure, you can use it to find the dimensions of other objects in your drawing. To see an example, check out Chapter 15, where we show you how to use the human head to determine proportions for the rest of the body. You can use a unit of measure made with a measuring tool to find the length of any other thing in your drawing in the same way that you use an inch or a foot to find numerical measurements.

2. **Use your unit of measure to determine one proportional relationship in your subject.**

 If you chose to use the height of an orange as your unit of measure in Step 1, you can compare the height of an orange to its width in this step (see Figure 7-12).

Figure 7-12: Using a measuring tool to compare the height and width of an object.

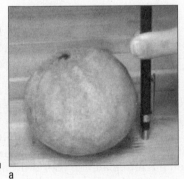

a b *Jamie Combs*

3. Use your measuring tool to compare the two dimensions you found in Step 2 in your drawing.

If you compared the height and width of an orange in Step 2, compare the height and width of the orange you drew in this step (see Figure 7-13). The proportional relationship you found in your drawing subject in Step 2 should be the same as the one you find in your drawing in this step. If the proportions aren't the same, you need to adjust one of the dimensions to make the proportional relationship right.

Because proportional relationships are based on such ratios as "one-third as long" or "one-half as high," the proportions of one thing compared to another will be the same whether you make the first thing 1 inch tall or 100 feet tall. In Figure 7-13, the height of the orange is roughly the same as the width. Therefore, if you decide to make the orange 4 inches wide, you also need to make it 4 inches tall.

Figure 7-13:
Checking
proportional
relation-
ships in your
drawing.

Jamie Combs

At first, using a measuring tool to compare your drawing to your subject may feel like a tedious task that's keeping you from the real fun of drawing. However, after you have a grasp on the basic process, you're sure to find this type of measuring enormously helpful. So try to stick with it for your first few projects. In the long run, the care you put into planning your drawings will lead to more satisfying drawing experiences overall.

For each drawing you make, it's important that you stick with your original unit of measurement. If you start off using the height of the human head, for example, you have the highest chance of keeping your measurements consistent throughout your drawing if you continue to use the human head as your unit of measure for the rest of that drawing.

Objects aren't the only things you can measure in your drawings. You can measure the spaces between the objects, too. After you know how to use a measuring tool to make reasonably accurate comparisons between one dimension and another, you can use the same strategy to measure the dimensions of negative shapes (see the earlier section "Comparing positive and negative shapes" for more about negative shapes).

Project: Using Lines and Shapes as Tools for Investigation

Like scientists, artists learn about the stuff of the world through exploration and observation. In the same way that scientists use microscopes to examine their subjects, artists use drawings to look at their subjects with a whole new intensity. Even when your subject is familiar to you, you gain new insights about it by drawing it. When you draw, even the back of your hand becomes uncharted ground.

In this project, you conduct some drawing research (by making a blind contour drawing) and use it to make a line drawing of a simple object. As you move through the following steps, you can copy the illustrations shown here, but you'll get more out of the project if you draw from a real, three-dimensional object. So choose a simple object with some variation in shape, such as a curvy bottle, lamp, or light bulb, and grab your sketchbook, 2H, 2B, and 4B pencils, vinyl eraser, kneaded eraser, and long, straight, narrow measuring tool (like a knitting needle, barbeque skewer, or thin paintbrush). Then follow these steps:

1. **Arrange your object so you can comfortably see it fully without moving around and set your sketchbook or sheet of drawing paper in front of you but beneath your eye level.**

 Figure 7-14 shows the object being used in this project.

2. **Use any pencil to make a blind contour drawing of your object.**

 Choose a starting point on your object and set your pencil down on the paper in a corresponding place. Slowly move your eyes along the contour of the object. Without looking at the paper or lifting your pencil, synchronize your hand with your eyes to draw the contour of the object. Stop when you get back to the starting point (see Figure 7-15). Check out the earlier section "Getting Comfortable with Lines" for more on blind contour drawing.

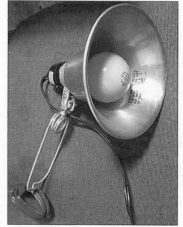

Figure 7-14:
Positioning your draw-ing subject in front of you.

Kensuke Okabayashi

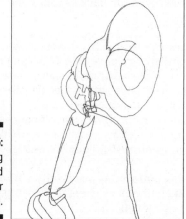

Figure 7-15:
Making a blind contour drawing.

Kensuke Okabayashi

3. **On a separate piece of sketchbook paper, use your 2H pencil to draw the simple shapes that make up your object (see Figure 7-16).**

 Visually break your object into simple shapes. To help you figure out where to break up your subject, look for changes in size or direction in the object. For example, because they're different sizes, the reflector of the lamp is a separate shape from the base of the lamp even though they're connected to each other.

Figure 7-16:
Breaking
your subject
into simple
shapes.

Kensuke Okabayashi

4. **Use your measuring tool to check proportions in the simple shape drawing you made in Step 3.**

 First choose one dimension of your object to use as a unit of measure. Then use your measuring tool to measure the real-life unit of measure, and compare the length of it to the height or width of any other part of the real-life object. Then use your measuring tool to make the same comparison in the drawing. If the real-life unit of measure is half the length of the other dimension you measured, the drawn unit of measure should also be half the length of the other dimension in the drawing. If the proportions are different, make adjustments and then check them again. (See the earlier section "Measuring one dimension against another" for more details about choosing and using a unit of measure to check proportions.)

5. **Use your kneaded eraser to lighten all the lines in your simple shape drawing.**

6. **On top of the simple shape drawing, use your 2B pencil to draw the contours of the object.**

 Consider the weight of the lines you use to draw the contours. Look for places where the object catches light and where it's in shadow. Vary the weight of the lines to mimic the effect of light, and consider places where you don't need a line at all (see Figure 7-17).

Figure 7-17:
Varying the
line weight
in your
contour
drawing.

Kensuke Okabayashi

7. **Use your kneaded eraser to lighten or erase any unnecessary lines and use your vinyl eraser to erase any stubborn marks.**

 If needed, adjust the lightness of light parts of the contour line with your kneaded eraser.

 To avoid disturbing the lines you don't want to erase while erasing the unnecessary lines, use an inexpensive erasing shield, which is a thin, flexible piece of metal with a variety of openings that allows you to mask your drawing while erasing unwanted marks. You can find an erasing shield in the drafting section at any well-stocked art supply store. If you don't have or can't find an erasing shield, try using the corner of your eraser to erase your lines. If your eraser is blunt, use a utility knife to slice off the end of the eraser, leaving fresh corners.

8. **Use your 4B pencil to add the finishing touches to your drawing.**

 Retrace any parts of the contour line to add emphasis where you need extra darkness. Some places to look for extra darkness on drawing subjects include the line between the object and the surface on which it sits and any place where one section overlaps another. Figure 7-18 shows the finished drawing of the lamp.

Figure 7-18:
Adding
finishing
touches.

Kensuke Okabayashi

Chapter 8

Exploring the Third Dimension

In This Chapter

▶ Training your eyes to see light and shadows as values

▶ Turning basic shapes into three-dimensional drawings

▶ Trying your hand at drawing a sphere

Drawing realistic images involves creating the illusion of three-dimensional space on a two-dimensional drawing surface. One of the most significant factors contributing to how you (and your audience) perceive three-dimensional forms (which are also called *volumes*) is the way light and shadows interact across them. Before you can draw realistic three-dimensional illusions, you need to understand how light and shadows work to create those illusions. In this chapter, you discover how artists look at light and shadow and how you can do the same. You examine interactions of light and shadow on three-dimensional forms and explore ways to use value to render functional light and shadows in your own drawings.

Seeing Light and Shadows and Using Values to Represent Them

Light and shadows visually define objects; to create three-dimensional objects on paper, you have to draw both of these elements. But before you can start drawing the light and shadows you see (and the objects they define), you need to train your eyes to *see* light and shadows like an artist.

So what exactly do artists see? The answer is simple — values. *Values* are degrees of light and dark; they range from black to white and include all the shades of gray in between. Artists use values to translate the light and shadows they see into shading, which creates the illusion of depth and third dimension (check out Chapter 9 for details on shading). But before you can start adding realistic shading to your drawings to create the illusion of depth, you need to be able to distinguish and create a full range of values. The following sections show you how to do just that.

Taking a closer look at light and shadows

Generally speaking, the values in light areas of drawing subjects are easier to render than the values in areas of shadow. In fact, many times, you can create light values in your drawings simply by leaving the paper white. Shadow areas pose a more complex challenge because they often include several different values; sometimes only subtle changes distinguish one value from another in a given shadow area.

To create a truly realistic illusion, you need to incorporate all the different values you see in your subject in your drawing. And to render accurate shadows and light, you need to know what you're looking at (what's light and what's shadow, for example). Figure 8-1 shows the different parts of light and shadow in a drawing; we define each of them here:

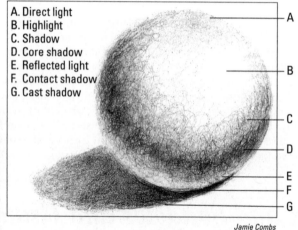

A. Direct light
B. Highlight
C. Shadow
D. Core shadow
E. Reflected light
F. Contact shadow
G. Cast shadow

— A
— B
— C
— D
— E
— F
— G

Figure 8-1:
Parts of
light and
shadow in
a drawing.

Jamie Combs

- ✔ **Light source:** The direction from which a dominant light originates. The light source tells you where to draw all the light values and shadows; its placement affects the setting and mood of your drawing. (Turn to Chapter 9 for details on how to draw values.)

 You can't always tell *what* the light source is, but you can tell *where* it is. For instance, in Figure 8-1, the light comes from the upper right.

- ✔ **Direct light:** The mass of light values. Direct light is any place that's bathed in light.

- ✔ **Highlight:** The lightest light value. Highlights are flecks of strong light that usually appear on reflective surfaces like glass or shiny metal.

- ✔ **Shadow:** The mass of dark values. Shadows appear in any place that's blocked from light.

✔ **Core shadow:** A band of shadow that appears only in rounded or cylindrical volumes and that echoes the curves of those volumes. The core shadow is very important to the illusion of roundness.

✔ **Reflected light:** Light that reflects from any surface and bounces into a shadow. Reflected light is never as strong as direct light.

✔ **Contact shadow:** The thin, very dark shadow between an object and anything an object presses against, for example, the surface on which the object sits. The contact shadow usually looks like a black line underneath objects or between two objects that are pressed together.

✔ **Cast shadow:** The shadow thrown onto a surface when an object blocks the light from shining on it.

You can't see all the possible parts of light and shadow in every drawing. For instance, the core shadow appears only on rounded volumes. More often than not, though, you can see most of them.

Take a look at Figure 8-2 to get some practice with locating the light source, shadows, and cast shadows around an object. As you look at the two drawings in the figure, ask yourself the following questions:

Figure 8-2:
Looking for
light and
dark values
and cast
shadows.

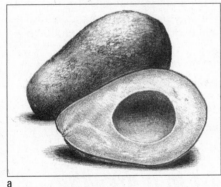 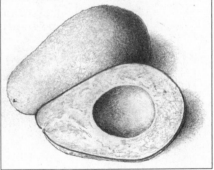

a b *Barbara Frake*

✔ **Where are the light values?** Look for the lightest areas on the object. Note the very brightest of the lightest values, or the highlights. In Figure 8-2a, the lightest values are on the cut surface of the avocado to the right and up from the cavity left by the pit. In Figure 8-2b, the lightest values are again on the cut surface of the avocado, but this time, they're to the left of the cavity left by the pit.

✔ **Where are the dark values?** Look for the dark values in and around the object; they often reveal the sections of the object that are in shadow. In Figure 8-2a, the shadows are on the right and lower-left sides of the

overturned half of avocado and on the upper part of the cavity left by the pit. In Figure 8-2b, the shadows are on the right side of the over-turned half of avocado and on the left side of the cavity left by the pit.

✔ **Where is the cast shadow?** The section of the cast shadow closest to the object is usually the darkest value in a drawing. In Figure 8-2a, the cast shadows are on the left side of the two avocado halves and on the lower-right side of the front-facing half. In Figure 8-2b, the cast shadows are on the right side of each avocado half.

✔ **Where is the light source?** By locating the shadows, particularly the cast shadow, in a drawing, you can usually discover the light source (or at least the direction from which it originates). In Figure 8-2a, the light is coming from the upper right, above and directly opposite the cast shadow. In Figure 8-2b, the cast shadow is also above and directly oppo-site the cast shadow, but this time it's coming from the upper-left side of the avocado.

Seeing how a light source affects an actual object is more challenging than examining light and shadows in a drawing, but doing so is key to creating realistic, three-dimensional drawings. To practice seeing light sources like an artist, place an object on a table in a dimly lit room. Shine a powerful flash-light or a lamp (the light source) on the object. Move the light source around to observe the effects of light from different angles. Try putting the lamp to the left and right, above and below, and in front of and behind the object. Each time you reposition the light source, identify the following:

✔ The shadows on the object (dark values)

✔ The brightest areas (the highlights)

✔ The light values (areas closer to the light source, or not in shadow)

✔ The cast shadow (the darkest value)

Exploring contrast in a drawing

Value contrast is the play of lights and darks in a drawing. As you may have guessed, achieving good value contrast is important to creating realistic illusions of volume and depth, but value contrast itself is also a powerful emotive element in a drawing. Like in a play or movie, lighting helps create setting and mood in a drawing. The three main types of value contrast are

✔ **Low:** *Low-contrast* drawings have mostly values that are close together. Foggy or hazy days are good examples of low-contrast situations.

✔ **High:** *High-contrast* drawings have mostly values in the extreme ranges — very light and very dark. Circuses and nighttime scenes flooded with city lights are good examples of high-contrast situations.

✔ **Full-value:** *Full-value* drawings have values that are extremes of light and dark as well as all the values in between. All you need is typical daylight or interior lighting, and you have a situation that demands a full spectrum of value.

So what kind of contrast creates the most realistic drawings? The answer is simple: all three. The key to realism is getting the value relationships in your drawing to look like they do in real life. If you see shadows next to light in your subject, draw them next to light on your paper. As you draw, make comparisons between your drawing and your subject to see whether you've created the right contrast. If you haven't, make the necessary adjustments.

Figure 8-3 shows you one subject under three different levels of contrast. Notice how the setting and mood seem to change with the contrast. In the low-contrast drawing in Figure 8-3a, it appears to be a bright, warm day. The air is filled with light. In the high-contrast drawing in Figure 8-3b, the feeling is a little cooler, and the shadows create a sense that it's later in the day. In the full-value contrast drawing in Figure 8-3c, you can see that the shadows play against a bright light, thus depicting a sunny afternoon.

Figure 8-3: Low contrast, high contrast, and full-value contrast.

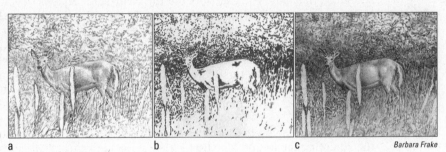

a b c *Barbara Frake*

Squinting to translate vision into values

Seeing value in your subjects is the first step to drawing in the third dimension. However, the range of values you see in any given subject can make you feel overwhelmed at the prospect of trying to draw it. After all, almost every subject has more than one value. Under normal circumstances, most things have some areas that are very light and others that are quite dark. For example, if you look closely at a mound of dark earth, you notice that it has several different values. If a fresh layer of bright-white snow covered the dirt mound, you'd still see lots of values. So how do you represent all those values on paper?

To make the process of capturing the full range of values in your drawings more manageable, you can simplify your subject into the basic value shapes that make it up. A *value shape* is the shape of an area of value. For example, imagine that a field of grass is all one value except for a few long rectangular shadows being cast on it by telephone poles. Each rectangular shadow is a

value shape. The lighter shapes of the grass surrounding the shadows are also value shapes. One funny-sounding but helpful strategy for simplifying values into shapes is squinting. Read on to find out how to use this technique to draw your way to three dimensions.

Seeing simple value shapes

Squinting helps you screen out details in your subject so you can more easily see — and draw — the basic value shapes (the large ones that make up the bulk of the drawing subject). To better understand the concept of basic value shapes and how they compare to smaller value shapes, which describe the details in a drawing subject, consider the crescent moon. The moon is a sphere even when you can't see the whole thing. The basic value shapes of the crescent moon are the light crescent shape and the dark shape of the remainder of the sphere; those are the only two shapes you see when you squint at a crescent moon. The surface details you see when you stare at the moon are the smaller value shapes (think about the craters that make up the face of the man in the moon).

Whenever you draw, try to simplify your subject as much as possible by squinting; that way, you can work out the basic value shapes of your subject before you try to tackle the smaller value shapes. For example, you can draw a nose a lot more easily when you start by drawing its largest, most basic shadow shapes like the ones you can usually find beneath the nose and along one or both sides of the nose and then moving on to smaller shadow shapes like the ones that make up the nostrils. By the time you're finished adding both basic and smaller value shapes, you'll have a complete, full-value drawing. (See Chapter 15 for more on drawing noses.)

Figure 8-4 shows you three stages of a drawing that the artist created using the squinting technique. The first stage (shown in Figure 8-4a) shows the simple value shapes in the subject. The second stage (shown in Figure 8-4b) shows the drawing after the artist added the next-darker value. The third stage (shown in Figure 8-4c) shows the final drawing. Squint at the third drawing and compare it to the first two drawings. Notice the difference in detail and value between the drawings.

Turning colors into values

Many drawing media, such as graphite and charcoal, are designed for black and white drawings. Yet, almost everything in the world is in color. To create the most realistic drawings, you need to adjust your visual perceptions to see all the colors in your subjects as shades of gray.

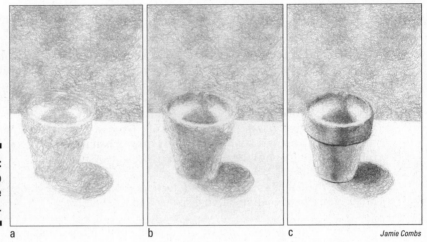

Figure 8-4:
Squinting to
see value
shapes.

a b c

Wouldn't it be nice if you could simply press a button in the middle of your
forehead and magically transform the world from full color to gray? A button
like that would certainly make drawing easier, but, it isn't likely to hit mar-
kets any time soon. No worries. You can develop your own color-to-gray skill
just by squinting.

Look around at different objects. Try to notice whether an object is light or
dark instead of looking at its color. Concentrate on the light and shadows;
then squint until you see the values of that object. Think about where the
lights and darks are and how you could draw them with your drawing medium
of choice. If you can't decide what the value of something is, compare it to
the lightest and darkest values you see. Don't get discouraged if you can't see
your subjects in lights and darks right away. With practice, you'll get better.

Sometimes translating colors into values is easy. For example, if your sub-
ject has light-pink and dark-red stripes, you can simply draw the dark red
as a dark value and the pink as a light value. Other times, however, trans-
lating colors into values is a little trickier. For example, if your subject has
stripes of dark green and dark red, you need to pick one to be a lighter value.
Otherwise, you'll end up drawing a solid tone rather than stripes.

To help you create realistic values, identify both the lightest value and the
darkest value in your subject before you start shading a drawing. You can use
these values as reference points against which you can measure the rest of
your values.

Taking Shapes into the Third Dimension

Just about anything you can think of has shape, and many things also have volume. What's the difference? *Shape* is the two-dimensional, or flat, quality you see in the outline of an object, while *volume* is the three-dimensional quality you see in all physical objects. In drawing, the difference between a two-dimensional shape and a three-dimensional object is the illusion of volume. So when you draw the outline of a banana on a piece of paper, you're drawing the banana's shape. When you draw a banana so that you can see its fullness coming out of the paper, you're drawing its volume.

To make the flat shapes of your subjects pop out into three-dimensional volumes, you can use perspective drawing and/or shading.

- *Perspective drawing* is a way of drawing in which you use point of view to determine the way objects and spaces should appear on the page. For example, you can use the principles of perspective drawing to transform a flat square into a cube that appears to have six sides. (Turn to Chapter 11 for everything you need to know about perspective drawing.)

- *Shading* is the act of adding shades of gray and black to a drawing. You can use shading to mimic the way shadows look when light strikes three-dimensional objects. (We cover shading and the techniques you can use to create it in Chapter 9.)

In the following sections, you find out how to turn flat shapes into three-dimensional volumes. Squares become cubes, rectangles become cylinders, triangles become cones, and circles become spheres. Conveniently for you, cubes, rectangles, cylinders, and cones are the building blocks for all three-dimensional forms, so after you know how to draw them accurately, you can draw convincing illusions of volume for any object.

From squares to cubes

You may remember from high school geometry that a *square* is a two-dimensional shape with four equal sides and four right angles and a *cube* is a three-dimensional version of a square with six square surfaces of the same size. To transform a square into a realistic cube, you need to add light, shadows, value contrast, and perspective with shading (see Chapter 9 for more details on shading and Chapter 11 for more on perspective).

Figure 8-5 shows the transformation from square to cube. In the first stage, you see a square. In the second stage, you see a cube with its top and two sides facing you and receding in space. To achieve this recession, the artist drew the cube according to the principle of two-point perspective, which

allowed her to make only two of the cube's sides visible to the viewer (see Chapter 11 for details). Because you know these sides are on a cube, you know each of them is a square, yet the squares appear distorted from their pure geometrical shape. This distortion reflects what would happen to the sides of a cube if you looked at it from the point of view of the artist. In the third stage, shading helps make the basic cube from the second stage more realistic and three-dimensional. Notice the light, shadow, reflected light, and cast shadow in the shaded cube (see the section "Seeing Light and Shadows and Using Values to Represent Them" for details about these elements).

Figure 8-5:
Adding perspective and shading to turn a square into a cube.

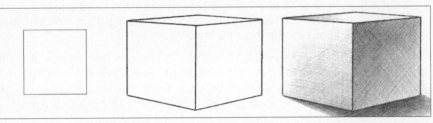

© 2003 Brenda Hoddinott

From rectangles and triangles to boxes, cylinders, and cones

You need to be familiar with other basic shapes besides the square before you can successfully turn any object you see into a three-dimensional volume on paper. In case you don't have many fond memories from your geometry class (or any memories at all!), we sum up what you need to know here:

- ✔ A *rectangle* is any four-sided shape in which all its corners have 90-degree angles. True, a square is one type of rectangle, but unlike the square, the sides of a rectangle don't have to be equal in length. Like the square, any rectangle can become a three-dimensional volume with the right perspective drawing and/or shading.

 When the sides of the rectangle you're drawing aren't all equal, the volume you create is simply called a *box*. But when you replace the straight lines on either pair of opposite ends with ellipses, you turn your rectangle into a *cylinder*. (In case you're wondering, an *ellipse* is a circle that recedes in space.)

- ✔ A *triangle* is any three-sided shape. A triangle can become a three-dimensional volume called a *cone* if you draw an ellipse that goes from one corner of the triangle to another.

Figure 8-6 shows how basic rectangles and triangles transform into three-dimensional boxes, cones, and cylinders when you add a little shading and perspective (see Chapter 9 for details on shading and Chapter 11 for information about perspective). Take note of how light and shadows work together to add a third dimension to these simple shapes (see the earlier section "Taking a closer look at light and shadows" for more details):

- ✔ **Box:** Look at the box in the top center of Figure 8-6. The value contrast shows what happens when light strikes this box strongly on one side (notice the extra-bright values on the left side). The dark value of the underside of the box shows you it's being blocked from the light and is in deep shadow. The side of the box that faces you is a middle value, telling you that the front side of the box isn't completely blocked from light but that it isn't getting direct light.

- ✔ **Cylinder:** Look at the skinny cylinder on the left side of the figure. A long core shadow runs the length of the left side of the cylinder. The core shadow shows what happens when the curving volume of the cylinder turns away from the direct light that strikes the front of the cylinder.

- ✔ **Cone:** Look at the cone in the top left of the figure. Even if you cover the ellipse at the bottom of the cone, you can still tell this object is no flat triangle. The shading on the left and right sides of the triangular part of the object curves away from the strong spot of direct light and around toward the back of the cone. This curved shading tells you this object is a rounded three-dimensional form.

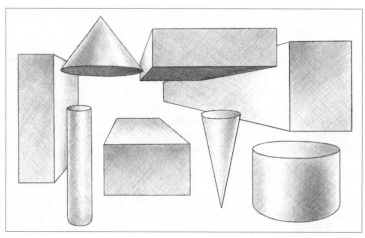

Figure 8-6:
Using
shading to
turn 2-D
shapes into
3-D objects.

© 2003 Brenda Hoddinott

From circles to spheres

Simply stated, a *sphere* is a three-dimensional version of a circle. Examples include planets, orbs, and balls. To create the illusion of volume in the spheres in your drawings, use a combination of light and shadows.

The easiest way to draw light on your spheres is to let the lightest areas be the white of the paper (see Figure 8-7). To create the other light and dark areas, use shading. When shading to build rounded volumes like spheres, keep the following pointers in mind (see Chapter 9 for more details on shading):

✔ The core shadow helps create the illusion of roundness in any rounded volume (see the earlier section "Taking a closer look at light and shadows" for details about core shadows).

✔ Rounded volumes (like spheres) look more realistic if you make your shading follow the contours of the volume. In other words, make your shading marks as though you mean to sculpt the form with them. Check out Figure 8-7 for an example; notice how the shading lines curve along with the swell of the sphere.

The word *contour* is often confused with the word *outline*. An *outline* is a line that traces a shape. A *contour* is the entire outer surface. The contour of an orange, for example, is the entire peel, not just the circular shape you see when you look at the fruit head-on.

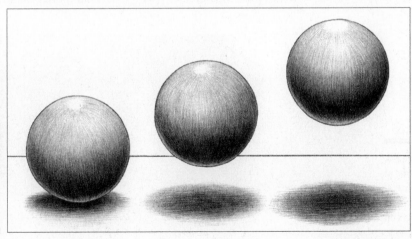

Figure 8-7:
Light and shadows transform a circle into a sphere.

© 2003 Brenda Hoddinott

To get a better idea of how shadows and changes in value (which you create by shading) can suggest volume in your drawings, take a look at Figure 8-8; notice the following:

- The manner in which value changes occur in a given drawing describes what happens to light when it encounters a particular volume. For example, value changes happen gradually and softly around the sphere in Figure 8-7. The surfaces of rounded volumes like spheres, cones, and cylinders change direction gradually and softly, moving into and away from the light a little at a time. In contrast, the value changes on the surfaces of the boxes and cubes in Figures 8-5 and 8-6 happen abruptly, letting you know a big shift in direction takes place as you move from one side of the box or cube to another.

- A beltlike core shadow wraps around the lower part of the sphere.

- Directly beneath the core shadow, reflected light illuminates the base of the sphere. See the earlier section "Taking a closer look at light and shadows" for details on reflected light.

- The cast shadow is darkest near the sphere and then gets lighter as it moves away from the sphere. The edges of a cast shadow are often uneven in firmness, and the shadow itself is usually made up of two or more values. Generally, you can expect the edge of a cast shadow to become softer and lighter as it gets farther from the object; however, you don't want to overdo it. If you're drawing from your imagination, try to keep your cast shadows fairly light, only allowing them to get dark closer to the object; by doing so, you make them more realistic.

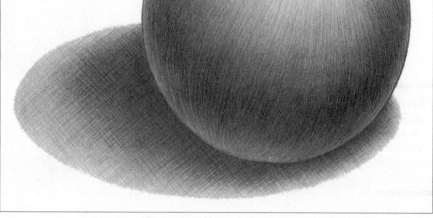

Figure 8-8:
Looking at the value changes and shadows on a sphere.

If you think you've developed a good sense of how to draw shadows but your spheres still don't look very three-dimensional, you probably need to practice drawing light. Find a sphere (a ball or another round object) and place it on a lightly colored surface. Shine a light on the sphere from above and closely examine the sphere's edges that are closest to the surface on which it sits. Notice the reflected light along those edges; it's lighter in value than the shadows on the sphere but darker than the sections of the sphere that are closer to the light source. If an object is sitting on a colored surface, you can often see that same color in the reflected light.

Take a look at Figure 8-9 to see how you can draw reflected light on your spheres. The best way to represent reflected light realistically is to use light values that gradually get darker until they meet the dark shading of the shadows on the sphere.

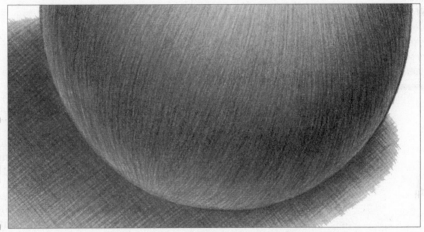

Figure 8-9: Drawing reflected light on the shadow side of a sphere.

© 2003 Brenda Hoddinott

Project: Drawing a Sphere

Turning two-dimensional shapes into three-dimensional objects on paper may look a little complicated, but it really isn't too hard. In this project, you turn a basic circle into a realistic sphere complete with light, shadows, and plenty of value contrast.

Before you get started, gather your sketchbook, erasers, and 2H (or HB), 2B, and 6B pencils; then follow these steps:

1. **Use your 2H pencil and a light touch to draw a circle slightly to the right of your drawing space (see Figure 8-10).**

 If you feel uncomfortable drawing circles freehand, use a compass. Just make sure that you keep your drawing very light because you'll need to erase some of your lines later.

2. **Draw an oval shape (an *ellipse*) to represent your sphere's cast shadow (refer to Figure 8-10).**

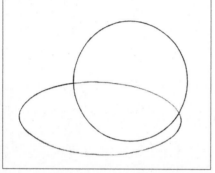

Figure 8-10: Breaking down an object into its simple shapes.

© 2003 Brenda Hoddinott

Notice that the oval shape in the figure looks like a partially flattened circle and extends past the circle toward the left of the drawing space. It's entirely in the bottom half of the drawing space and is vertically shorter and horizontally longer than the circle.

Don't worry if your oval is shaped a little differently than the one you see here. Even a slight repositioning of the light source can change the shape of a cast shadow.

3. **Use a kneaded eraser to daub away the lines of the circle and ellipse until you can barely see them; erase the part of the ellipse that's inside the perimeter of the circle.**

4. **Use a 2H or HB pencil to draw the light values on the sphere (see Figure 8-11).**

 The light source in the drawing in Figure 8-11 is from above, slightly to the right, and a little in front of the sphere.

Don't forget to identify the location of the highlight and to leave that space white. Also leave a lighter section along the bottom edge of the sphere to represent the reflected light (see the earlier section "Taking a closer look at light and shadows" for details on light sources, highlights, and reflected light).

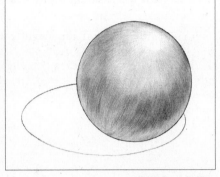

Figure 8-11:
Adding basic value shapes to the light areas of your object.

Use whichever shading technique you feel most comfortable with as you add the light values to your sphere (we describe the different shading techniques in Chapter 9). Regardless of which technique you use, make sure your lines follow the contour of the sphere. Imagine that you're using the pencil to sculpt a sphere out of clay. "Feel" the curved surface swell and turn away beneath your pencil.

5. **Use a 2B pencil to add the middle values and a 6B pencil to draw the dark shadows on the sphere (see Figure 8-12).**

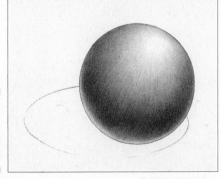

Figure 8-12:
Building values gradually.

For the sake of continuity, it's important that you stick with whichever shading technique you started with, so be sure to use the same shading technique you used to shade the light values in Step 4.

6. **Use your 2B and 6B pencils to draw the shading of the cast shadow (see Figure 8-13).**

 Start with the 2B pencil and shade the whole shadow lightly first. Then continue to use the 2B pencil to add layers of value in places where the shadow needs to be darker. Make sure your shading gets darker closer to the sphere and gets lighter toward the outer edges of the ellipse. Lastly, use your 6B pencil to add the very darkest values. You may only need it to draw the contact shadow.

Figure 8-13: Shading the cast shadow using the same order of operations you use to shade the rest of the object.

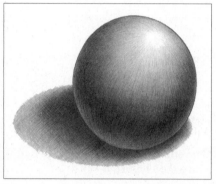

© 2003 Brenda Hoddinott

Chapter 9

Adding Life to Your Drawings with Shading

*I*n drawing, the term *value* refers to the lightness or darkness that appears in the drawing. In essence, value represents the light and shadows you see in the natural world. When it comes to your drawings, you can use value to show the way light moves through a particular space and to create the illusion of three-dimensional form.

So how do you create value in your drawings? You use a process called *shading,* which allows you to build or adjust values in your work. You can choose from two shading methods, depending on whether you want to build value by adding something to your drawing or by removing something from it. Coincidentally, these two methods are referred to as *additive* and *subtractive* drawing. In general, additive drawing works more efficiently when you're creating a tightly rendered drawing, while subtractive drawing works better when you're creating a more loosely rendered drawing.

In the majority of your drawings, though, you'll use both methods to create the most realistic images. For example, you probably won't finish a subtractive drawing without using an additive drawing technique or two. If you're using an eraser to pull light out of a ground you've toned with a layer of graphite or charcoal, you may need to go back in with a pencil or charcoal to adjust the dark values of that ground. You may also add light to a subtractive drawing by using white charcoal pencil to emphasize the lightness of values you built with an eraser.

In this chapter, we show you various techniques for building value and then describe a painless process for using these techniques in your own drawings. With a little practice, you'll find that adding realistic shading to your drawings is not only possible but also quite fun.

Using Additive Drawing Techniques to Build Value

Additive drawing is exactly what it sounds like: the process of adding marks to paper. More specifically, it's the drawing you do when you layer different shades of dark values (using graphite or another drawing medium) over the light values of the white paper. When you use additive drawing techniques, the white of the paper has a strong presence in the drawing because it does the work of supplying the lightest values in your drawing.

In this section, you discover three additive drawing techniques — continuous tone, hatching, and crosshatching — and get to practice using them to build a variety of values. Think of these techniques as tools in your drawing toolbox; you can use any or all of these techniques to build value in your drawings.

Creating continuous tone

When building value in your drawing, you don't want it to look choppy and disconnected. Instead, you want your drawing to look like one endless sheet of value that changes as naturally as light does in real life. One way to achieve this level of cohesiveness is to use a technique called *continuous tone* by first creating a light, even, all-over layer of tone and then adding on darker values through layering. If you do it right, your values will appear to grow naturally, one out of the other.

The continuous tone technique requires a consideration you don't have to worry about with other kinds of shading techniques — that is the consistency with which you move your drawing medium. To build values with smooth, even transitions, you need to find a way to move your pencil constantly without changing the pressure you put on it. (For this reason, graphite pencils are the easiest tools to use to create continuous tone.) If you do

change the pressure on your pencil, some of your marks will be darker than others, meaning you'll see distracting seams where the different marks overlap each other.

The easiest way to keep an even pressure as you build value in your drawings is to figure out your natural mark and stick with it. Your *natural mark* is the kind of mark you can make mindlessly for ten minutes without changing either the size of mark or the pressure on your pencil. Finding your natural mark takes some practice (and — like so many things — patience), but when you get the hang of it, not only will your drawings look even and smooth but you may even find the whole process relaxing.

Using the natural mark technique takes tenacity. When you first start practicing it, you may find yourself resistant because of how slowly things change. But if you try to speed up the process by making marks that are faster or longer than what's natural to you, sooner or later your brain and hand will relax to your natural mark, making the size of your marks inconsistent. Relax and give in to the process. Trust us, when you see the final results, you'll be glad you did.

To see how continuous tone works, gather your 2H, 2B, and 6B pencils and your sketchbook and follow these steps:

1. **Use a ruler and any pencil to draw three 2-x-2-inch squares on a page in your sketchbook.**

2. **In the first square, move your 2H pencil in a continuous, steady rhythm to create a light, even layer of tone (see Figure 9-1a).**

3. **Repeat Step 2 exactly for the next two squares so that all three squares look the same.**

4. **Skipping the first square, use your 2B pencil to add a second even layer of tone to the last two squares (see Figure 9-1b).**

 Be sure to use the same even pressure you use in Step 2 for this second layer.

5. **Using your 6B pencil, add a final layer of tone to the third square (see Figure 9-1c).**

 Again, be sure not to change your pressure as you draw this third layer.

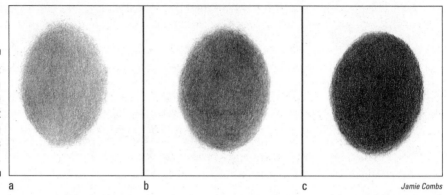

Figure 9-1:
Creating
three
different
values using
continuous
tone.

a b c

Trying your hand at hatching and crosshatching

If you're ready to do some shading but you'd like to try out a few more techniques before you start, you're in luck because we cover hatching and crosshatching — two more additive options — here. The first technique, called *hatching,* is the process of drawing a series of lines (called a *set*) close together to give the illusion of value. This very simple method of shading can produce a complete range of different values in your drawings.

The second technique, called *crosshatching,* is actually just a variation on hatching. Like hatching, crosshatching is a shading technique that produces a complete range of values. The key difference is that, in crosshatching, you use two or more sets of hatching lines that cross over each other (hence the name).

The following three factors affect the darkness or lightness of the value you create with hatching and crosshatching:

- **How close the lines are to each other:** In general, the closer the lines are to each other, the darker the value.

- **How you hold your drawing medium:** The harder you press and the tighter you grip your pencil, the darker the value. To achieve a lighter value, all you have to do is press down a little more lightly and loosen your grip.

- **What kind of drawing medium you use:** Some pencils just lend themselves to making light marks. For example, the 2H is great for light marks. On the other hand, the 2B is a natural tool for making medium values, and the 6B makes great dark values. Check out Chapter 2 to see the full range of values created by different pencils.

The following sections show you how to use the hatching and crosshatching techniques to achieve just the right value in your drawings.

Drawing hatching lines

Practicing the hatching technique is as easy as drawing a set of lines. To get started, grab your sketchbook and 2H, 2B, and 6B pencils and then follow these steps to create three sets of hatching lines, each one with a different value:

1. **Use a ruler and any pencil to draw three 2-x-2-inch squares on a page in your sketchbook.**

2. **In the first square, use your 2H pencil and a light, steady pressure to draw a set of parallel lines that are far apart from each other (see Figure 9-2a).**

 The old expression *few and far between* works well here. The lines you draw in this step should be far apart and few in number.

3. **In the second square, use your 2B pencil and the same light, steady pressure you used in Step 2 to draw a set of parallel lines that are closer together than the lines you drew in Step 2 (see Figure 9-2b).**

 Notice that the second set has more lines than my first set and that the value of this set is darker and heavier.

4. **In the third square, use a sharp 6B pencil and a light, steady pressure to draw a set of hatching lines that are even closer together than the lines you drew in Step 3 (see Figure 9-2c).**

 When you draw each set in this exercise, make sure to draw with the same light, even pressure. That way, you can see the range of values you get just by switching to softer pencils.

 Notice that the third set has more lines that are much closer together than the lines in the second set and that the value of this set is very dark.

Figure 9-2:
Creating three different values using hatching.

 a
 b
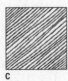 c

© 2003 Brenda Hoddinott

When you start hatching, try out several different ways of moving your pencil or changing the angle of your lines until you find the motions that are the most natural for you. For instance, you may decide to draw the first line in the upper-left corner and continue making lines until you get to the lower-right corner. Experiment with different directions and angles until you find what's comfortable for you.

Keep in mind that your hatching marks don't always have to be plain-vanilla straight lines. Different styles of hatching marks lend different moods to your drawings. In Figure 9-3, we show you a small sampling of six hatching styles, including both curved and straight lines. Some styles have long or short lines or even combinations of different lengths. Some styles also have noticeable spaces between the lines, while others have lines that are very close together (see Chapter 7 for an in-depth discussion of lines).

In Figure 9-3, notice the textures you can create just by using different hatching styles. Some have hairy textures, while others have more jagged or rough textures (check out Chapter 10 for a lot more about textures). Imagine how you could apply each of these hatching styles to something in a drawing.

Figure 9-3:
Making
different
hatching
marks.

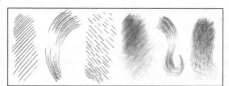

© 2003 Brenda Hoddinott

Take a few minutes to draw some different types of hatching lines in your sketchbook. For inspiration, look at some of the drawings throughout this book, taking note of the different ways the artists use hatching. (**Hint:** Take a closer peek at the fur on the animals!)

Drawing crosshatching lines

To try your hand at drawing crosshatching lines, grab your sketchbook and 2H, 2B, and 6B pencils and then follow these steps to create three sets of lines, each with a different value:

1. **Use a ruler and any pencil to draw three 2-x-2-inch squares on a page of your sketchbook.**

2. **In the first square, press lightly with your 2H pencil to draw a set of parallel lines that are far apart from each other; then draw a second set of parallel lines that cross over the first set (see Figure 9-4a).**

 Notice that your two sets of hatching lines become a crosshatching set in this step.

Figure 9-4: Creating three different values using crosshatching. a b c

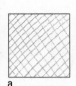

3. **In the second square, press harder with your 2B pencil to draw a set of parallel lines that are closer together than the lines you drew in Step 2; then draw a second set of parallel lines that cross over the first set (see Figure 9-4b).**

 Notice that the lines in this square are darker than the ones in the first square.

4. **In the third square, use your 6B pencil and press a little harder to draw two overlapping sets of parallel lines that are even closer together than the ones you drew in Step 3 (see Figure 9-4c).**

 Make sure that you don't press so hard on your pencil that you incise the paper.

When it comes to crosshatching, your sets of overlapping lines can cross over each other at any angle. In fact, it's perfectly fine to use lines that cross over each other at various angles within the same drawing.

The best angle to use when you're crosshatching is always the one that works best for you. Experiment with drawing different styles of crosshatching lines until you discover which angles you prefer. Figure 9-5 shows you ten examples of different ways you can use crosshatching, but we bet you can come up with ten more.

One of the best uses for crosshatching is creating the illusion of three-dimensional form. You can draw the crosshatching marks so that they form a mesh-like structure of shadows that rises and falls with the swells and valleys of a particular form's contours. The simple egg-like structure in the bottom row of Figure 9-5 shows you what we mean. When you need your lines to conform to the contours of a complex curving form, allow the form itself to dictate the angles at which your hatching lines cross over each other.

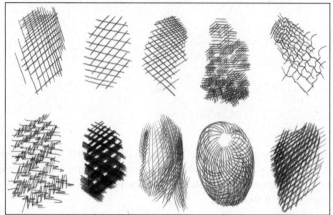

Figure 9-5:
Different styles of crosshatching lines.

Artists often use both hatching and crosshatching techniques in the same drawing to achieve just the right value. For a wonderful art-historical example, type *Rembrandt elephant drawings* into your favorite search engine. In the image results, notice how Rembrandt used a variety of hatching and crosshatching marks to render the beautiful and extremely realistic folds of baggy elephant flesh in his drawings.

Scaling from light to dark

The key to realistic drawing is achieving a full range of values (in other words, a complete scale of lights and darks). To create a full range of values in each of your drawings, you need to be able to control your drawing medium. Lucky for you, we're here to help you do just that. Hatching, crosshatching, and continuous tone are all great techniques for creating a wide range of values.

Note: In this section, you see an example of how you can use crosshatching to create a full scale of values from light to dark. After you follow along with the steps we describe here, you can practice using hatching and continuous tone techniques to do the same thing.

If you're having trouble visualizing what we mean by *full scale of values,* look closely at a black-and-white image (either a paused movie frame or a photograph). Find the darkest dark and the lightest light in the image. How many variations of light and dark do you see? Are you surprised by how many subtle grays really exist between white and black? All those subtle grays combined with the lightest lights and the darkest darks make up the full scale of values in the image.

To practice making a full range of values using the crosshatching technique, grab your sketchbook, a ruler, and your 2H, 2B, and 6B pencils; then follow these steps:

1. **Use your ruler and any pencil to draw two 2-x-5-inch rectangles horizontally on your paper; divide each rectangle into 5 equal boxes (see Figure 9-6).**

2. **With your 2H pencil, use a light, even pressure to make a patch of crosshatching marks in the first box.**

3. **Switch to your 2B pencil and, with the same light, even pressure, make the same kind of crosshatching marks you made in Step 2 in the second box, except make your marks a little closer together.**

4. **Use your 2B pencil and apply the same even pressure to make the same kind of crosshatching marks you made in Steps 2 and 3 in the third and fourth boxes; for each rectangle, make the marks a little closer together (refer to Figure 9-6).**

5. **Exert a little more pressure on your 2B pencil to draw crosshatching marks that are closer together and darker in the fifth and sixth rectangles.**

6. **Use your 6B pencil to make crosshatching marks in the seventh through tenth rectangles; for each rectangle, increase your pressure on the pencil and the density of the marks.**

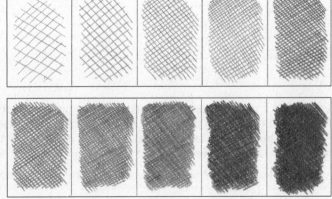

Figure 9-6: Cross-hatching ten shades of gray.

© 2003 Brenda Hoddinott

Rendering graduated values

In drawing, a *graduation* is a continuous progression of values; these progressing values are often called *graduated values*. You can use any of the additive techniques we describe in this chapter to create graduated values.

To get a better idea of what graduation is, imagine that all the values in Figure 9-6 are melded into one continuous stream, in which the values gradually change from one to the next without any break in the stream. The transition of values in a graduation can be from either dark to light or light to dark.

When it comes to graduations, your goal is to keep the transition between the values as seamless as possible. To do so, you need to make gradual changes in the way you work as you progress through a drawing.

Sound complicated? Well, don't panic. We show you how to render graduated values in this exercise. Gather up your 2H, 2B, and 6B pencils and your sketchbook and follow these simple steps:

1. **In your sketchbook, draw a long rectangle that's about 1½ inches wide and 6 inches long.**

2. **On the left side of your rectangle, press very lightly with your 2H pencil to draw the lightest lines in your graduation.**

 Make your marks in whatever direction feels comfortable to you. If you're left-handed, you may find it easier to work from right to left. Don't worry, though, you can still start with the lightest marks and work toward the darkest.

3. **Move your pencil to the right, gradually pressing harder on your pencil and making your hatching lines closer together (see Figure 9-7).**

Figure 9-7:
Beginning
a hatching
graduation.

© 2003 Brenda Hoddinott

4. **When you hit a plateau and your marks don't seem to be getting darker, switch to your 2B pencil and add the medium values by gradually pressing harder and making your hatching lines closer together as you move to the right (see Figure 9-8).**

 Remember to keep the pressure light and even at first, gradually increasing pressure as you move along.

5. **When your medium marks don't seem to be getting darker, switch to your 6B pencil and begin making marks that slightly overlap the last medium ones; gradually press harder until the end of your graduation is very dark (see Figure 9-9).**

 Make sure your pencil is sharpened for this step. Remember to use light pressure at first and then adjust your pressure until your marks are noticeably darker.

Figure 9-8:
Adding
the middle
values of
a hatching
graduation.

© 2003 Brenda Hoddinott

Figure 9-9:
Adding the
darkest
values of
a hatching
graduation.

© 2003 Brenda Hoddinott

If you notice that the transition between your values isn't as smooth as you'd like it to be, you can improve it. Try adding a few more short hatching lines in between some of your lines. Use your location in the graduation as a guide to help you decide which pencil to use. For example, if you need to add lines to smooth a transition near the beginning of the graduation, use your 2H pencil. (If you tried to use your 6B pencil, your transition would be even less smooth than it was before you tried to improve it!)

Resist the temptation to use your fingers to smudge your values together. Smudging with your fingers feels satisfying at first because it rubs out the texture, but anyone who's tried smudging knows that although the end result looks okay, it isn't as smooth as you'd like it to be. The problem is that you can't control the way the graphite spreads out when you smudge with your fingers. The graphite deposits unevenly beneath your fingers, and you end up with distracting splotches instead of a smooth transition of value.

Using Your Eraser to Build Value

When you think about drawing something, additive drawing methods like the ones we cover in the previous sections are probably the first to come to mind. But we're here to tell you about another interesting way to draw — via subtractive drawing. *Subtractive drawing* is literally drawing by removing media from paper. Basically, this process involves using an eraser on a piece

of paper toned with graphite or charcoal to "draw" the light values of your drawing. In this way, you build value by subtracting.

Before you can try out subtractive drawing, you need to tone your paper. *Toning your paper* means applying a layer of removable drawing media (powdered graphite or powdered charcoal works best) to your whole drawing space. To do so, use your powdered medium to completely cover your paper and then gently smooth the graphite or charcoal by rubbing it with a tissue or paper towel. Don't worry about making the tone look completely smooth. You're going to mess the surface up later in the subtractive process anyway. All you need to do is make sure the white of the paper isn't visible.

If you can't find powdered graphite or charcoal at your local art supply store or you just don't want to spend money on them, you can make your own. Simply rub pencils or charcoal sticks across sandpaper and let the dust fall on the paper you want to tone. If that sounds like too much trouble, you can also use soft graphite in sticks or pencils (6B or softer), soft vine charcoal, or compressed charcoal sticks. (See Chapter 2 for more details on different drawing media.)

When you're ready to try out subtractive drawing to pull light out of your toned paper, you need one or both of these erasers:

- ✔ **Vinyl eraser:** This eraser works well for removing large areas of light value. If the edge of your vinyl eraser gets too dirty to remove graphite or charcoal, simply rub the eraser on a clean piece of paper or cut a small slice off the end of it with a very sharp blade or knife.

- ✔ **Kneaded eraser:** This eraser is great for lifting small shapes out of graphite or charcoal. To do so, you can either pat or gently rub the surface of your paper. To draw fine detail, simply mold its tip to a point. To clean your kneaded eraser, just stretch and reshape it several times until it comes clean (this process is called *kneading*).

For this exercise, you need a soft graphite stick or pencil (6B), tissues or paper towels, your sketchbook, a kneaded eraser, and a vinyl eraser. When you have everything ready to go, follow these steps:

1. **Draw a 6-x-6-inch square in your sketchbook and press lightly with the graphite stick or pencil to fill in the square with scribble marks.**

2. **Use a tissue or paper towel to rub the graphite around until the white of the paper is no longer visible (see Figure 9-10a).**

 You don't have to make the graphite look perfectly even.

3. **Using your vinyl eraser, practice pulling graphite out of your drawing (see Figure 9-10b).**

For this step, hold the eraser like you would if you were going to erase a mistake; use it to stroke the paper.

Try using different edges and corners of the eraser to see the different types of marks you can make. Vary the pressure you put on the eraser. Begin drawing lightly with your eraser and then see what happens when you increase the pressure.

4. **Using your kneaded eraser, practice pulling graphite out of your drawing by daubing the eraser on the paper (see Figure 9-10c).**

Try making a variety of marks with your kneaded eraser. See what it looks like when you tap the eraser on the paper compared to what it looks like when you rub the paper with the eraser. Experiment with the amount of pressure you exert on the eraser.

Frequently, when you adjust the light values in a drawing, you'll notice dark values that you need to work on, too. To do so, just use one or more of the additive techniques we cover in the earlier section "Using Additive Drawing Techniques to Build Value." Subtractive drawing is unique because it compels you to think about the back-and-forth nature of making a drawing.

Figure 9-10: Using erasers to add light values to toned paper.

a b c

Jamie Combs

Applying Shading to Your Drawings

After you map out the basic shapes in your drawing, you're ready to apply the shading necessary to make your drawing three-dimensional (see Chapter 7 for details on how to map out shapes and lines in your drawing). You can use any of the techniques we describe in this chapter to apply shading to your drawn shapes. If you're looking to add graphite or charcoal marks, try out the continuous tone, hatching, and crosshatching techniques; if you want to remove a mark or two, work with your eraser.

The following sections show you how to put the additive and subtractive techniques to use to create a realistic drawing with a wide range of value.

Blocking in your basic values

So you want to achieve a full range of values in your drawing. The best way to do so is to begin simply by breaking the values of your subject down into what's generally light and what's generally dark.

Whether you're drawing from life or from your imagination, it's a good idea to simplify the values into basic light and basic dark. Exactly how you determine the different values in your drawing depends on the inspiration behind your drawing. So before you start shading, do the following:

✔ **If you're drawing from life, spend some time looking at your subject to analyze its values.** Look at a subject you want to draw and imagine that you have only two values — light and dark — to choose from. Take a mental walk around your subject and sort each part into either light or dark. If you have trouble distinguishing between light and dark, try squinting at your subject. Squinting helps minimize any reflections, which makes it easier to see the basic values of an object. (Check out Chapter 8 for more info on squinting while drawing.) After you determine what's light and what's dark, you're ready to start shading.

✔ **If you're drawing from your imagination, spend some time planning where your light and dark values need to go to re-create the vision in your mind.** Think about your imaginary light source. Ask questions like the following: What direction will the light move through the space? Which objects will be illuminated by the light source? Which objects will be in shadow? When you have answers to those questions, you're ready to start shading.

Because real life exists in an infinite range of values between white and black, you need to include a wide range of those values to make your drawing look realistic. Although the infinite possibilities out there may seem overwhelming, if you begin breaking apart your drawing by using one middle-gray value to block in all the dark values and leave the light areas alone (so they're the

white of the paper), you can quickly and efficiently get a sense of the whole drawing in terms of what's light and what's dark. At that point, you can begin to darken and lighten the gray and white spots as needed.

Refining your values

After you block in the simple layout of lights and darks in your drawing, notice that your drawing looks pretty flat. To liven it up, you need to add *volume,* which is the illusion of three-dimensionality. (I explain how light creates the illusion of the third dimension in Chapter 8.) You can do so by adjusting your values.

As you begin to refine your values, think about making simple, gradual changes and keep in mind the following guidelines:

- ✔ **Work from light to dark.** By drawing your light values first, you can then layer your medium shading on top of your light shading, creating a nice, smooth transition between different values.

- ✔ **When you work on the light areas, pay attention to where the strongest lights are.** Add varying degrees of shading to everything in the light area that isn't as light as the strongest light.

- ✔ **Work from the middle of the dark values and gradually get darker.** Hold back on the darkest darks until the end. You can then build the darkest values in layers on top of the medium values.

Don't press too hard with your pencils as you refine your values. Not only do these areas become impossible to touch up, but you also leave dents in your paper. When you try to draw over dents in the paper with a soft pencil, such as a 2B or 6B, the dents show up as light lines, spoiling the overall appearance of your drawing. If you feel yourself pressing too hard, switch to a darker pencil, perhaps a 4B or 6B.

If you're working from a real-life subject, look at it closely to see which areas you need to make darker and which ones you need to make lighter. Locate the darkest dark and the lightest light on the subject and compare those spots to your drawing. If you see an especially dark area in your drawing, check it against the darkest dark in your subject and ask yourself, "How close is this dark to the darkest dark?" If you aren't sure how much darker your drawing needs to be, error on the lighter side; you can always get darker. The more closely your values mirror the ones you see in your subject, the more believable your drawing will look when you're finished.

If you're working from your imagination, refining values is trickier. Turn to Chapter 8 for tips on how to build realistic volumes.

Project: Drawing an Egg

Believe it or not, eggs aren't quite as easy to draw as they look. It's tough giving them life on the page. In this project, we show you how to use shading to add volume to this familiar oval shape. We use continuous tone to add shading, but you can use any of the additive techniques we describe in the section "Using Additive Drawing Techniques to Build Value." In fact, you may want to try all three.

Before you get started, grab an egg and set it in front of you so that you can see it easily. Shine a strong light on it. You can use light from a sunny window, a desk lamp, a clamp light, or another source you have handy. (See Chapter 12 for more ideas on how to add lighting to your still-life subjects.) Grab your sketchbook, erasers, and 2H, 2B, and 6B pencils; then follow these steps:

1. **Use a 2H pencil to draw a simple, light line that outlines the shape of the egg (see Figure 9-11).**

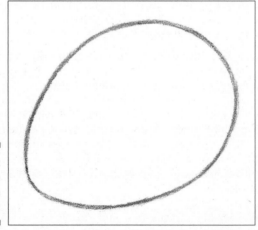

Figure 9-11: Drawing the basic shape of an egg.

Jamie Combs

2. **Look at the subject and mentally sort the values into darks and lights.**

 Don't forget about the values on the surface beneath the egg.

3. **Use a 2H pencil to block in the dark values (see Figure 9-12).**

 Figure 9-12 shows what the dark values look like using continuous tone, but you can also use hatching or crosshatching. If you use continuous tone, remember to find your natural mark and to use a light, even pressure to build value on the dark part of your egg and the shadows underneath (see the earlier section "Creating continuous tone" for more details).

Check out the earlier section "Blocking in your basic values" for info on how to block in values in your drawing.

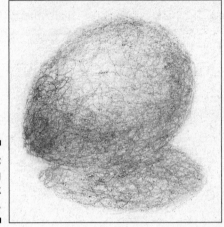

Figure 9-12:
Blocking in the dark values.

Jamie Combs

4. **Use a kneaded eraser to lighten the line around the contour of the egg.**

 The line should be barely visible.

5. **Press lightly with a 2H pencil to build value into the light parts of your egg and the surface on which the egg sits.**

6. **Switch to a 2B pencil and build another even layer of shading over the dark values of the drawing (see Figure 9-13).**

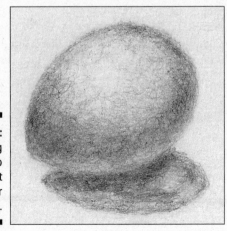

Figure 9-13:
Building value into the light parts of your egg.

Jamie Combs

7. **Analyze the values of your subject and refine the values in your drawing by using your 2H pencil to adjust light values and your 2B pencil to adjust dark values.**

 For example, look at the shadows in Figure 9-13. All the shadowy areas are dark, but some parts of the shadows are darker than others. Using a 6B pencil, refine the values of those shadows by building an even layer of shading on the areas of darker value within the dark areas (see Figure 9-14).

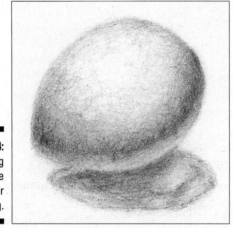

Figure 9-14:
Building more value in your drawing.

Jamie Combs

8. **If the lightest part of your subject has become covered with graphite, use your kneaded eraser to daub away the graphite (refer to Figure 9-14).**

9. **Use your 6B pencil to add the darkest dark to your drawing (see Figure 9-15).**

 A good place to look for the darkest dark is in the *contact shadow*, which is the line between an object and any surface on which it sits or with which it comes into contact. In Figure 9-15, the contact shadow is beneath the egg.

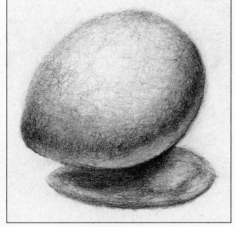

Figure 9-15:
The finished
egg with the
darkest
values
appearing in
the contact
shadow.

Jamie Combs

Chapter 10

Identifying and Rendering Textures

*T*extures provide vital information about your drawing subjects, such as whether their surfaces are smooth, shiny, rough, or fuzzy. You need to draw textures as realistically as you can to create the illusion that an animal is furry, a human face is smooth, or an eye is glistening. You can even get creative and have fun with textures by drawing something unexpected like a fluffy snake.

This chapter shows you several examples of textures you may want to incorporate into your drawings and walks you through the process of planning and then drawing them. It finishes up with a couple of texture-inspired projects to help you practice your new skills.

Seeing — and Feeling — the Difference between Textures and Patterns

People often use the words *texture* and *pattern* interchangeably when describing the surface of an object, but in drawing, these terms have two distinct meanings:

✔ **Texture:** The surface detail that tells your eyes what an object would feel like if you touched it (fuzzy, smooth, bumpy, or hairy, for example)

✔ **Pattern:** An interlocking repetition of shapes and/or values (striped, reticulated like a giraffe's skin, checkerboard, plaid, or polka-dot, for example)

Keep in mind that an object can — and often does — have both pattern and texture. For example, a smooth, glazed porcelain cup can have a pattern of stripes of different colors, but its texture is still shiny, not striped. A wool sweater can also have a striped pattern, but its texture is bumpy. Figure 10-1 shows two different examples of striped textures: Figure 10-1a has a furry texture, while Figure 10-1b has a smooth texture.

Figure 10-1:
Examining an identical pattern of stripes on two different textures.

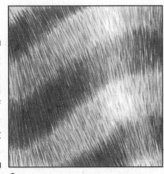 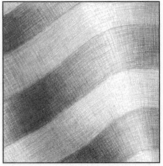

a b © 2003 Brenda Hoddinott

When you're dealing with patterned textures in your drawings, consider both the pattern and the texture before you decide how to do the shading. For example, if you're drawing a zebra, consider that the pattern of its fur is striped while the texture is furry (refer to Figure 10-1a). To create the striped pattern, you need to draw the dark stripes with dark values and the light stripes with light values. To create the illusion of a furry texture, you need to shade those stripes using the hatching technique covered in Chapter 9. (Basically, the *hatching* technique involves drawing a series of curved or straight lines very close to each other to build value and/or texture.)

If you're drawing a striped, silky fabric like the one shown in Figure 10-1b, consider that the pattern is striped but the texture is smooth. To create the striped pattern, you need to use the same dark and light value graduations you use to draw the zebra fur in Figure 10-1a, but, instead of using the hatching technique to create a furry texture, you can use the crosshatching technique to define the finely woven texture of the fabric. (*Crosshatching* is the same thing as hatching except that you make two sets of lines, one that crosses over the other. See Chapter 9 for more details on crosshatching and other shading techniques.)

Identifying Textures

Nature presents many diverse textures, from the smooth, placid surface of a serene pond to the jagged edges of a rocky cliff. As an artist, you have to be

able to re-create those textures if you want to draw something realistically. For example, by re-creating the texture of fur in your drawings, you identify the light source and define the form of an animal. You use different textures to define hair and fur as curly, straight, or frizzy. The shiny texture you create for your animals' eyes provides a strong contrast to their fluffy fur. You define the appearances of your human subjects by drawing their skin rugged like an old piece of leather or smooth like porcelain.

Human-made objects bring even more exciting challenges to the texture-drawing table. Think about the smooth texture of glass or the uneven textures of clothing like knit sweaters. The world is chock-full of different textures for you to draw, but the majority of these textures fall into one of the following categories:

- **Smooth:** When you run your hand over a *smooth* surface, you feel no unevenness or roughness; in fact, you don't feel many surface features at all. Smooth textures can have surfaces that are dull and matte (like a smooth stone), wet and glistening (like the smooth petals of a rose after rain), or shiny and soft (like a smooth silk shirt).

- **Rough:** The surface features on a *rough* surface are visible, and when you touch them, their textures feel uneven, irregular, or jagged. Think about the rough textures of a piece of tree bark, a piece of coarse sandpaper, or the surface of a cheese grater.

- **Matte:** *Matte* surfaces are dull and *lusterless* (not shiny) and often have additional textural characteristics, such as smooth or rough. Many fabrics, smooth rocks and stones, and unfinished wood have matte textures.

- **Shiny:** *Shiny* surfaces appear glossy or highly polished; they're defined by highlights reflecting off the surfaces themselves (see Chapter 8 for more on highlights). Think about the surface of polished stone, brass, porcelain, or new pennies.

- **Glistening:** Very pronounced highlights identify *glistening* surfaces, which appear sparkling and sometimes wet. Think about the shimmer of the sun's light on calm water, the surface of your eye when you're close to tears, or a freshly shined, new car glistening in the sunlight.

- **Furry, fuzzy, fluffy, and hairy:** *Hairy* or *furry* surfaces like human hair and animal fur can be soft or coarse, long or short, thick or thin, and curly or straight. The surface of a peach and the hair on a newborn infant's head both feel soft and *fuzzy.* The outside shell of a coconut or the beard stubble on a man's face feels coarse and fuzzy. A sweatshirt, carpeting, and a blanket can be fuzzy or *fluffy.*

- **Grassy:** Grassy textures are similar to hairy or furry ones. They can be long or short, wavy or straight, dense or sparse, fine or coarse. Grassy textures may appear to be soft or scratchy. The straw that lines a horse's stall, your backyard, and a field of flowers all have grassy textures.

Don't feel overwhelmed by identifying and drawing textures. Consider each of your drawing subjects to be an opportunity to solve a fun problem. The truth is if you can see and draw shapes of value, you can also draw texture (see Chapter 9 for more on drawing value). Expect to experiment with several different techniques before you get your textures to look exactly right. With a little time and patience, you'll discover your favorite shading techniques to use for rendering any realistic texture you see or imagine.

The following sections provide more details as well as illustrations about each of the textures we describe here. In your sketchbook, try to use shading to copy the textures in some or all of the illustrations you see. Grab a few sharp pencils (2H, 2B, and 6B are good choices) and good erasers and get ready to start adding texture to your drawings. (See Chapter 9 for detailed information about shading.)

If you're worried about getting the drawings just right, feel free to use tracing paper to trace the major lines in the illustrations shown here. Don't worry — tracing the lines isn't cheating if your goal is to practice rendering textures.

Smooth, matte, shiny, and glistening textures

Explore the contrasting textures of the garments in the two drawings in Figure 10-2. The soft, matte texture of the delicate fabric in Figure 10-2a is shaded with smooth, even marks and gradual transitions in value. The contrast in value is low with mostly light and medium values. Quite a bit of the white paper is preserved here to show light. But because of the low contrast, even though the drawing has very light values, you get the sense here of a gentle, diffuse light. Notice the seam of the sleeve: Every gentle pucker you see is there because the shapes and values of the shadows are accurate.

In contrast, the shiny leather texture of the jacket in Figure 10-2b is rendered with extremes in values and pronounced highlights.

Figure 10-2:
Comparing soft, matte fabric with shiny leather.

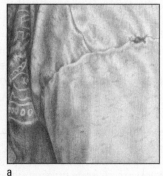
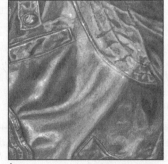

a

b

© 2003 Brenda Hoddinott

For another example, compare the textures of the two sections of spheres (yes, an eyeball is a sphere) in Figure 10-3. The surface of the sphere in Figure 10-3a seems dry because its texture is smooth and matte, while the cat's eye in Figure 10-3b appears to be wet because of its smooth and glistening texture. Notice that in Figure 10-3a the transition between values is more gradual and the contrast between the lightest and darkest values is lower. In Figure 10-3b, the transition between values happens a little more quickly and the contrast between the lightest and darkest values is higher. The line separating the eyeball and eyelid goes all the way to black. The strong contrast between this black shadow and the distinct highlights on the eye suggests a sparkly, wet surface.

Figure 10-3:
Comparing the smooth, matte surface of a sphere to the smooth, glistening surface of a cat's eye.

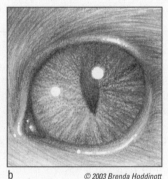

a b © 2003 Brenda Hoddinott

Fuzzy and fluffy textures

You can walk into any department store and see the infinite range of fabrics people use for dressing their homes and themselves. Fabrics are lots of fun to draw because of their diverse textures and patterns.

In Figure 10-4a, you can see the soft, fluffy texture of the fibers that make up each individual strand of yarn. Curved hatching lines create the illusion that each strand is circular. Take note of the lines and shapes of the darkest values. If you place the darkest lines and shapes in the right places, they function as shadows that separate the strands of yarn. Without these shadows, the yarn would be a formless mess. Figure 10-4b shows how the soft, fluffy yarn changes to a fuzzy, bumpy texture when it's knit into a sweater. Notice how the shapes of dark value between and outside of each little knot create the braids in the sweater. Look at the sweater's striped pattern of light and dark values, and notice how the darkest values in the drawing are reserved not for the pattern but for the shadows that make up the sweater's texture. Although you don't have to know how to knit to render this fuzzy texture, you do need a sharp pencil and lots of patience.

Figure 10-4:
Examining
the fluffy
and fuzzy
textures of
strands of
yarn and a
sweater.

 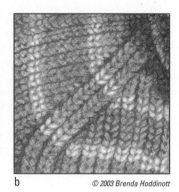

a b © 2003 Brenda Hoddinott

Furry and hairy textures

Here's a helpful tip to keep in mind as you practice drawing textures:
Sometimes when you can't figure out how to draw what's in front of you, you
have to draw what isn't there; in other words, you have to draw the spaces in
between what's in front of you.

This tip comes in handy when you're trying to draw the diverse textures of
animal fur and human hair. Most of the time shadows make up the spaces
between individual sections of hair and fur, so as long as you draw these
shadowy spaces correctly with the right shapes and values, the hair or fur
will emerge from them. If the fur or hair isn't directly catching light or if
it's just dark colored, you can use whatever shading technique you like to
render the mass of hair or fur, but then you have to draw the shadows in
between the individual sections of hair or fur to make sense of the mass.
(See Chapter 9 for everything you need to know about shading.)

To see what we mean, compare the furs of the long-haired dog shown in Figure
10-5a to the short-haired cat shown in Figure 10-5b. Notice that, in both draw-
ings, the soft and downy part you think of as the fur appears to have light shin-
ing on it. In drawings like these, the only parts you can draw are the shadows!
Even though you're drawing only shadows, you still have to think hard about
the way you move your pencil because you have to establish whether the
shadows are wavy or straight, short or long. You also have to make sure the
relative amount of darkness among the shadows is in the correct proportion.

Take a closer look at Figure 10-5a. You can tell the dog's ear overlaps part of
its head because of what happens to the dark values under the ear. Where
the ear overlaps the head, you see a *cast shadow* (the shadow one object
makes on another because it blocks the light). The value of the cast shadow
is distinctly darker than any other value. Some of the light values of the fur
end in the cast shadow, while others overlap the cast shadow, breaking it
into smaller shapes. (See Chapter 8 for more details about cast shadows.)

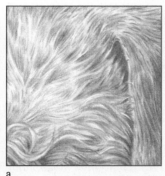
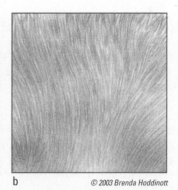

Figure 10-5:
Comparing the fur texture of a long-haired dog to that of a short-haired cat.

a b © 2003 Brenda Hoddinott

Being able to draw the texture of human hair is important for any artist because hair plays such an important role in creating realistic portraits. The texture of hair outlines the face, defines the shape of the skull, and creates a strong contrast to the texture of the skin and eyes.

So how do you render the right texture for different hair types? Compare the two drawings of hair in Figure 10-6 to see the difference between the textures of light versus dark hair. Notice that the overall value contrast is lower in Figure 10-6a than in Figure 10-6b, which is why you can tell the first drawing is of lighter hair than the second one. Regardless of the level of contrast, however, the darkest values in both drawings happen in the shadows between sections of hair, not in the hair itself.

The key to drawing realistic hair is to think of it as a mass. Instead of trying to draw individual strands, use your pencil to draw a shape of value that describes the changing directions of the undulating mass of hair. (Turn to Chapter 14 for more on drawing fur and Chapter 15 for more on drawing hair.)

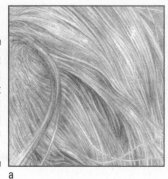

Figure 10-6:
Comparing the different values used for drawing the textures of hair.

a b © 2003 Brenda Hoddinott

Rough and grassy textures

From the rough bark on tree trunks to diverse rugged ground surfaces and rocks, rendering accurate textures is integral to creating realistic landscape drawings.

Figure 10-7 is a perfect example of how using different shading techniques can help you create different textures. In Figure 10-7a, notice how hatching lines of different widths, lengths, and values give the trunk of the tree a rough texture. Compare that rough texture to the soft grassy textures of the ground foliage in Figure 10-7b. Notice how the combination of *textural mark making* (the act of making marks like the hatching marks that describe the grasses in the figure expressly to describe texture) creates diverse textures in the grass and ground foliage. In both drawings, the shadows between the clumps of grass and other foliage keep them from being formless masses of lines.

Figure 10-7:
Examining
the shading
of some
rough
and grassy
textures.

a b © 2003 Brenda Hoddinott

Translating Textures into Drawings

When you're first starting out, the key to translating textures into drawings is keeping it simple. Try to use simple shading techniques to capture the essence of the texture without getting too caught up in the intricate details.

Before you can start shading, however, you have to identify which textures you need to draw so that you can plan how to create them. To do so, take a look at your drawing subject and think about the different textures covered in the earlier section "Identifying Textures." Use your vision, sense of touch, and general knowledge of the subject to help you identify the properties of your subject's textures. Then read on to find out how to render those textures in your drawing.

If you're someone who easily gets bogged down by the details, try squinting slightly at your subject as you plan your textured drawing. Doing so helps you block out some of the details and lets you focus on the overall texture.

Planning your textured drawing

After you identify your subject's texture, look closely at your subject and use your judgment to decide which shading techniques will work best to render that texture. For example, to create the illusion that an object is smooth, you may decide to draw hatching lines close together (see Chapter 9 for more details).

Use the following tips to help you prepare to add texture to your drawing:

- **Look for lines in your subject's texture.** If the subject has a hairy or furry texture, look for the lines that make up the hair or fur; the length of these lines and whether they're straight, wavy, or curly dictates the type of marks you need to make to render the hairy or furry texture. If the subject is a woven fabric, look for the gridlike lines that make up the weave of the fabric, and use them to help you render the fabric's texture.

 For example, the fur in the two drawings in Figure 10-5, earlier in this chapter, is well suited to curving hatching lines. But you can also capture the furry textures using a combination of additive and subtractive techniques. (See Chapter 9 for more info on shading.)

- **Examine the highlights and shadows for clues about how drawing the subject's values can help define its texture.** For an example, take a look at both drawings in Figure 10-2, earlier in this chapter. Notice how changes in value suggest the folds of each type of fabric. The value changes are soft and subtle in the soft, matte fabric in Figure 10-2a, while the value changes that describe the shiny leather in Figure 10-2b are more dramatic. (See Chapter 9 for more on drawing values.)

 Unless you're drawing with light media on a dark background, the most important part of drawing textures is getting the shadows right (the right place, the right shape, and the right amount of darkness).

- **Look for the shapes created by the light and dark values in your subject.** The rough texture of the tree trunk in Figure 10-7a is a perfect example of using light and dark shapes to define texture. (Turn to Chapter 8 for details on how to identify the shapes of light and shadows.)

Keep in mind that these tips are merely suggestions. Choosing techniques for specific textures is a matter of personal preference, so plan to add texture to your drawings using the techniques you're most comfortable with.

Creating texture on paper

To get a "feel" for shading textures, find a simple object, such as a leaf or a rock, with an interesting texture. (***Note:*** To get the most benefit from your practice, draw from an actual object rather than a photograph or another drawing.) Examine the object closely and try to visually translate what you see using an appropriate shading technique. (Refer to the preceding section for guidance.) After you decide how you want to render your subject's texture, begin your drawing by following these steps:

1. **Draw the basic shape of the object.**

2. **Block in the basic light and dark values.**

 See Chapter 9 for details on how to block in your values.

3. **Shade the light areas of the object with light values by using the shading technique you feel best illustrates its texture.**

 Keep in mind that the texture appears smaller on the more distant surfaces of the object because of perspective. (See Chapter 11 for everything you need to know about perspective.)

4. **Draw darker textural shading in the shadow areas.**

 Take note of how light and shadow define the form of your object.

Combining three-dimensional form with patterns and textures

Thinking about texture and pattern can be overwhelming to the beginner, especially if you feel like you're still struggling to get your objects to look three-dimensional and your values to look realistic. But you don't have to wait until you master these skills before you try to draw texture and pattern.

Use your sketchbook to play with samples of texture and pattern. Who says you have to make a whole drawing every time? Grab an object with a fun pattern and texture and devote a 2-inch square (or more) in your sketchbook to drawing just that object's texture. Then, in another 2-inch square, practice

drawing the object's pattern. After a little practice, you'll be ready to put everything together — three-dimensional form, value, pattern, and texture, that is — and it'll be much easier to do if you've been practicing all along.

If you're confused about how to draw a particular patterned texture, break it down into its pieces and focus on only one or two of them. For example, think about a beautiful, shiny, multicolored snake. You can still draw its body realistically if you choose to render only its texture or its pattern, but if you choose to draw both its texture and its pattern, don't try to include too many textural details. After your drawing skills improve, you can choose a more complex approach, such as shading the patterns and rendering the shiny texture of the scales, in addition to drawing the snake's three-dimensional form.

To get a little practice with combining forms, patterns, and textures in your drawings, try this quick exercise. Find an object with a simple pattern (a striped or checkered dishcloth makes for a good subject here) and place it in front of you. Use any pencils you want and follow these steps:

1. **Draw the shape of the object.**

2. **Map out the outlines of the object's pattern.**

3. **Shade the object and its pattern with the shading technique you feel best defines its texture.**

 As you add shading, pay close attention to the different values that define the pattern. Observe how some areas are darker than others. Take note of how the pattern changes shape and direction with the three-dimensional form of the object.

Project: Creating Two Fun Textures

This project has two parts. The first part challenges you to discover and draw a useful and versatile texture using an intuitive approach to mark making. The second part takes you step by step through drawing the patterned texture of spotted fur.

Sketching with textural mark making

Textural mark making is a fairly simple shading technique. You make any kind of mark you can think of and use increasing density to adjust the value.

The example in this section uses a bunch of squiggly, curved lines that cross over in many different directions to create value and texture (a process often called *scribbling*). The more lines you draw, the darker the value becomes.

As with any shading technique, you can illustrate changes in form, light, and shadows in a drawing simply by incorporating value graduations into your textural mark making (see Chapter 9 for a refresher on drawing graduations).

To practice textural mark making, grab your sketchbook and follow these steps to create the texture you see in Figure 10-8. The artist of that drawing used a 2B pencil for the first two steps and then switched to a 6B pencil for the third step, but you can use whichever pencils you prefer. See Figure 10-8 for a look at the final product.

1. **Draw light curving marks like the ones on the left side of Figure 10-8 across your entire drawing space.**

2. **Beginning about one-third of the way from the left, add another layer of curving marks all the way to the far right; increase the density of your marks as you move across your drawing space.**

3. **Beginning about two-thirds from the left, draw another layer of curving marks all the way to the far right; increase the density of your marks as you go until the end of your drawing space is really dark.**

Figure 10-8:
Practice
textural
mark
making.

© 2003 Brenda Hoddinott

Drawing furry spots

To draw spotted fur, you need to create pattern and texture simultaneously. Fortunately, you can do so somewhat easily as long as you choose an appropriate shading technique for the type of fur you're drawing and focus on getting the shape and quality of the values right. For this project, you create a close-up drawing of some spotted fur to practice rendering both pattern and texture.

When you're ready to get started, grab your sketchbook, your kneaded eraser, and some pencils (HB, 2H, 2B, 4B, and 6B) and follow these steps:

1. **Use your HB pencil to draw a 2-x-3-inch rectangle.**

2. **Use your HB pencil to very lightly map out some spots in your drawing space (see Figure 10-9).**

 Make the spots all different shapes and sizes. (Don't worry about drawing your spots exactly like the ones in the figure.) Try making a couple of partial spots that seem to disappear off the edges of your drawing space.

Figure 10-9: Drawing the simple shapes that make up the fur's pattern.

© 2003 Brenda Hoddinott

3. **Use your kneaded eraser to lighten your mapping lines until you can barely see them.**

4. **With your 2H pencil, draw a bunch of hatching lines of different lengths in all the areas without spots (see Figure 10-10).**

 Turn to Chapter 9 for everything you need to know about drawing hatching lines and other shading techniques.

 Although this drawing is based on your imagination, we recommend that you define a light source. Pretend the light is coming from the left. Make your lines light on the left and then graduate darker as you move to the right (refer to Figure 10-10 to see what we mean). See Chapter 8 for more details on light sources.

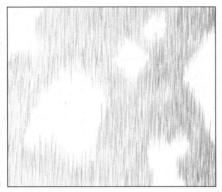

Figure 10-10: Drawing hatching lines to represent the first layer of texture and value.

5. **Use your 2B pencil to draw a bunch of hatching lines of different lengths in all the spots (see Figure 10-11).**

Gradually increase the density of the marks to darken the value of the spots. Switch to your 4B pencil if you need to draw darker values than the 2B will allow and then to your 6B for the very darkest values.

Notice that the marks that make the texture of the spots in Figure 10-11 interweave with the marks that make the texture of the spaces between the spots. Textures like this one look most realistic if you allow the lines from the separate parts of the pattern (the spots and the fur between the spots) to mingle with each other.

If your imaginary light source is coming from the left, gradually make your dark shading darker as you move to the right (refer to Figure 10-11).

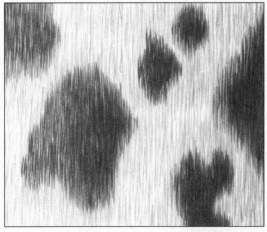

Figure 10-11: Using hatching lines to draw the different spot lengths and values.

Chapter 11

Investigating Perspective Drawing

In This Chapter
▶ Identifying perspectives with vanishing points and horizon lines
▶ Using vanishing points and horizon lines to create spatial depth
▶ Exploring the effects of atmospheric perspective and foreshortening
▶ Getting some practice with three types of perspective drawing

*T*he idea that you can create the illusion of three-dimensional space on flat paper seems almost magical. For instance, some cityscape drawings have illusions so dynamic you may feel as though you're standing in the street, craning your neck to see the tops of buildings. Likewise, some still-life drawings are so believable that you want to reach out and touch the objects.

With proper use of perspective, you can make your representational drawings more realistic by allowing the elements in the drawing to behave the way they would in real life. In this chapter, we show you how to use the tools of perspective to create the illusion of three-dimensional space in your drawings. We explain some basic guidelines for rendering different types of perspective and show you how to apply them to your drawings.

Understanding Geometric Perspective

Put simply, *geometric perspective* means point of view. When you employ the tools of geometric perspective (sometimes called *linear perspective*), you can create a drawing that tells the viewer what it would look like to view a specific scene from a particular point of view — from far below or far above or from far away or close up. One of the main uses for geometric perspective is to make your subjects appear to recede in space in a natural way. Using geometric perspective makes your drawings appear three-dimensional (rather than flat) and more realistic.

Before you start using geometric perspective in your own drawings, take a minute to familiarize yourself with the following perspective-related elements (see Figure 11-1 for examples):

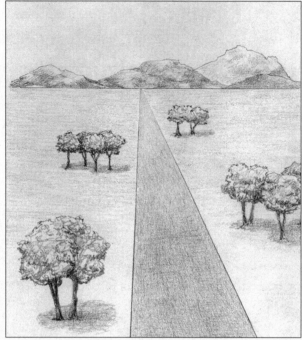

Figure 11-1:
Looking
at a few
perspective-
related
elements.

Barbara Frake

✓ **Horizon line:** Sometimes referred to as your *eye-level line,* the *horizon line* is an imaginary horizontal line that divides earth from sky. The horizon line is exactly at the level of your eyes as you look straight ahead.

Objects below this line are below your eye level, and objects above this line are above your eye level.

✓ **Convergence:** The appearance that two or more receding parallel lines will eventually meet is what we mean by *convergence.* Imagine standing on a set of railroad tracks. You know they're parallel, and, yet, the ties appear to get closer and closer together as they recede in space.

✓ **Perspective lines:** *Perspective lines* are straight lines that appear to converge at a point on the horizon line. They help establish guidelines for drawing objects in proper perspective.

✓ **Vanishing point:** The *vanishing point* is the point on the horizon line where perspective lines converge.

Objects become smaller and smaller the closer they get to the vanishing point, and, when they reach that point, they seem to completely disappear (or *vanish*). Some objects have more than one vanishing point. (We tell you about one-, two-, and three-point perspective later in this chapter.)

Lines of objects that are parallel or perpendicular (at a right angle) to the horizon line don't appear to go back in space and, therefore, don't converge at the vanishing point. For example, the top, bottom, and side edges of a building from a frontal view don't seem to retreat into space; they maintain their forefront position in the drawing.

The following sections take a closer look at the elements of geometric perspective and show you how to use them to make your drawings look more realistic.

Looking to the horizon line

In every perspective drawing you create, you determine the viewer's eye level by choosing the position of the horizon line. You control whether you want viewers to feel like they're looking at the objects in your drawing from above, below, or straight on. For this reason, always begin a perspective drawing by lightly drawing the horizon line; make sure it's parallel to the top and bottom of your drawing space (if it's square or rectangular). Then you can place your subjects around that line based on the perspective you want to create.

If you want viewers of your drawings to feel like they are

- **Looking downward:** Draw the subjects below the horizon line.
- **Looking upward:** Draw your subjects above the horizon line.
- **Looking straight on:** Draw your subjects so that they touch or cross over the horizon line.

Be careful whenever you try to drastically change the perspective of an object in a drawing by drawing the horizon line way above or below your viewer's eye level. Before you can change the perspective of the objects in your drawing, make sure you're familiar with the objects from all sides so that you can accurately represent the parts of the objects your viewers will see from your drastic perspective.

In Figure 11-2a, the horizon line (which represents your viewer's eye level) is close to the top of the drawing space and higher than all the cubes, meaning that your eye level is very high and you're looking down on most of the drawing. Even if you couldn't see the horizon line, though, you could still figure out your perspective by noticing that you can see the tops of all the cubes, meaning your eye level has to be above them.

In Figure 11-2b, the horizon line is close to the bottom of the drawing space and below all the cubes, meaning that your eye level is very low. Like with Figure 11-2b, though, you don't need a horizon line to tell you what your perspective is because you can see the bottoms of all the cubes, meaning that your eye level has to be below them.

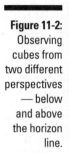

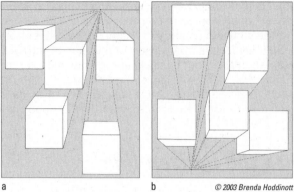

Figure 11-2:
Observing
cubes from
two different
perspectives
— below
and above
the horizon
line.

a b © 2003 Brenda Hoddinott

In Figure 11-3, the horizon line is just higher than the center of the drawing
space. (In case you're wondering, the horizon line is the top horizontal line.)
The objects that overlap the horizon line are directly at your eye level. Notice
that you can't see the tops or bottoms of those objects, but you can see their
receding sides. Visually follow these receding sides to the vanishing point on
the horizon line. Pay attention to the following:

✔ Perspective lines of objects at your eye level (objects that touch the hori-
 zon line) converge both downward and upward toward the horizon line.

✔ Perspective lines of objects above your eye level (objects that are above
 the horizon line) converge downward.

✔ Perspective lines of objects below your eye level (objects that are below
 the horizon line) converge upward.

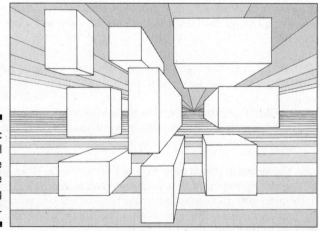

Figure 11-3:
An eye-level
perspective
with one
vanishing
point.

© 2003 Brenda Hoddinott

Adjusting your perceptions on perspective

Drawing in proper perspective means unlearning some of what your brain currently knows about what it sees and readjusting its perceptions to a new set of rules. For one, you have to let go of what you think things look like and trust your eyes. Did you notice that the tops and bottoms of the cubes in Figures 11-2 and 11-3 aren't true rectangles? (Take a look again if you didn't.)

Perspective distorts the appearance of edges that recede in space. You know the top of a cube must be a square, but if you draw it as a square, it won't look like it goes back in space.

Imagine that you're trying to draw the top of a rectangular table. Unless you're suspended above it and looking straight down, you don't actually see it as a true rectangle. Check out the section "Managing foreshortening" for more information on why this kind of distortion exists.

Does all this perspective stuff seem a little overwhelming? Well, don't worry. Perspective is a complex aspect of drawing. Don't expect to master all the components right away. Be patient with yourself. All you need is a little time and practice to improve your skills.

Finding vanishing points

When an object's perspective lines recede into a properly placed vanishing point, your drawings appear more three-dimensional, realistic, and visually correct. So how do you find just the right place for the vanishing point in your drawing?

Finding the vanishing point in a photograph or other image

Looking for vanishing points in photographs is a good way to practice the basic principles of perspective. After you get used to identifying vanishing points in pictures, you can apply the same principles to real life — and your drawings.

To practice finding vanishing points in photographs, first find a photograph or other image (like the drawing in Figure 11-4a) that shows at least one human-made object that's level in real life and that has horizontal lines that recede in space. (Railings, decks, wharfs, horizontal siding, steps, and roofs are all good choices.) Then follow these steps:

1. **Pick out an object in the image that you know is level and that has at least one set of parallel lines that go back in space.**

 In Figure 11-4a, look at the parallel lines that define the top and bottom of the railing and the level wooden planks in the deck.

2. **Tape a piece of tracing paper over the entire image.**

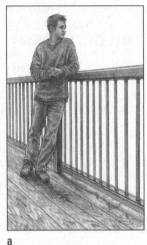 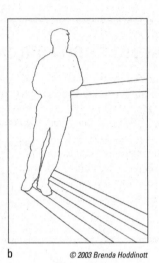

Figure 11-4: Tracing the outlines of the edges of a railing and the planks in a deck to find the vanishing point.

a b

3. **Use an HB pencil and a ruler to trace the upper and lower edges of the object you identified in Step 1, as well as any other lines that you know to be parallel to those edges (see Figure 11-4b).**

 In the figure, the artist traced the outlines of the upper and lower edges of the railing and some of the spaces between the wooden deck boards.

4. **Tape your traced drawing to a larger sheet of drawing paper so that you have enough room to extend the parallel lines of the object you drew in Step 3.**

 See if you can visually identify which lines are going to eventually converge.

5. **Use your ruler and a pencil to extend all the parallel lines until they meet.**

 Keep your lines light, in case you want to erase them later. Note the point where most of the lines converge. This is your vanishing point, which is located on the horizon line.

 When an object has only one vanishing point, its perspective is called *one-point perspective.*

6. **Draw a straight line through the vanishing point that is horizontal and parallel to the top and bottom of your drawing paper.**

 This line is the horizon line. Figure 11-5 shows the location of the vanishing point (marked *VP*) and the horizon line (marked *AB*).

Sometimes you can see more than one side of an object in an image. For example, imagine a photo that shows the corner of a building. If the angle (or corner end) of the building is closer to you than one of its sides, you need to use the same method we use in the preceding steps to locate the second vanishing point (this type of perspective is called *two-point perspective*). Horizontal lines

on other visible sides of the building also converge at vanishing points some-where on the same horizon line. (For more details on two-point perspective, check out the later section "Project: Drawing Two-Point Perspective.")

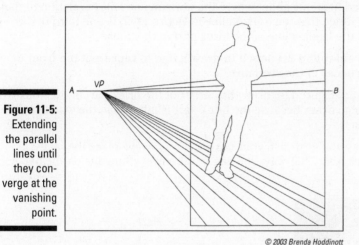

Figure 11-5:
Extending
the parallel
lines until
they con-
verge at the
vanishing
point.

© 2003 Brenda Hoddinott

Finding a horizon line and vanishing point in real life

To identify the horizon line in a real-life scene, look straight ahead; the hori-zon line is in line with the farthest point you can see. (Remember that your eye level and the horizon line are one and the same.) Note that you don't have to be out of doors to find a horizon line. If the farthest point you can see when you look straight ahead is a spot on the wall, that's your horizon line.

After you identify the horizon line in a real-life scene, you need to look for a vanishing point. To do so, focus on one of the objects in the scene — a build-ing perhaps — with sides that recede in space. Then grab your sketchbook, ruler, and some pencils and follow these steps:

1. **Determine where your real-life object is in relation to the horizon line.**

 Many times when you draw from life, the horizon line is obscured if not completely invisible, but don't worry. Remember that the horizon line is also your eye-level line, so to find your eye-level line, all you have to do is look straight ahead at the scene you want to draw. Whatever point lines up with your eyes is on your horizon, or eye level, line.

 If your subject crosses the horizon line, make note of how much of the structure is above the horizon and how much is below it. Figure 11-6a shows an example of a real-life scene with an object with receding sides that lead toward an unseen horizon line. In this figure, the eye-level line falls about one-third of the way up the height of the house.

2. **On a fresh page in your sketchbook, use a ruler and 2H pencil to draw a horizon line on your paper (see Figure 11-6b).**

 To determine where to place the horizon line on your paper, first decide how tall you want your subject to be on the paper. Then use what you discovered in Step 1 about where the horizon line falls in relation to the subject. Notice that the horizon line in Figure 11-6b is one-third of the height of the leading line of the brick part of the house.

3. **Use your ruler and 2H pencil to draw a line to represent the front or leading corner of the structure.**

 The artist of Figure 11-6 drew the corner of the brick part of the house as the leading corner because the brick part is taller than the wooden part in front of it.

 As soon as you've drawn your horizon line, always place the tallest structures first. That way, you can be sure everything fits on the paper.

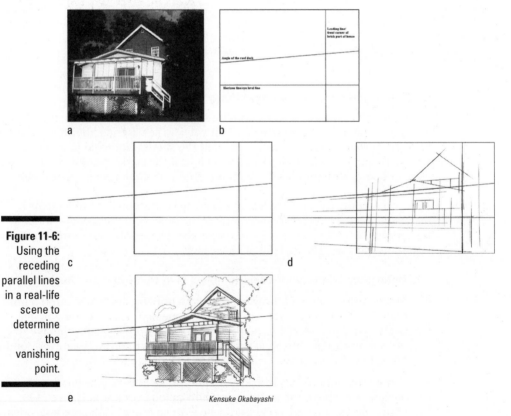

Figure 11-6: Using the receding parallel lines in a real-life scene to determine the vanishing point.

a

b

c

d

e

Kensuke Okabayashi

4. **Visually estimate the angles of the perspective lines that define the receding sides of your object.**

 To do so, hold something long, thin, and straight (like a knitting needle, paintbrush, or extra pencil) in your nondominant hand and line it up with the top or bottom edge of any receding side of the object. Don't point the tool away from your face; instead hold it straight up and down and twist your wrist until the stick lines up with the angle you're measuring. It's very important to keep the tool parallel to your eyes when completing this step.

5. **While you hold your straight tool up to the real-life object, use a pencil to draw the angle of the line you're estimating in your sketchbook (refer to Figure 11-6b).**

 Here, the artist estimates the angle of the roof of the deck (a line that the artist knows must be horizontal but that looks diagonal from her point of view, or perspective).

6. **Use a ruler to extend the perspective line toward the horizon line.**

 Figure 11-6c demonstrates how the perspective line from the roof of the deck will eventually converge with the horizon line. As you can see, you may need to extend your horizon line far beyond the limits of the paper to get the right angles for perspective lines like this one.

 The place where the perspective line converges with the horizon line is the vanishing point.

7. **Draw vertical lines to indicate the placement of vertical elements in your drawing subject.**

 In Figure 11-6d, the artist has drawn vertical lines to establish the placement of vertical elements of the house, such as windows, doors, and corners.

8. **Use the lines you've drawn as guidelines to figure out where and how to draw the details of your drawing subject.**

 In Figure 11-6e, the artist has used the angles of the horizon line and first perspective line to figure out the angles of the horizontal features like siding, brick, and trim. The first vertical was helpful for figuring out the angle of the vertical elements in the drawing such as the railing posts.

If your real-life scene doesn't include a building or similar object, you can use two parallel lines of the edges of straight roads, railway tracks, and fences to find the vanishing point.

Identifying Your Perspective on Depth

When it comes to creating a realistic illusion of depth in your drawings, you have several different perspective devices to choose from. In addition to geometric perspective, consider using the following three devices to add a little more depth to your work (see Figure 11-7 for examples of all three):

- **Scale:** The farther away an object is from you, the smaller it looks. The closer an object is to you, the larger it looks.

- **Overlap:** Some objects overlap other objects that are behind them, providing an obvious clue that some objects are in front of others.

- **Vertical location:** You can tell how far away an object is by looking at its vertical location in relation to the horizon line. The closer an object is to the horizon line, the farther away it is from you. The farther away from the horizon line an object is, the closer it is to you.

Figure 11-7:
Many perspective devices combine to make up the illusion of depth.

© 2003 Brenda Hoddinott

Like any other object, people appear to become smaller and smaller the closer they get to the horizon line; Figure 11-8 shows you an example. Notice that as people move back in space and become smaller, their feet seem to be planted higher vertically on the paper. They also seem to disappear entirely at the vanishing point.

Take another look at Figure 11-7. Imagine a figure moving along the sidewalk toward the horizon line. Do you see the way the sidewalk itself moves in a steady diagonal line ever higher until it meets the vanishing point? As you look at the figure, notice how the following clues all help create the realistic illusion of perspective and depth:

✔ All objects seem to disappear from view at the same point (the vanishing point).

✔ The trees, houses, and boats seem to be smaller the farther away they are.

✔ The widths of the sidewalk, road, fence, and beach appear narrower the farther away they are.

✔ Big trees overlap some houses, creating the illusion that they're closer to you than the houses behind them.

✔ The tops of little trees overlap driveways, creating the illusion that they're in front of the driveways.

✔ The larger objects and wider spaces are close to the bottom of the drawing space and appear to be closer to the viewer.

✔ The position of the horizon line (where the earth seems to meet the sky) is close to the top of this drawing creating the illusion that you're looking down on this scene from above.

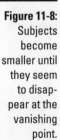

Figure 11-8: Subjects become smaller until they seem to disappear at the vanishing point.

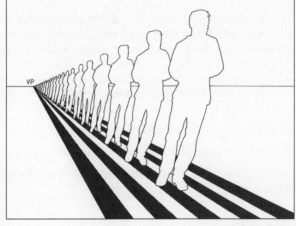

© 2003 Brenda Hoddinott

Expanding on Elements of Perspective

Creating the realistic illusion of spatial depth in your drawings requires more than an understanding of geometric perspective. Two other important elements of perspective you need to know are

✓ **Atmospheric perspective:** The farther an object recedes into the distance, the grayer in value it seems to become, and the more blurred its edges and details look. (Atmospheric perspective is sometimes called *aerial perspective.*)

✓ **Foreshortening:** As the angle of viewing becomes more extreme, visual distortion becomes more pronounced.

Incorporating atmospheric perspective into your drawings

On a clear day, your ability to see faraway objects is affected by a variety of atmospheric components, such as tiny particles of dust and pollen or droplets of moisture. Your ability to see becomes even more obscured on days when the air is filled with haze, fog, smoke, rain, or snow. Because the atmosphere affects the way you see real life, you need to incorporate that same effect into your drawings via atmospheric perspective.

In Figure 11-9, the combination of atmospheric and geometric perspectives creates a more realistic view of a forest than you'd see if the artist chose to use only geometric perspective. As you look closely at the figure, notice the following:

✓ The trees in the front have more contrasting values than the ones in the distance. In other words, their shadows are darker, and their highlights are brighter.

✓ The trees in front appear more detailed than distant ones.

✓ The trees in front are larger than the ones in the distance.

✓ The bases of the trees become progressively higher on the paper as they recede into the distance.

Managing foreshortening

Foreshortening creates the illusion that the length of an object appears to shrink as the object is pointed straighter at you (see Figure 11-10 for an example). What's more, the foreshortened qualities of objects become more noticeable when you see long objects from one end, as you see the boards in Figure 11-10.

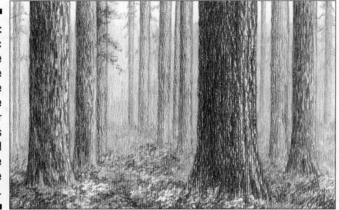

Figure 11-9:
Atmospheric
perspective
makes the
trees in the
distance
look grayer
and less
detailed
than the
ones in the
front.

© 2003 Brenda Hoddinott

By drawing objects with proper geometric perspective rather than trusting your visual perceptions, you can successfully manage foreshortening and create realistic drawings. Plus, if you practice the techniques of geometric perspective now, you can train your eyes to see the effects of foreshortening more clearly. Then eventually, you won't have to use such a mechanical method of drawing to create realistic images; you'll be able to draw just as accurately in a more freehand way.

To see foreshortening at work, take a look at Figure 11-10. Assume that each of the boards is the exact same length even though the ones closer to the left seem to be longer than the ones on the right. Note that the one directly under the vanishing point seems to be the shortest of all because its end seems to be pointing straight out toward you.

Figure 11-10:
Fore-
shortening
creates
the illusion
that objects
look shorter
when
pointed
toward you.

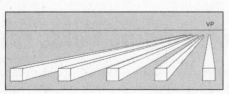

© 2003 Brenda Hoddinott

A classic example of the effect of foreshortening is the human nose. In profile, the nose is a fairly straightforward triangular shape. However, from the front, a nose is highly complicated to draw because of the distortion created by foreshortening.

Take a look at Figure 11-11 to compare a nose in profile (Figure 11-11a) to a nose in frontal view (Figure 11-11b). The nose in Figure 11-11a forms a triangle that points out away from the face. As the nose turns to become a frontal view, however, the length of the nose is foreshortened. In Figure 11-11b, you can see a rounded volume, which is often referred to as the *ball of the nose,* that represents the end of the nose that points away from the face. Lightly drawn, gently curved lines define the left and right sides of the ball of the nose. *Note:* Because you can't see actual lines separating the ball of the nose from the sides of the nose on a real-life nose, it's important to keep any lines you use to define the ball of the nose light.

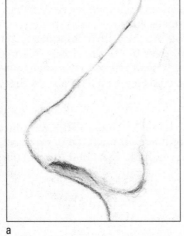

Figure 11-11:
Managing foreshortening when drawing a nose in profile and in frontal view.

a b *Jamie Combs*

Project: Drawing One-Point Perspective

One-point perspective occurs when the frontal face of an object (such as a cube) is closest to you and its edges recede in space and converge at a single vanishing point.

For this project, your focus is on accurately rendering a rectangular form with one-point perspective. Grab your sketchbook, ruler, and 2H and 2B pencils and then follow these simple steps:

1. **Use a ruler and a 2H pencil to draw a horizon line parallel to the top and bottom of your drawing space.**

2. **Place a small dot in the center of the horizon line to represent the vanishing point.**

 The vanishing point in Figure 11-12 is marked *VP.*

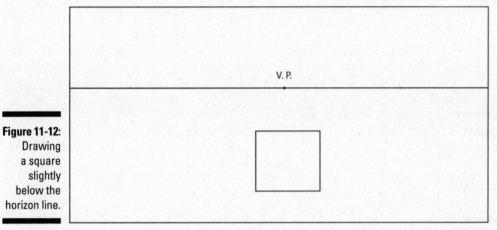

V. P.

Figure 11-12:
Drawing
a square
slightly
below the
horizon line.

Jamie Combs

3. **Use your 2B pencil to draw a square or rectangle in the middle of the drawing space and slightly below the horizon line (see Figure 11-12).**

 The top and bottom lines of this shape need to be parallel to the horizon line, and the two sides need to be perpendicular (at a right or 90-degree angle) to the top and bottom lines and the horizon line.

4. **Use your ruler and 2B pencil to draw lines from the top two corners of the square to the vanishing point (see Figure 11-13).**

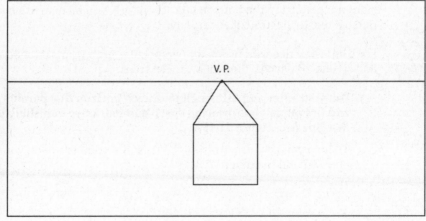

V. P.

Figure 11-13:
Drawing
lines from
the square
to the van-
ishing point.

Jamie Combs

5. **Complete your three-dimensional form by adding a line that connects the two diagonal lines you drew in Step 4 (see Figure 11-14).**

 This line needs to be parallel to the top of the square and the horizon line.

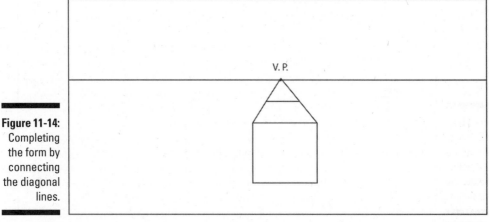

Figure 11-14: Completing the form by connecting the diagonal lines.

Jamie Combs

Project: Drawing Two-Point Perspective

Two-point perspective occurs when the corner edge of an object — created when two sides of an object (such as a cube) meet — is closer to you than either side of the object. The edges of the two sides lead back to two vanishing points on the same horizon line.

For a real-life example, consider a building. When the corner of a building (or any straight-sided form) is closer to you than any of its sides, none of its sides are parallel to the horizon line. Therefore, you have to use two-point perspective to illustrate it accurately.

For a little practice with two-point perspective, grab your sketchbook, ruler, and 2H and 2B pencils; then follow these steps:

1. **Use your ruler and 2H pencil to draw a horizon line parallel to the top and bottom of your drawing space and mark two vanishing points on that line (see Figure 11-15).**

 To help you keep track of which vanishing point is which, you can label one *VP-1* and the other *VP-2*.

Figure 11-15:
Setting
up your
two-point
perspective
drawing.

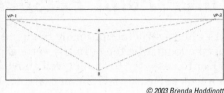

© 2003 Brenda Hoddinott

2. **Use your ruler and 2B pencil to draw a line vertical to the horizon line to represent the leading corner of your straight-sided form or building.**

 In Figure 11-15, this line is marked *AB*.

3. **Use your ruler and 2B pencil to connect the top and bottom of the line you drew in Step 2 to each of the vanishing points (refer to Figure 11-15).**

4. **Use your ruler and 2B pencil to draw two lines parallel to the line you drew in Step 2, making sure the end points for each line lie on the diagonal perspective lines you drew in Step 3 (see Figure 11-16).**

 You can make these two lines (which are marked *CD* and *EF* in the figure) as close to or as far from the first line as you like. They don't have to be equidistant from it.

5. **Use your ruler and 2B pencil to connect the end points of the first line you drew in Step 4 to the vanishing point on the opposite side of the paper; connect the end points of the second line you drew in Step 4 to the vanishing point on the opposite side of the paper (refer to Figure 11-16).**

 In the figure, points *C* and *D* are connected to *VP-2* and points *E* and *F* are connected to *VP-1*. Now all the sides of your rectangular form are in their proper places.

Figure 11-16:
Finishing
up your
two-point
perspective
drawing.

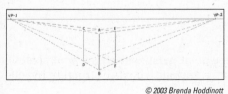

© 2003 Brenda Hoddinott

Project: Drawing Three-Point Perspective

Three-point perspective occurs when a structure normally rendered in two-point perspective is tall or deep enough that the normally vertical parallel lines that define its sides appear to converge to a point well above or well below the horizon line. Take a look at Figure 11-17 for an example. This drawing of a skyscraper has many things in common with a two-point perspective drawing. However, unlike a building drawn in two-point perspective, the lines that should be vertical in this drawing appear to slope in a slow, steady diagonal. This steady slope is actually much more true to life than strictly vertical lines would be.

Geometric perspective has some limitations as a system for drawing and can be particularly problematic in three-point perspective when the vanishing points are placed inappropriately in the drawing space, causing massive distortion. To minimize the potential for distortion, make your vanishing points as far apart as possible. You can even attach your paper to a drawing board or table and draw your vanishing points on the surface outside the paper.

Figure 11-17:
Skyscraper
drawn in
three-point
perspective.

Jamie Combs

For a little practice with three-point perspective, grab your sketchbook, ruler, and 2H and 2B pencils; then try drawing a boxlike structure by following these steps:

1. **Use your ruler and 2H pencil to draw a horizon line parallel to the top and bottom of your drawing space and mark two vanishing points on that line.**

 Label the points *VP-1* and *VP-2*.

2. **Add a third vanishing point high on the paper and about midway between the two vanishing points (see Figure 11-18).**

 You can label this point *SVP* for *special vanishing point.*

3. **Use your ruler and 2B pencil to draw a line that starts somewhere below the horizon line and continues upward to the third vanishing point.**

4. **Use your ruler and 2B pencil to draw perspective lines from the bottom of the line you drew in Step 3 to the first and second vanishing points on the horizon line (see Figure 11-19).**

5. **Decide how tall you want your boxlike structure to be, and make a mark along the leading edge line to denote the highest point.**

6. **Use your ruler and 2B pencil to draw perspective lines from this point down to the first and second vanishing points (refer to Figure 11-19).**

7. **Decide how wide you want the base of your boxlike structure to be, and make marks along the bottom two perspective lines to indicate the width of the left and right sides of the structure.**

8. **Use your ruler and 2B pencil to draw two lines connecting the marks you made in Step 7 to the third vanishing point.**

 This completes the box. If you want to turn the box into something like a skyscraper, you can erase the eye-level line and excess segments of perspective lines.

Figure 11-18:
Adding three
vanishing
points
to your
drawing.

Jamie Combs

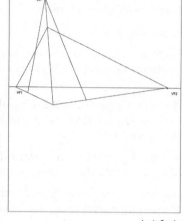

Figure 11-19:
Drawing
three-point
perspective
above eye
level.

Jamie Combs

9. **Repeat Step 1 on a separate sheet of paper.**

10. **Add a third vanishing point beneath the horizon line and about midway between the two vanishing points (see Figure 11-20).**

 You can label this point *SVP* for *special vanishing point.*

11. **Use your ruler and 2B pencil to draw a line that begins somewhere below eye level and extends to the third vanishing point.**

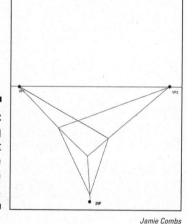

Figure 11-20:
Drawing
three-point
perspective
below eye
level.

Jamie Combs

12. Use your ruler and 2B pencil to draw perspective lines from the top of the line you drew in Step 11 to the first and second vanishing points on the horizon line (refer to Figure 11-20).

13. Decide how low you want your boxlike structure to be and make a mark along the leading edge line to denote the lowest point.

14. Decide how wide you want the base of your boxlike structure to be and make marks along the two perspective lines you drew in Step 12 to indicate the width of the left and right sides of the structure.

15. Use your ruler and 2B pencil to draw perspective lines from the marks you made in Step 14 up to the first and second vanishing points (refer to Figure 11-20).

16. Use your ruler and 2B pencil to draw two lines connecting the marks you made in Step 14 to the mark you made in Step 13.

Figure 11-20 shows what the finished below-eye-level three-point perspective drawings looks like.

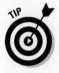

Three-point perspective drawings can be highly naturalistic, but artists usually use three-point perspective to create *dynamism* (an energetic or forceful arrangement of objects in space). Think graphic novels and animations. The distance between the special vanishing point and the first and second vanishing points affects dynamism in three-point perspective drawings. The closer the third vanishing point is to the first two vanishing points, the more dynamic the angles of the tall building or deep opening you're drawing will be. However, if you place the third vanishing point too close to the other vanishing points, the result may be quite distorted. You can experiment with various placements for the third vanishing point to get different levels of dynamism in your structures.

Project: Blasting into Space with Dynamic Perspective Drawing

Three-point perspective is a great tool for creating more precise realism, but its most exciting use is for creating imaginative, dynamic drawings like the imaginary city you create in this section.

For this three-point perspective project, you need your sketchbook, 2H and 2B pencils, vinyl eraser, and ruler. After you have your tools handy, follow these steps:

1. Using your 2H pencil and ruler, draw a horizon line parallel to the top and bottom of your drawing space, mark two vanishing points on that line, and label the points *VP-1* and *VP-2*.

2. Add a third vanishing point high on the paper and somewhere between the two vanishing points, and label it *SVP*.

3. Follow Steps 3 through 8 in the section "Project: Drawing Three-Point Perspective" to draw the first box, or building, of your cityscape (see Figure 11-21).

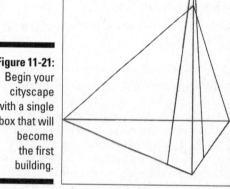

Figure 11-21:
Begin your cityscape with a single box that will become the first building.

Jamie Combs

4. **Add more boxes, or buildings, to your cityscape (see Figure 11-22).**

 To draw the second box, choose a spot along either the left or right perspective line you drew between the lower front corner of the first box and the left and right vanishing points. Use your ruler and 2B pencil to draw a line between that point and the first and second vanishing points. Repeat steps 5 through 8 from the previous section "Project: Drawing in Three-Point Perspective."

 Repeat this process until you have drawn as many buildings as you want to include in your cityscape. Varying the heights of the buildings makes your drawing more exciting and lifelike.

5. **Use your kneaded eraser to lighten and lift out all unnecessary lines.**

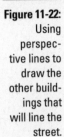

Figure 11-22:
Using perspective lines to draw the other buildings that will line the street.

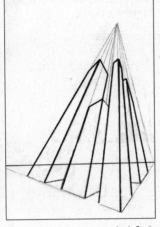

Jamie Combs

6. **Add windows, doors, and other embellishments to the buildings you drew in Step 4 (see Figure 11-23).**

 Doors and windows are rectangles, too. To keep them in perspective, use your vanishing points to draw them just as you did for the buildings themselves. If a door is on a wall that recedes in space, use the same vanishing point you used for the top and bottom of the wall to draw the top and bottom of the door.

Figure 11-23:
Using your vanishing points to draw the doors and windows.

Jamie Combs

7. **Erase any extra lines and add finishing touches, like shading, to make your drawing more realistic (see Figure 11-24).**

Use your 2B pencil to darken important lines.

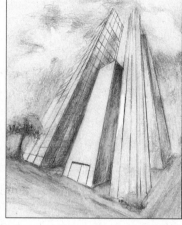

Figure 11-24:
A dynamic imaginary city invented with three-point perspective.

Jamie Combs

Part III
Experimenting with Subject Matter

"Oh, those? I thought drawing might help relieve the tension around here a little. I did these while you were napping. I'm particularly fond of the Red Cross ship. What do you think?"

In this part . . .

After you know what you want to draw, it's time to choose a subject. Essentially, anything you can think of or imagine can make a good subject for a drawing. Having so many potential options may be a little overwhelming at first, but don't worry! You don't have to choose just one. Part III is all about experimenting with different drawing subjects. Each chapter is an exploration of one major category of subject matter from still lifes and landscapes to animals and people.

If you're just getting started with drawing, you owe it to yourself to try lots of different drawing subjects. Every new drawing subject holds a new way for you to think about the way drawing works. If you've been drawing for a while, Part III may offer you some new insight into subjects you already know, or it may introduce you to some subjects you've never explored before. Regardless, you can work through all the chapters in this part, or just select one or two.

Chapter 12

Making Meaningful Still-Life Drawings

In This Chapter

▶ Choosing subjects to include in your still-life drawings

▶ Arranging and lighting your still lifes

▶ Creating your own still-life drawing

The still life is one of the most popular subjects in the history of art, likely because it offers so many clear advantages over any other type of subject. One of the most important of these advantages is time. Unlike human models, who eventually have to leave your studio to eat, sleep, and so on, still lifes work on your schedule. You can work on them for a while, take a break, and come back to them whenever you're ready. And unlike when you work with landscapes, you don't have to worry about changing weather conditions and the like when you work with still lifes.

When most people think of still-life art, they think of a bowl filled with fruit or a vase filled with flowers. The truth is, though, anything that sits still can make a good subject for a still life. The trick is to choose objects that are meaningful to you so that you don't lose interest before you finish your drawing.

Because still-life drawings offer you the freedom to work when and for as long as you want, they make for a great, pressure-free way to practice your drawing. In this chapter, we show you how to select subjects for your still lifes, how to set them up and light them properly, and, finally, how to draw them accurately.

Selecting Subjects for Still-Life Drawings

You can make a good still-life subject from just about any combination of objects. For example, you may choose objects that seem to belong together because of some functional relationship, like the ingredients and tools for making breakfast. Or you may choose objects that seem to belong together because of some visual similarity, like a group of round things or plaid things.

Regardless of how you choose your objects, try to pick items that are meaningful to you. Doing so helps you feel more enthusiastic about making the drawing. (In case you're wondering, enthusiasm for your subject is a great source of motivation.)

The number of objects you choose is entirely up to you. For example, you can make a beautiful still-life drawing of a single stalk of asparagus, or you can select a large number of items to draw like a table loaded with bags of groceries. (See Chapter 6 for more information on creating a strong composition.) The following sections show you how to select just the right objects for your still lifes, how to group your objects based on function and visual elements, and how to use transparent objects for maximum impact.

Although grouping a large number of objects in one still life can make for a very visually stimulating drawing, you need a lot of patience to complete such a drawing. But don't let that dissuade you. If you love a challenge, go for it!

Choosing still-life subjects that are meaningful to you

Many still-life drawings include classical subjects, such as fruit, fancy dishes, tools, ornamental objects, and flowers, but anything that interests you can make a beautiful still-life subject. (For more about drawing flowers, see Chapter 13.) If you choose objects that are somehow meaningful to you, you'll have more fun drawing them. Keep in mind, though, that objects don't have to be family heirlooms to be meaningful, and you don't have to go out of your way to find them.

Look around you at the things you use every day. Choose objects that strike you as unique and somehow important, and then draw them. For example, the artist of Figure 12-1 chose to draw the sink in Figure 12-1a because she liked its quirky angle. She chose to draw the plants and lamp in Figure 12-1b because she liked how the lamp seemed to be growing up from its round base just like the plants were growing out of their round pots.

Drawing objects — and anything else, for that matter — is a very powerful way of getting to know them. So before you start drawing your next still life, get ready to see your familiar subjects in a whole new way.

If you're stumped on which objects to include in your next still life, explore garage sales, flea markets, and antique stores. Old, weathered, and worn objects have a lot of personality and meaning, which you can identify and incorporate in your drawings. Even your lunch can provide fun drawing subjects. For example, take a nice, shiny apple, place it in front of you, and sketch it. Take a bite and then draw it again. Continue to do a whole series of drawings until you get down to the core!

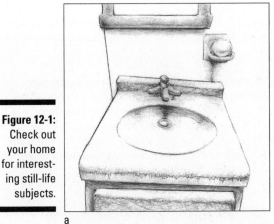
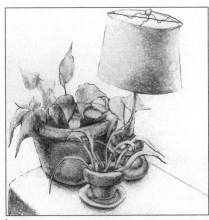

Figure 12-1:
Check out
your home
for interest-
ing still-life
subjects.

a

b

Jamie Combs

Grouping still-life objects

When it comes to gathering objects for a still life, you basically have two options. You can group objects based either on their visual elements *(formal similarity)* or on their basic uses or meanings *(functional relationship)*. Regardless of how you choose your objects for a still life, keep in mind that your objects must work well together to create a sense of *unity* (wholeness) in your compositions.

If you choose to group your still-life objects together based on *formal similarity,* you're putting together objects that have two or more similar *visual elements* (the lines, shapes, spaces, values, patterns, textures, and so on that make up a piece of art). In art, these visual elements combine to create the illusion of real things. For example, a drawing of a chair is simply a combination of lines that make shapes, spaces between the shapes, and values.

Formally similar objects likely don't seem to belong together aside from their visual elements. For example, you may decide to make a still-life drawing of a series of round objects by setting up a bowling ball, an orange, and some gumballs. With formal similarity, the possibilities are endless!

An important subset of still-life groupings based on formal similarity is the grouping based on the combination of formal similarity and difference. In this kind of still life, you may include two or more contrasting groups of objects in a single still life. For example, you may set up a still life with black objects, white objects, and objects covered with a pattern of white and black stripes.

Contrast is helpful to think about when you're setting up a still life based on functional relationships, too. For example, if you're setting up a still life composed of art supplies, you can create interesting contrast by including some

objects that aren't art supplies. In Figure 12-2a, the jars that hold brushes and pens are larger than the art supplies, making a pleasing counterpoint to the smaller objects. The jars also help to organize the supplies into bouquet-like arrangements.

In Figure 12-2, you can see examples of the difference between groupings based on formal similarity and groupings based on functional relationships. The two drawings are similar in appearance, but the ideas behind them are very different. Figure 12-2a is a drawing of objects that seem to belong together because of a functional relationship. (All these objects are used for making art.) Figure 12-2b is a drawing of objects that seem to belong together because of a formal similarity. (All these objects are rectangular.)

Figure 12-2:
Grouping objects based on functional relationships and formal similarity.

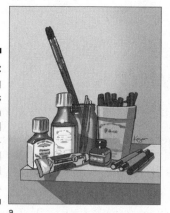

a b *Kensuke Okabayashi*

You can unify a still-life drawing by choosing objects that relate to one another in some thematic way. Consider themes based on physical objects, such as gardening tools and plants, kitchen utensils and food, and table settings, or themes based on ideas, such as history, family, identity, politics, music, fictional characters, stories, and so on. For example, if you want to create a still-life grouping based on a story, you can make an arrangement of things you suspect might be on Sherlock Holmes's coffee table.

Enjoying the challenge of transparent objects

Glass and crystal objects have long been favorite subjects for still-life artists, perhaps because transparency is such a playful illusion. Transparency allows you to see through an object at the same time that you're fully aware

of the object's surface. The shiny textures of transparent objects need strong highlights and a full range of values (including some really dark ones) to look realistic; check out the drawings in Figure 12-3 to see what we mean. (See Chapter 10 for more on drawing textures.)

In Figure 12-3a, the transparent qualities of the glass determined the values the artist used to shade this unusual bottle.

- ✔ The darker values from the top section of the background appear in the upper half of the bottle.

- ✔ Lighter values from the surface on which the bottle is sitting are visible in the lower section.

- ✔ The dark values of the shadow under the bottle are visible in the base of the bottle.

- ✔ The edges of the bottle seem to disappear in a few places. When light flickers across a three-dimensional glass form, it illuminates parts of the surface and casts other parts into shadow. Still other parts of the bottle appear to be the same value as the background; those are the ones that seem to disappear.

- ✔ Dark values help define hard edges, and light values help define soft edges. Hard edges alert your eye to a sharp change of direction along the surface of an object, while soft edges alert your eye to a gentle transition happening along the surface of a form. For example, the artist used a dark line to draw the left side of the bottle to firmly articulate the corner's abrupt change in direction.

The crystal angel in Figure 12-3b provides an intricate study of a highly detailed transparent subject. Many of the medium values actually appeared in the background, but the artist decided to leave the background white to further accentuate the complex texture of this particular subject.

Figure 12-3:
Using value
and texture
to draw
transparent
still-life
objects.

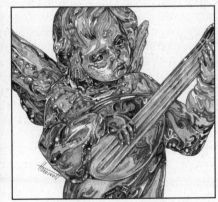

a b © Brenda Hoddinott

Identifying the shape of a cast shadow

A *cast shadow* is a shadow that occurs when one object blocks light from hitting another object. For example, when you stand on the sidewalk at dawn or dusk, you have a shadow because your body is blocking the light of the sun from hitting the sidewalk.

The shape and form of an object and the surface on which it sits determine the shape of its cast shadow. For example, if you look at an apple's shadow on a flat tabletop, it's similar in shape to the apple itself. However, if the apple sits on wrinkled or gathered fabric, the shape of the shadow follows the contours of the folds in the fabric.

The origin of the light source also affects the shape and size of a cast shadow. For example,

in the middle of the day when the sun shines almost directly above, your shadow, if you have one at all, is small and close to your body. Later in the evening when the sun sits lower in the sky at a diagonal to you, your shadow stretches across the ground, growing longer as the sun sets.

Find several differently shaped objects, place them one at a time near a strong light, and observe their shadows. Move the light around (or move the objects around) and watch how the shadows change shape. Place the objects on gathered fabric and see how the shapes of the shadows follow the folds of the fabric. (Refer to Chapter 6 for more information on shadows.)

Although drawing transparent objects is a technical challenge, you'll certainly feel empowered after you figure out how to render just the right textures and values to create successful illusions, so don't give up! Turn to Chapter 9 for more info on creating values and Chapter 10 for more on rendering textures.

Arranging Your Still Life

When you're ready to set up your still life, imagine that you're the director of your drawing and you have to arrange your "actors" on a stage. The arrangement you choose sets up the basic rhythms of the drawing and tells the viewer something about the objects in it. If possible, try to arrange your objects in a way that accentuates the qualities that attracted you to them in the first place. For example, surrounding a tall vase with other tall vases makes the tall vase look like just one of the vases, whereas surrounding a tall vase with short vases makes the tall vase stand out and look very tall. (For more detailed information on composition, see Chapter 6.)

Setting up even the simplest still life may seem daunting if you've never set one up before. But don't panic! The following tips are here to help you:

✔ **Choose a variety of objects that complement each other.** Whether you decide on a functional grouping or a formal grouping, select objects that look good together. Try not to use extremes of scale within the same still life. It's a good idea to use objects of various heights, but make sure they're all substantial enough that none of them get lost. For example, if you place a small crystal candleholder next to a large metal vase, the vase will overwhelm the candleholder, and your viewers may not even notice the candleholder is there.

✔ **Keep it simple.** Three objects is a good number to start with. If each object is a slightly different height than the others, you can arrange them almost any way and they'll look good.

✔ **Decide where to set up your still life.** If you don't have a private studio, choose a spot where you can leave your still life set up until you're finished drawing it.

✔ **Set up some kind of background behind your still life.** Don't make the background an afterthought. After all, the background will be part of your finished drawing. You can set your still life up against a wall or a window, or you can hang a cloth or tape some colored paper to a board behind the still life to add some color.

✔ **Decide what to use for a base.** If the surface of the table you're using for your still life isn't something you want to draw, cover it with something else. Plain or patterned fabric can be a beautiful accent to a still life; however, the folds of fabric are challenging to draw. So if you're new to drawing, we recommend skipping fabric in favor of white or colored paper as a base.

✔ **Experiment with arrangement.** Try a number of arrangements before settling on one. Here are just a few examples:

- Spread out your objects.

- Huddle your objects close together.

- Group two objects together and separate one out. Experiment with which ones you group together and how far away the isolated one is.

- Line up your objects in height order.

- Line up your objects with the tallest in the center.

✔ **Consider whether to use vertical, horizontal, square, or round drawing paper.** Most still-life drawings are either horizontal of vertical, but how do you choose which one's for you? Take your cue from the general orientation of your subject matter. If your still life is made up of a group of fruit spread out horizontally on a blanket, a horizontal format is a good choice. On the other hand, if your still life is narrow and dominated by a tall vase or two, a vertical format is the best choice.

✔ **Make sure you have a comfortable place to sit or stand when you draw.** After you start your drawing, you can't change your position from sitting to standing without drastically altering the way you see the objects of your still life. And when you alter the way you see the objects, you can't possibly draw them from the same perspective. For example, imagine you start out standing up and looking down on the objects and then decide you'd rather sit down. As soon as you sit, you can't see as much of the tops of the objects as you could when you were standing. If you try to continue your drawing anyway, the perspective of the objects will be off. (See Chapter 11 for a lot more info on perspective.)

After you've been drawing for a while, you may want to try some more challenging still-life setups. You can still use any objects you like because even the most ordinary objects can offer new challenges if you experiment with their setup. One great way to ramp up your setup is to sit yourself at an unconventional perspective from your objects to create an atypical view. Try this: Sit on the floor and look up at the top of a bookshelf; draw your books and mementos from below. Check out Figure 12-4 for an example of how this setup might look.

Figure 12-4:
Drawing common objects from uncommon perspectives.

Barbara Frake

Lighting Your Still Life

If you've ever been in a dark room and watched your friends hold flashlights underneath their chins, you know that lighting has quite an impact! (If you haven't ever done this sort of experiment, grab a friend and try it!)

Lighting sets the scene and the mood for your drawing, letting your viewers know whether it's day, night, calm, intense, or anything in between. As the director of your drawing, you're responsible for choosing the right lighting

to create whatever setting and mood you want your drawing to have. If you aren't sure what you're looking for, experiment. Try looking at your objects in several different lighting situations to see which one works best.

When it comes to lighting, the first thing you need to decide is whether you want to use natural or artificial light. If you want to use artificial light, you can purchase inexpensive clamp lights and high-watt bulbs at any hardware store. These room brighteners make great light sources for still lifes.

If you want to use natural light, be aware that the light will change from time to time as the sun ducks behind and out of the clouds and as daylight turns to night. Don't let this tidbit dissuade you from using natural light, though, because it produces beautiful shadows and can be useful in adding mood to your drawing. For example, winter light creates a different feeling than summer light, and morning light creates a different feeling than twilight.

To deal with the problem of constantly changing natural light, do one of the following:

- **Keep several pieces of paper handy so that you can start a new version of your drawing each time the light changes.** That way, you can get the partially finished drawings out again the next day and work on each of them as the light becomes right. Making several drawings at once may actually be an exciting experience. The downside is that if it rains on the day you start drawing, you have to wait until it rains again to work on that series of drawings.

- **Go along with the changes.** You don't have to constantly redo the light and shadows in your drawing to go along with changes in light. You can simply use the light and shadows you have when you have them. At the end of the day, your drawing will look like a record of the light at different points during the day.

- **Take a photograph before you get started and use it as a reference as you complete the drawing.** You'll lose some of the complexity of the lights and shadows because photography condenses values, but at least you'll have a record of where the shapes of value were when you started drawing.

After you choose which type of light to use, you need to decide where to position it in relation to your still-life subject. Keep in mind that how you position your light source affects how three-dimensional or flat your subject appears. Figure 12-5 shows you how changing the lighting position affects the way a still-life vase appears to the viewer. Note your different impressions of the vase based on the four light positions.

To get a better idea of how light affects still-life subjects, find an object, a flat, white surface, and a portable light source. (You can use any light source you want, such as a clamp light, a lamp, a flashlight, or even the glow from your

computer.) Place your object on the flat surface, set up each of the following four lighting options, and see which ones you like the most:

✔ **Light from above and slightly to the right of the object (see Figure 12-5a):** This traditional lighting option emphasizes the vase's shadows, highlights, and three-dimensional forms.

✔ **Light from the right and slightly below the object (see Figure 12-5b):** This lighting option creates lots of contrast between highlights and shadows and also illustrates the vase's three-dimensional qualities. Look for *reflected light* (light that bounces into a shadow from someplace nearby, often the surface the object sits on) on the edge of the shadow side of your object. (Check out Chapter 8 for more about light, shadows, and reflected light.)

✔ **Light from directly behind the object (see Figure 12-5c):** The silhouette presentation of backlighting provides a less detailed image because you see only the shadow side of the vase. When drawing this type of still life, you need to shade most of the object with dark values.

✔ **Light from directly in front of the object (see Figure 12-5d):** The lack of visible shadows, which are out of your line of view (behind the object), makes an object lit from the front appear soft and flat. Frontal lighting is very common in photos for which you use a flash.

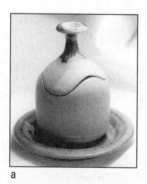
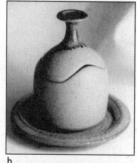

Figure 12-5: Lighting the same object four different ways.

a

b

c

d

© Brenda Hoddinott

 Use photos only as reference tools and try to draw from actual objects whenever possible. Otherwise, your drawing won't be an accurate portrayal of the object itself. For example, the photograph in Figure 12-5b didn't capture the slight rim of reflected light that appeared clearly on the shadow side of the actual vase.

 If you have a specific artistic reason for wanting still-life objects to look flat instead of three-dimensional, try using frontal lighting or backlighting. Using either of these options sets up a dramatic contrast between the value of the object and that of the background. Dramatic value contrast can add heightened emotional or psychological effects to a drawing. Twentieth-century artists like Picasso and Matisse made still-life art that focused on the flat shapes of objects. If you're interested in trying your hand at working like them, using flattening lighting can help you more easily see the outer contours of objects.

Project: Drawing a Still Life

The key to drawing anything is to break it down into the simplest, most general shapes you can and then work gradually toward greater levels of specificity. Before you start drawing a still-life object, spend some time just looking at it. Try to forget that you know what it is; examine the object as though you've never seen it before. Look at the basic shapes (cylinders, spheres, boxes, and cones) that make it up. When you're able to see the simple shapes that make up an object, you're well on your way to making an accurate drawing.

 For this project, choose any drawing media you like. The artist of the figures shown here used a 2B graphite pencil to begin and then switched to a 4B graphite pencil later in the drawing. You also need some paper and an eraser. To get started, choose an object you want to draw, and follow these steps:

1. **Place your object on a flat surface so that you can see it fully without having to move around.**

 Figure 12-6 shows the coffee mug being used for this still-life drawing.

2. **Look at the object, hold your 2B pencil near the top of the paper, and visualize a line running through the center of the object; keeping your eyes on the object, draw the imaginary line from top to bottom.**

 This line is your object's *axis* (the line that runs through the center of an object). See Figure 12-7 for the coffee mug's imagined axis.

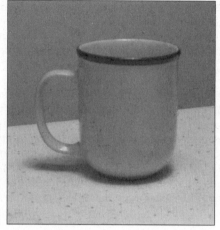

Figure 12-6:
The still-life subject set up on a flat surface.

Figure 12-7:
Drawing the coffee mug's imagined axis on the paper.

3. **Look at the object again to determine what shapes you see; lightly and quickly draw the simple shapes of your object using the line you drew in Step 2 as a guide for the shapes.**

 The coffee cup from Figure 12-6 breaks down into a box with half of a sphere sticking out of its side (see Figure 12-8).

 You probably won't get the shapes exactly right in a single line. But don't take time to erase every mistake; if you do, you'll lose momentum. Plus, if you erase a mistake, you may forget where it was and redraw the same mistake. Don't be too fussy with your drawings in the beginning. You can erase all the extra lines later.

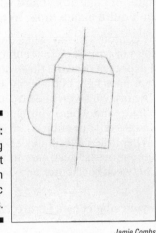

Figure 12-8:
Breaking
the object
down
into basic
shapes.

4. **Use the lines you drew in Step 3 as a framework to help you as you connect and smooth out the contours of your object (see Figure 12-9).**

The top of the cup is especially tricky to draw. Your brain knows the top of the cup is a circle, but, if you try to draw it as a circle, the coffee cup won't look realistic. When a circle turns away from you like it does when a cup sits on a table in front of you, the circle is squashed into an oval-like shape called an *ellipse* (refer to Figure 12-9 for an example). To draw an ellipse well, keep your eyes trained on your subject and move your hand, imagining that you're actually drawing on your subject's ellipse. Try to forget about the paper and just feel your pencil around the edge of the ellipse.

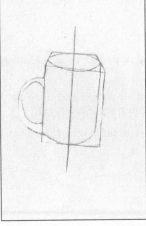

Figure 12-9:
Using the
basic shape
lines as a
framework
while you
smooth out
the contours
of your
object.

5. **Look carefully at the curves and angles of your object and adjust any of the lines in your drawing that don't quite match those in the object.**

 Notice that the lines that describe the contours of the coffee cup aren't all equally thick. Changing the thickness of your lines (a technique called *line weight variation*) is an important aspect of drawing three-dimensional objects. It's a good idea to keep all your lines light in the early stages of a drawing, but as you start to refine the drawing, you need to emphasize certain parts of the contour lines. To figure out where your lines need extra emphasis, look carefully at the edges of your subject. Pick out the darkest parts and the lightest parts. Where the edges look darker, use your 2B pencil to retrace the lines in those areas. Take care to retrace delicately, making gentle transitions between the lighter and darker parts of the lines.

6. **Erase the lines that don't appear in your object (see Figure 12-10).**

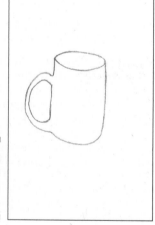

Figure 12-10:
Erasing the lines you no longer need.

Jamie Combs

7. **Use whichever shading technique you prefer to add shadows to your object (see Figure 12-11).**

 For this step, the artist switched to a 4B pencil and used continuous tone. (For more information on shading, see Chapter 9.)

 Be sure to add the line that indicates the table on which your still life sits.

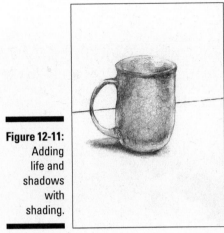

Figure 12-11:
Adding
life and
shadows
with
shading.

Jamie Combs

Chapter 13

Representing the Natural World in Your Drawings

Few drawing subjects have more power to captivate your viewers than nature. Nature is alive and exhilarating with its frequent changes from fierce and unforgiving to gentle and welcoming. Every part of the world, including the one you live in, offers its own exotic reason why you should keep your drawing supplies close at hand whenever you step outside.

Drawing natural phenomena like skies, trees, and flowers is extremely rewarding, but it also poses some unique challenges. For example, how do you draw a sky when it's constantly changing? How do you represent something ephemeral like clouds? How do you make a believable drawing of a tree when its intense tangle of limbs is almost completely obscured by a million tiny leaves?

In this chapter, you discover answers to these questions and many more. Here, we show you how to embrace nature by re-creating it with your pencil and sketchbook.

Lucky for you, you don't have to figure out how to draw an ever-changing sky or the intricate leaves and limbs of a tree all on your own. You can study the work of the countless artists throughout history who have worked hard to tackle these types of issues. From Chinese floral and landscape paintings to modern botanical illustrations, you can find numerous techniques and solutions for translating the beautiful intricacies of nature into eye-catching drawings. Visit your local library to look for books on nature in art or go online and type *nature drawings* into your favorite search engine to see how other artists render nature in their drawings.

Exploring Sky and Land

When you're drawing a landscape, the way you draw the sky needs to complement the way you draw the land because the land as a whole is subject to the changes occurring in the sky. For example, when the sun goes down, the earth gets dark. When a storm rolls in, it soaks the ground with rain. When a cloud floats by in a clear blue sky, it throws its shadow on an otherwise brightly illuminated hill.

The key to drawing realistic landscapes is remembering that the sky and land are equally important features. Although the sky generally isn't as full of activity as the land, the activity that does take place in the sky gives shape to everything that happens on the land. Take a look at Figure 13-1. Every area of light and shadow in the drawing conspires to create the illusion of a warm afternoon. The sun is powerful and bright, as you can tell by the distinctive shadows on the grass under the chair.

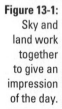

Figure 13-1:
Sky and land work together to give an impression of the day.

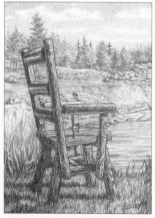

© 2003 Brenda Hoddinott

Note: Many artists choose to include some reference to the existence of people in their landscape drawings to represent the different relationships people have to nature. For some artists, adding human references to nature drawings gives them the chance to document their own experiences of nature. For others, it allows them to depict nature as a habitat for humans. For still others, it gives them an outlet to critique the way humans sometimes mistreat nature. These people references can be subtle, such as a worn path through a wooded area or footprints in the snow, or more obvious, such as a birdbath, outdoor chair, buildings, or canoe.

The following sections show you how to combine elements of both the sky and land to create well-put-together landscapes so that you can visually express your own experience of nature.

Capturing different skies and clouds on paper

Every time you go outside or peek through the windows of your home, take a minute to observe the cloud formations in the sky. Analyze their shapes and forms and note the range of values you see in the clouds themselves and in the sky beyond them. Then imagine how you would draw them.

Clouds are basically three-dimensional objects. They aren't exactly solid in the conventional sense, but they have shape and volume. And although clouds change quickly, especially on windy days, you definitely don't want to give up drawing clouds in person and work only from photos. After all, the subtle beauty that makes clouds so worth drawing is often all but lost in photographs.

As you get ready to draw your first few landscapes, keep in mind that it's more important to get a sense of what the clouds are generally like than to make a portrait of one or two specific clouds. Before you start drawing, spend some time observing the way the clouds look and move. As you do so, ask yourself the following questions to get a better idea of how to represent them on paper:

✔ **Do the clouds appear to be lighter or darker than the sky?** Focus your drawing energies on whichever element — the clouds or the sky — is darker. If the sky is darker than the clouds, allow the white of the paper to serve as the white part of the clouds and use your pencils to shade in the sky around the clouds. If the clouds are darker than the sky, focus on rendering the values of the clouds, and you can either let the sky be the white of the paper or lightly shade the sky, making sure to keep the values lighter in the sky than in the clouds. (See Chapter 9 for more details on shading.)

✔ **Are the edges of the clouds firm or filmy?** Even if clouds are somewhat firm looking, they should never have black outlines around them. To make them look as realistic as possible, draw guidelines for the contours of the clouds very lightly so that you can erase them cleanly later. If the edges of the clouds are filmy, make soft, gradual value transitions to gently separate cloud from sky. If the clouds are firm, remember they still aren't made of plastic, so keep a gentle grip on your pencil even as you clearly define the separation between clouds and sky.

✔ **If you can see a shadow on the cloud, how much of the cloud does the shadow take up, and is the whole shadow made up of one value or are some parts of the shadow darker?** Apply your initial shading to the shadows on clouds more lightly than they actually look. You can always build darker values on top of the first values later.

When drawing clouds, remember that perspective affects the forms of clouds in the same way it affects three-dimensional solid objects. In other words, you can create the illusion that clouds near the horizon line are farther away than those directly overhead by drawing them smaller, closer together, and lower in contrast. (Find out more about perspective in Chapter 11.)

Figure 13-2 shows three different skies. Think about how the artist rendered each one.

- **Clear and calm:** The artist of Figure 13-2a creates the illusion of distance in a clear sky using atmospheric perspective. According to the principles of *atmospheric perspective,* you can create a realistic illusion of depth in your drawings by mimicking the effects of the atmosphere on your subjects, thus reducing the clarity and contrast of objects as they recede in space (see Chapter 11 for more details). In this drawing, the shading graduates from dark at the top of the sky to very light above the horizon line, thereby creating the illusion of depth in this warm, tranquil scene.

- **Stormy and angry:** In Figure 13-2b, the artist illustrates the sky's power to portray ominous or angry emotions through dramatic value contrast. The sky is dark and crossed by streaks of white lightning, which burst from the clouds and reflect on the surface of the water. A small section of a dark cloud reaches down toward the land with the potential destructive touch of a tornado.

- **Cloudy and picturesque:** The artist of Figure 13-2c makes the clouds appear soft and gentle by keeping the value contrast low and drawing the edges of the clouds to look soft and filmy. The artist also suggests vast depth in the drawing using atmospheric perspective to render the gradual reduction in contrast and clarity as the mountains and clouds recede into the background.

Figure 13-2: Representing three different skies on paper.

 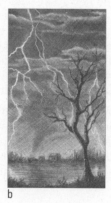 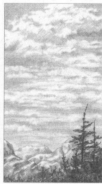

a b c © 2003 Brenda Hoddinott

This exercise offers you some practice with drawing clouds, so take a walk outside on a cloudy or partly cloudy day and find a patch of sky you want to draw. Gather your sketchbook, HB, 2B, and 4B pencils, and your kneaded eraser and follow these steps:

1. **With your HB pencil, lightly sketch the shape of the clouds.**

 If you're looking at the sky as you draw, the shapes and positions of the clouds may change as you work. Don't worry about it; change the shape if you feel like doing so or just keep working.

2. **Determine whether the sky or the clouds are darker and use your 2B pencil to begin lightly shading the darker element.**

 If, as in Figure 13-3, the sky is darker than the clouds but the clouds have shadows on them, go ahead and lightly shade the sky and the shadows on the clouds. Leave the lightest parts of the clouds the white of the paper.

 You can use whichever shading technique you prefer (see Chapter 9 for descriptions of several different techniques). In Figure 13-3, the artist used hatching to add shading to the sky and then to add some light shading to the clouds.

3. **Use your 4B pencil to add darker values where you need them.**

 Keep a light pressure on the pencil even as you add darker values. Build dark values by layering your shading marks rather than increasing your pressure. If you press too hard on your pencil, you may have a hard time erasing cleanly if your values get too dark.

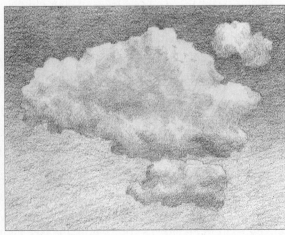

Figure 13-3:
Rendering
realistic
clouds.

Barbara Frake

Examining and drawing trees

When you were little, you probably thought you knew how to draw trees — a rectangle for the trunk and a rounded blob for the treetop for deciduous trees and a triangular mass of diagonal lines on top of a short rectangular stump for evergreens. Your memory of this symbolic way of drawing trees can be a little inhibiting as you try to draw realistic trees in your landscapes. After all, the basic tree symbols you used as a child don't really correspond to what you see when you look at an actual tree.

At the same time, though, the basic tree symbols can provide a little guidance as you begin a drawing of a tree. As we explain in Chapter 7, it's very helpful to simplify your drawing subjects into their most basic shapes when you first start drawing them, and the basic rectangle and circle shapes you used as a child to draw trees can help you simplify trees as you draw them now.

If your mind tries to hang on to the basic tree symbol too much, keeping you from rendering realistic trees, take a close look at a real tree in your backyard as though you've never seen one before. Forget what you already know about trees and simply see and experience the tree as it is. Then read on to find out how to draw that tree as it is.

In this section, we offer a few tips you can use to take some of the mystery out of drawing trees. We also show you how to draw groups of trees in the distance as well as individual ones that are right in front of you.

Drawing distant trees

Distant trees look the most like the symbolic trees of your childhood, but to draw them realistically, you need to call on more than just simple shapes, as you can see in this section.

Most of the time trees in the distance appear to be part of a mass with other trees. So to draw them, you need to start by thinking of them as a mass instead of trying to draw each individual tree. If you can see the trunks from where you are, start with the mass of treetops and then add the individual trunks.

To practice drawing a mass of trees in the distance, grab your sketchbook, HB, 2B, and 4B pencils, and kneaded and vinyl erasers and then follow these steps:

1. **Using your HB pencil, draw one big shape that combines all the tree-tops in the mass of trees (see Figure 13-4a).**

2. **Draw the basic shapes of the trunks and any other objects surrounding the trees that you want to include in your landscape (see Figure 13-4b).**

 Keep the trunks and other objects simple for now. Just try to get the basic shapes in as quickly as you can; you can worry about making them more accurate later.

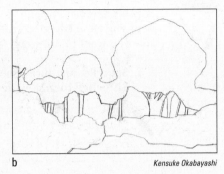

Figure 13-4:
Drawing the basic shapes of the treetops and then the trunks.

a b *Kensuke Okabayashi*

3. **Using your 2B pencil, add some light shading to the trees, trunks, and other objects to make them look more realistic (see Figure 13-5a).**

 See Chapter 9 for more details on shading.

4. **Using your 4B pencil, add darker shading to the areas where the shadows of the trees and other objects are darker (see Figure 13-5b).**

 To enhance the illusion of depth, remember to incorporate atmospheric perspective into your drawing. According to the principle of atmospheric perspective, the farther back something is in space, the smaller and less distinct it appears. Therefore, add the darkest values to the trees nearest the front, and reduce the dark values gradually as the trees work their way back in space. (See Chapter 11 for more details on atmospheric perspective.)

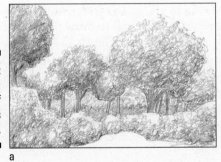
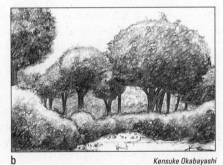

Figure 13-5:
Refining a mass of distant trees by shading.

a b *Kensuke Okabayashi*

Sketching nearby individual trees

Drawing realistic-looking individual trees is a lot easier than you may think. After all, drawing a tree is just like drawing any other object; you just have to break the overall process into smaller, more manageable steps. This section shows you how to do just that.

For this exercise, you need your sketchbook, 2B, 4B, and 6B pencils, and both your vinyl and kneaded erasers. After you've gathered your supplies, find a tree you want to draw and follow these steps:

1. **Spend some time observing the tree you want to draw and use your 2B pencil to make a few gesture drawings of it.**

 See Chapter 7 for instructions on gesture drawing. Figure 13-6 shows an example of a gesture drawing of a tree.

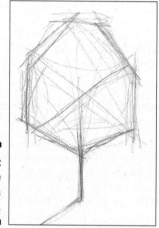

Figure 13-6:
Gesture
drawing of a
tree.

Jamie Combs

2. **Choose one gesture drawing to use as a skeleton for developing a drawing of a tree and use your 2B pencil to draw the simple shapes that make up the trunk and treetop (see Figure 13-7).**

 If the treetop has so many gaps in foliage or the branches are so bare that you can't see the treetop as a whole shape, imagine wrapping a rope around the treetop so that it bridges the gaps between the foliage and branches. Use the gesture drawing as a guide for where to place your shapes. Draw the simple shapes right on top of the gesture drawing. You'll lighten all your gesture lines and the lines of simple shapes later.

3. **Use your 2B pencil to refine the shapes of the tree to make them look more realistic (see Figure 13-8).**

 Two important elements that you need to refine in this step are the contours of the foliage and the place where the trunk meets the treetop.

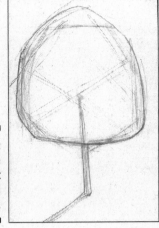

Figure 13-7:
The simple shapes that make up a tree.

Jamie Combs

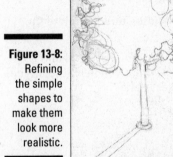

Figure 13-8:
Refining the simple shapes to make them look more realistic.

Jamie Combs

4. Erase any lines you don't need and use your 2B pencil to lightly apply shading to the shadow areas of the trunk and treetop and to add simple textures (see Figure 13-9).

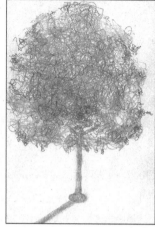

Figure 13-9:
Applying
shading
to add
values and
textures.

Jamie Combs

Choose a shading technique that allows you to mimic the texture of a leafy tree, but don't try to copy the texture exactly. The trick is to look at the leaves while you're working and move your pencil in a way that feels leaf-like. See Chapter 9 for more information on the different shading techniques you can use.

5. **Use your 4B and 6B pencils to refine the shading and complete the drawing (see Figure 13-10).**

 After you establish your basic dark values, use your 4B pencil and a light, steady pressure to build darker values where you need them. Then switch to your 6B pencil and add your darkest darks.

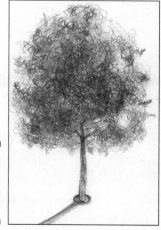

Figure 13-10:
Finished
drawing of a
tree.

Jamie Combs

Creating convincing flowers

Whether you're in a formal garden or a field of California poppies, flowers make a fun subject for drawing. And, lucky for you, they're easier to draw than you may think! After all, you don't have to replicate every single petal of a flower exactly as it looks in real life to create a realistic-looking flower drawing.

To get a little practice with drawing flowers, find some floral models and draw them from various perspectives. Try to capture the grandeur of a massive sunflower, the delicacy of a simple daisy, and the intricate details of a rose. Do close-up, detailed drawings of the textures and forms of the individual petals and leaves that make up a flower and notice how their unique qualities impact the overall look of the flower itself. Then keep reading to find out how to make complete, realistic drawings of both groups of flowers and individual flowers.

Drawing groups of flowers

The key to making convincing bunches of distant flowers look real on paper is to simplify the scene as much as you can and dedicate most of your time to getting the value contrasts right. In other words, treat flowers surrounded by greenery as masses of value set against other masses of value rather than as individual flowers surrounded by other vegetation.

To draw a group of different types of flowers, such as those found in a garden, grab your sketchbook, HB and 2B pencils, and kneaded eraser and follow these steps:

1. **Use your HB pencil to lightly draw the simple rounded shapes made by each flower in the group (see Figure 13-11).**

Figure 13-11: Drawing the basic shapes of the flowers in a group.

Kensuke Okabayashi

Don't try to draw individual petals! If you're looking at flowers from a distance, you can't see the petals clearly anyway. Plus, the point is to break down the flowers into their basic shapes so that you can get their positions right. Then you can focus on adding more detail.

2. **Draw the stems of the flowers, as shown in Figure 13-12.**

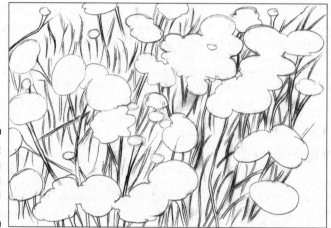

Figure 13-12: Continuing the drawing by filling in the stems.

Kensuke Okabayashi

3. **Use your 2B pencil to add shading and value to represent the greenery surrounding the masses of flowers (see Figure 13-13).**

See Chapter 10 for some ideas about rendering textures and value with shading.

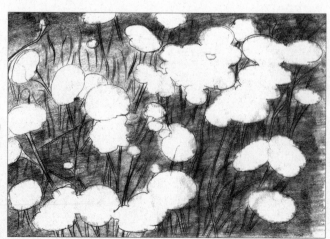

Figure 13-13: Using shading to add texture to your drawing.

Kensuke Okabayashi

4. **Use your 2B pencil to add shading to differentiate the various types of flowers in the mass (see Figure 13-14).**

 For example, purple petunias tend to be darker than peonies, so add darker values to any purple petunias (or other dark flowers) you see in your flower group. In Figure 13-14, the artist chose to showcase lighter flowers. In this case, shading in the stems in the background makes the light-colored flowers pop out of the busy details.

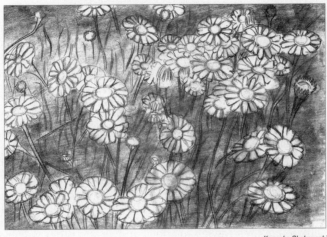

Figure 13-14: Adding value to the various types of flowers in a group.

Kensuke Okabayashi

5. **Use your 4B pencil to refine the range of value to make the flowers and greenery look more realistic (see Figure 13-15).**

 Turn your attention to the flowers, greenery, and any other objects that are nearest the front of the drawing. Increase the range of value slowly as you approach the front of the drawing, building toward strong darks that emphasize the shadows of objects nearest the viewer. Articulate the shapes of the closest flowers more clearly than those in the distance. Finally, add the detail values and shading to make the flowers look more realistic.

 Here, your goal is to refine the masses of flowers enough to make them look finished without refining them so much that they lose their cohesiveness as a group.

Focusing on individual flowers

If you want to draw just one flower rather than the group of flowers we cover in the preceding section, get ready to be a little more detailed. Although you don't have to draw each petal exactly as you see it to make a flower look realistic, you do need to be specific about the character of your particular flower so that your viewers can identify it fairly easily.

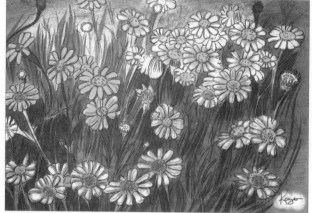

Figure 13-15: Refining a mass of flowers without sacrificing unity.

Kensuke Okabayashi

Before you start drawing individual flowers, spend a little time just looking at a flower model. Look at the way its petals grow out from the center and the way they overlap each other. Examine the back of the flower to see the way the flower connects to its stem. Then you can start drawing.

Like with any object you draw, first simplify the flower into its simple shapes. (You can use a gesture drawing to do so; see Chapter 7 for details.) Then you can gradually refine the drawing to add shadows and other values that make the flower look real.

Figure 13-16 shows an example of a finished drawing of a flower. Notice how the artist incorporates the following floral aspects to make this flower look alive and real:

- **The petals are imperfect triangular shapes that undulate gently away from the center of the flower.** The floppiness and irregularity of the petals help make the flower as a whole look real.

- **The petals interact with each other and with the flower's center in a way that makes them appear to grow out of the center.** Each petal seems to tuck underneath the center because of the shadows being cast on the petals by the center. When a petal overlaps another petal, the front petal casts a shadow on the petal behind it.

It's important to draw flowers from life rather than your imagination because doing so helps you make your drawings look more realistic. As you draw, pay attention to the idiosyncrasies of a particular flower so that you can get to know how the real flower looks as opposed to the generalized flower you might render if you tried to draw one without looking. Drawing from life gives you the opportunity to really see the world around you. When you turn off your pre-conceptions and make an effort to draw something exactly as it is, you make discoveries about it that you simply wouldn't be able to make otherwise.

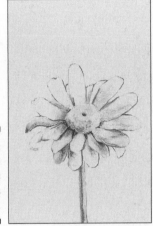

Figure 13-16:
Noticing the
way parts
of flowers
interact.

Jamie Combs

Project: Using Your Eraser to Create a White Winter

In this project, you draw a landscape using a combination of subtractive and additive drawing techniques. In other words, you draw the light values with your erasers and the dark values and shadows with your charcoal pencil. (See Chapter 9 for more details on subtractive and additive drawing.)

To get started, grab your sketchbook, vinyl and kneaded erasers, a 2B stick of charcoal, a tissue or paper towel, and a 4B or 6B charcoal pencil and follow these steps to create the landscape drawing shown in Figure 13-17:

1. **Draw a rectangle that's approximately 10 x 5 inches.**

2. **Shade in the entire rectangle with your stick of charcoal.**

 Use the side of your charcoal instead of the end — it's a lot faster that way. Try to maintain a dark middle value throughout the rectangle; you can lighten up this initial shading later.

3. **With a piece of paper towel or soft tissue, gently rub the whole surface until you have one solid tone.**

4. **Use your kneaded eraser to begin erasing or pulling out light areas in your landscape.**

When you draw with an eraser, try to imagine that you're actually drawing the light values that make up the objects. For example, look at the five trees in Figure 13-17; the artist basically erased the light values onto the trees to make them show up in the drawing. The gray of the paper becomes the middle value of all the objects, as well as the sky and the

ground, while the two light areas that the artist added on the lower-right and -left sides of the drawing represent white snow.

© 2003 Brenda Hoddinott

5. **Dab the paper with your kneaded eraser to draw more snow on the ground (see Figure 13-18).**

 Be sure not to add too many light values. Note that the water and lots of shadowy areas in the figure are still the same dark value as the original charcoal shading.

6. **Use your kneaded eraser to lighten up the sky in your landscape.**

 Notice how the artist of Figure 13-18 outlined some dark trees in the background while lightening the sky. By leaving these sections of the paper dark, the trees in the background become well defined against the lighter values of the sky.

7. **Switch to your vinyl eraser and use a sharp edge to pull out some whiter, brighter areas, such as the banks of the stream shown in Figure 13-18.**

8. **Lighten the left side of all the trees a little more with the sharp edge of your vinyl eraser.**

 By lightening the left side of all the trees, you establish the light source for your landscape, thus adding dimension and life to the drawing.

9. **Use your vinyl eraser to lighten the areas of snow that aren't in shadow on the ground and on the fir trees.**

10. **Add a third small trunk of a tree on the left side of the landscape (refer to Figure 13-18).**

11. **Draw more branches on the deciduous trees with the sharp edge of your vinyl eraser (see Figure 13-19).**

12. **Press firmly with your vinyl eraser to add some really light values to the left sides of the deciduous trees and to clearly define the edges of their trunks.**

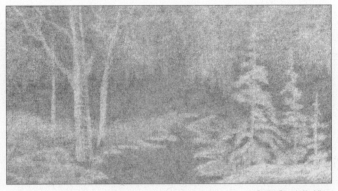

Figure 13-18:
Using your kneaded eraser to draw the sky and lighten up the lighter areas of the landscape.

© 2003 Brenda Hoddinott

13. **Press firmly with your vinyl eraser to add a few very white highlights to the snow on the ground and on the branches of the fir trees.**

14. **Use a very sharp edge of your vinyl eraser to draw some thin white lines in the stream to look like ice (refer to Figure 13-19).**

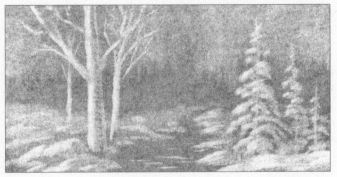

Figure 13-19:
Pressing firmly with the edge of your vinyl eraser to add the lightest lights to your landscape.

© 2003 Brenda Hoddinott

15. **Use your charcoal pencil to add darker details and shadows to your drawing (see Figure 13-20).**

 Notice the darkest marks are in areas where you would expect to find cast shadows, such as beneath the evergreen boughs and at the points where the large limbs of nearby deciduous trees branch from the trunks.

16. **Check to make sure that your dark and light values appear to have the right contrast; touch up any areas you aren't happy with by adding (or taking away) value.**

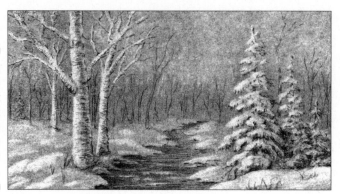

Figure 13-20:
Adding the darkest and lightest values to complete your landscape.

Project: Lovely Lily

In this project, we show you how to visually simplify the intricate details of a complex flower so that you can draw its most important elements. Although this project is based on drawing a lily from start to finish, you can use these steps to draw any flower.

When you're ready to start drawing a flower, grab your sketchbook, your HB, 2B, and 4B pencils, and your vinyl and kneaded erasers; then follow these steps:

1. **Use your HB pencil to draw a large rounded shape to represent the main part of the flower (see Figure 13-21).**

 You can draw most flowers by reducing them to simple circular shapes set at various angles. To get the angle of your flower's shape right, keep your eyes trained on the flower while you draw its main part. Find a starting point on your paper and set your pencil there. Without looking at the paper, move your arm in a circular motion to search for the right shape. Imagine that you're drawing on the flower and try to feel the line around its perimeter. You will make extra lines on the way to finding the right shape, but don't worry; you can erase them later.

2. **Add a small rounded shape inside the large one to mark the center of the flower.**

3. **Draw a single line to represent the centerline of the stem (refer to Figure 13-21).**

 It's much easier to capture the curve of a linear object (like a stem) if you imagine a line running through the center of it. Draw that line first; then you can draw the stem around the centerline.

Figure 13-21:
Drawing
the basic
shape of the
flower.

4. **Draw the simple flat shapes that make up the petals and leaves of the flower, making sure that each one originates from the center of the flower (see Figure 13-22).**

 Real petals and leaves are all a little different. Some curve, some droop, some are perky, and depending on your perspective, some are shorter, thinner, and so on. The goal here is to look at each petal as though it were behind a piece of glass and then trace a line around the outside of it.

5. **Draw a single line to represent the centerline of each of the flower's stamens, and top each one with a rounded shape (see Figure 13-23).**

 The flower's *stamens* are the shorter stemlike parts of the flower that protrude from its center.

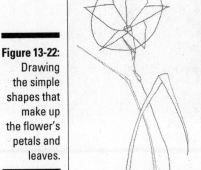

Figure 13-22:
Drawing
the simple
shapes that
make up
the flower's
petals and
leaves.

6. **Use your kneaded eraser to lighten all your sketch lines until you can barely see them.**

7. **Switch to your 2B pencil and refine the shape of each petal (see Figure 13-24).**

 Look at whichever petal you're working on and adjust the contour of the simple shape you made so that it's more reflective of what you actually see on the flower.

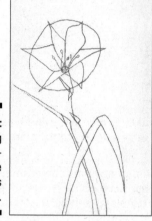

Figure 13-23: Drawing the center-lines of the flower's stamens.

Jamie Combs

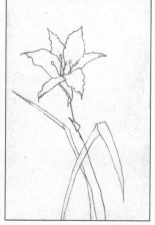

Figure 13-24: Refining the shape of each petal to make the drawing look more accurate.

Jamie Combs

8. **Using the centerlines you drew in Steps 3 and 5 as a guide, refine the contours of the flower's stem and stamens (see Figure 13-25).**

As you glance along the stem, look for places where the edge of the stem looks light and where it looks dark. Use your 2B pencil to retrace only the parts of the stem that appear dark.

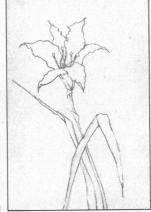

Figure 13-25: Refining the contours of the flower's stem and stamens.

Jamie Combs

9. **Refine the contours of any leaves on the flower.**

10. **Use your 2B pencil to lightly apply shading to the shadowy parts of the flower and stem (see Figure 13-26).**

 See Chapter 9 for everything you need to know about applying shading to your drawings.

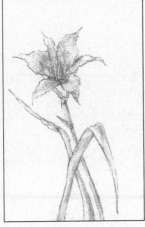

Figure 13-26: Applying light shading to the shadowy areas of the flower and stem.

Jamie Combs

11. **Use your 4B pencil to darken any shadows that appear darker than the shading you added in Step 10 (see Figure 13-27).**

 Pay special attention to places where leaves or petals overlap each other.

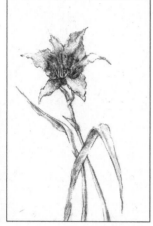

Figure 13-27: Adding the darkest values to complete the drawing.

Jamie Combs

Chapter 14

Bringing Animals to Life on Paper

In This Chapter

▶ Shading to render realistic textures

▶ Drawing animal portraits

▶ Putting your animal-drawing techniques to the test with a fun project

Artists have been drawing animals since the days when men and women recorded their histories on cave walls. Surprisingly enough, the techniques used to create these drawings on rock aren't that different from the ones you and other artists use today on paper. Whether you're interested in drawing lifelike renditions of your own pets or you just want to capture the essence of the creatures you see at a local park or zoo in your sketchbook, you've come to the right place.

In this chapter, you discover strategies for making animal drawings come vibrantly alive. You find out how to capture the spirit of an animal through the posture of its body and how to create realistic textures of fur and feathers. Finally, you get the chance to practice drawing a whole animal. Although we draw a few specific animals in this chapter, you can use the techniques and strategies you find here to draw any kind of animal.

Animals rarely hold still long enough for you to tackle anything beyond quick sketches, so have a camera handy when you're scouting animal subjects. Take pictures of any animals you'd like to draw, but make sure that you draw a few sketches of the animals, too. That way, you'll have a sense of the animals from both your in-person perspective and your camera's two-dimensional copy of the scene. Later you can synthesize the sketches and photographs to create a complete drawing. (Toward the end of this chapter, we show you how to do just that!)

Rendering Furry and Feathered Textures

The sheer variety of coats that animals come dressed in may make your head spin. Fur, feathers, scales, and fins, stripes, spots, and calico, shiny, fuzzy, silky . . . we could fill this page (and probably several more) with all the different textures you find on animals. Fortunately, with only a few tricks up your sleeve, you can draw them all.

No matter what animal you're drawing, you can render its image using lines, shapes, and values. All you have to do is get the shapes and values you draw to work together in the same way they do in real life. After you master that technique, you can draw just about anything — with a little practice and patience, of course!

Here are a few pointers to keep in mind when you're drawing fur or feathers:

- ✔ Notice the direction in which the fur or feathers grow and draw your shading lines to follow that direction.

- ✔ In general, use curved lines more often than straight lines when you're applying shading to animal drawings.

- ✔ Pay special attention to light and shadows when you're shading fur or feathers because the appearance of texture depends mostly on the interaction between values.

The following sections take a closer look at how to add furry and feathered textures to your animal drawings to make them really come alive.

Identifying the long and short of fur

Whether fur is long or short, it reveals the underlying structures of an animal's body. Because short fur closely follows the contours of an animal's body, for example, you can easily see the bone structure and superficial muscles of the animal beneath it. On the other hand, long fur obscures the appearance of some of the more subtle aspects of an animal's structure, but the prominent, rounded forms of an animal's body still push against the fur to create swells you can see no matter how long or fluffy the fur is.

Regardless of how long or short the fur on your drawing subject is, follow these guidelines:

- ✔ Use hatching lines to render the texture of most types of fur (see Chapter 9 for more details). To make fur look short, draw short, mostly curved hatching lines; draw long, curved hatching lines to create the illusion of long fur.

✔ Use a corner of your vinyl eraser to draw light onto strands or sections of fur and then go back with your pencil to draw the dark spaces between the lightened strands or sections.

✔ Use bold, thick marks to give the illusion of coarse fur and use gentle, thin marks to make fur look soft.

Rendering texture accurately takes great tenacity. When you're drawing something like a furry dog's ear, you can't afford to let your mind wander away from the subject, or you risk flatness. To make believable drawings, you must be attentive to the most subtle swells and valleys in the dog's form. If you find your mind wandering, take a break and come back to your drawing later with a fresh eye. Trust me, you'll be glad you did!

Drawing short fur

Whenever you draw fur on an animal, you create an illusion of three-dimensional *volume* (or form) at the same time that you render the furry texture. This concept is especially true when you're drawing short fur because it follows the animal's form so closely. To create the most realistic illusion of volume on your short-fur animals, you need to use accurate values to represent their fur. (See Chapter 8 for more on creating three-dimensional illusion and Chapter 10 for more on combining texture and three-dimensional form.)

To increase the accuracy of your furry values, keep your marks light and soft in the beginning. (If you press too hard or make your marks too dark too early, your drawing may end up looking flat.) Instead of using firmer pressure on your pencil to darken your values, aim to build darker values by layering light marks. Then, when you have built a foundation of fur, switch to softer (darker) pencils like 4Bs and 6Bs to add the darkest values to your fur.

Pay attention to the direction of the fur's growth. Look for it to change along with the swells, depressions, and any other places where muscles tug at the animal's skin. While you draw, keep your eyes trained on the animal's body, glancing at your paper only occasionally to check your progress. To make it easier to draw your marks in the direction of the fur, imagine that you're brushing the animal's coat with your pencil. The goal is to draw a coat of short fur that appears to wrap around the form of the animal's body.

Look at Figure 14-1a. Notice the way the dog's short fur traces curves around her eyebrows, snout, and neck. Then check out the close-up of her ear in Figure 14-1b. Look closely at the white spots. Notice that the white spots aren't firmly defined shapes; instead, the strands of dark fur that ring around the spots meet the edge of the spots in a jagged way. Also observe the way the hairs curve out, down, and up like gentle waves. If you were drawing this dog's ear, you'd need to make your marks in the direction that follows the form they're supposed to lie on. Naturally, you'd have to change the direction

of your marks as soon as the form changes. Look at Figure 14-1c to see all the different values, from white to medium gray, that the artist used to represent the light fur on the dog's snout. A range of values from medium gray to black depicts the dark fur.

Figure 14-1: Drawing spotted, short fur involves lots of shading and a full range of values.

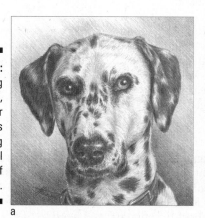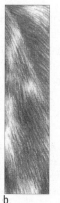

a b c

© 2003 Brenda Hoddinott

Rendering long fur

Long fur presents different challenges than short fur because the individual strands of long fur often curve in different directions and overlap one another many times. To make long fur easier to draw, try to adopt the following mantra: Essence is more important than exactitude. Basically, what this means is that you can draw a good representation of what long fur looks and feels like without drawing every single strand.

To see this mantra in action, take a look at the close-ups of fur in Figures 14-2a and 14-2b. Notice that you don't see individual hairs. Instead, you see curving strands of fur. In each strand or group of strands, you can see a light, curving fur strip that tapers into a darker end with a shadow made of dark fur behind or underneath it. Imagine using your pencil to build the mass of long, curving marks you see in Figure 14-2c. Pay attention to the direction the fur grows and try to replicate that direction with your pencil strokes. Then imagine using your vinyl eraser to draw highlights on the mass of furry value you just drew. Can you see the fur emerge from your pencil and eraser marks? To finish up the drawing, imagine going back in with your pencil and darkening the shadows behind and between the strands of fur you made with your pencil and eraser.

Long fur doesn't define the bone structure of an animal as well as short fur does. However, when you look at the longhaired dog in Figure 14-2c, you can

still tell the shape of the dog's snout. The rounded forms of the snout push against the fur, causing the fur to flop around and down toward the chin. The contrasting light and shadow on the fur tell you the snout comes forward, and the patch of light above the nose tells your eyes that overhead light is falling on the snout. At the same time, the shadowy fur to the left and right of the nose tells you that the sides of the snout have turned down and away from the light.

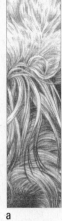 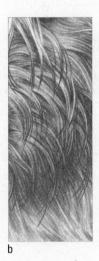 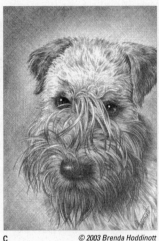

Figure 14-2: Drawing long, soft fur on an animal.

a b c *© 2003 Brenda Hoddinott*

Using fur to reveal underlying form

You can make a drawing in which the fur works with the structure of the animal to reveal its underlying form as long as you pay attention to the direction the fur grows and the way light plays across it.

The following steps walk you through the process of drawing a longhaired Scottish Highland cow. Before you get started, grab your sketchbook, HB, 2B, and 4B pencils, and vinyl eraser. For this exercise, you can either copy along with the drawing shown here or search the Internet for an image of a Scottish Highland cow and use these instructions to make a drawing of the image you find.

1. **Using your HB pencil, lightly draw the simple shapes that make up the cow's body (see Figure 14-3a).**

 Although the Scottish Highland cow is draped in long, coarse fur, you can guess its underlying shapes by concentrating on some of the landmarks on the body. For example, the skull gives shape to the cow's head, while the spine and pelvis give shape to the back of the cow.

2. **Use your HB pencil to draw a more precise contour drawing; then use your kneaded eraser to lighten the lines.**

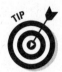

3. **Use your HB pencil to begin shading the values you see; use curved hatching lines to represent the long, wavy fur (see Figure 14-3b).**

 Pay attention to the direction in which the fur grows and turn to Chapter 9 for details on drawing hatching lines.

4. **Use your 2B pencil to darken the shading in the shadow areas (see Figure 14-3c).**

5. **Use your vinyl eraser to pull light off the parts of the fur that are catching light.**

6. **Use your 4B pencil to add dark lines at places where you see dark separations between sections of the fur and anywhere else you need dark shadows in your drawing (see Figure 14-3d).**

 Some of these dark separations occur at points where several strands and groups of strands overlap.

Figure 14-3: Using fur to depict the underlying structure of an animal.

Jamie Combs

Drawing wings and feathers

Wings come in a wide range of shapes and sizes. Some wings are designed to expand and contract like an accordion while others are quite flat and simply open and close like a door or window. To draw an accurate representation of a wing, you have to get the structure right first; then you can move on to creating the feathered texture.

To practice drawing the structure of realistic wings, grab your sketchbook, HB, 2B, and 4B pencils, and vinyl eraser. Then follow these steps:

1. **Find a photo of a bird (or just a wing) online or in a nature book; look at the bird's wing, focusing on the simple shapes that make it up.**

2. **Use your HB pencil to draw the basic shapes of the wing.**

 Figure 14-4a shows an example of a basic shape drawing of a wing. Turn to Chapter 7 for more details on breaking objects down into their simple shapes.

Figure 14-4:
Drawing
wings
using basic
shapes
and simple
shading
techniques.

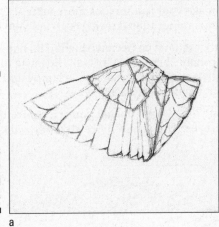
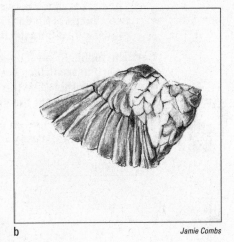

a

b

Jamie Combs

3. **Use your HB pencil to lightly apply shading to the parts of the wing that appear to be in shadow.**

 Make sure your marks follow along with the direction of the feathery fibers.

 You can use a combination of curved hatching lines (to help larger feathers look realistic) and continuous tone (to illustrate tiny feathers). We show you how to shade using these techniques in Chapter 9.

4. Use your eraser to apply light to any parts of the wing that need to be lighter.

5. Use your 2B pencil to darken values that need to be darker.

6. Use your 4B pencil to add the small amounts of darkest dark value beneath and between areas of the wing that need it to make the drawing really snap into focus (see Figure 14-4b).

To draw the many feathers of a wing with accuracy, you need to understand an individual feather's basic shape and construction. Take a look at the drawing of a feather in Figure 14-5 and focus on the following:

✔ The fibers of the feather radiate out from the *shaft* (the long, skinny thing in the center).

✔ Clumps of feather fibers attach to the shaft at regular intervals; the artist used extra-dark values to represent these attachments. Use a soft pencil and a little extra pressure to create spots of extra darkness at the points of attachment and to make the fibers of your feather appear to grow naturally from the shaft.

✔ The darkest lines between the feather fibers happen in the gaps between two clumps of fibers. To make your feather look more natural, think about drawing the fibers in clumps rather than drawing each individual fiber.

✔ The highlight on the feather is uneven because highlights happen when a particular surface is strongly illuminated by light. Because the surface of this feather (like the surface of lots of objects) is lumpy and bumpy, it makes sense that the light would hit it unevenly.

Watch out for uneven patches of light. If what you see contradicts your rational mind, trust your eyes. They know more about drawing.

Figure 14-5:
Taking a close-up look at a feather.

Capturing Life in Animal Portraits

Creating a portrait of an animal goes beyond simply depicting its basic shapes and textures. A portrait encompasses both the animal's mysterious inner being and the external facts of an animal's appearance. Some animal portraits also include the habitat in which the animal lives. The *gesture* — or posture — of an animal gives away a great deal about that animal's emotional state. Think back to a time when you saw two or more animals engage each other in nonverbal communication. Perhaps your pet cat stood staring at your new dog the day you brought him home. Or perhaps you remember seeing a TV show in which two male lions paced back and forth as they approached each other. Animals strike meaningful poses to make their intentions clear to other animals. With just one glance, you can probably tell what different animal gestures mean and whether an animal is calm, happy, frightened, bored, or dangerous.

To represent the true character of an animal as expressed by its body language, you can start by making a gesture drawing; then you can use that drawing as a framework for building the finished drawing. A *gesture drawing* is a quick sketch that summarizes a body's basic pose. In the following set of illustrations, the gesture drawing tells you the general direction of the cat's upper and lower body, the relationship between the body and head, and the angles traced by the cat's tail. For a lot more about gesture drawing, see Chapter 7.

The following steps walk you through the process of making a lifelike drawing of an animal. Although the animal shown in the corresponding figures in this section is a cat, you can use these instructions to draw any animal. Before you get started, be sure to take a photograph of the animal you want to draw so that you have something to use to finish the drawing in case the animal moves. (The photograph will be especially useful in Steps 4 through 7.) For this exercise, you need your sketchbook, HB, 2B, and 4B pencils, and vinyl and kneaded erasers.

1. **Use your HB pencil to make a gesture drawing of the animal you're drawing.**

 Place your pencil on the paper and then try to forget about the paper entirely. Keep your eyes trained on your subject and imagine that you're actually drawing on the subject. Draw a circle for the head and a line that runs through the imaginary axis of the animal's body (see Figure 14-6a). Draw lines that follow the outside contours of the animal's body, making sure to change directions with your pencil whenever the direction of the body shifts (see Figure 14-6b). Draw a line that runs through the imaginary axis of the tail and any limbs you see (see Figure 14-6c).

After you've established the axis lines of the body, begin to draw the simple shapes that make up the body. Circles work best for the forms on most animal bodies (see Figure 14-6d). Again, keep your eyes on the subject as you draw and imagine that you're wrapping lines around the rounded sections of the animal's body.

2. **Use your HB pencil to connect and smooth out the contours implied by the simple shapes of the animal's body (see Figure 14-7).**

 Be sure to keep the lines light so that you can easily erase them later. You can look at the drawing to make sure that your pencil is in the right spot, but, other than that quick peek, continue to look at your subject and "feel" your pencil on the subject.

3. **Use your kneaded eraser to lighten the lines of the drawing (refer to Figure 14-7).**

4. **Use your 2B pencil to add texture by lightly shading the shadows and dark values on the animal's body (see Figure 14-8a).**

 Hatching is a great shading technique for shading furry animals because it allows you to build value and texture at the same time. Just be sure to shade in the direction that the fur grows (see Chapter 9 for more details on shading and the earlier section "Identifying the long and short of fur" for more details on rendering fur).

a

b

Figure 14-6:
Drawing
the basic
gesture of a
house cat.

c

d

Jamie Combs

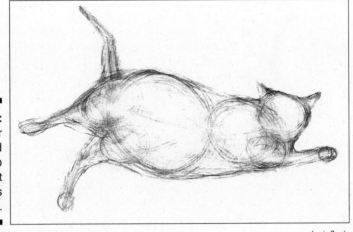

Figure 14-7:
Using your pencil and eraser to smooth out the cat's form.

5. **Use your 2B pencil to build as many layers as you need to represent the darker values where you see them on the animal's body (see Figure 14-8b).**

6. **Look closely at your drawing to see how the values compare to the actual animal; use your eraser and 2B pencil to make any necessary changes.**

7. **Switch to your 4B pencil and draw the darkest values on the animal's body (see Figure 14-9).**

Look for the darkest values wherever parts of the animal's body or strands of fur press together or overlap.

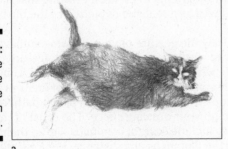
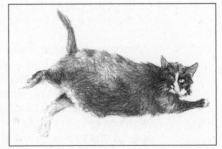

a b

Figure 14-8:
Building the appearance of texture through shading.

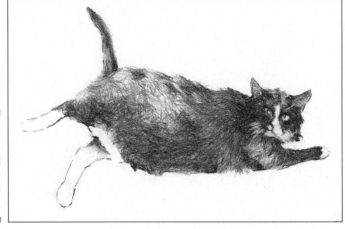

Jamie Combs

Figure 14-9:
Add the darkest values to complete the drawing.

Project: Wings on the Water

This project shows you how to combine different source material to create a realistic animal portrait. Although the drawings in this particular project represent flamingos, you can follow these steps for any bird you want to draw.

Because most birds are constantly moving unless they're sleeping, you more or less have to take a few photographs of them in your yard or at the local zoo to draw them accurately. Wherever you find your drawing subject, after you take a few photos, make a couple of gesture drawings of the bird and the movements it makes. You can then combine the information you get from your gesture drawings and photographs to create a drawing that has a sense of movement and volume as well as a realistic depiction of the bird's texture.

After you photograph and draw the gesture of your drawing subject, you need to do a little preparatory work to get your composition ready. For instance, you need to decide whether you'll draw your subject from a distance or close up and whether you'll have a single point of focus or several focal points within the composition. You also need to plan a path for the viewer's eyes to follow through your drawing space. The artist of the drawings in this project wanted to include several flamingos within their natural habitat, so she chose to set the flamingos at a distance. Because she wanted to make each of the flamingos a point of focus, she spaced them evenly across the drawing. To create a path through the drawing, she used the

bodies of the flamingos to create an imaginary line that leads the viewer's eyes across the drawing from the left. (See Chapter 6 for details on how to do all these preparatory tasks.)

When you have your gesture drawings, photographs, and composition in order, grab your sketchbook, HB, 2B, and 4B pencils, and kneaded and vinyl erasers and follow these steps:

1. **Draw a rectangle in your sketchbook to mark out your drawing space.**

 Make the rectangle equal or proportionately equivalent to the dimensions of the photograph you're using for your drawing.

2. **Make a light mark in your drawing space to indicate where the top part (likely the head) of your subject will be.**

3. **Make a light mark in your drawing space to indicate where the lowest part of your subject will be.**

4. **Use the photograph to make a quick gesture drawing of the subject that fits between the marks you made in Steps 2 and 3.**

5. **Compare the gesture drawings you made when you were watching your subject in its natural surroundings to the one you made in Step 4.**

 If your photo-derived gesture drawing seems a little flat, borrow attributes from the on-site gesture drawings.

6. **Draw the simple shapes of your subject (see Figure 14-10).**

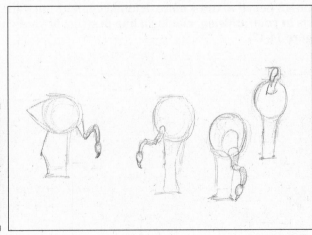

Figure 14-10: Drawing the simple shapes that make up your drawing subject.

Kensuke Okabayashi

7. **Add information from the photograph to your drawing space to complete the composition (see Figure 14-11).**

Don't feel like you have to include everything from the photograph. Focus on drawing the simple shapes that make up the main elements in the background of the photo; see Chapter 6 for more details on composition.

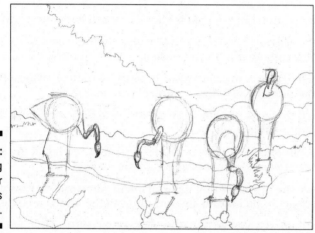

Figure 14-11: Adding to your drawing's composition.

Kensuke Okabayashi

8. **Use your kneaded eraser to lighten all the lines you've made so far.**

9. **Use your HB pencil to draw more detailed contour lines around all the elements in your drawing, making a line drawing of your composition (see Figure 14-12).**

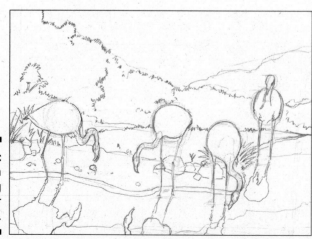

Figure 14-12: Making a line drawing of your composition.

Kensuke Okabayashi

10. **Use your 2B pencil to lightly apply shading to the whole drawing (see Figure 14-13).**

 See Chapter 9 for details on the different shading techniques you can use for this step.

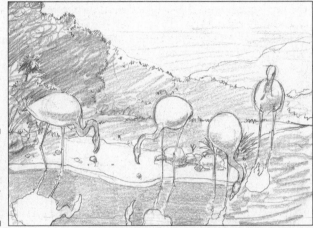

Figure 14-13: Applying shading to your drawing.

Kensuke Okabayashi

11. **Apply additional layers of shading where needed to add the right textures and values to your drawing (see Figure 14-14).**

 Be sure to increase the darkness of your shading where you need the values to be darker.

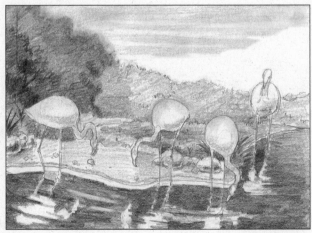

Figure 14-14: Adding darker layers to your drawing.

Kensuke Okabayashi

12. **Compare the values in your drawing to the values in your photograph and make any adjustments necessary to lighten or darken the values in your drawing.**

13. **Switch to your 4B pencil and add the darkest values to your drawing (see Figure 14-15).**

Look at the spaces beneath the wings and underneath the birds' beaks; these spaces likely require the darkest values in your drawing. Although the darkest dark values are often rather small, they're very important to the overall impact of your drawing. They draw attention to all the other values.

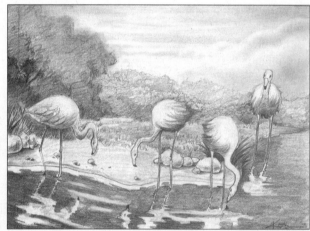

Figure 14-15:
Adding the
darkest
values to
your
drawing.

Kensuke Okabayashi

Chapter 15

Drawing People

The human figure is arguably the most revered drawing subject of all, not to mention one of the most intimidating! Mentally, the process of drawing people realistically can seem like the work of magician-like artists. In practice, however, drawing people isn't that different from drawing coffee cups or tadpoles — you start by getting an overall sense of shape and position and then work in stages toward greater specificity.

This chapter walks you through the basics of drawing people. We begin by showing you how to draw the basic shapes and features of the human body and then move on to the face-specific features like the nose, eyes, mouth, ears, and hair. As an added bonus, we cover the basics of drawing people in the distance and people in motion. Then we help you test your figure drawing skills with a simple project.

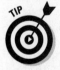

If you love the idea of drawing people and want a more in-depth exploration, check out *Figure Drawing For Dummies* by Kensuke Okabayashi (Wiley).

Drawing the Body

At first glance, you likely see the human body as a complex drawing subject, but when you look a little closer, you can see that it's actually made up of simple forms and shapes that make it just as easy to draw as most other subjects. The secret to drawing people well is looking past the totality of the body to see how its simple forms work together to become one body.

In the following sections, we walk you through the process of drawing a body. We help you get a basic idea of the underlying structures of the body — in other words, the bones and muscles — and we show you a proportional

system that comes in handy when you're trying to decide how big to make the head of your subject compared to the legs and arms. We also show you how to move through a simple order of operations for every person drawing you make. You start with a gesture drawing and then use simple shapes to build the parts of the body on top of your gesture drawing. Finally, you use contour lines to complete your body drawing.

Examining superficial human anatomy

"The head bone connected to the neck bone, the neck bone connected to the back bone. . ."

Remember that song from way back when? Well, by now, you know there's no bone called the "head bone," but for drawing, it doesn't really matter because you don't have to memorize the correct names of all the body's parts to be able to draw a body well. However, because many of the bones and muscles of the body are *superficial* — meaning you can detect them beneath the skin — you do need to know the basics of what's going on beneath the surface of the body if you want to re-create them accurately on paper.

Take a look at both views of the skeleton in Figure 15-1. The center of the body is the spinal column. The spinal column connects with the base of the skull, runs along the back of the ribcage, and then curves forward slightly and back again (creating the curvature of the lower back) to connect with the back of the pelvis. The limbs of the body are extensions attached to the center of the body.

Now look at the front and back views of the superficial muscles in Figure 15-2. The body's muscles attach to and wrap around the bones. Groups of muscles exert tension in opposing directions to hold everything in place and keep the body upright. Individual muscles contract and extend to facilitate movement of the bones. When a group of muscles wraps around a particular bone, it creates a bulge that gives shape to that part of the body. For an example, compare the head and upper torso in Figure 15-1 to the head and upper torso in Figure 15-2. Notice that the muscles in Figure 15-2 have a lot to do with the characteristic shapes you see on those parts of the body.

Being able to identify the basic shapes of the bones and muscles in the body not only helps you understand where the lumps, bumps, and depressions in the body come from but also helps you see them more clearly as you draw. For example, take a look at Figure 15-2. Having a basic idea of what the neck looks like beneath the skin makes it easier to identify the real shape of the neck, which makes it easier to draw your subject's neck.

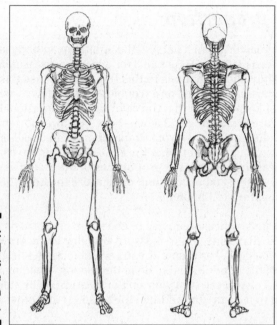

Figure 15-1:
Front and
back views
of the
human
skeleton.

Kensuke Okabayashi

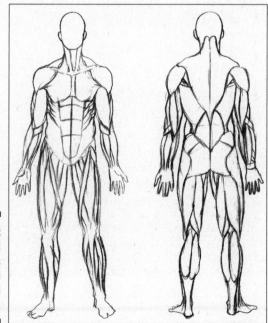

Figure 15-2:
Front and
back views
of the
superficial
muscles.

Kensuke Okabayashi

Measuring proportion

Regardless of the actual height of a person, the adult human body is generally about eight heads tall (see Figure 15-3 for a visual representation). Though you'll certainly find exceptions to this rule, you can use this proportional system as a starting point and as a troubleshooting device as you start drawing people. Just keep in mind that the eight-heads proportional system works only if the figure is standing and when there's no foreshortening. (See the later section "Building the body from simple shapes" for a definition of foreshortening.) Even so, no matter what the figure is doing, you can use the head as a unit of measure to check the proportions of the rest of your drawing. (For more on choosing and using a unit of measure to check the proportions in your drawing, turn to Chapter 7.)

When you choose a unit of measure to use to check the proportions in your drawing, you can use that same unit to measure anything in the drawing no matter how big or small it is. For example, you can compare the height of a head to the length of the upper leg as we do in the section "Building the body from simple shapes," or you can turn your unit of measure on its side and use the height of a head to measure the width of the torso (or any other part of the drawing).

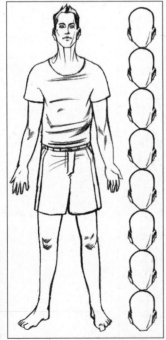

Figure 15-3:
Eight-heads
proportional
system.

Kensuke Okabayashi

Capturing gesture

The *gesture* of a figure is its general position in space. Perhaps a figure is sitting straight up with legs out to the left and bent so that the lower part of the legs strikes a diagonal to the floor. This particular position is the gesture. To capture the gesture of a figure in drawing, you must first look intently at the figure and then draw lightly with rapid flowing movements, keeping your eyes on the subject the entire time to re-create the essence of the pose on your paper.

Figure 15-4 shows an example of a gesture drawing. Notice that the artist didn't try to capture any real details of the figure (or anything else in the scene) in the gesture drawing; he simply tried to represent the figure's basic position in space. After you finish your gesture drawing, you can use it as a foundation for the rest of your drawing. Keep in mind, though, that you'll most likely erase the lines of your gesture drawing later anyway, so don't stress over making it perfect. (For more on gesture drawing, see Chapters 7 and 14.)

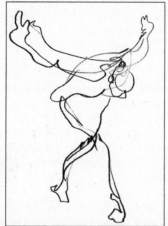

Figure 15-4: Example of a gesture drawing.

Kensuke Okabayashi

Building the body from simple shapes

After you establish the gesture of a figure, you can begin to build the volumes of its body by reducing them to simple shapes (see Figure 15-5 for an example of what we mean). In the figure, the head is an egg-like shape that's rounder at the back and narrower near the chin.

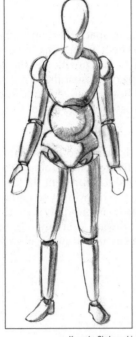

Figure 15-5:
Simplifying
the body
into its basic
shapes.

As you break the body into simple shapes, don't forget to consider the proportions of those shapes. To help you get the sizes right for all your body parts, determine what size you're going to make the head in your drawing; then use that dimension to determine the sizes of other parts by comparison. For example, if the head you draw is 1 inch tall, the upper leg will be 2 inches tall because it's the equivalent of 2 heads high (see the earlier section "Measuring proportion" for more details).

When your figure is seated (as it is in Figure 15-6), you need to take foreshortening into account to see the simple shapes. (*Foreshortening* is basically the illusion that the length of an object — like your figure's leg — appears to shrink as the object is pointed straighter at you; see Chapter 11 for more details.)

The first thing you need to do when drawing the simple shape of a foreshortened object is to imagine what it would look like flat. For example, if you're trying to draw the upper part of a bent leg, imagine that you're looking at it behind a piece of glass and use your imaginary pencil to trace the outer edge of the upper leg. When you have an idea of the shape, draw that shape where it should go on your paper. Next check the proportions of the shape to make sure they're right.

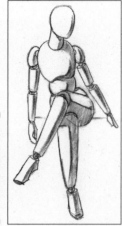

Figure 15-6:
Simplifying
the seated
body into
its basic
shapes.

Kensuke Okabayashi

Foreshortening makes it impossible to use the eight-heads proportional system to check the proportions of the upper part of the bent leg, but don't worry; you can still use the head as a unit of measure to determine the height and width of the bent upper leg. When you use the head as a unit of measure to check proportions, you basically just compare the height of the real head to the dimensions of the real object (like the upper part of the leg) and then use the comparison to determine the dimensions of the drawn object. If the object you're measuring is half the height of the head, the drawn object should be half the height of the drawn head. (See Chapter 7 for even more information about using a unit of measure to check proportions.)

If you have a hard time seeing the simple shape of a foreshortened shape or form on your figure, close one eye. Doing so eliminates the double-vision that often occurs when both eyes try to focus on something pointed toward them. To see how closing one eye improves your ability to see a volume pointed toward you, point a finger directly at your nose; then close one eye. Notice how much better you can see it with one eye closed than with both eyes open.

Using contour lines to refine your drawing

After you've drawn your figure's simple shapes on top of your gesture drawing and erased the majority of the gesture lines, you can use *contour lines* (weighted lines that move along the exterior and interior edges of your subject) to refine the drawing and make it look like a real person. Simply use your kneaded eraser to lighten the lines of the shapes and then begin to use lines to build more realistic contours on top of the lightened shapes. Figure 15-7 shows what Figure 15-6 looked like after the artist lightened the basic shapes and added contour lines (see the next section for details on how to add hair and facial features to your figure).

Figure 15-7:
Using con-
tour lines to
refine the
drawing in
Figure 15-6.

Kensuke Okabayashi

Start drawing your contour lines with a medium pencil like an HB or 2B so that you can erase any mistakes you make fairly easily. When you finish drawing the contour lines, you can use a softer pencil, like a 4B, to retrace any of the lines that could use heavier line weight.

As you add your contour lines to your drawing, don't confuse them with simple *outlines,* which are simple lines that depict the edges of flat shapes. Outlines are the same weight, or thickness, throughout the drawing (think about the objects in children's coloring books). Contour lines, on the other hand, are lines that depict the exterior and interior edges of a form that has volume. The weight of contour lines varies a lot within a single form to show the way light strikes a three-dimensional form differently in different spots. Artists use contour lines (not outlines) to render realistic line drawings of people. When you're drawing a darker area (like the line that separates the arm from the torso), use a thicker, darker line; when you're drawing a lighter area (like the curve of a shoulder that's catching light), use a thinner, lighter line. (See Chapter 7 for more info on contour drawing and varying your line weight.)

Picking up Portraiture

When it comes to portraiture, the main problem is that most people think it's all about the face. Beginning artists often forget about the head or think they can draw the shape of the head after they draw the rest of the facial features, but, unfortunately, working in this order almost never results in a realistic portrayal of the drawing subject. The eyes end up too far apart or too close together, while the nose ends up a little too long or a little too short. On the other hand, if you draw the head first, you have a much better chance of getting all the facial features right because you have a defined space in which to put them.

The following sections show you how to draw the head first and then how to place and draw the rest of the facial features with respect to the head's position and size.

Measuring proportions for the head and face

When you're drawing the head and face of your figure, it's a good idea to start with a few basic proportions. For example, on most human faces, the eyes are actually found halfway between the chin and the *crown,* or the highest visible part of the head. (In portraits drawn by beginners, the eyes are almost always too high.)

Whenever you begin a portrait, begin by drawing the shape of the head. Then locate the position of the facial features by subdividing the head according to these basic proportions (see Figure 15-8 for a visual guide):

✔ Draw a line halfway down the head for the eyes.

✔ Draw a line one-third of the way down the head for the brow.

✔ Draw a line two-thirds of the way down the head for the root of the nose.

✔ Draw a line one-third of the distance between the root of the nose and the chin for the line of the lips.

✔ Draw marks for the ears on the side of the head between the lines for the brow and the root of the nose.

Note: The top of the head is the highest point you can see and may be pretty far back.

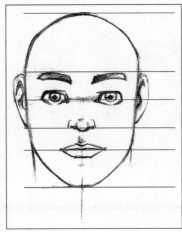

Figure 15-8:
Marking the proportions of the head and face.

Kensuke Okabayashi

To check the position of your own eyes on your head, grab a ruler and find a mirror. Hold the ruler vertically so that you can see it next to your head as you look in the mirror. Line the bottom of the ruler up with your chin and notice how many inches are between your chin and the midline of your eyes. Then line the bottom of the ruler up with the midline of your eyes and check to see how many inches are between that midline and the top of your head.

Keep in mind that the head is basically a rounded, egglike volume that is the fullest at the back and tapers to the chin. (The jaw breaks the egg shape at the point where the jaw and back of the skull meet, but drawing the head as an egglike shape is still a helpful, simple place to start.) The features (eyes, nose, mouth, and so on) are fixed in place on and within the rounded volume of the head, so when the head turns or tilts, the features move with it. For example, the eyes are parallel to the brow. No matter how the head tilts, the eyes are always parallel to the brow — even though your brain is used to seeing eyes that are parallel to the ground.

When you're drawing a head that's turned or tilted, make sure that you pay attention to what your eyes see and not what your brain thinks it knows about the face. For example, notice how the eyes on both faces in Figure 15-9 are parallel to their respective brows, not to the ground. Also, notice how much space the facial features actually occupy compared to the width and height of the turned and tilted heads in the figure. Don't let your brain's expectations about the angle of facial features interfere with the angles you actually see; if you do, you may draw a tilted head with features that are sliding off the face because your brain believes the features must be horizontal. Likewise, because your brain is used to thinking of the portrait as a picture of a face, you may be tempted to place the features in the front of your drawing even when the head is turned away.

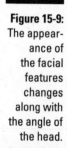

Figure 15-9:
The appearance of the facial features changes along with the angle of the head.

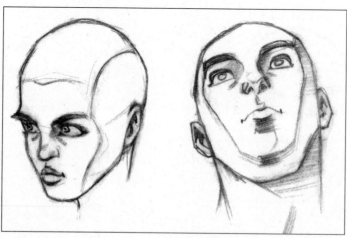

Kensuke Okabayashi

Drawing facial features

As a child, you probably learned to draw faces with symbolic features, like a big circle for the head, two dots or small circles for the eyes, and a wide *U* for the mouth (an upside-down *U* represented a frown). Although these symbolic features helped you visualize and represent different emotions as a child, they can get in the way as you practice drawing realistic portraits as an adult. So to draw facial features successfully, focus your eyes on your subject, analyze what you see, and try to forget everything you once knew about drawing faces.

The next four sections give you a chance to practice accurately drawing a nose, an eye, a mouth, and a set of ears. The first time you move through the steps in each section, copy the examples in the exercise or find a photograph of a person facing front. Then find a mirror and use the steps to draw your own nose, eyes, mouth, and ears. For each exercise, you need your sketchbook, your 2H, 2B, and 4B pencils, and your kneaded eraser.

The nose knows no bounds

Beginners often find the nose complicated to draw because when you look at the face straight on, you're seeing the nose in a foreshortened view (see Chapter 11 for more on foreshortening). To draw the nose successfully, you must create the illusion that the nose is pointing out toward the viewer. The secret to creating this illusion lies in trusting your eyes rather than your brain; doing so allows you to accurately record the shapes and values you see.

Follow these steps to draw two noses, one in profile and one facing front:

1. **Use your 2H pencil to draw the simple shapes of the nose in profile and the nose that faces front (see Figure 15-10a).**

 Notice that in each case, the basic shape of the nose is a triangle. The bulk of the nose is a tent-like structure, and a bony ridge runs down the top, flanked by two rectangular sides. At the end of the nose, you see a ball-like spherical shape that is more or less pronounced depending on the person you're drawing. To the left and right of the ball are smaller spherical shapes that contain the nostrils.

2. **Lighten the simple shape lines with your kneaded eraser and use your 2B pencil to draw contour lines on top of the lightened shapes (see Figure 15-10b).**

 When drawing the front-facing nose, you may want to add light contour lines to indicate the sides of the bony ridge of the nose. Just make sure that you don't draw them too dark. As you draw these particular contour lines, be sure to keep your eyes trained on the subject while you draw; as soon as you look at the paper, you force yourself to draw from

memory, which is hard to do because the subtle changes that define the curves of the nose are difficult to memorize. For this reason, it's much easier to draw any lines that vary in weight or direction while you're looking at the subject's nose. Simply choose a starting point on your paper, place your pencil there, and then move your pencil while looking at the nose. Try to forget about the paper and imagine you're actually drawing on the nose. Doing so takes patience, but it saves a lot of time in the end.

3. **Use your 2B pencil to draw the nostrils of each nose (see Figure 15-10c).**

 As you draw the nostrils, focus on what they actually look like on your subject. In other words, try not to let your brain's perception of nostrils as dots or circles influence your drawing. Although nostrils are openings, they aren't perfectly round like circles; instead, they're shaped more like kidney beans.

4. **Use your kneaded eraser to clean up any stray lines and your 4B pencil to add emphasis to lines that need extra weight (see Figure 15-10d).**

 See Chapter 7 for a discussion of line weight.

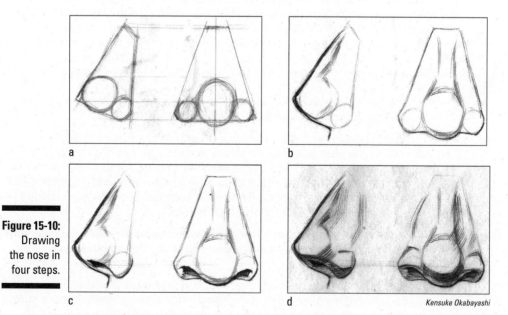

Figure 15-10: Drawing the nose in four steps.

a

b

c

d

Kensuke Okabayashi

The eyes have it

The eyes are made up of eyelids and eyeballs. The eyeballs sit inside the skull's *ocular cavities* (the openings between the brow and the cheekbone). The eyelids (each eye has an upper and a lower one) stretch like awnings around the spherical eyeball, and the upper lid generally has a crease somewhere in the middle of it. Both the upper and lower eyelids also have a fringe of eyelashes attached to them. The eyebrow is a fringe of hair that grows out of and along the *brow bone,* which is the bony ridge that's situated above the eye.

Follow these steps to draw an eye:

1. **Use your 2H pencil to draw a rounded oval to indicate the position and size of one of your subject's eyeballs.**

2. **Use your 2H pencil to draw the flat-shaped upper lid at the top of the oval you drew in Step 1 (see Figure 15-11a).**

3. **With your 2H pencil, draw the flat shapes to the left and right of the upper lid that angle off to the inner and outer corners of the eye (see Figure 15-11b).**

4. **Use your 2H pencil to draw the lower lid (refer to Figure 15-11b).**

 The lower lid is more horizontal in the front because the swell of the eyeball pushes it forward. To the left and right of the center, the lower lid angles toward the corners of the eye. To draw the lower lid, simply draw the line that separates the lid from the eyeball. Be sure to look at the subject carefully while you draw because the curve of the line is different for every person. It's easier to get right if you draw the center part first and then the two sides.

5. **Use your 2H pencil to draw the crease of the upper lid (see Figure 15-11c).**

 As you look at your subject, notice how far above the opening of the eyelid you see the crease. Place your pencil where the middle of the crease needs to be on your paper; then look at the crease on your subject and draw the line.

Figure 15-11: Drawing the simple shapes that make up the eyeball and lids.

a　　　　　　　b　　　　　　　c　　　*Kensuke Okabayashi*

6. **Use your 2H pencil to draw the basic shape of the iris (see Figure 15-12a).**

 As you look at your subject, notice how much of the white of the eye is filled up by the iris and whether the iris touches the lower lid, is over-lapped by the lower lid, or leaves a gap of white above the lower lid.

Figure 15-12:
Drawing the
iris, lashes,
and
eyebrows.

 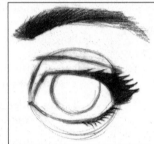

a b c *Kensuke Okabayashi*

7. **Use your 2B pencil to draw the eyelashes (see Figure 15-12b).**

 Don't try to draw every lash. Instead, draw the shapes you really see on your subject. For example, on the upper lid, you may notice that the fringe of lashes looks like a dark shape that roughly lines up with the curve of the lid. On the lower lid, you may see small wisps of lashes.

 Notice that on both lids, the lashes don't go all the way to the inner corner of the eye. Focus on your subject as you draw the eyelashes and be sure to start and end them at the right places.

8. **Use your 2B pencil to draw the eyebrows (see Figure 15-12c).**

 Notice that the top and bottom edges of the brow aren't defined by lines but that you get an impression of line because of the arrangement of the hairs of the eyebrow. Eyebrows look more realistic if you build them using hatching marks, which mimic the way hairs really grow (see Chapter 9 for more on hatching). If you draw the shape of the eyebrow and then fill it in, your eyebrow will look unnatural.

Put your money where your mouth is

To draw a realistic-looking mouth, you need to keep in mind the following points:

✔ The mouth is made by a pair of overlapping lips stretched around the rounded volume of the head.

✔ The lips are a continuation of the skin of the face.

✔ The most important aspect of getting the mouth right is accurately drawing the line between the lips.

Follow these steps to practice drawing a mouth:

1. **Use your 2H pencil to make three small marks to indicate the center and both corners of the line between the lips (see Figure 15-13a).**

 The center of the line between the lips is generally one-third of the way between the root of the nose and the chin. To find the corners of the line, locate the position of each side between the corner of the nose and the side of the face. Notice that the corners of the line between the lips usually sit slightly lower on the face than the center of the lips.

2. **Use your 2H pencil to make a small contour line for the center of the line between the lips (see Figure 15-13b).**

 Notice that you can see the line between the lips more clearly where the lips part and less clearly where they press together.

3. **Use your 2H pencil to draw the left and right sides of the line between the lips (see Figure 15-13c).**

 Begin each side of the line from the center, and draw out toward the corner. Keep your eyes trained on the subject while you draw.

4. **Use your 2B pencil and any shading method you prefer to lightly build shadows on the upper lip and beneath the lower lip (see Figure 15-14a).**

 See Chapter 9 for info on the different shading techniques you can use.

5. **Use your 4B pencil to build shading into areas of the lips where the values are darker (see Figure 15-14b).**

Figure 15-13:
Drawing the line of the lips in three stages.

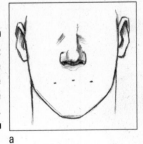
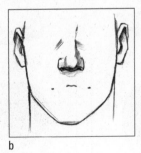

a b c *Kensuke Okabayashi*

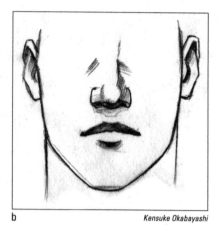

a b *Kensuke Okabayashi*

When your subject's lips are parted, you can follow the same steps you use for closed lips, except you have to account for the opening of the mouth, too. To make the opening of the mouth realistic, draw the inner line of the top lip the same way you draw the line between the lips, beginning with the middle and working out to the corners. Then draw the line that defines the inside of the bottom lip. Use a 2B pencil to lightly shade the opening of the mouth (see Figure 15-15a). Even if the opening of the mouth looks quite dark, keep the shading in the opening of the mouth somewhat transparent so that the opening of the mouth actually looks like an opening. If the shading is too solid, the opening of the mouth will look like a solid shape rather than an opening. Finally, look at the inner contours of each lip. If you see an area where the contours look darker than in other areas, use your 4B pencil to retrace them in the drawing (see Figure 15-15b).

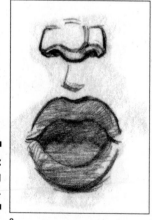 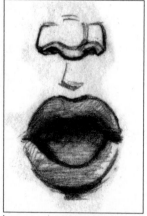

Figure 15-15:
Drawing
parted lips.

a b *Kensuke Okabayashi*

If you can see teeth in your subject's open mouth, you need to figure out how much of the opening of the mouth is actually taken up by teeth. Then follow the same directions you use for drawing an open mouth, except before you shade the opening of the mouth, use your 2H pencil to draw the simple shapes of the teeth you see (see Figure 15-16a). Use your kneaded eraser to lighten the lines around the teeth, and use your 2B pencil to shade the opening of the mouth. Then use shading to define the edges of the teeth. Finally, use a very sharp 2B pencil to draw marks between the teeth at any point where you see dark spaces (see Figure 15-16b).

Figure 15-16:
Drawing
realistic
teeth.

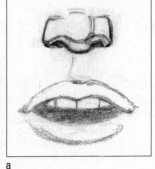

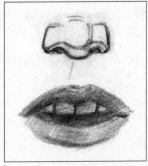

a b *Kensuke Okabayashi*

All ears

Ears are made of intricate spirals of cartilage with some soft tissue around the edges. Like eyes, noses, and mouths, every ear has unique characteristics. Unless you're drawing a portrait in profile, the ears will always be somewhat foreshortened, if you can see them at all. In general, ears fall between the brow bone and the root of the nose. However, don't forget to look carefully at your subject because everyone's ears are different.

Unless you're making a drawing specifically about ears, keep them simple. You can suggest realistic ears without going into much detail. Because ears are small, you can't see a lot of detail from a typical viewing distance anyway.

Follow these steps to draw ears:

1. **Use your 2H pencil to draw the simple shape of each ear where it appears on your subject.**

 Most of the time, this shape is something like a half-circle or oval.

2. **Break the shape of each ear into two or three sections based on the big divisions you see.**

Look for shadows made by overlapping sections of cartilage and use any combination of lines and shading to represent the shadows. Usually, you can see one division near the top of the ear where the top of the ear curls over the interior of the ear. You may see a second division where a large piece of cartilage extends back and downward from the top half of the interior of the ear.

3. **Switch to a 2B pencil to add contour lines.**

4. **Use your kneaded eraser to clean up any stray lines and add or refine any shading to finish the drawing (refer to Figure 15-13c).**

Drawing hair that actually appears to grow out of the head

Drawn hair looks realistic only when it appears to grow out of the head and has the texture of a soft, moveable mass. (For detailed information about creating hairlike textures, see Chapters 10 and 14.)

To draw hair that looks like it grows out of the head, you have to replicate what happens along the hairline. Figures 15-17a and 15-17b show what happens when you use an eraser to break the hairline in different spots to let the scalp break through the hair like it does in real life. Notice how much more convincing the hair looks in Figure 15-17b.

Figure 15-17:
Comparing
two
renditions
of the front
view of hair.

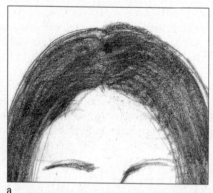 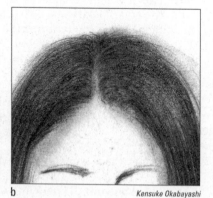

a b

Kensuke Okabayashi

Figures 15-18a and 15-18b show a similar example except in these drawings, the view is from the back of the head and the artist uses the eraser to break the line along the part of the hair. Notice how much more realistic the hair is in Figure 15-18b.

 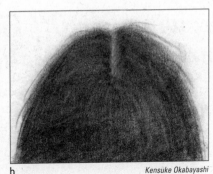

Figure 15-18: Comparing two renditions of the back view of hair.

a

b *Kensuke Okabayashi*

To draw realistic hair, grab your sketchbook, kneaded eraser, and 2H, 2B, and 4H pencils and follow these steps. The first time you work through the steps, copy the drawings you see in this exercise; then find a friend to model for you or use a mirror to draw your own hair.

1. **Use a 2H pencil to make hatching marks that describe the general direction and overall shape of the hair (see Figure 15-19a).**

 See Chapter 9 for more on the different shading techniques you can use to add volume and texture to drawings.

2. **Use a kneaded eraser to lift out the light shapes in the hair and use your 2B pencil to build shading on the darker shapes (see Figure 15-19b).**

3. **Use a soft pencil, like a 4H, to add dark marks that separate different sections of hair (see Figure 15-19c).**

 These marks represent shadows that occur when one section of hair overlaps another.

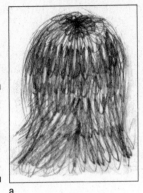 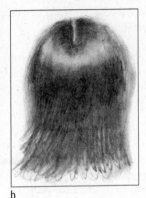 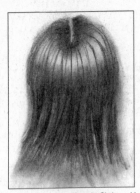

Figure 15-19: Drawing realistic hair in three stages.

a b c *Kensuke Okabayashi*

Drawing Far-Off Figures and People in Motion

To draw both far-off figures and people in motion, you have to look for essence rather than detail. In both cases, you add realism to your drawings by using less detail. After all, the only time you really see details on people in real life is when they're fairly still and at a normal conversational distance from you. The farther someone is from you, the less you notice the details about them. Similarly, movement blurs your ability to perceive details, so the more someone moves, the less detail you see. Regardless of whether your subject is far away or in motion, you notice gesture, shape, size, and light and dark values rather than specific details.

In this section, you find strategies for showing distance or motion in your drawings. You practice making a drawing that incorporates both distant crowds of people and people in motion.

Drawing people and crowds in the distance

To draw figures that seem to be in the distance, you need to incorporate the effects of atmospheric perspective into your drawing. Simply put, *atmospheric perspective* means that the farther an object recedes into the distance, the smaller and less distinct it looks. In other words, the figures you draw in the distance need to look like suggested forms rather than detailed people. Figure 15-20 shows an example of what we mean by *suggested forms*. (See Chapter 11 for more information on atmospheric perspective.)

When people are in groups and/or crowds, the effect of atmospheric perspective is that the people in front look more distinct than the people farther back. However, if the whole group or crowd is meant to be in the distance, no one will be very distinct.

To help you get a handle on drawing groups of people, think of the crowd you're drawing as a mass rather than individuals. Draw the general shape of the mass first. Then you can add the necessary details to the people in the front of the crowd and the basic forms of the people in the back.

To see how atmospheric perspective comes into play when you're drawing realistic crowds or groups, grab your sketchbook, kneaded eraser, and 2H, 2B, and 4B pencils and follow these steps. As you work through the steps, copy the drawings you see here, or, if you have a photograph of a crowd, make your own drawing based on that photograph.

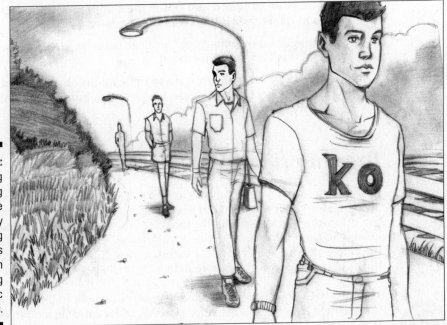

Figure 15-20:
Drawing
convincing
people in the
distance by
suggesting
features
rather than
adding
specific
details.

1. **Use your 2H pencil to draw rounded shapes to indicate heads within the crowd (see Figure 15-21a).**

 Make the heads in the front slightly larger than the ones in the back.

2. **Use your 2H pencil to draw the bodies of figures in the crowd (see Figure 15-21b).**

 Begin with the figures in the front and keep the clothing simple.

3. **Lighten all your lines with a kneaded eraser.**

 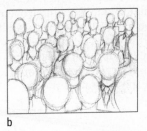 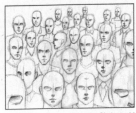

Figure 15-21:
Drawing a
crowd.

a b c

4. **Switch to your 2B pencil and refine the contours of the heads and clothes of the figures in the front of the crowd.**

 Even though you're adding contour lines here, be sure to keep the lines light, and don't add intricate detail.

5. **Use your 4B pencil to draw lines to indicate the shadows that would be cast by lines of brows, noses, and mouths, but don't actually render the features (see Figure 15-21c).**

Drawing figures in motion

Gesture drawing is a great way to capture the activity of figures in motion. In fact, the only chance you have at sketching figures in motion with any realism is to work quickly and fluidly, focusing only on the essence of the movement. Then, after you make the gesture drawing, you can worry about adding the details of your subject and its surroundings. (Check out the earlier section "Capturing gesture" for more details on making gesture drawings.)

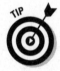

Your ability to draw believable motion depends on your understanding of what motion feels like. To get some practice with capturing motion on paper, take your sketchbook to a place where you can count on a lot of activity, perhaps a playground or a busy city street. Remind yourself that your subject is the motion and allow yourself the freedom to make what may look like a swirling, crazy mess. As long as you feel engaged with the movement you're trying to draw, you're doing it right. Figure 15-22 shows a few examples of gesture drawings of people standing, walking, and sitting. Notice that you can't see details, but you definitely get a sense of what the people are doing and even how they may be feeling. For example, the people in Figure 15-22a are both standing with their backs to you, but the pose on the left conveys confidence while the one on the right looks more timid.

Another way to make a drawing of figures in motion is to use a photograph as a reference. On the plus side, using a photographic reference allows you the luxury of seeing frozen motion and gives you the time to represent it on paper. On the minus side, copying frozen motion can lead to a drawing in which the action looks stilted. To prevent this stiffness, begin the drawing by making gesture drawings from objects in the photograph. The fast, free movements you make to capture the essence of the figures in the photograph give your drawing an energetic foundation. Figure 15-23 shows one figure jumping and the other leaping through the air.

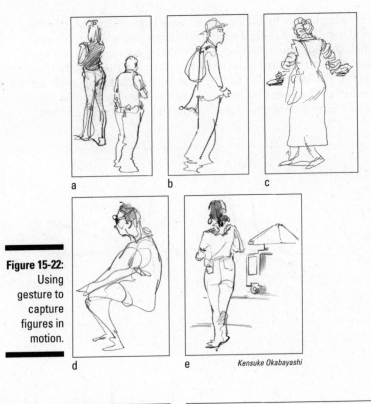

a b c

Kensuke Okabayashi

Figure 15-22:
Using
gesture to
capture
figures in
motion.

d e

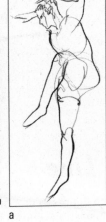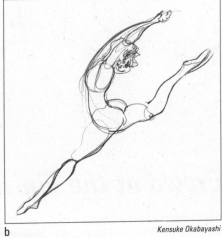

Figure 15-23:
Beginning
with gesture
drawing
even when
you use a
photograph
as a
reference.

a b

Kensuke Okabayashi

When you're drawing figures in motion, try to use a kind of shorthand to suggest the feet and hands. If you spend time rendering hands and feet in detail, your figure will look still even if the body is not. You can simplify hands by drawing a shape that fans out from the wrist in a direction that follows the motion of the arm. You can simplify feet by drawing the lines that would be the bottoms of the feet or the lines that separate the feet from the ground. Figure 15-24 shows some examples of shorthand, motion-inspired hands and feet.

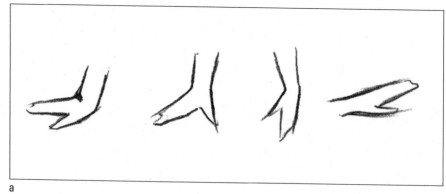

a

Figure 15-24: Simplifying hands and feet to show motion.

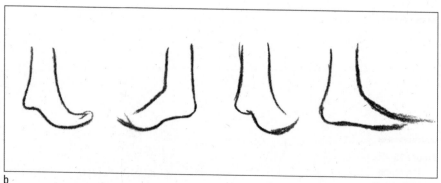

b

Kensuke Okabayashi

Project: Crowd at the Finish Line

This project combines a crowd in the distance with figures in motion. To complete this project, you can either copy from the illustrations shown here or find a photograph of the finish line of a race to use for making a drawing based on the following steps. Whichever method you choose, grab your sketchbook, your 2H, 2B, and 4B pencils, and your kneaded and vinyl erasers and follow these steps:

1. **Use your 2H pencil to draw the simple shapes that make up the crowd, the runners, and the background (see Figure 15-25).**

 Begin with a quick gesture drawing to place the figures and other objects in the drawing. Then build the people and objects using simple shapes.

Figure 15-25: Use gesture drawing to get a sense of placement and posture and then use simple shapes to build people and objects.

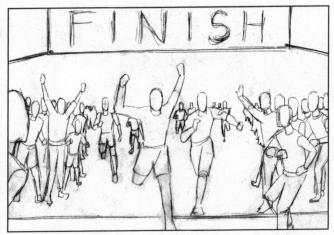

Kensuke Okabayashi

2. **Use your kneaded eraser to lighten the lines you drew in Step 1.**

3. **Switch to your 2B pencil and use whatever shading technique you prefer to lightly build the simple value shapes that make up the figures and background (see Figure 15-26).**

Figure 15-26: Use a single value to block in all the shadows you see.

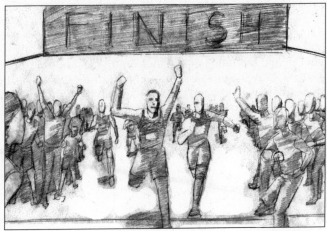

Kensuke Okabayashi

The simple values at this stage should be all one value. See Chapter 9 for more on using shading techniques to add value.

4. **Use your kneaded eraser to lighten any of the dark values that need to be lighter; then use your 2B pencil to build darker values into areas where the shadows look darker (see Figure 15-27).**

 Lightly add suggestions of facial features.

Figure 15-27: Use your eraser to lighten values and a softer pencil to darken values where needed.

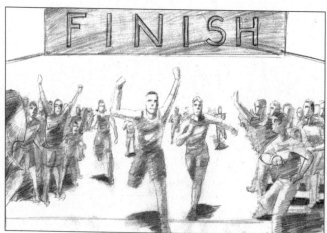

Kensuke Okabayashi

5. **Use your 2B pencil to slightly clarify the facial features, hands, and feet of the closest figures (see Figure 15-28).**

 Instead of adding a lot of detail to all the figures in a distant drawing like this, you amplify the clarity of people and objects that are closest to you. Doing so increases the effect of atmospheric perspective, making the people in the back seem farther away because they're less clear. Even as you slightly clarify the facial features on the closest people, take care not to add too much detail. Instead, think of adding emphasis to the suggested features. For example, in Figure 15-28, the details on the faces of the nearest figures haven't changed much from those in Figure 15-27, but they're darker and made with crisper lines.

6. **Switch to your 4B pencil and add the darkest darks where you need them (see Figure 15-29).**

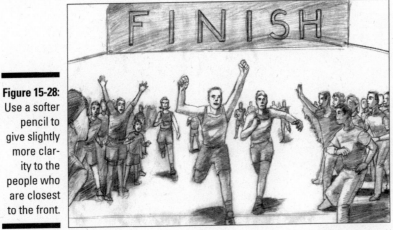

Figure 15-28:
Use a softer pencil to give slightly more clarity to the people who are closest to the front.

Kensuke Okabayashi

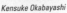

Figure 15-29:
The finished drawing with the darkest values in place.

Kensuke Okabayashi

Part IV
The Part of Tens

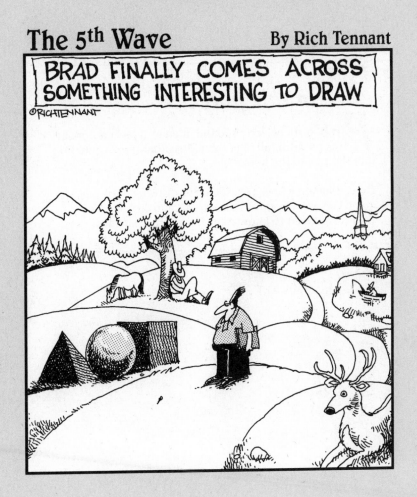

In this part . . .

*P*art IV is an eclectic section, indeed. The chapters in this part are full of helpful ideas that don't quite fit into the rest of the book.

Here, you find a few great ideas for drawing cartoons, some key ways to grow as an artist, and a handful of things you need to know to protect your drawings.

Chapter 16

Ten Tips for Drawing Cartoons

In This Chapter

▶ Getting the creative juices flowing

▶ Creating the initial sketch and working out the details

▶ Transforming your sketch into a finished cartoon

Drawing cartoons is a fun and creative way to use your drawing skills. After all, a cartoon is basically just a drawing of life into which you inject your personal point of view. When you draw cartoons, you have a license to give form to anything you can imagine. So if you want to draw a tree conversing with a rock, go for it! Your cartoons can be silly, sweet, serious, or anything in between. You can use cartoons to tell jokes or stories or just to bring your unbelievable ideas to life. The sky's the limit when it comes to drawing cartoons, and this chapter is here to help guide you from idea to sketch to completed cartoon.

Coming Up with an Idea

You may not know exactly what you want to draw every time you get the urge to pick up your pencil and sketchbook. Sometimes ideas of what to draw come easily one right after another like colorful handkerchiefs from a clown's pocket. Other times, they may not be that easy to find, so whenever you get an idea for a drawing, be sure to write it down. Keep track of your ideas in a notebook and don't try to judge them when they come. You never know where your next masterpiece will come from.

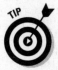

If you've hit a bit of an idea dry spell, try out the following suggestions for jogging your creativity:

- Think of an object and then imagine a characteristic you wouldn't ordinarily expect that object to have. Draw it.

- Think of two things that don't have any relationship to each other and create a drawing of what would happen if you combined them.

- ✓ Think of someone you know (or know of) and pick out a defining characteristic of that person. Imagine drawing that person so that the characteristic you're thinking of is more noticeable than the person's physical likeness.

- ✓ Ask your friends or co-workers what their favorite foods are; then transform the people into walking, talking versions of those foods.

- ✓ Imagine that you can do something you'd never actually be able to do. Consider how other people might react to your new ability or power. Draw a cartoon of this scenario.

- ✓ Imagine that you have a very loving, very large pet. How would you react to the oversized pet? Draw a cartoon of how the pet changes your life.

- ✓ Imagine what you would do if you woke up one morning with six legs. Draw a cartoon of what you'd look like and what you'd do with your extra limbs.

- ✓ Imagine what might happen if the government contacted you and asked you to do a dangerous job that only you could do. Draw a cartoon of what the job might be and how you would respond.

- ✓ Imagine what would happen if the only way you could move around were on stilts, a pogo stick, or roller skates. Draw a cartoon of that scenario.

- ✓ Think about where and when you would go if you and your family could be transported in time. Create a cartoon of what you would wear, where you would go, and whom you would see.

Embracing Your Influences without Losing Yourself

When you were little, you figured out how to do most things by copying the actions of other people around you. Eventually, you mastered some basic life skills, and then — probably about the time you became a teenager — you started developing your own style of doing things. It's the same way with drawing.

If you love the idea of cartooning, you've likely been inspired by some other artists' cartoons, and you may want to borrow your favorite cartoonists' styles and use them to make your own visual stories. Borrowing another artist's style not only helps give you direction as you draw your first cartoons but also is a terrific way to develop your cartooning skills. Moreover, it's comforting to create works that resemble the cartoons you like because it feels like you're finding your style. The truth, though, is that if you want to grow beyond copying your idols and become the unique artist you're meant to be, the real work begins as soon as you figure out how to imitate another artist's style — when it's time for you to branch out on your own and develop your own style.

Borrowing from your influences is something artists have always done. It's a good and healthy practice — most of the time. However, borrowing becomes problematic when you overborrow and your work becomes basically indistinguishable from someone else's. One good example of overborrowing is fan fiction. *Fan fiction* refers to stories written by devoted fans of a particular storyline with the sole intention of making alternative episodes of the exact same story. If your drawings look like alternative episodes to someone else's drawings, you may be overborrowing.

Although it's sometimes tricky to know if you're overborrowing from your influences, one sure way to tell is by what you say when someone asks you to describe your work. If the first word out of your mouth is the name of another artist's style, you're classifying your work as a part of someone else's work rather than your own, meaning you're overborrowing.

If you feel like you're copying another artist's work too closely, follow these tips to help you start becoming your own artist:

- ✔ **Stop defining yourself as a practitioner of a particular style.** Your *style,* or the way you do things, is always a work in progress; it changes as you develop your skills and as your interests change. The key to borrowing successfully is figuring out what you like about how someone else's work looks and then borrowing something (but not everything) about it to build your own drawings. You can always tell people who your influences are, but let them know you've got your own style.

- ✔ **Spend some time every now and then drawing from life rather than your imagination.** Cartoons are supposed to be imaginative, and it's definitely a good idea to work from your imagination when you draw them. However, even the most imaginative cartoonists benefit from honing their observational skills.

 Even if you think drawing from life has nothing to do with the artist you want to be, give it a try anyway. Drawing from life improves your drawing skills and your sense of how the world really works. It's also a great way to discover the quirks that make your drawings unique because when you're focused on what something really looks like, you don't have to think about your style (or the style of anyone else, for that matter). When you're relaxed about style, things that make you who you are naturally make their way into your drawings.

 If you don't know how to start drawing from life, take a few minutes to flip through Part III of this book. It's full of information about drawing from real life, including objects, nature, animals, and people.

- ✔ **Give yourself "influence vacations."** An *influence vacation* is when you spend a day or two drawing without allowing any characteristics of your favorite influences to be part of your drawings. For example, if you always draw characters that have hairstyles you borrow from another artist, take an influence vacation and don't allow yourself to make hair that way. See what happens when you have to draw hair a different way.

Try not to judge your work as you draw. Sometimes it takes a few days to figure out how you feel about making changes in your techniques and style. The more you practice thinking about yourself as an artist with a unique, developing style, the more you'll make intentional decisions about borrowing from other artists, and the closer you'll be to finding your own drawing voice.

Making Decisions with Your Idea in Mind

So you have an idea for a cartoon . . . great! Now it's time to think about how you can turn that idea into your next drawing. Regardless of the subject matter, all drawings, including cartoons, are made up of five compositional elements: lines, shapes, spaces, values, and textures. Essentially, the way you draw these elements conveys your idea to the viewer. For instance, imagine two drawings of your living room, one made with smooth, curving lines and the other made with sharp, jagged lines. Even though both drawings depict the same space, they feel very different because of the different decisions the artists made about lines and textures.

Think about your idea and the story you want your cartoon to tell and make sure that your compositional choices support them. For example, within your drawing, you can arrange objects any way you like, depending on the sense of space you want to portray. You can group characters together or place them far apart to set up the dynamics of relationships between them. You can use compositional tools like eye path and focal point to lead the eye of the viewer to the most important character or action in your cartoon. (See Part II for more details on incorporating different lines, shapes, spaces, values, and textures into your drawings and on using eye paths and other tools to convey your ideas.)

When you aren't sure what lines, shapes, spaces, values, and textures to incorporate into your drawing, go back to your original idea and think about which choices make the most sense for that particular idea.

Choosing the Right Materials

You can use almost any art materials to make a good cartoon; however, it's a good idea to decide upfront which materials you'll use early in the drawing process versus which ones you'll use to finish your cartoon. The best materials to use when you're getting started give you maximum flexibility so

that you can easily make changes, while the best materials to use during the final stages perform in a reliable way every time you use them and give you maximum impact. (See Chapter 2 for more on what tools you need for any drawing.)

Here are the best materials to use when you're starting your cartoon:

- **Pencil:** Mechanical pencils offer the cleanest lines and are easy to erase. All you need is a 2H pencil if you plan to ink your cartoon later.

- **Vinyl eraser and kneaded eraser:** When it comes to eliminating marks, vinyl erasers are more powerful than kneaded erasers. They're great for erasing any graphite you want to get rid of completely, whether you need to erase a large area of your drawing or just some stray marks. Kneaded erasers are gentler and more versatile. They're perfect for lightening lines you want to keep. To use a kneaded eraser, you can either rub the eraser across the paper to remove marks or press the eraser down on the paper and lift up to lighten marks.

- **Ruler and plastic triangle:** A ruler is the ideal tool for drawing straight lines. But you can also combine a ruler with a plastic triangle to draw perfect 90-degree angles. Simply place one edge of the triangle up against one edge of the ruler; where they meet is a perfect 90-degree angle. This duo comes in handy when you're drawing buildings, windows, doors, and so on.

- **Tracing paper and smooth drawing paper:** We suggest using marker paper for your cartoon drawings because the surface is very smooth and bleed-proof, but you can also try out illustration board and Bristol board. *Illustration board* is a smooth, lightweight cardboard. *Bristol board* is basically just a double-sided, textured paper; it comes in a variety of thicknesses. Most well-stocked art supply stores carry these different papers. They're a little more expensive than standard drawing paper but definitely worth the extra money.

Here are the best materials to use when you're finishing your cartoon:

- **Dip pens:** You dip these pens into ink to make your marks on paper. You can buy one or more interchangeable nibs of various shapes and sizes to fit your dip pens so that you can create interesting line variations.

- **Brush pens:** These felt-tipped markers have flexible brush-shaped nibs that allow you to draw *calligraphic lines* (flowing lines with gradual, brush-like transitions between thickness and thinness). Like dip pens, brush pens are useful for inking drawings of any subjects that need a variety of line widths, such as people, animals, and trees.

 ✔ **Technical pens:** These pens make it easy to draw lines of precise, dependable widths. You want to have a range of widths (.005, .05, and so on) on hand so that you can control the width of the lines but still create lines of a variety of widths.

 ✔ **Good-quality colored pencils:** Ask someone at the art supply store to recommend a good brand of colored pencil. Although they're more expensive, the price is well worth the results they create. Cheaper colored pencils like the ones you used to fill in maps at elementary school don't begin to compare. You can purchase good colored pencils individually so that you don't have to pay a large sum of money to get started.

Setting Up a Place to Draw

Find a space in your home where you can sit comfortably and have easy access to all your drawing supplies. Tape your drawing paper to the surface you're working on so that it doesn't move around while you're drawing. We suggest that you use a portable drawing board rather than a table as your drawing surface so that you can rotate the board while you work. (See Chapter 2 for more details on how to set up a drawing work space.)

Make sure that you have good, consistent light around you so that you can see what you're drawing. Whatever light source you use, whether it's a desk lamp, an overhead light, or something else, just make sure that it's bright enough that you're not struggling to see but not so bright that you feel blinded.

Sketching Your Idea

After you have your idea and you've given some thought to the types of lines and values you want to use, you can begin to sketch your idea. Start with thumbnail-sized sketches. Small sketches allow you to work through several ideas quickly so that you can look for the one that tells your story the most effectively. In addition to giving you options to choose from, your thumbnail sketches give you a chance to work out the bugs in your composition before you commit them to a larger and more involved drawing.

Plan to make five or six possible compositions for any drawing you want to make. (Five or six is just a guideline; if you feel like you need more than six sketches, go ahead and draw them!) In each thumbnail, experiment with the placement of objects and determine which composition you like best. If you make one that you like but realize you'd like it better if only part of it were

different, make another sketch to test this idea. (See Chapter 6 for more details about making thumbnail-sized sketches and creating different compositions.)

After you choose the sketch you think will work the best, use your 2H pencil to develop it into a full-sized sketch on your smooth drawing paper.

Evaluating Your Sketch

To evaluate your completed sketch, consider your original cartoon idea. Try to decide whether or not other people will be able to get a sense of your intention from your sketch. Show the sketch to a trusted friend to get some feedback. Then make any changes you think will help make your idea clearer and your drawing more effective.

Planning Your Values

If you plan to shade your drawing, use some tracing paper to plan your values before you commit to them. Try out a few variations to give yourself several options. For example, you can try out different settings for your drawing by using mostly dark values in one tracing-paper plan to suggest nighttime and using mostly light values to suggest daytime in another plan. Then decide which one you think works best in your drawing. (See Chapter 9 for everything you need to know about shading and adding values to your drawings.)

You can use any kind of marks to create a full range of values from light to dark. For example, you can build values with dots, stripes, scribbles, exclamation points, and anything else you can think of. It's simply the accumulation of marks that makes values darker.

Cleaning Up Your Drawing

Before you add the final values, colors, and/or ink to your cartoon, spend some time cleaning up the drawing. Use your vinyl eraser to get rid of any lines you don't need and any smudges you see. Use your 2H pencil to firm up any lines that seem too tentative. Then tap all your lines with the kneaded eraser to remove excess graphite.

Inking Your Work

Before you commit to ink, make sure that you're happy with your sketch and confident about the values you want to create. Wait until you're feeling calm to apply ink to your work. Inking your work just after you spill a pot of coffee may lead to jittery mistakes that you can't undo! Practice making your ink strokes on a separate piece of paper to get a feel for how wide of marks your pens make and for what happens when you lift the pen off the paper. When you're finished practicing, take your pen in hand and draw smoothly and confidently. Don't worry if you make a few mistakes; everyone makes them from time to time. You can always start over. As frustrating as starting over can be, each drawing you make increases your skills and your confidence.

When you're using ink to add shading to a drawing, you can use several different techniques, like hatching and cross-hatching, to make your drawing appear to have varying shades of gray, despite the fact that all your ink is one color. (Check out Chapter 9 for details about these different shading techniques. Although we describe and illustrate them using pencil, the basic ideas are the same for ink.)

Consider whether you want to add any color to your work. If you do, decide whether you want to use colored pencils, colored inks, watercolors, or another type of colored media. Some colored media, like watercolors and colored inks, work well with black ink; however, be sure to always experiment with combining different drawing media before you add them to your final drawing.

Chapter 17

Ten Ways to Grow as an Artist

In This Chapter

▶ Appreciating different drawing styles and media

▶ Developing creative individuality as an artist

▶ Expanding your artistic journey and sharing your work with others

The 21st century is a great time to be an artist because every aesthetic avenue is open to you. Whether you like your art to be playful, serious, shocking, or anything in between, you can find your niche in today's art community. Just don't put too much pressure on yourself to decide what kind of artist you want to be. As you begin to develop preferences and become aware of your artistic tendencies, your artistic persona will emerge on its own. All you have to do is stay true to yourself, trust your instincts, and embrace change and growth when they come your way. Sounds simple enough, right?

No matter how successful you become, always try to find new ways to challenge yourself. The challenges you face in drawing are undoubtedly one of the main reasons why you keep coming back to your drawing table.

This chapter offers some great tips for how to find your way into the art world and how to keep growing as an artist once you get there.

Step into Art Appreciation

If you're ready to start growing as an artist, we recommend beginning with the art of others. Yep, you heard us correctly — put down your drawing pencil and pick up your note-taking pencil. You can discover so much about yourself as an artist by studying the works of others, and thanks to museums, galleries, art books, and the Internet, you don't have to go far to find more than enough art to study. So take some time to examine and appreciate a diverse range of art and artists. Don't worry if you don't like everything you look at; appreciating art means finding out what it's about, not loving every piece you see.

Here are just a few ways to start appreciating art:

✔ **Visit art museums and galleries so you can look at art in person.** Seeing art up close is a very different experience from seeing it in books or online. When viewing a work of art in person, you can see all the so-called imperfections that photography covers up; these imperfections offer proof that human hands, not cameras or other techno gadgets, created the work you're seeing. Take a sketchbook and pencil with you every time you visit a museum so that you can keep track of the artists you like and want to know more about.

✔ **Watch your local newspapers and media for upcoming art exhibitions and plan to attend as many as possible.** You can usually meet and chat with artists in your community by attending the openings of these exhibitions. Don't be intimidated by their success. Take the opportunity to ask your fellow artists what inspires them or how they come up with the ideas behind their pieces. You may be surprised by how much you can learn about yourself just by talking to your peers.

✔ **Get involved in a local art association.** You can learn as much from participating in a conversational circle as you can from viewing art itself. Just remember to keep an open mind and enjoy the diversity of creative concepts being explored by contemporary artists. Don't worry if you feel like the art appreciation group is speaking a foreign language the first few times you meet; you'll get the hang of it, and you have much to gain even if you just listen to everyone else talk.

Experiment with Drawing Media

When you're first getting started with drawing, you may feel too overwhelmed by the new skills you're trying to master to think much about what drawing media you're using. Even in the beginning, though, it's a good idea to branch out and try other drawing tools besides just pencils. You may love pencils, and that's perfectly fine, but you can learn a lot about drawing and about yourself simply by trying new drawing media. In time, your favorites will make themselves known to you, but even then, try to keep an open mind. Step away from what's comfortable every now and then — especially if you ever feel like you're stuck in a rut.

Here are some drawing media that can be really fun to work with but that we don't have time to cover fully in this book:

✔ **Chalk pastels:** Pastels come in an infinite range of colors that you can layer and blend to create paintlike qualities of color and value. Check out *Pastels For Dummies* by Sherry Stone and Anita Giddings (Wiley) to find out a whole lot more about this colorful drawing medium.

✔ **Charcoal:** This medium works great for sketching because it creates such rich, intense blacks. It also blends well — thanks to its soft texture — and is fairly easy to erase. But because charcoal is somewhat messy, easy to smudge, and slightly abrasive (in other words, not as smooth to draw with as graphite), you have to put in a little extra work to keep your drawings clean.

Charcoal comes in the following four main forms:

Compressed charcoal is rectangular or round, makes a very dark mark, and is the hardest form to control.

Charcoal pencils can be sharpened with a regular pencil sharpener, make very dark marks, and are the easiest form to control.

Vine or *willow charcoal* is shaped like a twig, is very crumbly, makes soft grays, and is the easiest form to erase.

Powdered charcoal is a fine powder that can be applied with a brush, cotton swab, or your fingers; it's excellent for toning surfaces to do subtractive drawing.

You can use water and a brush to make charcoal wash drawings. If you want to try this technique, make sure you use a paper that can stand up to water washes; watercolor paper is a great option.

✔ **Colored pencils:** Colored pencils come in vast ranges of colors that you can purchase individually or in sets at art supply stores. You can dry mix different colors by layering them on top of one another. Colored pencils don't smudge easily and are very clean to work with, but they're also difficult to erase.

To get unconventional effects with colored pencils, you can use a brush and odorless mineral spirits. If you want to try this technique, read all the health cautions on the mineral product and make sure you're in a well-ventilated area.

✔ **Conté:** Conté (also called *conté crayon*) shares many of the same characteristics as charcoal, but, unlike charcoal, it comes in a wonderful range of earth tones. A basic set of conté includes black, a couple of grays and sepias (browns), and white.

✔ **Ink:** Today's inks come in a wide range of colors. You can use various tools, including brushes and technical pens, to apply ink to paper; however, disposable pens and markers have become popular in recent decades and are much more convenient to use. A thin wash of ink provides gorgeous abstract backgrounds for drawings.

✔ **Thread:** Embroidery has long been used to add beautiful embellishments to domestic objects and clothing. Today many artists embrace embroidery as a medium for drawing, too. You can use pencil to sketch your ideas on cloth and then use a needle to draw those ideas with any of the beautifully colored threads available at any craft or fabric store.

Figure Out Who You Are as an Artist

Figuring out who you are as an artist is something you'll work on throughout your artistic life. Just like your sense of self as a person, your sense of self as an artist is always changing. The added bonus of constantly asking yourself who you are as an artist is that the answer can help you address another ever-present question: What kind of work should you do?

Following are some ways to figure out who you are as an artist (see Chapter 5 for details on how you can start seeing as an artist):

- **Pay attention to your responses to life.** Those responses are the keys to understanding what you're really interested in.

- **Start collecting things that catch your eye.** Newspaper clippings, postcards, and photographs are good places to start. Set up a bulletin board so that you can display these items in the space where you do your creative work. At first, this process may seem self-indulgent, but it's a great habit to cultivate. Over time, you may notice patterns in the kinds of things you collect, which can help lead you to who you are (or want to be) as an artist.

- **Keep a journal to record your thoughts about art.** Pay special attention to any shifts in thinking; these shifts can help you discover where you want to go next in your artistic life.

- **Post images of art you like on a blog and try to generate thought-provoking discussions with your friends.** Creating an online art-related forum is a great way to share your thoughts with others and hear what others have to say in return. Make a note to yourself about your responses to any discussions you have as a result; you may be surprised by what you learn about yourself as a person and as an artist.

Investigate Different Drawing Styles

Some individuals try to fit all art into neatly labeled categories like the ones you see here:

- *Abstract art* (sometimes called *nonrepresentational art*) focuses on form rather than specific visual references. In other words, it focuses on the elements of art, like lines, shapes, colors, values, and textures, and their arrangement on the drawing surface. Appreciating abstract art sometimes requires understanding and patience because it may not include any recognizable subjects.

- *Impressionism* tends to be an impression of a subject rather than a depiction of the way the object actually looks. Impressionistic drawings are often bold and vibrant and usually lack fine detail.

✔ *Realism* (also known as *representational art*) is an approach to art whereby the artist intends to represent subject matter as it actually is.

✔ *Photorealism* is a style in which the drawings look more like photographs than drawings. Because cameras have only one lens for viewing the world (compared to the two eyes that human beings have), all photographs have some distortions no matter how realistic they appear. Photorealists faithfully re-create the effects of these distortions in their drawings and paintings.

✔ *Surrealism* is a style in which artists let their imaginations influence realistic subjects. The objects in surreal drawings are usually recognizable but transformed by creative imagery. Some surrealist artists feel their images surface from their subconscious.

Although one or more of these drawing styles may seem to describe your current work more than the others, as with clothing, styles of art tend to go in and out of fashion. Instead of trying to fit into one of these labels, draw what you want and how you like; try to stay true to yourself, not an artistic label.

To stay true to yourself, you need to do some introspective exploring to gain insight into your unique artistic strengths and preferences. Although you (and your work) are always changing, your personal artistic identity emerges based on the following:

✔ The subjects you find most appealing and love to draw

✔ Your unique way of viewing the world around you

✔ The styles of drawings you prefer

✔ The drawing techniques you enjoy and the media you use

✔ Your acceptance of the challenge to deviate from the "norm" and be true to yourself

✔ Your personal needs to communicate through your art

✔ Your unique storehouse of life experiences and personal values

Your style continues to evolve and change for as long as you draw. Maintain your sketchbook and save some of your drawings. Reflecting on your personal journey is an important part of your continued growth as an artist.

Work from Life and Photographs

Drawing what you see in life is an invaluable experience. It's the best way to study (and figure out how to represent) the way light and shadows play across three-dimensional forms. However, working from life isn't always an option. Imagine, for example, that you want to draw a circus. Although you can't really set up and draw from life at the circus, don't just abandon your

idea! Instead, turn to the next best thing to real life — photographs. Use a photograph (or a series of photographs) of a circus and draw from what you see in it.

Whenever you're going to a place where you'd love to sketch but you know doing so is impractical, tuck your camera into your bag. That way, you're ready when you see something you'd love to draw!

Although photographs offer a great alternative to real life, you need to be aware of a few special problems associated with them:

- ✓ **The camera looks at the world with a single lens; it can't replicate the depth you see with your eyes.** If you're faithful to a photograph, the image you create will be somewhat flat.

- ✓ **Photographs and copyright issues often go hand in hand.** For example, if you find a great photograph in a magazine and make a drawing from it, you may be unwittingly committing plagiarism. (See Chapter 18 for more information about copyright issues and how to avoid them.)

It's perfectly safe to draw from your own photographs, photographs given to you by friends or family, and very old photographs. And you can certainly draw from famous photographs published in magazines and other sources as long as you do so to develop your drawing skills and you don't take credit for creating the image.

Attend Art Classes, Lessons, and Workshops

You can always benefit from attending drawing classes and workshops. Not only do you meet others like you who are looking to improve their drawing skills, but you also expose yourself to different techniques and drawing styles. This exposure can help you further develop your own style and maybe even branch out to something entirely new.

If you can, try to attend a life-drawing class. This type of class offers the highly rewarding opportunity to draw from live models, which can really help you develop your drawing skills. Before you go to such a class, check out Chapter 15 for everything you need to know about drawing people.

As you uncover local art resources, you meet other artists and have opportunities to become involved in art groups. Many art groups organize inexpensive figure-drawing sessions, workshops, and even informal critiques. Check out your local community-based educational facilities and recreational centers for art programs in your area.

You can find lots of drawing help on the Internet. Check out Chapter 4 for some great suggestions about locating online drawing tutorials.

Give Painting a Try

If you're thinking about taking up painting, stop thinking and do it! Although having drawing skills can help you develop painting skills, you don't have to be able to draw well to begin to learn to paint. Because painting reinforces the habit of comparing relationships of shape, size, and value, you'll probably find that taking up painting actually strengthens your drawing skills.

Because painting takes a lot of specialty equipment and is easiest to learn with the guidance of an experienced teacher, look for a community class or summer workshop. And if you're interested in a specific type of painting, consider checking out one of the following titles (all published by Wiley):

- *Acrylic Painting For Dummies* by Colette Pitcher
- *Oil Painting For Dummies* by Anita Giddings and Sherry Stone Clifton
- *Watercolor Painting For Dummies* by Colette Pitcher

Ignite Your Sparks of Creativity

Trust in the value of your ideas. No one looks at the world exactly the way you do. Keep a sketchbook with you so that you can jot down ideas for drawing the moment you have them.

Refill your creative well. When ideas don't come to you naturally, don't try to force them; you'll only frustrate yourself. Instead of focusing on yourself, look outward at things like books, movies, music, walks, and conversations with friends. You may be surprised by how much spontaneous inspiration you'll find when you're not forcing it!

Put Your Drawings on the Internet

If you're ready to start sharing your drawing skills with friends, family, and others (and receiving feedback from them), you have many free or inexpensive options to choose from online. Many photo-sharing Web sites offer free memberships, and anyone can fill out a profile form and then upload an unlimited number of images. Depending on your preferences, you can usually opt to share them privately or publicly.

Here are a few good photo-sharing Web sites to try out:

- www.picasa.google.com
- www.flickr.com
- www.photobucket.com

Although showing your work to others can be scary, especially if doing so is new for you, it's an important and exciting part of being an artist. All the feedback you get, even the negative stuff, is helpful if you embrace it the right way. Because you know your work so thoroughly from your own point of view, other people can often point out things you may not see. You don't have to agree with everything your viewers says, but knowing what kind of response people have to your work is important to your growing as an artist.

If you'd rather create your own free Web page where you can display your work, simply type *free personal Web pages* into any search engine and choose a home for your site. Most of these resources offer easy-to-follow instructions for setting up your page and getting it online.

Interested in drawing with your computer? Web sites like www.ratemy drawings.com enable you to use digital tools to create drawings online and then share them with the site's member audience. Sites like this one allow you to get feedback on your work and find a community of art-minded people to share ideas with. (Check out Chapter 4 for more details on drawing with your computer.)

Look for Other Ways to Get Your Work Out There

So you've been drawing for a little while now and you'd like to do something with the pile of artwork that's accumulating? Well, maybe it's time to think about exhibiting your work in a show. By displaying your work for others to see, you create an opportunity to see how people respond to your work.

Local galleries can be intimidating when you're first starting out, but don't worry. They aren't the only place in town to exhibit your work. Many restaurants and coffee houses love to exhibit work by local artists. Look around your town for venues that display original art made locally. Check with the venues' staff to find out about their submission policies.

Many towns have cooperative galleries, which are typically run by members who pay regular dues. In exchange for dues and possibly volunteer work, members have the privilege of showing artwork. At some cooperative galleries, you can display your work all the time. At others, you may be invited to take part in periodic group and/or solo shows. Research the galleries in your town to find out whether any of them are cooperative.

Chapter 18

Answering Ten Common Copyright Questions

All artists — yes, we mean you, too — need to understand and respect the laws of copyright as they pertain to art. To help you understand what copyright is and what it means for you as an artist, we dedicate this chapter to answering ten common copyright-related questions.

Note: These answers are meant only as a guide. To be sure you're handling copyright issues legally, consult the U.S. Copyright Office or a lawyer who specializes in copyright law. If you live outside the United States, find a similar government office in your country.

In some cases, copyright laws depend on where you live and work in the world. If you have any questions about copyright issues regarding your work, consult a lawyer who is familiar with the laws in your specific region.

What Is Copyright?

The U.S. Copyright Office says that *copyright* is a form of protection that grants artists the exclusive right to sell, reproduce, exhibit, and make derivative works from their original drawings or other creative works. The original artist is the sole owner of the copyright to his or her work.

What copyright means for you as an artist is that you get to control what happens to your drawings or other creative work after you make them. For example, if you upload an image of a drawing you created to the Internet, your copyright makes it illegal for someone else to use your drawing as a T-shirt design, greeting card, or anything else without first obtaining your permission.

What Kinds of Works Are Protected by Copyright?

You can copyright any original drawing or other creative work that you make. According to the U.S. Copyright Office, "Copyright law protects original works of authorship." *Original* means wholly new. So if you copy the work of another, whether in whole or in part, the work you create isn't considered original, no matter how much you change or add to the copied work — which means you can't copyright it. *Authorship* is the fact of having created something. A work of authorship is any original, creative product, whether it's a book, computer program, sculpture, drawing, or any other creative work. When you create an original drawing, you're the author of that drawing, according to copyright law.

U.S. Copyright law states that copyright doesn't protect ideas; however, it may protect the way ideas are expressed. For example, ideas, such as love, loss, and growth, are impossible for anyone to own, but the way ideas are expressed — the artistic form through which artists represent ideas — can be original and, as such, can be copyrighted.

When Is an Artwork Not Original?

An artwork is not original when the art is copied from an idea or image that is copyrighted by someone else. So if you base your drawings on cartoon characters or artworks by other artists, pictures in books or on the Internet, or photographs taken by someone else, you can't claim copyright for your works because they aren't considered original.

It's okay to copy from the copyrighted works of other artists as long as you either get permission from the original artist or you do so only for research and learning purposes. Although you can't claim your reproductions of other artists' work as your original drawings, copying from other artists is a great way to improve your drawing skills. (See the next section on drawing from copyrighted images for more details.)

Can I Draw from Copyrighted Images?

You can draw from a copyrighted image if you have the permission of the person who owns the copyright (in most cases, this is the person who conceptualized and physically created the original work) or if the reason why you want to copy the image is covered in the fair use doctrine of U.S. copyright law. According to the U.S. Copyright Office, the fair use doctrine (section 107 of U.S. copyright law) "contains a list of the various purposes for which the reproduction of a particular work may be considered fair, such as criticism, comment, news reporting, teaching, scholarship, and research."

If you want to copy from a copyrighted work for the purpose of research, don't expect to present your copy as an original work or to use it for any other purpose because doing so would be illegal. If you have any doubts about whether your purpose for copying an original work is covered by the fair use doctrine, consult a copyright lawyer.

If I Make Changes to a Copyrighted Image, Can I Make It My Own?

Making changes to a copyrighted image does not make that work your own. You may hear that you can draw from a copyrighted image, change 10 percent of the image, and copyright the work as your own, but, according to the U.S. Copyright Office, you can't.

Can I Draw from the Illustrations in This Book?

This book is designed to help you use the illustrations featured in it as tools for developing your drawing skills. We straight-up tell you to copy from the illustrations! However, you can't claim copyright to any of the drawings you create based on the illustrations or images you see in this book. Doing so would be considered plagiarism.

Plagiarism is attempting to take credit for someone else's original artwork or other creative work. According to the U.S. Copyright Office, if someone plagiarizes someone else's copyrighted artwork, the owner of the copyrighted work may be able to sue for damages. Fortunately, you can easily avoid plagiarism! Just be sure you don't present reproductions of anyone else's copyrighted artwork as your own.

How Do I Claim Copyright to My Original Art?

If you live in a country that has signed the Berne Convention for the Protection of Literary and Artistic Property (often just called the Berne Convention), the act of claiming copyright is simple. From the moment your art is completed, you automatically own the copyright. Just a few of the countries that have signed the Berne Convention are Australia, Canada, China, France, Germany, India, Italy, Mexico, the Russian Federation, the United Kingdom, and the United States of America.

If you're curious about whether your country has signed this convention, just type *Berne Convention signatories* into your favorite search engine. If your country hasn't signed the Berne Convention, your country may have alternative copyright regulations in place. To find out if it does, do some research to determine whether your government has an office of copyright law. If you can't find an office of copyright law, check with your local library.

Just because you claim copyright doesn't mean you can legally prove you own your copyright. To find out how to obtain legal proof of copyright, check out the next section.

How Can I Prove That I Own Copyright?

In the United States, the only official way to prove you own your copyright is to register your work with the U.S. Copyright Office. Why would you need to prove you own copyright to your work? The U.S. Copyright Office says that in order to bring an infringement lawsuit, you must have registered your original artwork with the Copyright Office. (An *infringement* is a violation; a copyright infringement is any violation of copyright law.)

To find out how to register your work, check out the Web site www.copyright. gov. You have to pay a fee to register your works, but it may be worth the peace of mind you get from knowing your work is protected.

You may have heard of an old method for guaranteeing ownership of a work of art that involved simply mailing a copy of the work to yourself. Although this strategy may help you win an argument amongst friends, according to U.S. copyright law, it won't hold up in court.

Can I Put a Copyright © Symbol on My Original Art?

As long as you're the original creator of an artwork, you have the right to put the copyright symbol on it. Your work doesn't have to be officially registered with the U.S. Copyright Office for you to use the copyright symbol.

How Do I Use the Copyright © Symbol?

A legitimate statement of copyright needs the following three elements:

- ✔ The copyright symbol
- ✔ The year the artwork was created
- ✔ The name of the artist

Here's an example: **Copyright © 2015, Joe Artist.** You can put this information anywhere on your drawing, but the ideal spot for it is one that's clearly visible but that doesn't distract the viewer from looking at the artwork.

Index

• *M* •

• *Q* •

Notes

Notes

Apple & Macs

iPad For Dummies
978-0-470-58027-1

iPhone For Dummies,
4th Edition
978-0-470-87870-5

MacBook For Dummies, 3rd
Edition
978-0-470-76918-8

Mac OS X Snow Leopard For
Dummies
978-0-470-43543-4

Business

Bookkeeping For Dummies
978-0-7645-9848-7

Job Interviews
For Dummies,
3rd Edition
978-0-470-17748-8

Resumes For Dummies,
5th Edition
978-0-470-08037-5

Starting an
Online Business
For Dummies,
6th Edition
978-0-470-60210-2

Stock Investing
For Dummies,
3rd Edition
978-0-470-40114-9

Successful
Time Management
For Dummies
978-0-470-29034-7

Computer Hardware

BlackBerry
For Dummies,
4th Edition
978-0-470-60700-8

Computers For Seniors
For Dummies,
2nd Edition
978-0-470-53483-0

PCs For Dummies,
Windows
7 Edition
978-0-470-46542-4

Laptops For Dummies,
4th Edition
978-0-470-57829-2

Cooking & Entertaining

Cooking Basics
For Dummies,
3rd Edition
978-0-7645-7206-7

Wine For Dummies,
4th Edition
978-0-470-04579-4

Diet & Nutrition

Dieting For Dummies,
2nd Edition
978-0-7645-4149-0

Nutrition For Dummies,
4th Edition
978-0-471-79868-2

Weight Training
For Dummies,
3rd Edition
978-0-471-76845-6

Digital Photography

Digital SLR Cameras &
Photography For Dummies,
3rd Edition
978-0-470-46606-3

Photoshop Elements 8
For Dummies
978-0-470-52967-6

Gardening

Gardening Basics
For Dummies
978-0-470-03749-2

Organic Gardening
For Dummies,
2nd Edition
978-0-470-43067-5

Green/Sustainable

Raising Chickens
For Dummies
978-0-470-46544-8

Green Cleaning
For Dummies
978-0-470-39106-8

Health

Diabetes For Dummies,
3rd Edition
978-0-470-27086-8

Food Allergies
For Dummies
978-0-470-09584-3

Living Gluten-Free
For Dummies,
2nd Edition
978-0-470-58589-4

Hobbies/General

Chess For Dummies,
2nd Edition
978-0-7645-8404-6

Drawing
Cartoons & Comics
For Dummies
978-0-470-42683-8

Knitting For Dummies,
2nd Edition
978-0-470-28747-7

Organizing
For Dummies
978-0-7645-5300-4

Su Doku For Dummies
978-0-470-01892-7

Home Improvement

Home Maintenance
For Dummies,
2nd Edition
978-0-470-43063-7

Home Theater
For Dummies,
3rd Edition
978-0-470-41189-6

Living the
Country Lifestyle
All-in-One
For Dummies
978-0-470-43061-3

Solar Power Your Home
For Dummies,
2nd Edition
978-0-470-59678-4

Internet

Blogging For Dummies,
3rd Edition
978-0-470-61996-4

eBay For Dummies,
6th Edition
978-0-470-49741-8

Facebook For Dummies,
3rd Edition
978-0-470-87804-0

Web Marketing
For Dummies,
2nd Edition
978-0-470-37181-7

WordPress
For Dummies,
3rd Edition
978-0-470-59274-8

Language & Foreign Language

French For Dummies
978-0-7645-5193-2

Italian Phrases
For Dummies
978-0-7645-7203-6

Spanish For Dummies,
2nd Edition
978-0-470-87855-2

Spanish
For Dummies,
Audio Set
978-0-470-09585-0

Math & Science

Algebra I
For Dummies,
2nd Edition
978-0-470-55964-2

Biology For Dummies,
2nd Edition
978-0-470-59875-7

Calculus For Dummies
978-0-7645-2498-1

Chemistry For Dummies
978-0-7645-5430-8

Microsoft Office

Excel 2010 For Dummies
978-0-470-48953-6

Office 2010 All-in-One
For Dummies
978-0-470-49748-7

Office 2010 For Dummies,
Book + DVD Bundle
978-0-470-62698-6

Word 2010 For Dummies
978-0-470-48772-3

Music

Guitar For Dummies,
2nd Edition
978-0-7645-9904-0

iPod & iTunes For
Dummies, 8th Edition
978-0-470-87871-2

Piano Exercises
For Dummies
978-0-470-38765-8

Parenting & Education

Parenting For Dummies,
2nd Edition
978-0-7645-5418-6

Type 1 Diabetes
For Dummies
978-0-470-17811-9

Pets

Cats For Dummies,
2nd Edition
978-0-7645-5275-5

Dog Training For Dummies,
3rd Edition
978-0-470-60029-0

Puppies For Dummies,
2nd Edition
978-0-470-03717-1

Religion & Inspiration

The Bible For Dummies
978-0-7645-5296-0

Catholicism For Dummies
978-0-7645-5391-2

Women in the Bible
For Dummies
978-0-7645-8475-6

Self-Help & Relationship

Anger Management
For Dummies
978-0-470-03715-7

Overcoming Anxiety
For Dummies,
2nd Edition
978-0-470-57441-6

Sports

Baseball
For Dummies,
3rd Edition
978-0-7645-7537-2

Basketball
For Dummies,
2nd Edition
978-0-7645-5248-9

Golf For Dummies,
3rd Edition
978-0-471-76871-5

Web Development

Web Design
All-in-One
For Dummies
978-0-470-41796-6

Web Sites
Do-It-Yourself
For Dummies,
2nd Edition
978-0-470-56520-9

Windows 7

Windows 7
For Dummies
978-0-470-49743-2

Windows 7
For Dummies,
Book + DVD Bundle
978-0-470-52398-8

Windows 7 All-in-One
For Dummies
978-0-470-48763-1